Aesthetic Programming
A Handbook of Software Studies

Winnie Soon and Geoff Cox

Web https://www.aesthetic-programming.net

Repository https://gitlab.com/aesthetic-programming/book

AESTHETIC PROGRAMMING
A Handbook of Software Studies

Winnie Soon and Geoff Cox

Published by Open Humanities Press 2020
https://openhumanitiespress.org/

ISBN (print) 978-1-78542-094-8

ISBN (PDF) 978-1-78542-093-1

Table of Contents

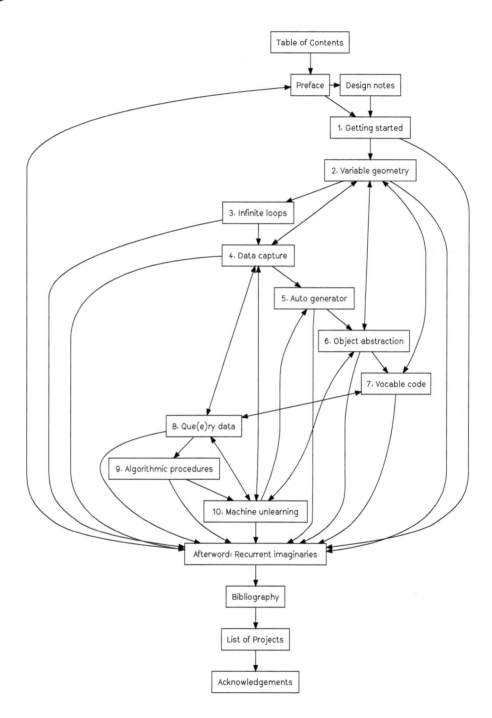

Preface

Contents

What kind of book is this?

As indicated by its subtitle, this book is meant to be a handbook of sorts, but not in any conventional sense of it being a prescribed set of technical instructions. (1) It is not meant to be read to simply learn to code nor to offer critical reflection upon the practice of coding alone, instead it offers something more messy and at the same time more "useful" we would say: a book about the more complex and deeply entangled set of relations between writing, coding and thinking. (2)

Most programming books are written with the primary objective of teaching readers how to learn a programming language to become a good (or better) programmer, with an emphasis on state-of-the-art technology, as well as practical examples that are explained and then designed to be deployed in technology-related or creative industries. Not many programming books address the cultural and aesthetic dimensions of programming as a means to think and act critically. (3) Emerging trans-disciplinary fields involving computational technology — such as software studies, platform studies, and digital humanities to an extent — incorporate the practice of programming into the object of study, yet little practical detail is provided in terms of putting programming into a critical perspective, especially for those studying non-technical or non-scientific disciplines. This book attempts to address this gap between available literature and the growing interest in "computational thinking" (4) to expand programming beyond the confines of computer science or software engineering (or even the digital humanities, which ultimately presents another set of limitations). We consider our approach to be distinctive from other books in this regard, as well as from other theoretical books in which source code becomes an illustration of the programmer's thinking or a too-easy analogy for the hidden layers of operations (if not ignored altogether).

Whilst operating broadly in the spirit of Software Studies, (5) the book offers an applied and overtly practice-based approach to understanding the importance of programming — reading, writing and thinking with software — as a critical tool for our times, in recognition of the way in which our experiences are ever more programmed. It is offered as a deep learning "tool" in its widest sense — a handbook for those unaccustomed to programming — that allows for the programmer's conceptual skills to develop as they become technically more proficient.

To reiterate the point, our intention is for readers to acquire key programming skills in order to read, write and think with, and through, code (and we will return to the issue of literacy later). We feel that it is important to further explore the intersections of technical and conceptual aspects of code in order to reflect deeply on the pervasiveness of computational culture and its social and political effects — from the language of human-machine languages to abstraction of objects, datafication and recent developments in automated machine intelligence, for example. In other words, the book embraces both the technical aspects and formal qualities of code as well as opens up imaginaries of code, including acknowledgment of the material conditions of programming practice, the non-human agency of code itself, and its inherent relationality within broader ecologies.

Alongside learning to program, we aim to bridge the gap between theories of computational culture, aesthetics and cultural studies. As part of this, we take a particular interest in power relations that are under-acknowledged, such as inequalities and injustices related to class, gender and sexuality, as well as race and the enduring legacies of colonialism. (6) This is not only related to our own subject-positions and cultural backgrounds (see our biographies for more on this) and a politics of representation (the contested space between the subject and the representation of the subject), but also to how power differentials are implicit in code in terms of binary logic, hierarchies, naming of attributes, accessibility, and how wider societal inequalities are further reinforced and perpetuated through non-representational computation. In short, the handbook introduces and demonstrates a distinctive approach to the reflexive practice of what we call "aesthetic programming" as we explain and perform it, and to how it constitutes us as subjects.

Why aesthetic programming?

The argument the book follows is that computational culture is not just a trendy topic to study to improve problem-solving and analytical skills, or a way to understand more about what is happening with computational processes, but is a means to engage with programming to question existing technological paradigms and further create changes in the technical system. We therefore consider programming to be a dynamic cultural practice and phenomenon, a way of thinking and doing in the world, and a means of understanding some of the complex procedures that underwrite and constitute our lived realities, in order to act upon those realities.

The phrase "aesthetic programming" usefully describes this approach in our opinion. We claim a certain distinctiveness in this, but of course aesthetic programming is close to other phrases such as "creative coding" and "exploratory programming" that have been introduced in related literature in recent years to emphasize the expressivity of computer programming beyond something pragmatic and functional, in which cultural production, or critical thinking using the practice of programming, can be developed from the broad perspective of the arts and humanities. (7) It should be explained that the title "aesthetic programming" actually derives from one of the undergraduate courses of the Digital Design degree program at Aarhus University in Denmark, which has been taught in parallel to a course in Software Studies since 2013. Taken together, as they were designed, these courses offer ways of thinking with software to understand wider political and aesthetic phenomena. (8) We follow the principle that the growing importance of software requires a new kind of cultural thinking, and curriculum, that can account for, and with which to understand better, from within, the politics and aesthetics of algorithmic procedures, data processing, and abstracted modeling. The book's structure largely emerges from the experience of teaching these courses and we owe gratitude to all our students and fellow teachers for their valuable contributions and critical feedback along the way. (9)

Continuing the discussion of aesthetics, it should be clear that we do not refer to ideas of beauty as it is commonly misunderstood (aka bourgeois aesthetics), but to political aesthetics: to what presents itself to sense-making experience and bodily perception

(to paraphrase Jacques Rancière's *The Politics of Aesthetics*, as one key reference). (10)
How we perceive the world in this political sense is not fixed, but is in constant flux, much like
software itself and bound to wider conditions, and ecologies.

Political aesthetics refers back to the critical theory of the Frankfurt School, particularly to the
ideas of Theodor Adorno and Walter Benjamin, that enforce the concept that cultural
production — which would now naturally include programming — must be seen in a social
context. Understood in this way programming becomes a kind of "force-field" with which to
understand material conditions and social contradictions, just as the interpretation of art
once operated "as a kind of code language for processes taking place within society." (11)
The much-cited essay by Benjamin on technical reproducibility has become a touchstone for
collapsing some myths of artistic production including the dismantling of the aesthetic
experience of "aura" (the mark of an artwork's authenticity and originality). (12) It is also
worth remembering that Adorno and Benjamin famously disagreed on the consequences of
this destruction of aura: whilst Benjamin expressed the positive aspects of this shift and
viewed the destruction of aura as a kind of political emancipation, Adorno expressed the
negative view that standardization and pseudo-individuality would follow. It would seem that
both tendencies have accelerated with computational culture, hence the continuing need for
sharp critique, and one also based along the lines of "immanent criticism," that which is
inherent, as it operates within its object, in the inner workings of software and its material
conditions. (13) Yet it remains in question as to what extent these old (white, male)
references are up to the task of unpicking the complexity of computational operations, and
address the ways in which most people use computers or think about them. This is as much
to do with what aesthetic programming is becoming as to what it is or was, and why we still
take our point of departure from such references, also aware that they perpetuate problems
in themselves, and require alternatives.

If everything is in flux, as it would seem, then we also need to be sensitive to our received
methods, based as they are on Western traditions of knowledge production, and notions of
progress, rooted as it is in European colonialism and extraction practices. (14) We find the
work on Anna Lowenhaupf Tsing useful in this regard as it offers a feminist perspective in
which indeterminacy is taken more seriously to reflect the precarity of lived conditions. (15)
Not only are our theories of history and technology bound up with this but also critical
practices and other nonhuman imaginaries. Other ecologies open up ways of thinking that
are multidirectional, across times and scales, more open-ended and indeterminate, based on
ideas of "assemblage," as Tsing puts it. (16) We don't look to mushrooms for inspiration as
she does, but to the immanent and relational qualities of technology itself. More precisely we
have been working with fundamental programming concepts, such as geometry and object
abstraction; loops and temporality; data and datafication; variables, functions, and their
naming, as well as data capturing, processing and automation, as the starting point for
further aesthetic reflection whereby the technical functions set the groundwork for further
understanding of how cultural phenomena are constructed and operationalized.

Aesthetic programming in this sense is considered as a practice to build things, and make
worlds, but also produce immanent critique drawing upon computer science, art, and cultural
theory. From another direction, this comes close to Philip Agre's notion of "critical technical
practice," with its bringing together of formal technical logic and discursive cultural
meaning. (17) In other words, this approach necessitates a practical understanding and

knowledge of programming to underpin critical understanding of techno-cultural systems, grounded on levels of expertise in both fields (as in the case of Wendy Hui Kyong Chun or Yuk Hui, for example, who have transdisciplinary expertise (18)). Such practical "knowing" also points to the practice of "doing thinking," (19) embracing a plurality of ways of working with programming to explore the set of relations between writing, coding and thinking to imagine, create and propose "alternatives." (20) By engaging with aesthetic programming in these ways, we aim to further "queer" the intersections of critical and technical practices as in the many examples we refer to in this book (see "List of Projects," and exemplified by our references to Winnie Soon's work throughout), and to further discuss power relations that are relatively under-acknowledged in technical subjects. We hope to encourage more and more people to defy the separation of fields and practices in this way.

And software studies?

As stated, we draw heavily upon the field of Software Studies, and to an extent Critical Code Studies — the work of Wendy Chun, Matthew Fuller, Mark Marino, and others, including our own earlier work — to deal with and communicate knowledge of software as a cultural form via analyses of examples of software artefacts and close readings of theoretical texts and source code. In terms of approach we take our inspiration largely from Fuller's *Software Studies: A Lexicon* from 2008, structured literally as a lexicon of key terms, it in turn taking its cue from the Raymond Williams's *Keywords: A Vocabulary of Culture and Society* first published in 1958. (21) In many ways, and simply put, our book can be thought of adopting a similar approach of zooming in to the formal logic of computation and zooming out to the cultural implications of software. In this respect it is also important to recognize that the book *Software Studies* derived from a provisional workshop, and it is worth quoting the project page for its clarity of intention:

> "[T]he project aims at folding the internalist/externalist question of science studies inside out, the mechanisms of the one conjugating the subject of the other: what does software-enabled scholarship, in software, art, and literary practice have to say about its own medium? The purpose of this interaction is therefore not to stage some revelation of a supposed hidden truth of software, to unmask its esoteric reality, but to see what it is and what it can be coupled with: a rich seam of paradoxical conjunctions in which the speed and rationality of computation meets with its ostensible outside." (22)

We believe that paying attention to fundamental, or key, concepts from programming provides the opportunity to open up new insights into aesthetics and critical theory, as well as new perspectives on cultural phenomena increasingly bound to computational logic. In this way, although aware that we inhabit the problem, we think it important to work in this way, from the inner workings of software and its material conditions. By extending the discussion beyond formal logic to its outside, we also emphasize the usefulness of artistic practice for opening up more speculative, alternative, and messy imaginaries. In this spirit, and in keeping with the development of software studies in Europe at least, we take inspiration from what has been referred to as "software art" (although admittedly the

category was only meant as a placeholder) or "computational art." (23) That we draw upon examples from artistic (and critical design) practices as part of our argument, stresses our point that programming is not simply a practical tool that produces an artwork, but is a critical-aesthetic object (24) in itself. Curator Inke Arns neatly clarifies this:

> "'Software art' [--] refers to artistic activity that enables reflection of software (and software's cultural significance) within the medium – or material – of software. It does not regard software as a pragmatic aid that disappears behind the product it creates, but focuses on the code it contains – even if the code is not always explicitly revealed or emphasized. Software art, according to Florian Cramer, makes visible the aesthetic and political subtexts of seemingly neutral technical command sequences. Software art can base itself on a number of different levels of software: source code level, abstract algorithm level, or on the level of the product created by a given piece of code." (25)

We would argue something similar for this book. Moreover, in order to discuss the aesthetic dimensions of code and computational processes, we incorporate artistic works that explore the material conditions of software and the operations of computational processes as practical and theoretical examples. They are an integral part of our argument in other words, as well as serve to demonstrate some of the ideas in practice and offer unexpected epistemic insights. We might add, repeating what has already been introduced, that we are not simply interested in a critical aesthetics of programming but also programming as critical aesthetics.

Open publishing

More to the point, text is in code (in the ways that it is made human-readable) and code is in text (in the use of the text editor, interfaces and online platforms we use to render these thoughts). There is more to say on this, and we will return to these issues across the various chapters of the book, each following the logic of fundamental programming concepts. Suffice to say for now, that the book sets out to express how writing and coding are deeply entangled, and how neither should be privileged over the other: we learn from their relationality. Writing code and writing about code are forced together in ways that reflect broader cultural and technical shifts in data practices and open publishing initiatives, and, moreover, emphasize that writing a book is necessarily a work in progress. Like software, this is a book to be read, and acted upon, shared and rewritten.

There are clearly many precedents for such an overtly collaborative approach to software production, and clearly, free and open source principles underscore our thinking. It is worth emphasizing that FOSS development is a collective practice that challenges the normative relations of production associated with commercial development, such as a narrow definition of authorship and copyright, and fixed divisions of labor, which can be extended to the production of books and the associated reputation economy of academic publishing. However, we also recognize that the release of source code and open access books represents a number of ambiguities related to the sharing economy, free market capitalism,

and opportunities to capitalize on free labor. We persist in the hope that our efforts challenge reductive logic, and our publisher, Open Humanities Press, broadly reflects FOSS principles of transparency and reproducibility in its commitment to open access for scholarly work. (26) As such, this book can be downloaded for free or purchased as a hard copy at a reasonable price.

This is nothing particularly original. We acknowledge there are numerous other experimental publishing initiatives and even "anti-platforms" for decentralized article publishing. (27) There are also plenty of other examples that have picked up on the perversity of writing books about programming where you have to type out the examples to run them, and live coding platforms demonstrate alternatives (e.g. Jupyter Notebook or DevDocs (28)). Our use of print and an associated software repository is our way of managing this problem. This has also informed our choice of designers for the book: Open Source Publishing collective (OSP) design using only free and open source software — "pieces of software that invite their users to take part in their elaboration," as they put it (29) — and make all files freely available using a Git versioning system that contains all the files for the project, distributed under the terms of Version 2 of the GNU General Public License. The following chapter introduces this in more detail.

In brief, the use of a Git repository for our writing further emphasizes FOSS working principles, and, by treating writing as software, or indeed software as writing, allows us to formalize the production of the book as an iterative process, in need of timely updates, allowing for forking and endless reversioning. By allowing new versions to be produced by others, we hope in a modest way to challenge commercial publishing conventions and illuminate our capacity to understand some of the infrastructures through which we encode our ideas and distribute them across networks. We believe that this way of working marks a departure point for collectively engaging with programming and creating changes in the social-technical systems (both inside and outside). We aim to do something similar to what Adrian Mackenzie has identified as "auto-archaeology" to indicate how the object of study is fully integrated into the analysis, which he demonstrated using the associated GitHub site for his 2017 book *Machine Learners*. (30) This helps us as readers to understand something of the iterative process of writing a book about code in the spirit of how software developers collaborate, host, review, and merge code, as well as build software together. (31)

Flow of contents

Throughout this book, we use JavaScript as the main programming language with a primary focus on the open source and web-based library called p5.js, which already comes with a comprehensive and accessible resource for beginners to learn programming (more details will be included in chapter 1, "Getting started"). Our resource combines the aquisition of technical knowledge as a necessary part of doing critical work, all part of learning to program in its widest sense, programming as doing and thinking, as world-making.

Each chapter of the book starts with a flowchart (32) to provide a "diagram" of entangled relationships between the formal/technical and aesthetic/conceptual aspects of its contents. Each captures the dynamic (learning) processes in both concrete and abstract

representation for thinking with, especially the relations between the stage setup as expressed in the section "setup()," starting point as expressed in "start()," artefacts and sample code as expressed in "Source code," formal and discursive activities concerning code and syntax as expressed in "Exercises and discussion in class," and the further extended discussion as expressed in "While()." If a flowchart is conventionally used as an aid to the design of computational processes both for technical understanding and communication, (33) then we also consider critical reflection to be an integral part of that process. Indeed, the flowchart serves as the starting point to exemplify our approach of turning concepts "inside out" and the need to understand computational and programmable objects, relations, and processes in both logical and discursive forms.

Beginning with the first chapter, "Getting started," we illustrate the tools and environments that are required to use the book. The chapter is a guide to making your first program as a means to think through the notion of literacy, both in terms of writing code (RunMe) and writing about code (ReadMe). Chapter 2, "Variable geometry," explores the use of variables, and the drawing of geometric shapes, sizes, positions, space, and so on, to connect to the discussion of emojis and the politics of representation they invoke. Chapter 3, "Infinite loops," moves from static to moving objects using different syntaxes for transformation. Using the graphical spinning wheel icon of a preloader, we learn about conditional statements, loops, and time-related syntaxes, to reflect on how technologies play a crucial role in our experience of time. Chapter 4, "Data capture," introduces how a program captures and processes input data (via audio and webcam devices, mouse and keyboard press, as well as customizable and clickable buttons), and further discusses the consequences of capture and datafication. Chapter 5, "Auto-generator," focuses on how rules and instructions are performed, and how they can produce unexpected and/or complex results in generative systems, and produce emergent/queer life forms. At this point the book becomes more technically complex, and chapter 6, "Object abstraction," introduces object-oriented programming in which customizable properties and behaviors of objects are introduced, alongside a discussion of the movement between abstract and concrete reality. Chapter 7, "Vocable code," pays close attention to notation and computational structure, exploring the poetic relationships between program code and natural language. With a particular focus on voice, we reflect on how the human subject is implicated in coding practices and how coding itself can voice wider political issues. Engaging with the real-time query of an Application Programming Interface (API), chapter 8, "Que(e)ry data," takes a closer look at how to request and acquire data, exploring how information processing is coupled with data selection, normalization, extraction, transmission, and presentation. As such, we gain an insight into the politics of a query-driven society and the ways in which search engines produce knowledge in compromized forms. Working towards the end of the book, chapter 9, "Algorithmic procedures," does not focus on code syntax, but instead how we can break down the procedural operations of an algorithm into a logical form. It introduces flowcharts as a means to unfold the practical and conceptual aspects of algorithms, and to explore the political consequences of procedural operations (a strategy adopted to map each chapter, as mentioned above). The last chapter, "Machine unlearning," introduces machine learning algorithms to explore the implications of training, teaching, and learning in general, drawing together many of the issues across the chapters, and operating as a further reflection on the purpose of the book as a learning tool. But this is not simply didactical, and we offer a bonus chapter in the form of an "Afterword: Recurrent Imaginaries," a machine-generated chapter based on the

contents of the book, on what has been learnt, and what might be unlearnt. In summary, the first six chapters set up the ground from which to understand the fundamental elements of programming, and the last four chapters build upon this towards more speculative forms and imaginaries.

Creative practice is at the forefront of our approach. Every chapter comes with an example that utilizes different technical syntax, facilitating the discussion of the formal aspects of code. But beyond that, we also have experienced in our teaching that students, especially beginners, have difficulty in putting different functions together in a sketch. Although each chapter builds on others, we have found that it is important to repeat the use of syntax and to show how different functions and syntax can be combined and used in multiple ways. Most individual functions can be found using the p5.js reference page or are available in other instructional online videos, (34) however we stress the importance of how to bring making and thinking together. Our examples are developed with this in mind and increase complexity across the chapters, and each sketch has around one hundred lines of code for relative ease of comprehension. It should be said that we do not take effective and efficient code to be a priority here and sometimes twist the expected use of syntax accordingly. Indeed we do not aim to offer a comprehensive list of the core p5.js functions like many other programming books, but rather we offer ways of explaining the syntax according to the examples that we have selected and for their ability to generate further discussion. Our examples, inspired by other artists, designers, scientists and theorists, are custom-made according to the perceived pace of learning and their critical potential, with the incorporation of syntax and features that are closely aligned to the corresponding focus of the chapter. Examples are thus provided to spark both the technical and conceptual discussion in and outside of the classroom, including the mini exercises (aka "miniX") that we have set out for each chapter.

Using the dual elements (35) of "RunMe" and "ReadMe" to cultivate reflection by writing code and writing about code, students are encouraged to question the application of their learning in the making of artefacts. Using the pedagogic principle of "low floors, high ceilings," (36) students can easily get started with the materials in the book but each miniX also encourages independent learning by addressing the theme openly instead of looking for a prescribed outcome. We introduce various set and open tasks as well as questions throughout the chapters to test the limits of what is known at any point in time. When it comes to practice and iterative learning, we have also included peer-feedback for every miniX so as to encourage peer learning through reading other people's code, (37) and to further emphasize the diversity of approaches as well as the value of sharing ideas in public, like a shared recipe. The analogy to cooking is something we have adopted in the book by making conceptual parallels between, for example, variables and kitchen containers, algorithms and recipes, and so on. We take inspiration here from our book designers Open Source Publishing who have extensive experience of running workshops for beginners, and adopt their use of kitchen metaphors: drawing together practices of coding and cooking, tasting and testing, to invite further experimentation with various ingredients: "In the OSP kitchen, source files = ingredients." (38)

What we have attempted to outline follows the principle of "situated knowledge," in the sense that what we offer reflects the particular conditions in which it was produced, and the situatedness of the knowledge producers (us, as well as the students we have worked with). (39) Specifically, the book has been developed over the past five years through the

actual setting of classroom teaching and assignments, in a very specific cultural and educational context, situated within an educational degree program in the humanities with a focus on software studies. Students mostly have had no prior programming experience. The course has run for fourteen classes with blocks of eight and three contact hours every week — for Aesthetic Programming and Software Studies respectively. Though we offer ten main chapters here, in practice (40) we provide a "pause week" to slow things down by not introducing new functions and syntaxes, instead revisiting previous ones and discussing what constitutes aesthetic programming, and how this links to their weekly practice and learning. We also have project weeks for preparation towards the final assessed submissions. Some flexibility is recommended if you are following this book for your own curriculum and clearly the intention is for readers to adapt, modify and re-arrange the contents to suit their purposes and the particularity of the context in which they work. Our contents are offered as an open resource, to open up different possibilities for making "cuts" across the various materials and ideas, (41) and to encourage readers to fork a copy and customize their own versions, with different references, examples, reflections and new chapters for example, for further modification and re-use. (42) Thus, adopting the words of Jennifer Gabrys, our project is "an invitation to make, organize, orchestrate, conjure, and sustain people, technology, and worlds toward openings rather than prescribed ends." (43)

The book object

Finally we would like to stress that this book is not simply the physical object that you might be holding in your hands as you read these words, but a computational and networked object, distributed across various other spaces and temporalities, made available to both readers and writers alike. In saying this we reference Benjamin again, and his essay "The Author as Producer" in which he writes: "The reader is always prepared to become a writer, in the sense of being one who describes or prescribes. [..] And writing about work makes up part of the skill necessary to perform it. Authority to write is no longer founded in a specialist training but in a polytechnical one, and so becomes common property." (44) Interestingly, for Benjamin, as with this book, cultural production requires a pedagogic function.

That is precisely our point. The book expresses itself as a dynamic object not fixed in terms of attribution or commodity form or specific determination. It follows that, although this preface is only the beginning of the book, there can be no end: this book is purposefully stuck in an endless loop of its own becoming.

Notes

1. The casual address "for dummies" could also be used, as it has been for many technical books, but this carries the unfortunate connotation of learning disability.

2. The book aims to provide some "useful knowledge." Here we refer to nonstandard literacy, such as in the article: Marilyn M. Cooper, "Really Useful Knowledge: A Cultural Studies Agenda for Writing Centers," *The Writing Center Journal* 14, N°2 (Spring 1994): 97-111, https://jstor.org/stable/43441948.

3. Mark Guzdial suggests there are other purposes for programming beyond the normative focus on economic impact and the development of professionals for the software industry that open up various possibilities for learning and teaching programming. See Mark Guzdial, "Computing for Other Disciplines," in *The Cambridge Handbook of Computing Education Research*, Sally A. Fincher and Anthony V. Robins, eds. (Cambridge: Cambridge University Press, 2019), 584, https://doi.org/10.1017/9781108654555.020.

4. Seymour Papert's influential book *Mindstorms* from 1980 introduced computing to children's learning. He coined the term "computational thinking" to emphasize the practice of constructing procedures with the early programming language Logo (which does not simply use software as a tool), aiming to bridge the gap between mathematics, the culture of science and education as well as social critique. Donald Knuth made the concept of literacy more apparent in the book *Literate Programming* and considered a program literature which involves viewing programming languages as natural languages for human readers. In recent years the notion of computational thinking was also picked up by scholars in the field of software studies, such as David Berry, Matthew Fuller, Nick Montfort and Annette Vee. See Seymour Papert, *Mindstorms: Children, Computers and Powerful Ideas* (New York: Basic Books, 1980); Donald Ervin Knuth, *Literate Programming* CSLI Lecture Notes, N°27 (Stanford, CA: Center for the Study of Language and Information, 1992); Jeannette M. Wing, "Computational Thinking," *Commun. ACM* 49, N°3 (March 2006): 33–35; Michael, Mateas, "Procedural Literacy: Educating the New Media Practitioner," *Horizon* 13, N°2 (June 1, 2005): 101-11; David M. Berry, and Anders Fagerjord, *Digital Humanities: Knowledge and Critique in a Digital Age* (Hoboken, NJ: John Wiley & Sons, 2017); Matthew Fuller, *How to be a Geek: Essays on the Culture of Software* (Cambridge: Polity Press, 2017); Nick Montfort, *Exploratory Programming for the Arts and Humanities* (Cambridge, MA: MIT Press, 2016); Annette Vee, *Coding Literacy: How Computer Programming Is Changing Writing* (Cambridge, MA: MIT Press, 2017); Ole Sejer Iversen, Rachel Charlotte Smith and Christian Dindler, "From computational thinking to computational empowerment: a 21st century PD agenda." *Proceedings of the 15th Participatory Design Conference Full Papers — Volume 1*, N°7 (August 2018): 1-11.

5. Software studies is an interdisciplinary research field that studies software and its social and cultural effects, see Matthew Fuller, ed. *Software Studies: A Lexicon* (Cambridge, MA: MIT Press, 2008).

6. See, for instance, Syed Mustafa Ali's "A Brief Introduction to Decolonial Computing," *XRDS: Crossroads, The ACM Magazine for Students* 22, N°4 (2016): 16–21.

7. Here we are referring to John Maeda, *Creative Code: Aesthetics + Computation* (London: Thames & Hudson, 2004); Kylie A. Peppler and Yasmin B. Kafai, "Creative coding: Programming for personal expression." *The 8th International Conference on Computer Supported Collaborative Learning (CSCL)* 2 (2009): 76-78; Montfort, *Exploratory Programming for the Arts and Humanities*; Noah Wardrip-Fruin, *Expressive Processing: Digital Fictions, Computer Games, and Software Studies* (Cambridge, MA: MIT Press, 2012).

8. Our blend between formal logic and conceptual thinking is designed to open up space for further reflection. As one of our students commented in 2018, "Aesthetic Programming was not just programming 1.1, but instead a much more reflective and critical course." And from student feedback from the 2019 course, a student commented that the course structure provides "a hands-on experience with coding as a practice as well as a theoretical approach. [–] It was great to see behind the code and try to decode the greater picture in a digital culture context."

9. Special mention should be made of Magda Tyżlik-Carver and Christian Ulrik Andersen who have contributed to the teaching of these courses, as well as teaching assistants including Frederik Westergaard, Nils Rungholm Jensen, Tobias Stenberg, Malthe Stavning Erslev, Ann Karring, Simone Morrison, Nynne Lucca Christianen, Ester Marie Aagaard, and Noah Aamund.

10. Jacques Rancière, *The Politics of Aesthetics* (London: Continuum, 2006), investigates what aesthetics and politics have in common: according to Rancière, the delimitation of the thinkable and the unthinkable, the possible and the impossible.

11. The quote continues, "which must be deciphered by means of critical analysis," in Martin Jay, *Aesthetic Theory* (Minneapolis, MN: University of Minnesota Press, 1996), 177.

12. To quote Benjamin on this point: "The instant the criterion of authenticity ceases to be applicable to artistic production, the total function of art is reversed. Instead of being based on ritual, it begins to be based on another practice - politics." Walter Benjamin, "The Work of Art in the Age of Mechanical Reproduction" [1936], *Selected Writings, Volume 3, 1935–1938*, Howard Eiland and Michael W. Jennings, eds. (Cambridge, MA: Belknap Press of Harvard University Press, 2002).

13. Adorno says it better: "A successful work of art, according to immanent criticism, is one that resolves objective contradictions in a spurious harmony, but one expresses the idea of harmony negatively by embodying the contradictions, pure and uncompromised, in its innermost structure" (Adorno, in *Prisms* (1967), 32; quoted in Jay, *Aesthetic Theory*, 179).

14. Black and indigenous aesthetics would make an important addition here, such as found in Ron Eglash's *African Fractals*, as would reference to Afrofuturism, not to simply insert black voices into racist historical narratives, but to envision new imaginative forms. See, Ron Eglash's *African Fractals: Modern Computing and Indigenous Design* (New Brunswick, NJ: Rutgers University Press, 1999), and, for instance, Kodwo Eshun's "Further Considerations on Afrofuturism." *CR The New Centennial Review* 3, no. 2 (2003): 287-302.

15. Anna Lowenhaupf Tsing, *The Mushroom at the End of the World: On the Possibility of Life in Capitalist Ruin* s (Princeton: Princeton University Press, 2015).

16. Tsing, *The Mushroom at the End of the World*, 23.

17. Philip E. Agre, "Toward a critical technical practice: Lessons learned in trying to reform AI," in Geoffrey Bowker, Susan Leigh Star, William A Turner, William Turner, Les George Gasser, eds., *Bridging the Great Divide: Social Science, Technical Systems, and Cooperative Work* (ACM Digital Library, 1997). https://dl.acm.or g/doi/book/10.5555/549261.

18. Wendy Chun has studied both Systems Design Engineering and English Literature, which she combines and mutates in her current work, see https://en.wikipedia.or g/wiki/Wendy_Hui_Kyong_Chun. Yuk Hui studied both Computer Engineering and Philosophy, see http://digitalmilieu.net/ yuk/.

19. The notion of "doing thinking" suggests non-standard ways of knowing that draws upon artistic research and technofeminism in computing. See Loren Britton, Goda Klumbyte, and Claude Draude, "Doing Thinking: Revisiting Computing with Artistic Research and Technofeminism." *Digital Creativity* 30, N°4 (October 2, 2019): 313-28, https://do i.org/10.1080/14626268.2019.1684322.

20. Agre, "Toward a critical technical practice".

21. Fuller, ed. *Software Studies*; Raymond Williams, *Keywords: A Vocabulary of Culture and Society* (London: Fontana, 1983); updated by Blackwell in 2005 as *New Keywords: A Revised Vocabulary of Culture and Society*.

22. The project workshop description an be found archived at https://web.archive.or g/web/20100327185154/http://pzwart. wdka.hro.nl/mdr/Seminars2/softstudw orkshop.

23. We were highly influenced by the series of *Readme* festivals that promoted the artistic and experimental practice of software, which took place at the Marcros-Center in Moscow (2002), Media Centre Lume in Helsinki (2003), Aarhus University and Rum46 in Aarhus (2004), and HMKV in Dortmund (2005). The associated software art repository Runme.org was established in 2003, and many participants and people who submitted their works did not necessarily call themselves artists. Indeed the category of art in itself becomes inadequate to cover the kinds of creatives practices that have developed in the field. As an annual festival for art and digital culture, transmediale had started to use 'artistic software' or 'software art' from 2001-2004. Many artists and researchers have contextualized and written about the genre of software art, see Florian Cramer, and Ulrike Gabriel, "Software Art." American Book Review, issue "Codeworks"(Alan Sondheim, ed.) (2001); Goriunova, Olga, and Alexei Shulgin. *read_me: Software Art & Cultures* (Aarhus: Aarhus Universitetsforlag, 2004); Andreas Broeckmann, "Software Art Aesthetics," *Mono* 1 (2007): 158-167.

24. The field Critical Code Studies (CCS) makes this explicit, promoting the examination of source code as a cultural object for critical analysis. As Mark Marino suggests that CCS pays attention to code as textual materials and its main argument is that code itself can be considered as a "cultural text worthy of analysis and rich with possibilities for interpretation", and furthermore, code allows one to reflect "on the relations between the code itself, the coding architecture, the functioning of code, and specific programming choices or expressions, to that which it acts upon, outputs, processes, and represents". See Mark C. Marino, "Critical Code Studies", *Electronic Book Review* (December 4, 2006); "Field Report for Critical Code Studies," *Computational Culture* 4 (9th November 2014), http://computationalc ulture.net/field-report-for-critical-code-stu dies-2014%e2%80%a8/; Mark C. Marino, *Critical Code Studies* (Cambridge, MA: MIT Press, 2020).

25. Inke Arns, "Read_me, run_me, execute_me: Code as Executable Text: Software Art and its Focus on Program Code as Performative Text," trans. Donald Kiraly, *MediaArtNet* (2004), http://ww w.mediaartnet.org/themes/generative-t ools/read_me/1/.

26. For more on Open Humanities Press, see https://openhumanitiespress.org/.

27. For instance, dokieli is a client side editor for decentralized article publishing, annotations and social interactions, see ht tps://dokie.li/.

28. See https://jupyter.org/ and https://d evdocs.io/javascript/.

29. For more on Open Source Publishing (OSP), see http://osp.kitchen/about. We are interested in this approach as it somewhat breaks down the divisions of labor associated with traditional publishing in which writing, editing, and designing, and the people that perform these tasks, are distanced from each other.

30. See Adrian Mackenzie's "Preface" to *Machine Learners: Archaeology of a Data Practice* (Cambridge, MA: MIT Press, 2017); and on GitHub at https://gi thub.com/datapractice/machinelearner s.

31. As a dynamic repository Git collapses the distinction between storage and production. For more on Git, see Matthew Fuller, Andrew Goffey, Adrian Mackenzie, Richard Mills and Stuart Sharples, "Big Diff, Granularity, Incoherence, and Production in the Github Software Repository," in Matthew Fuller, *How To Be a Geek: Essays on the Culture of Software* (Cambridge: Polity Press, 2017).

32. The flowcharts for each chapter are programmed with Graphviz, open source software for graph visualization. All the source code is provided in the folder "graphviz" on the GitLab repository. See https://graphviz.org/.

33. Stephen Morris and Orlena Gotel, "The Role of Flow Charts in the Early Automation of Applied Mathematics," *BSHM Bulletin: Journal of the British Society for the History of Mathematics* 26, Nº1 (March 2011): 44–52, https://doi.org/10.1080/17498430903449207.

34. We extend our appreciation to the many educators' various ways of presenting code which this book was built on. In particular, we would like to acknowledge and thank Daniel Shiffman for his *The Coding Train* YouTube channel that offers excellent creative coding tutorials for us and our students to learn programming in an accessible manner. Since the basics are clearly covered in the instruction videos, students subsequently find it easier to digest the materials in this book providing room for alternative forms to take place.

35. Here we once again reference the series of Readme festivals, as well as the Runme.org software art repository, http://runme.org/.

36. A concept first formulated by mathematician, computer scientist, and educator Seymour Papert, MIT Professor, who created a design principle for a programming language called Logo. See Seymour Papert, *Mindstorms: Children, Computers, and Powerful Ideas* (New York: Basic Books, 1980).

37. The field of Critical Code Studies considers source code a cultural text for critical reading and interpretation beyond the understanding of how this code works technically and functionally. See Marino, *Critical Code Studies*.

38. See OSP's home page and note the URL: http://osp.kitchen/.

39. By "situated knowledge," we refer to the work of Donna Haraway, and others broadly in the field of feminist new materialism, to think outside of spurious universal and objective forms of knowledge. See Donna Haraway, "Situated Knowledges: The Science Question in Feminism and the Privilege of Partial Perspective." *Feminist Studies* 14, Nº3 (1988): 575-599.

40. You can find the curriculum and the messy notes for recent years' Aesthetic Programming courses here: https://gitlab.com/siusoon/aesthetic-programming/-/tree/master/.

41. We are referring to feminist new materialism here, and in particular Karen Barad's thinking, cutting "together/apart" how-to guides, across the fields of computer science, art, cultural studies, critical theory, and software studies. See Karen Barad, *Meeting the Universe Halfway: Quantum Physics and the Entanglement of Matter and Meaning* (Durham, NC: Duke University Press, 2007).

42. The whole repository, including the text, source code for all sample code and flowcarts, is currently hosted on GitLab as an open source project with a Creative Commons License. You are encouraged to fork or clone a copy if you have a GitLab account or download the whole repository (by pressing the icon of the download button). See https://gitlab.com/siusoon/Aesthetic_Programming_Book.

43. Jennifer Gabrys outlines her "how-to" approach in the "Introduction" to *How to Do Things with Sensors* (Minneapolis, MN: University of Minnesota Press, 2019). We'd like to think we were doing something along these lines too.

44. Walter Benjamin, "The Author as Producer" [1935], quoted in Geoff Cox and Joasia Krysa, eds. *Engineering Culture: On the Author as (Digital) Producer* (New York, Autonomedia, 2005), 22.

Design notes

Book Layout

Since 2013, Open Source Publishing (OSP) makes printed publications with web technologies: HTML, CSS, and Javascript. The use of these technologies allows for new kinds of layout and new publication pipelines where multiple output formats (website, book, ebook) can be produced based on the same content. The contents of this book were written in the Markdown markup language and synchronized between the authors and designers using Git, a collaborative tool. The sources were then transformed into HTML with Pelican CMS. The web version lets the reader view and live test the sample codes of each chapter. For the printed version of the book, the polyfill paged.js was used to augment browser support for styling paged media with CSS. Both versions are independent and complementary.

Fonts

All fonts of the book have been chosen because they were drawn with code.

Body and headers fonts used in this book are part of a larger font family drawn by A.V. Hershey in the 1960s and were developed specifically for vector plotters. Limited by the technical limitations of these plotters, curves are segmented into small, straight lines. Furthermore, as vector plotters draw using a single line width, varying line thickness is simulated by placing lines close to each other. The specific variants displayed in the book were reinterpreted with Metafont. The body fonts are from the Hershey Noailles family, interpreted by Antoine Gelgon, transforming the segmented curves into real curves. The Hershey Times in the headers was interpreted by Gijs de Heij and Simon Egli, (ab-)using Metafont's "most pleasing curve" to generate its particular shapes.

The code samples are set in OCR-pbi, a font family drawn with Metafont by Antoine Gelgon. The skeleton of this font is based on the OCR-B, drawn by Adrian Frutiger in an effort to draw a monospace font readable by both machines and humans.

1. Getting started

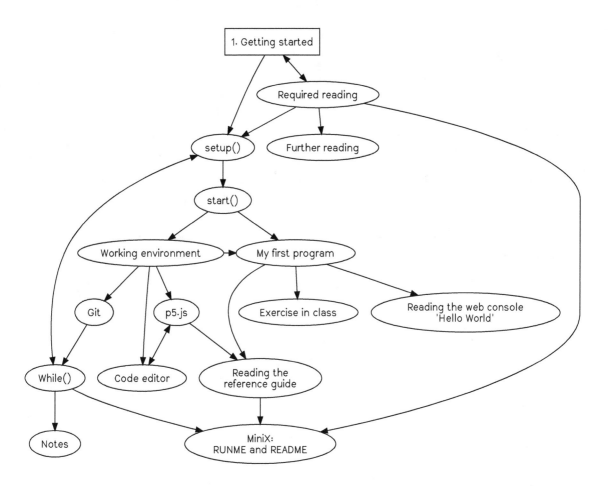

- 1. Getting started
- Required reading
- setup()
- Further reading
- start()
- Working environment
- My first program
- Git
- p5.js
- Exercise in class
- Reading the web console 'Hello World'
- While()
- Code editor
- Reading the reference guide
- Notes
- MiniX: RUNME and README

Contents

setup()

It has become commonplace to include programming in educational progrmes at all levels and across a range of disciplines. Yet this still remains relatively uncommon in the arts and humanities, where learning to program does not align explicitly with the related career aspirations. This raises questions about what does or doesn't get included in curricula, why this may be the case, and which knowledge and skills are considered essential for some subjects and not others. Certain forms of privilege (related to class, gender, race) are clearly affirmed in these choices. For instance, in very general terms, "high culture" has traditionally been described as the domain of university-educated (wealthy, white) people, whilst "low culture" the domain of non-university-educated (working class) ordinary people. Neither high nor low culture, programming cuts across this class divide as both an exclusive and specialized practice (1) that is also one rooted in the acquisition of skills with applied real-world use in both work and play. Yet, despite its broad applicability, access to the means of production at the level of programming remains an issue all the same.

We might usefully characterize this in terms of literacy — traditionally applied to the skills of reading and writing — and to further include the reading and writing of code. Indeed coding is often referred to as "the literacy of today," and as the twenty-first century skill "we must then learn to master [sic]." (2) Arguably, knowing some basic coding skills will not only enhance future employability, but will also enable the improved understanding of how things (codes) are "encoded" and "decoded." (3) Further echoing cultural studies, and its foundations in an expanded notion of literacy to include aspects of ordinary culture, Annette Vee's book *Coding Literacy* from 2017 is an attempt to shift our focus from technical skill to wider social relations. As she puts it, "Seeing programming in light of the historical, social, and conceptual contexts of literacy helps us to understand computer programming as an important phenomenon of communication, not simply as another new skill or technology." (4)

So, what are the implications of coding framed in terms of literacy, and to whom does this apply? Although Vee's book is not a programming book and does not address the question of how to program, it weaves together parallel histories of writing and coding to compare and trace what is meant broadly by literacy, and how to understand the rise of computing and the cultural discourse around the importance of code and coding. Indeed, it has become common to discuss writing and coding, text and code in parallel, especially in the fields of electronic literature, digital humanities, and software studies. (5) (This parallel is also something we will develop in more detail in Chapter 7, "Vocable code.") It applies to all of us. We hope that something of this expanded coding literacy is facilitated by reading and using this book, and we take inspiration from Vee's arguments for coding literacy, in that it is no longer just "reading for comprehension" but also "reading for technical thought as well as writing with complex structures and ideas." (6) It is not simply a new way of reading and writing, but also a new way of thinking and understanding other codes. Such a compelling argument for literacy not only benefits individuals who acquire certain skills, but also has potential wider cultural and social ramifications, helping to force coding out of its specialization in certain disciplines and open up its critical and aesthetic potential.

In 2016, Nick Montfort, a poet and academic, published *Exploratory Programming for Arts and Humanities*, a hands-on approach to programming. In the appendix, in response to the question "Why Program?" he outlines three key reasons (7): learning to program allows us to think in new ways by introducing different methods and perspectives to raise new questions; programming offers us a better understanding of culture and media systems, subsequently allowing us to learn to develop better, or better analyze, cultural systems; and, finally, programming can help us improve society by creating, designing, and discovering programs. In general, we agree with Montfort on these points, but at the same time we see this as a means to open up different working methods, and, using programming as a basis for our thoughts, to speculate on alternative forms and political imaginaries of programming practice.

This opening chapter introduces some ideas and exercises to get started (the `setup()` so to speak) and reflects on why we need to learn to program. We hope this will help sustain motivation across subsequent chapters. In addition as we imagine that our readers do not necessarily want to become professional programmers, we stress programming as a means to think differently (as we tried to outline in the Preface). This applies to us too and we have learnt from others along the way, challenging our preconceptions, especially through the experience of working with students with little or no programming experience. Learning to code can be enjoyable and rewarding, but also annoying and frustrating, especially when complex syntax and structure are involved. It takes time to familiarize oneself with precise, unforgiving computational logic, and procedures, but hopefully the case for the importance of learning to program has been established by now. The choice is simple: "to program or be programmed." (8)

start()

Figure 1.1: p5.js web interface

Throughout the book, we will use JavaScript as the main programming language, primarily focusing on p5.js and its associated libraries. Practically speaking, p5.js is a web-based library, (9) that utilizes an open source JavaScript framework that makes creating projects with code on the web accessible, as well as much easier to share via the Internet, such as p5.js Web Editor, Open Processing, and Git hosting platforms, without additional installation. A JavaScript-based project can be run and executed using a URL in a browser.

JavaScript was originally developed in 1995 by Brendan Eich with the aim to run a program in the Netscape browser. (10) Some people might be confused with the difference between JavaScript and Java, but basically they are two different systems. JavaScript is a lightweight programming language which is commonly used for animated visual and interactive web applications, and was originally designed to enhanced interface experiences, and to complement Java. Indeed, program code from any "high-level programming language" (i.e. one closer to human languages but further from machine language) requires a translation into native machine instructions/code for a computer to run and execute it. This translation process is usually done through interpreters

or compilers. JavasScript is an interpreted language by design that in modern browsers, generally operates using both an interpreter and just-in-time compilers to translate source code at runtime. (11) This makes it faster to kickstart the code running process, but takes longer when the application is more complex and with longer interactions, as extra runtime overhead will be incurred. (12) On the other hand, Java, a compiled and complex programming language, was first released to the public in 1996 by Sun Microsystems, meaning that source code is typically written in an Integrated Development Environment (IDE). (13) It is required to optimize and compile into static bytecode for computer processing by a Java Virtual Machine (JVM). (14) Java powers many desktop and mobile applications, from small apps on Android mobile devices to games like Minecraft, (15) while JavaScript mainly works for smaller web-based applications such as websites and bots. For an introduction to programming like this, we needed something that is relatively uncomplicated in terms of getting started, but has the capacity for proficiency development. This is often referred to as "low floors and high ceilings," (16) and JavaScript is a good tool from this perspective.

But there is much more to this than just introducing the tool from a pragmatic perspective. This book will use p5.js, a JavaScript library which was created by artist Lauren McCarthy in 2014 for the purpose of what we call "aesthetic programming." To be more precise about its genealogy, Casey Reas and Ben Fry developed the remarkable, influential open source project Processing in 2001, (17) a Java-based desktop environment with the aim to reach out to visual artists and designers. However, McCarthy observed that the various creative open source software available was mostly developed by white men, and there was a lack of diversity in such environments, and unfortunately programming remains a very male-dominated practice. (18) McCarthy started to explore what Processing would look like on the web. Importantly, the core idea for p5.js is not just to deploy Processing as a web-based platform, but to address diversity and inclusivity explicitly, and take these issues seriously in software development and communication. As McCarthy says, "thinking about community outreach and diversity is not a secondary goal of p5.js, it's the foundation on which the platform is built." (19) Within just a couple of years, the p5.js contributors had developed a community statement, translated the interface into a variety of popular languages such as Spanish and Simplified Chinese, (20) started the homepage series as part of p5.js which showcased work by and interviews by Asian women and gender non-conforming coders, (21) added a high constrast mode and audio feedback for people who have difficulty seeing, (22) and developed a series of workshops on creative expression called "Signing Coders" for people who have difficulty hearing, (23) amongst other things. As p5.js demonstrates, software is not just a tool, but also about people and politics. (24)

Working environment

You will need an editor to write and document your code. We will use Atom, (25) a free and open source text and source code editor that works across different platforms to write code. We choose a downloadable code editor as opposed to a web editor because we view code as more than just a piece of software, it is also about the relations with the configuration of your own computer and operating system, the way various browsers behave as well as data files, and the organization of folder paths, and so on.

Additionally we use Gitlab as our code and text respository, at least for this book. We also use Gitlab for teaching purposes, a place where students can upload their ReadMe and RunMe files every week, for peer feedback and to facilitate peer learning, and to read and share code and related thinking. We have found this to be an effective way to work both individually and collectively, and share materials in keeping with the best principles of free and open source software development, and students use Readme to explain the technical aspects as well as to develop critical discussion.

p5.js

1. First go to the download page of p5.js (26) and get the p5.js complete library (in the compressed "p5.zip" format) by clicking it and saving the file, which includes all the necessary libraries to run the code.

2. Double click to unzip the file to extract all the files it contains. A new folder will be automatically created called "p5."

3. The next part is crucial to the on-going development process, because you have to somehow identify where your work folder will be located. If you have no idea, you may consider using the "Desktop" folder. ("Foldering" is a concept used for organizing files on your device, which is similar to organizing papers, folders, books on a bookshelf. Increasingly streamlined UX designs mean that many people find it alienating to navigate to or locate the path and directory of files, such as images, on a device as people are becoming increasingly accustomed to putting everything on the first few pages of a phone or simply on the desktop.)

4. If you put the unzipped folder "p5" in a customized directory, then you should see the list of files in the folder as below. You should see the two p5.js libraries, one comprehensive file (p5.js) and one mini version (p5.min.js).

5. Click on the folder "empty-example," and you will see a list of the files you need to start:

 index.html the default Hypertext Markup Language (HTML) which will be first to be picked up by a web browser. HTML is a fundamental technology used to define the structure of a webpage and it can be customized to include text, links, images, multimedia, forms, and other elements.

 sketch.js the key work file for writing JavaScript. The word 'sketch' is used similarly to the way it would be in the visual arts, in other words it is a less formal means of working out or capturing ideas, and experimenting with composition.

 p5.js the p5.js core library.

 p5.sound.js the p5.js sound library (27) for web audio functionality, including features like playback, listening to audio input, audio analysis and synthesis.

Figure 1.2: p5 folder hierarchy

Figure 1.3: p5 folder hierarchy

Code editor

Atom is used as the code editor for this book. It supports cross-platform editing and can be run on Mac OS, Windows and Linux.

1. Download the software Atom from the homepage: https://atom.io/

2. Drag the "p5" folder that you have just unzipped into Atom. You should be able to see the left-hand pane with your project. Try to navigate to the "index.html" file under the "empty-example" folder, double click that file and the source code should display on the right-hand pane. See below:

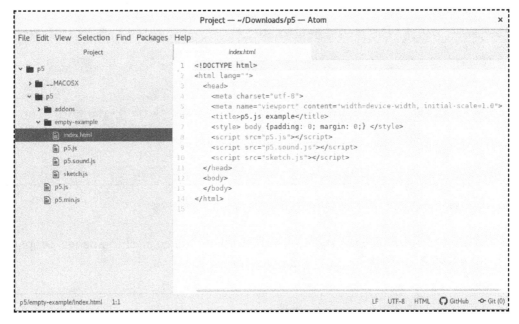

Figure 1.4: Atom's file structure

"index.html" is usually the default page the web browser will display. You can customize the page title and other styling issues, but the focus for this chapter will be on navigating the libraries and running your first program. Since p5.js is a library, the lines 8-10 indicate how to incorporate JavaScript files and libraries by using the tags `<script>` and `</script>`.

The script currently uses relative paths, which is a useful concept when we need to understand how the libraries are operated, how to locate the files and how to incorporate new libraries and files in the future. JavaScript libraries are simply files, and we have to incorporate these files into the HTML so that they can be imported and read by the program. This means that when we use p5 syntax, the program can recognize this syntax and the corresponding function. For this particular example, it is important to be aware that the JavaScript libraries and the HTML file are in the same directory. If we move the libraries somewhere else, we will need to update the path.

3. Next you will need to install a package called "atom-live-server," (28) which is useful for setting up a web server so you can update your code and see the results immediately in a browser without needing to refresh it. You can first check under "Packages" on your menu bar of Atom and see if the package is there. If not, then go to "Edit > Preferences > '+ Install'," then type "atom-live-server." Hit the blue install button and you should be able to find it again in the Packages menu.

Figure 1.5: Installing atom-live-server

4. If you want to customize the theme like the background color of the panes, simply go to "Preferences > Themes."

My first program

The default sketch.js is the work file. It contains only two functions. (A JavaScript function is a block of code designed to perform tasks.)

```
1  function setup() {
2    // put setup code here
3  }
4  function draw() {
5    // put drawing code here
6  }
```

function setup() → Code within this function will only be "run once" by the sketch work file. This is typically used to set the canvas size to define the basic sketch setup.

function draw() → Taking cues from drawing practice in visual arts, code within this function will keep on looping, and that means function draw() is called on for each running frame. The default rate is 60 frames/times per second, and this is especially useful when things are set in motion or constantly being captured (we will continue with this in Chapter 3, "Infinite loops").

From the above sample code, there are code comments which is indicated with the symbol "//", referring to text that are written for humans but not computers. This means a computer will automatically ignore those code comments when it executes the code. You may consider this as an explaination on how specific chunk of code works. Throughout the book, you will see // indicates a single line comment, and /*...............*/ indicates multiple lines of code comments with the starting symbols "/*" and the ending symbols "*/."

Let's try to input these into the sketch to draw a canvas with a changing background (subtly lighten the black background color), then the sketch will further draw an ellipse located somewhere on the top left corner. (Double check the spelling and punctuation like curly brackets and semi-colons, indicating the scope of the function and end of the line respectively. Details of the code will be explained below.)

```
1  function setup() {
2    // put setup code here
3    createCanvas(640, 480);
4    print("hello world");
5  }
6  function draw() {
7    // put drawing code here
8    background(random(50));
9    ellipse(55, 55, 55, 55);
10 }
```

To run the code, you need to go to "Packages > atom-live-server > Start Server" on Atom. A pop-up window appears, click on the "empty-example" folder; it should display something like this:

Figure 1.6: My first program

Exercise in cLass

This exercise is to familiarize you with the working environment, path and local directory so you learn that running a sketch in a web browser requires loading the exact path to the JavaScript libraries. You are also free to create your own folder name and rename the file sketch.js as you please. You can also try to change parameters by changing numbers to get a sense of how things work, but this will be explained in more detail later on in the book.

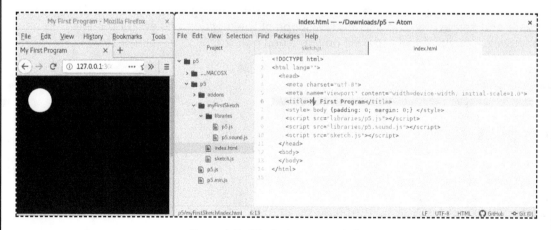

Figure 1.7: My first program 1.1

1. **Stop the server.** Stop the atom-live-server by going to "Packages > atom-live-server > Stop."

2. **Rename the folder.** Try to rename the folder "empty-example" as "myFirstSketch" (in order to help the computer to process better, don't use any spaces). In the subsequent chapters and for the exercises below, you will create your own folders.

3. **Structure the p5 libraries.**
 - Try to create a folder called "libraries" under "myFirstSketch."
 - Drag the two p5 libraries into the newly created folder: "libraries."
 - Change the relative path of the two js libraries in index.html

4. **HTML.** Change the title in the HTML file (line 6)

5. **RUN again.** Can you run the program again ("Atom > Packages > atom-live-server > Start Server") so that you can see almost the same screen as Figure 1.7 in a web browser?

Reading the web console "Hello World"

As you might realize by now, this book does not follow the conventions of most programming books by starting with the "Hello World" program that displays or prints "Hello World" onto the screen. In p5.js, print() is the function to print, (29) but in a web browser setting which makes the print() function write in the "console area." This is an area not intended for end users, but for programmers or developers to see if there are any error messages, which are logged to the console and to check that code is executing in the expected way.

In the sample code (see Figure 1.6), the line 4 prints "hello world." But to see the text, you need to open the web console area the location of which depends on the browser you are using. Try to search for it by navigating the menu bar. In Firefox, for instance, it is located under "Tools > Web Developer > Web Console" (or press the keyboard shortcut: Ctrl + Shift + K for Linux/Windows, and Option + Command + K for Mac).

Figure 1.8: The web console area

At the bottom of Figure 1.8, the web console area shows the highlighted words "hello world." This tells you the sketch is running properly and it is able to read the print function line. As you progress through this book, you will notice how important the web console area is, because it also displays error messages if, for example, the syntax is wrong (we will discuss errors in Chapter 8, "Que(e)ry data"). In such cases the browser will give you some good hints for debugging your code. (30) Figure 1.9 shows that the web console area is able to specify which file (sketch.js), which line of code (Line 8) has a problem (the syntax background was spelled wrong intentionally), and it even suggests how you may correct it.

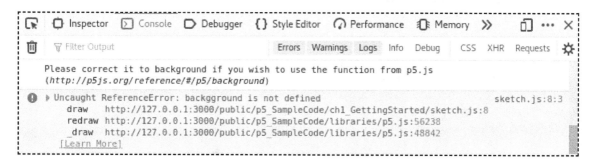

Figure 1.9: Example of syntax error

Hello World programs have a long history in computing, are typically used to introduce programming languages to beginners, and ensure things are running as they should. Readers understand the line print("hello world") quite literally as it is written in "natural" language. At the same time the computer is executing precisely what you tell it to do, printing a text through an "instruction," giving an immediate result which can be very rewarding. The immediate feedback "produces a feeling of power" as the programmer starts to exert control over the code and its meaningful expression in the world. (31)

The programmer learns to express themselves in a new language as if speaking for the first time, hence the seemingly naïve address, announcing themselves to the world. The project *hallo welt! (hello world!)*, (32) by Geoff Cox and Duncan Shingleton plays on this communicative act, looping more than 100 Hello World programs written in different programming languages, alongside a selection of human languages, combining them into a real-time, multilingual, machine-driven confusion of tongues (as in *The Tower of Babel*). (33)

Reading the reference guide

To further explain the remaining parts of the sample code, this book will show you how to learn independently, particularly by learning to read the reference guide so you can explore things on your own. In the sample code, there are a few functions that you will see alongside `print()`: these include `createCanvas()`, `background()`, `random()`, `ellipse()`.

To summarize, what the sample code above does is initialize the exact canvas size (`createCanvas(640,480);`), set the width to 640 pixels and the height to 480 pixels providing an overall drawing area (see Line 3 of the sample code). This is why the background covers only the canvas area and the rest of the area remains the (default) white background. The sketch will pick a random color (from grey to black) as the background color at a given time, covering the whole canvas (`background(random(50));`). The last part is to draw an ellipse at a certain position and of a certain size (`ellipse(55,55,55,55);`). Locating this within the `function draw()`, the program will constantly and repetitively execute the lines of code. The repetition is made obvious in the sample code by the background color changing over time.

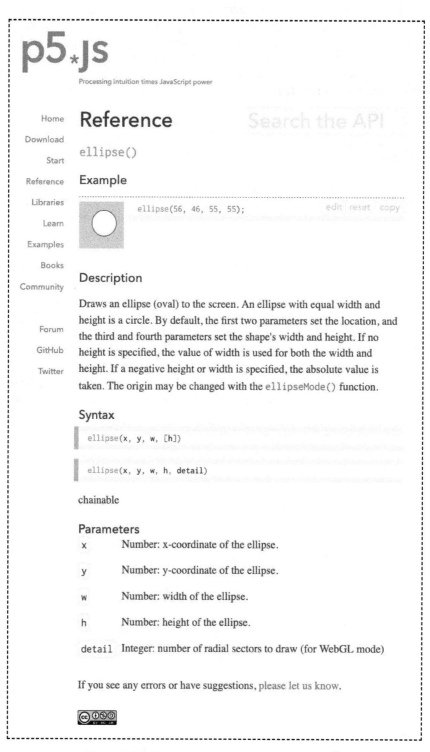

Figure 1.10: The reference guide example — ellipse()

To understand the parameters of each p5.js built-in functions, such as how many parameters in a function like ellipse(), we can turn to "References" from the p5.js website. The <u>reference page</u> lists most of the available p5.js built-in functions, and once you get used to their presentation, it will become easier and faster to learn and write the syntax provided.

Let's read the reference in Figure 1.10 together - ellipse(). (34) It usually starts with an example and an illustration, and you can click the "edit" button to modify the code, changing the parameters on the fly immediately displaying the results on screen. The description part of the reference page explains how the function syntax works and this is especially useful for beginners who might have little idea about the parameters/numbers and what this entails for each parameter within a function. The syntax area demonstrates how the built-in function should be written precisely, such as how many parameters for that function. For example, in the case of ellipse(x, y, w, [h]), it explains how the first parameter x and the second parameter y are used to set the location of the ellipse in terms of x and y coordinates. The canvas is demarcated using pixel units and the [0,0] coordinates start in the top left corner of the canvas. The parameter w and h refers to the width and height of the ellipse, and you can also think of this as defining the diameter, or setting the size, of the ellipse. The square bracket "[h]" is an optional parameter if the width and height of the ellipse is the same.

Figure 1.11: Visualizing the ellipse

What we want to demonstrate here is that it is important to start with the references, then explore other syntaxes and features, for example shapes like rectangles and polygons. There are still other syntaxes in the sample code that we haven't explained in detail, so perhaps you can find the corresponding references in the p5.js web reference material and explore these yourself. However, we will continue to explore the color function in the next chapter, and the random() function in the one following that.

Git

We use Git both to write this book as well as teach. Git is an open source software management system developed by Linus Torvalds in 2005, the creator of Linux Kernel architecture that is used in the Linux operating system. It is used to track changes in any files, facilitating versioning control of variations in a distributed network. It is particularly useful for large-scale collaborative programming in which individuals work on different parts of the software with their own machine by copying (forking), splitting (branching), and combining (merging). Git uses a distributed model in which every contributor maintains and has a copy of the main repository.

GitLab is an open source, web-based, Git repository platform that hosts software libraries and source code contributed by software developers. GitLab is also a social platform, where people can leave comments, follow other software development processes, fork the whole program into their own repository, and so on. All this book's content, including the readme files, source code and libraries are stored on the GitLab platform under a creative commons license, giving other people the rights to share, use and build upon this work. We imagine this is just the first iteration of this book and we hope to see many re-appropriations and forks of the entire book, so people can use the existing framework to make modifications, such as adding new chapters, examples and exercises, as well as more related content and references that facilitate the interactions between programming and thinking.

For simplicity's sake, we use GitLab's web interface for some of our writing and teaching, and for students to hand-in their weekly RunMe (35) and ReadMe (36) files. We also use GitLab for peer feedback so that students can read and learn from each other's work.

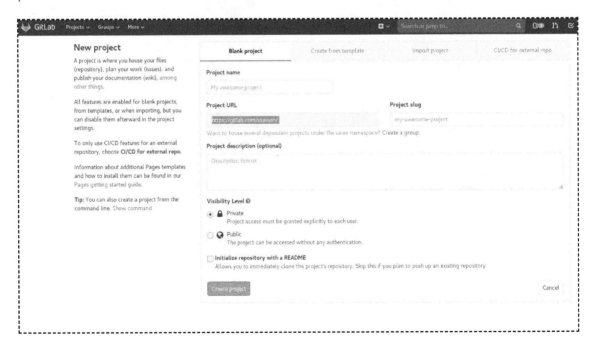

Figure 1.12: Create a new project with the GitLab web interface

1. Go to Gitlab.com, then register an account by clicking "Register" on the navigation bar.

2. To create a new project: Go to "Projects > New Project" (see Figure 1.12).

3. Provide a project name and project description, and click "Public" if you want others to be able to access this project without any authentication.

4. At this point you can also initialize a ReadMe within the repository by ticking the checkbox.

5. A folder in your repository will then be created.

6. To upload the file or create a directory, simply click on the "+" sign under the repository project name (see Figure 1.13). GitLab allows you to customize a commit message (to keep track of changes from a general and communications perspective), we can therefore input the message before clicking the button "Commit changes."

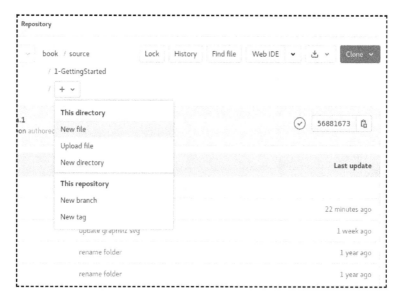

Figure 1.13: Manage directories/files using the GitLab web interface

If you need other features: previewing the markdown file, deleting or renaming files/folders, the GitLab Web IDE editor has some advanced features you can use (this is located at the top right, see Figures 1.13 and 1.14).

Figure 1.14: The GitLab Web IDE

WhiDe()

Briefly introduced above, Git is a distributed version-control system for tracking changes in source code during software development. It is designed for coordinating work among programmers, but it can also be used to track changes in any set of files, including the workflow of the chapters of this book. It is a repository that includes a complete history of changes and full version-tracking abilities. Its serious workflow management functionality is somewhat undermined by speculation surrounding the name "Git," and whether it is an acronym or not. Allegedly, Torvalds who developed it as a content tracker for Linux (which he also developed), named it "Git," an offensive British slang word in the common idiom "stupid old git," to mock himself. Similarly it has been referred to as a "stupid content tracker," but this is hardly the case as in reality it is a fast, scalable, and effective distributed revision control system. (37) For clarity, git is spelled "git" (for the command) and "Git" (for the product), not "Git" (for the person), since it is not an acronym, but rather an expression of the intent to do something: a tool which does not try to be overly smart but not stupid either. Moreover the ability to make multiple versions is an overtly social act, an expression of the belief in sharing ideas and labor (just like the p5.js community (38)) for the commons, and as such protected under the legal protection of the GNU General Public License which guarantees users the freedom to run, study, share and modify their software. (39)

Like the debates over "Git" and "git," the use of words becomes hugely significant in terms of their meaning and ability to do things in the world in programming as well as in everyday situations. Another example, of decolonizing software, is the use of the terms "master" and "slave" in programming (where one process exerts control over another process within a dependent relationship), which is considered "a broken metaphor" and "an oppressive metaphor" according to Ron Eglash and The Internet Engineering Task Force (IETF) respectively. (40) In daily interpersonal communications, a further example in language would be the politics of pronouns and how the use of "she," "he," or "they" indicates particular subject positions when referring to people and in the gendering of objects, given that language tends to be "man-made." (41) The importance of this is how to do things with words ethically given that words have effects as Judith Butler, amongst others, has incontrovertibly demonstrated; in *Excitable Speech*, Butler shows how words can be "injurious." (42) We will return to the analogy between speech and programming in Chapter 7, but for now it is enough to say that words have social and political consequences, and this extends to the naming of computational objects and functions. (43) Whether they are directly executable or not they still have effects.

This politics of language was touched upon in the first section of this chapter, through what we might call an "expanded literacy" — the ability to read, write, and "program" — an enhanced understanding of the relationship between what words mean and do in terms of wider culture. Literacy is crucially important to explain how new kinds of reading and writing are required to account for significant cultural and technical changes which includes issues of access. To clarify, we can refer back to the beginnings of Cultural Studies as a field, and Richard Hoggart's *Uses of Literacy* (published in 1957) that included working class (or mass) cultures as part of what we call "culture," previously the preserve of an elite, thereby introducing an expanded notion of literacy. (44) Clearly literacy is a shifting notion, changing across cultures, and underpinned by the changing relations between speaking and writing

that were also explored by Walter J. Ong in *Orality and Literacy*, who argued that the electronic age has sharpened our understanding through the "secondary orality" of media that all depend on writing in various ways. (45) The written words of programming, for instance, demonstrate how our language has been further enhanced by new forms, and how writing is a form of action and not simply a referent of thinking.

In this book we weave together the words and actions of human and computer languages, recognizing that they are not equivalents as such. The syntax of JavaScript that we use in this book is one specific instance of this — useful for learning programming fundamentals and basic concepts — but also allowing for experimentation with "secondary notation." By this, we mean adjusting the formal notation to allow it to be more easily understood, providing opportunities for other creative expressions through semantic ambiguity. Think, for instance, of the use of "class" to describe one or more objects in object-oriented programming as well as stratifications in society based on economic and social status. An excellent example of this is Harwood's codework *Class Library*, a melding of program code and written text that stresses the material conditions of working with code and the possibility of class action. (46) You might want to look this term up in the references section to clarify your technical understanding. (47)

This argument for programming or coding as a necessary skill for contemporary life seems indisputable, and there are plenty of examples of initiatives related to computational literacy and thinking, from online tutorials to websites such as Codecademy.org and Code.org. As introduced at the beginning of this chapter, Vee's *Coding Literacy* also explores these connections, arguing how the concept of literacy underscores the importance, flexibility, and power of writing for and with computers. (48) An important aspect of this is that, not only does this help us to better understand the social, technical and cultural dynamics of programming, but it also expands our very notion of literacy and its connection to a politics of exclusion (as with other non-standard literacies). Furthermore, and given that programming, like other forms of writing, performs actions, it presents itself as a way to reconceive politics too: not simply writing or speaking, arguing, or protesting in public, but also demonstrating the ability to modify the technical processes through which the action is performed, in recognition of the ways in which power and control are now structured at the level of infrastructure. (49)

Your first program is a means to engage with these ideas, to run some code. As this is not meant to be, nor can be, simply a technical exercise, we ask you to make the critical and practical aspects explicit in producing a ReadMe and a RunMe. This book serves as a guide for this initial task as well as subsequent ones: to run some code, and think with it.

MiniX: RunMe and ReadMe

Make a RunMe and a ReadMe.

Objective

- To learn the basic setup, including writing code with a code editor, running code with a web browser, independent study of code syntax, creating a ReadMe file, etc.
- To start thinking with programming conceptually.

For additional inspiration

- *Daily Sketch in Processing* by Saskia Freeke, https://twitter.com/sasj_nl (and her talk can be found at https://youtube.com/watch?v=nBtGpEZO-EQ); *All the Daily Things* by Saskia Freeke (2018), https://vimeo.com/309138645.
- Zach Lieberman's Instagram page, https://instagram.com/zach.lieberman/.
- "Basics in OpenProcessing," https://openprocessing.org/browse/?q=basics&time=anytime&type=all#.
- "Creative Coding with Processing and p5.js," https://fb.com/groups/creativecodingp5/.

Task (RunMe)

1. Study at least one example of syntax from the p5.js reference site, https://p5js.org/reference/. (Of course, it is always good to know more than one. Be curious!)

2. Familiarize yourself with the reference structure: examples, descriptions, various pieces of syntax and parameters (This knowledge will give you an essential, life-long skill for learning new syntax on your own).

3. Use, read, modify (or even combine) the sample code that you find (the most basic level is changing the numbers), and produce a new sketch as a RunMe.

Questions to think about in your ReadMe

- What have you produced?
- How would you describe your first independent coding experience (in relation to thinking, reading, copying, modifying, writing code, and so on)?
- How is the coding process different from, or similar to, reading and writing text?
- What does code and programming mean to you, and how does the assigned reading help you to further reflect on these terms?

Required reading

- Lauren McCarthy, "Learning While Making p5.js," *OPENVIS* Conference (2015), https://youtube.com/watch?v=1k3X4DLDHdc.

- "p5.js | get started," https://p5js.org/get-started/.

- Daniel Shiffman, "1.1: Code! Programming with p5.js" (2018), https://youtube.com/watch?v=yPWkPOfnGsw.

- Annette Vee, "Coding for Everyone and the Legacy of Mass Literacy," in *Coding Literacy: How Computer Programming Is Changing Writing* (Cambridge, MA: MIT Press, 2017), 43-93.

Further reading

- Wendy Hui Kyong Chun, "On Software, or the Persistence of Visual Knowledge," *Grey Room* 18, January (2005): 26-51, https://doi.org/10.1162/1526381043320741.

- Brian Lennon, "JavaScript Affogato: Programming a Culture of Improvised Expertise," *Configurations* 26, no. 1, Winter (2018): 47-72.

- Nick Montfort, "Appendix A: Why Program?" Exploratory Programming For the Arts and Humanities (Cambridge, Mass.: MIT Press, 2016), 267-277.

Notes

1. In the 1960s the opportunities for getting a job, regardless of gender and educational background, in the area of programming was enormous. With low entry barriers, prior coding experience nor college-educated training were not prerequisites, and companies generally offered on-the-job training. Many women entered the programming field and climbed up the "computer ladder" during the early years of computing history, according to Lois Mandel, "The Computer Girls," *Cosmopolitan* (April 1967): 52-56. However, although computer programming "started out with an ambiguous gender identity, [it] was gradually and deliberately transformed into a high-status, scientific, and masculine discipline," according to Nathan Ensmenger, "Making Programming Masculine," in *Gender Codes: Why Women are Leaving Computing*, Thomas J. Misa, ed. (Hoboken, NJ: John Wiley, 2010), 115-141.

2. Having programming skills has become a prerequisite in education and business globally. See, for instance, https://ec.europa.eu/digital-single-market/en/coding-21st-century-skill and https://news.microsoft.com/apac/features/coding-way-brighter-future-2018-beyond/. The opening up of programming beyond specialized disciplines, the so-called "STEM" subjects, sets the conditions for what we refer to as "aesthetic programming."

3. We are thinking of Stuart Hall's essay "Encoding/Decoding" in which he argues that people can play an active role in decoding messages, in Stuart Hall et al, eds. *Culture, Media, Language* (London: Hutchison, 1980), 128-38.

4. Annette Vee, *Coding Literacy: How computer programing is changing writing* (Cambridge, MA: MIT Press, 2017), 4. Beyond coding literacy, we can also observe other kinds of literacy in mainstream media, policy making, and academic discourse, such as procedural, data and digital literacy. See Ian Bogost, "Procedural Literacy: Problem Solving with Programming, Systems, & Play," *The Journal of Media Literacy* 52, no. 1-2 (2015); Michael Mateas, "Procedural Literacy: Educating the New Media Practitioner," *On the Horizon. Special issue. Future of Games, Simulations and Interactive Media in Learning Contexts* 13, no.1 (2005); Annette N. Markham, "Taking Data Literacy to the Streets: Critical Pedagogy in the Public Sphere," *Qualitative Inquiry* (August 2019). doi:10.1177/1077800419859024; Teressa Umali, "Exclusive: Promoting Digital Literacy in the Philippine Education System." *OpenGov Asia*, available at https://www.opengovasia.com/promoting-digital-literacy-in-the-philippine-education-system/.

5. John Cayley, "The Code is Not the Text Unless it is the Text," *Electronic Book Review* (2002), available at http://electronicbookreview.com/essay/the-code-is-not-the-text-unless-it-is-the-text/, see also Katherine Hayles, *Writing Machines* (Cambridge, MA: MIT Press, 2002).

6. Vee, *Coding Literacy: How computer programing is changing writing*, 45-58.

7. Nick Montfort, *Exploratory Programming for the Arts and Humanities* (Cambridge, Mass.: MIT Press, 2016).

8. We take this from Douglas Rushkoff's *Program or Be Programmed: Ten Commandments for a Digital Age* (New York: OR books, 2010).

9. A library is a collection of resource in the form of code containing programming functions and their details. Those functions can be used to develop software programs and applications.

10. Charles Severance, "Javascript: Designing a Language in 10 Days," *IEEE Computer Society*, February (2012), 7-8.

11. Lin Clark works at Mozilla and turns code into cartoons. Here she explains how JavaScript is run in the browser, see https://hacks.mozilla.org/2017/02/a-crash-course-in-just-in-time-jit-compilers/.

12. Seong-Won Lee and Soo-Mook Moon, "Selective Just-in-time Compilation for Client-side Mobile JavaScript Engine", in *Proceedings of the 14th International Conference on Compilers, Architectures and Synthesis for Embedded Systems (CASES '11)* (New York: ACM, 2011), 5-14. DOI: https://doi.org/10.1145/2038698.2038703

13. IDE is a software application that provides a more comprehensive and integrated environment for software development. It usually consists of a source code editor, build automation tools and a debugger. In this book we use Atom as the code editor, but it requires another tool for debugging such as a browser's web console. One example of IDE would be Processing, an open source, standalone application built for the visual and electronic art communities. See https://en.wikipedia.org/wiki/Integrated_development_environment.

14. JVM refers to a virtual environment in a machine (usually a computer) that can run and execute programs in the form of Java bytecode written in programming languages such as Java. JVM performs operations such as loading, verifying, executing code and offers a runtime environment. See https://en.wikipedia.org/wiki/Java_virtual_machine.

15. See https://minecraft.gamepedia.com/Development_resources.

16. A concept was first formulated by mathematician, computer scientist, and educator Seymour Papert who was an MIT Professor and created the design principle for a programming language called Logo. See Seymour Papert, *Mindstorms: Children, Computers, and Powerful Ideas* (New York: Basic Books, 1980).

17. See https://processing.org.

18. The lack of gender diversity is also reflected in the Aesthetic Programming course feedback in 2017, with a student commenting that "code is not a gentlemen's club that only belongs to computer scientists." Artist Juli Laczko's research and practice address the issue of gender and stereotyping in the history of computing. One of the examples is the artwork *webmachine*, which is a reversed analog weaving computer. It is an online software piece that uses punch card technology to translate a binary text into visual code. The project looks into the history and labor practices of weaving and how culture reinforces stereotypes in computing. See https://digital-power.siggraph.org/piece/webmachine/.

19. Lauren McCarthy, "P5js Diversity & Floss Panel Introduction" (2015). Video available at http://opentranscripts.org/transcript/p5js-diversity-floss-panel-introduction/.

20. p5.js is now available in Spanish, see Maya Man, *Processing Foundation* (2016), available at https://medium.com/processing-foundation/p5-js-is-now-available-in-spanish-3d1eab9dffa0; see also Kenneth Lim, Chinese Translation for p5.js and preparing a future of more translations (2018), available at https://medium.com/processing-foundation/chinese-translation-for-p5-js-and-preparing-a-future-of-more-translations-b56843ea096e.

21. Such a series with a focus on diversity within code+art and placed under the subdomain of p5.js, created and curated by Chelly Jin, diversity.p5js.org.

22. A UX-research project by Claire Kearney-Volpe, https://www.clairekv.com/p5js-ux-research.

23. A project by artist and educator Taeyoon Choi, http://taeyoonchoi.com/soft-care/signing-coders/.

24. Chun politicizes the concept of software, and, in particular, she traces the history of automatic programming, the rise of the binary distinction between hard and software, as well as the erasure of gazes. See Wendy Hui Kyong Chun, "On Software, or the Persistence of Visual Knowledge," *Grey Room* 18 (January 2005): 26–51. https://doi.org/10.1162/1526381043320741.

25. https://atom.io/.

26. p5.js download page, https://p5js.org/download/.

27. https://p5js.org/reference/#/libraries/p5.sound.

28. https://atom.io/packages/atom-live-server.

29. https://p5js.org/reference/#/p5/print.

30. p5.js has built in "The Friendly Error System" to help coders especially beginners. The library considers a well-designed and user friendly debugger "written in a right tone "can lower the barrier for inexperienced users." See A. Mira Chung, "Friendly Error System for p5.js", *Processing Foundation* (2017), https://medium.com/processing-foundation/2017-marks-the-processing-foundations-sixth-year-participating-in-google-summer-of-code-d365f62fc463.

31. Wendy Hui Kyong Chun and Andrew Lison argue the first "Hello World" program we learn is enjoyable and seductive. We will say more about this in the following chapter. See Chun and Lison, "Fun is a Battlefield: Software between Enjoyment and Obsession," in Olga Goriunova, ed., *Fun and Software: Exploring Pleasure, Paradox and Pain in Computing* (New York, London: Bloomsbury, 2014), 180.

32. *hallo welt! (hello world!)* was a collaboration between Geoff Cox and Duncan Shingleton, see http://www.anti-thesis.net/hello-world-60/.

33. *The Tower of Babel*, designed to reach heaven, displeased God such that "he" decided to confound the single language of Adam so that people would not understand each other's speech (*Genesis* 2:19 & 11:1-9). Subsequently everyone is left to "babble" in a diversity of languages the so-called confusion of tongues. The code expresses this confusion, but also invokes free speech, allowing the web browser to "speak" through software according to what it is said/written. "It is both a computer-readable notation of logic and a representation of this process, both script and performance; and in this sense it is like spoken words" as Cox reminds us. See Geoff Cox, *Speaking Code: Coding as Aesthetic and Political Expression* (Cambridge, Mass: MIT Press, 2013), 3.

34. See https://p5js.org/reference/#/p5/ellipse.

35. To run the JavaScript via GitLab on a web browser, you need to do some configuration in the repository before uploading any source code. A new file (.gitlab-ci.yml) is created in the root of the project repository, containing a set of jobs and their specifications that are required to run on GitLab. You can follow GitLab's guidelines (in terms of the code in the yml file as well as the use of repository as a website) here, https://gitlab.com/pages/plain-html/-/blob/master/README.md.

36. The readme file is structured in a markdown format with the file extension as ".md". It is a lightweight markup language supporting simple text formatting with special syntax. Files with this extension can be processed by GitLab and display in a more readable form visually on the web. For more about the syntax of writing in markdown, see: https://docs.gitlab.com/ee/user/markdown.html.

37. This discussion is summarized at https://stackoverflow.com/questions/43959748/what-is-the-abbreviation-of-git.

38. See https://github.com/processing/p5.js/wiki.

39. See https://www.gnu.org/licenses/lgpl-3.0.txt.

40. Not before time many software communities have decided to stop using "master-slave," such as Django and Python, and have replaced with alternative terms. See, https://tools.ietf.org/id/draft-knodel-terminology-00.html#rfc.section.1.1. According to Ron Eglash, the term master-slave suggests the element of control in a dependent relationship, however it is not accurately described technically and has further raised the ethical issues in using broken metaphor in computing. See, Ron Eglash, "Broken Metaphor: The Master-Slave Analogy in Technical Literature," *Technology and Culture* 48, no.2 (2007): 360–69. https://doi.org/10.1353/tech.2007.0066.

41. Foundational reading on this issue would be Dale Spender's *Man—Made Language* (1980), https://www.marxists.org/reference/subject/philosophy/works/ot/spender.htm.

42. Judith Butler, *Excitable Speech: A Politics of the Performative* (London: Routledge, 1997).

43. See also Geoff Cox & Alex McLean, *Speaking Code: Coding as Aesthetic and Political Expression* (Cambridge, MA: MIT Press, 2013).

44. Richard Hoggart, *The Uses of Literacy: Aspects of Working Class Life* [1957] (London: Penguin, 2009).

45. Walter J. Ong, *Orality and Literacy: The Technologizing of the Word* [1982] (London: Routledge, 2002).

46. See Harwood's "Class Library", in Fuller ed., *Software Studies*, 37-39.

47. See, https://p5js.org/reference/#/p5/class.

48. Vee, *Coding Literacy*.

49. This point is largely derived from Kelty's *Two Bits*, which uses the phrase "running code" to describe the relationship between "argument-by-technology and argument-by-talk." See Christopher Kelty *Two Bits: the Cultural Significance of Free Software* (Durham: Duke University Press, 2008), 58. Clearly programmers are able to make arguments as people can in other rhetorical forms, see Kevin Brock, *Rhetorical Code Studies: Discovering Arguments in and around Code* (Ann Arbor, MN: University of Michigan Press, 2019).

50. Processing Foundation announced the official release of the p5.js Web Editor in 2018, an online platform for learning and running code, and it is easy to get started with no additional installation of software. See https://medium.com/processing-foundation/hello-p5-js-web-editor-b90b90 2b74cf.

51. See https://p5js.org/reference/.

2. Variable geometry

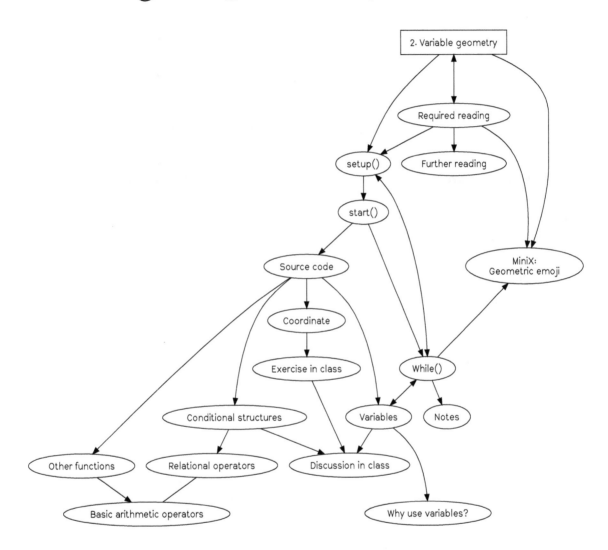

Contents

setup()

Aside from the difficulties of learning anything new and complex, learning to code can be enjoyable and rewarding (we hope!). That programming can be fun is demonstrated by the numerous titles that explicitly reference this, such as Linus Torvalds's book *Just for Fun: The Story of an Accidental Revolutionary*, written with David Diamond, part autobiography and part story of the development of Linux.(1) Fun was, in this case, combined with the serious effort of making source code freely available and open to further modification. Like sharing a joke, or indeed recipe, programmming is a social activity and relies on collective understanding in order to "get it."

There are many more examples that reinforce the idea of fun, as if simply stating this would be enough to convince users to work through learning to program and not be too put off by its underlying difficulty. In what follows we encourage you to have fun with geometry, following on from drawing an ellipse in the previous chapter. The idea is to further explore various shapes, sizes, positions, space, and lengths, all which are regarded as geometry by mathematics and have multiple applications in everyday life including, but not limited to, typography, signage, graphic design, and architecture, as well as other organizational forms. More specifically, points, lines, and planes are regarded as the foundational elements of design as these elements are used to constitute objects, and the world is made up of various objects that have particular properties. Fun with geometry comes from manipulating these properties, and reconstituting them anew, creating alternative patterns of recognition and understanding.(2) As Olga Goriunova states in her edited book *Fun and Software*, fun with computers is considered to be a mode of thinking,(3) and, furthermore, fun can be had with the paradoxes that arise in the process. By creating new computational objects, you will manipulate learnt procedural logics, and explore how these might be adapted and redrawn. Variable geometry in this sense is about shape-shifting: re-imagining all sorts of new shapes, compositional forms, and spatial relations, thereby challenging geometric conventions.(4)

We take the example of emoticons — ideograms, typically smileys — as typographic shorthand for expressing facial emotional states such as happiness, ":D". These have become pervasive in communication, and are no longer simply typographic, but actual pictures which can be funny at times as emojis, but also come with underlying issues related to the politics of representation. More on this below, but for now, suffice to say, emojis make a good example as they consist of geometric shapes, using lines, points, planes, and colors. This chapter is about having fun with this (even if some of the underlying issues are not fun at all), exploring the affective dimension of emojis, and the varying representations that we encounter in everyday communications.

The relationship between emoji standardization and a politics of representation has been explored by many commentators. The essay "Modifying the Universal," written by Roel Roscam Abbing, Peggy Pierrot and Femke Snelting is a good example,(5) as it investigates the politics of emoji "universalism." Emojis emerged from the Unicode project, that has set the computing industry standard for the consistent encoding, representation, and handling of text for software internationalization in all major operating systems and writing applications since 1987. Interestingly, on a technical level, Unicode provides a unique code

point (a number) to represent a character in an abstract way and leaves the visual rendering (size, font, shape, geometry) to other software, such as a web browser or word processor. It is the question of representation that interests us here.

Much like the utopian project of developing a universal language to be spoken and understood by the majority of the world's population (such as Esperanto) Unicode is clearly important to communicative operations across international/multilingual systems. By the time of the most recent version, Unicode 12.1's release in May 2019, there were 137,994 characters covering 150 scripts, as well as multiple symbol sets and emojis. (6) Yet, as the standard expanded from the underlying characters and glyphs to symbol sets and emojis, the universalism has become increasingly problematic. Criticism has unsurprisingly centered on the politics of representation, such as blatant gender stereotyping and racial discrimination: for example, female emojis were under-represented in certain professional roles, (7) there were also limitations of skin tone applied to emojis and "universal modifiers" that were not displayed "universally" across all devices and operating systems.

Our point is that using emojis may be fun and expressive, but they also tend to oversimplify and universalize differences, thereby perpetuating normative ideologies within already "violent power structures," (8) such that only selected people, those with specific skin tones for instance, are represented while others are not. There is a distinct inequality as to how people are represented, and we need to question who sets the standards for these representations. That such operations can be characterized as fun is part of the problem and masks other processes that monitor our emotional states not least in the workplace (we will return to this issue in Chapter 4, "Data capture"). The project *AIMoji* by Process Studio highlights some of these issues with the use of deep learning techniques and training existing emoji data (9) in order to mess up their reductive representational logic and produce noisy mutations that offer inbetween shapes, faces and emotions, thereby rejecting universalism. Above are some of the issues we want to explore in this chapter by introducing variable geometry and learning to be able to produce alternatives, more politically-correct ones perhaps. We will start with the work *Multi* by graphic designer David Reinfurt which will be used to demonstrate the basis of geometry and the variations of facial expression and composition that can be generated from simple typographic elements.

start()

Figure 2.1: Multi by David Reinfurt. Courtesy of the designer.

Multi (http://www.o-r-g.com/apps/multi), (10) is inspired by another designer Enzo Mari who spent a whole year in 1957 exploring the essential form of an object (an apple). Reinfurt explains that, "He was not looking to draw AN apple, but rather THE [universal] apple — a perfect symbol designed for the serial logic of industrial reproduction." *Multi* develops a variation of this idea for informational reproduction in the form of a mobile app with 1,728 possible arrangements, or facial compositions, built from minimal punctuation glyphs. But instead of using preset typographic characters, which admittedly is the conceptual charm of *Multi*, for our purpose we will draw these from scratch with foundational elements of geometry.

Source code

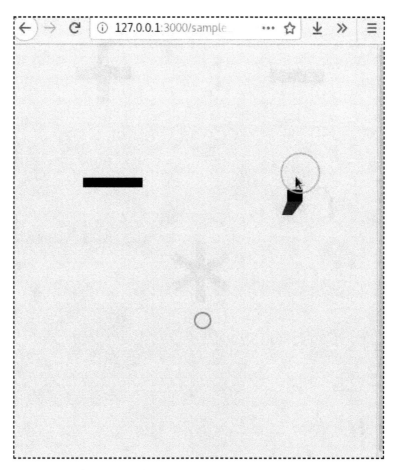

Figure 2.2: The screenshot of the remix of *Multi*

RunMe, https://aesthetic-programming.gitlab.io/book/p5_SampleCode/ch2_VariableGeometry/.

2. Variable geometry

```
1   /*Inspired by David Reinfurt's work - Multi*/
2   Let moving_size = 50;
3   Let static_size = 20;
4
5   function setup() {
6     createCanvas(windowWidth, windowHeight);
7     frameRate(15);
8   }
9
10  function draw() {
11    //background
12    background(random(230, 240));
13    //left
14    noStroke()
15    fill(0);
16    rect(97, 169, 79, 12);
17
18    //right
19    rect(365, 184, 20, 15);
20    fill(20, 20, 120);
21
22    beginShape();
23    vertex(365, 199);
24    vertex(385, 199);
25    vertex(372, 216);
26    vertex(358, 216);
27    endShape(CLOSE);
28
29    //bottom
30    noFill();
31    stroke(130);
32    strokeWeight(2);
33    ellipse(255, 350, static_size, static_size);
34
35    //mouse interactions
36    stroke(180);
37    ellipse(mouseX, mouseY, moving_size, moving_size);
38
39    if (mouseIsPressed) {
40      static_size = floor(random(5, 20));
41    }
42  }
```

The above code draws various shapes and performs simple interactions:

- the background is filled with flashing grey-scale colors
- on the left is a horizontal rectangle in the color black
- on the right is a rectangle in black and a polygon in blue
- on the bottom is an ellipse without any filled color but with grey stroke color
- when you move the mouse, an outlined ellipse in grey color follows the movement
- you can also click on the mouse to change the size of the grey ellipse

Coordinates

In the previous chapter, we briefly discussed the x and y coordinates that constitute a fundamental concept for positioning and drawing objects with various measurements on a canvas. A line of code like `createCanvas(windowWidth,windowHeight)` refers to creating a canvas with its width and height in line with your window size. Unlike the previous chapter where the exact pixel dimension was set as in the example `createCanvas(640,480);`, this approach gives you a flexibility of no fixed canvas size. Therefore, the background color of the sample code fills the whole window screen, and the concept of canvas as spaces change variably in terms of geometry. It is good to remind ourselves that in mathematics the origin [0,0] is usually positioned in the center of a grid paper/screen, but in programming language like p5.js the origin is situated in the upper left corner (see Figure 1.11 in the previous chapter). This impacts on how objects are placed, and shifts our perception/understanding of space/canvas by having a frame of reference.

Exercise in class

```
1  function setup() {
2    createCanvas(windowWidth, windowHeight);
3    frameRate(15);
4  }
5
6  function draw() {
7    background(random(230,240));
8  }
```

Remember the structure of a web page/application should include the HTML, a working JavaScript file (for example, sketch.js), as well as the associated p5.js libraries.

- Type/copy the above source code in the working JavaScript file, then save the code. Run the program on Atom (with the live-atom-server) and, on screen, the background should flash.

- There are few new examples of syntax, or a slightly different use of syntax, here:
 - `frameRate()`: This sets the number of frames per second that the computer will use when running the program. The default is 60 and this sets it to 15 (see Line 3), so you can see the background color for each frame quite clearly (you can also compare the flash/frame rate to the sample code in the previous chapter).
 - `random(230,240)`: In the earlier sample code, the function `random()` only took a single parameter. This sample code gives you a different use of the function with two parameters. If you look at the reference guide (https://p5js.org/reference/#/p5/random), (11) it explains that the random function returns a floating-point number, and this means that the number is not an integer, but a number with decimals. In this case, the program will return a floating-point number between 230.0 and up to, but not including, 240.0 (see Line 7). An example of such a returned value would be 231.34387.
- Next you need to remember how to use the web console (Under Tools > Web Developer > Web Console on Firefox).
 - Type `print(width);` and then press enter.
 - Type `console.log(width, height);` and then press enter.

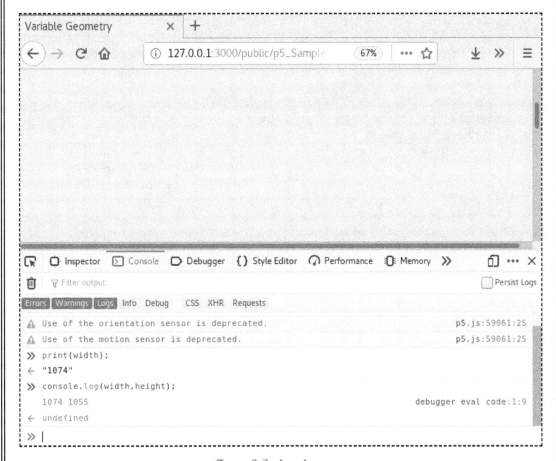

Figure 2.3: Simple exercise

When you type the syntax `print(width);` the web console area (see Figure 2.3) displays the actual width in pixels. Additionally, if you use `console.log(width, height);`, which is the equivalent of the print function in JavaScript (not a p5.js function), the screen displays two numbers according to your screen size (you may adjust the screen and try again to get a different number). With just two lines in the web console area, you have asked the program to give you the values for the width and height of the canvas. The program understands the two names "width" and "height" as they are pre-set names in p5.js which you can use specifically for asking the dimensions of the canvas.

Variables

In programming, both width and height are called "variables" — another important concept. Variables are used to store data and information in a computer program. You can think of variables as a kitchen container, in which you can put different types of things (like food, kitchen utensils, etc.) in a given container, replace them with other things, and store them for later retrieval. There are two main types of variables: "local variables" that are defined within a structure or a function, can only be used within that block of code; and "global variables" that can be used anywhere in the code. Global variables need to be defined before the setup of the program, usually in the first few lines of code.

In the previous exercise, the value in the sample code (line 2) behind `windowWidth` is the width of the window set as the canvas width. To continue the analogy, a container with the name "width" (as we have just typed in the web console) is labeled and stores the value. The program is able to retrieve the measurement of the canvas by using the variable `width` and this value can be changed according to your window width, and can be retrieved and displayed using the web console. (You can also use the variables `width` and `height` in other parts of your sketch, and for other purposes.)

It is important to note that you can also assign your own variable names (in other words, you can create your own type of container and store other values).

```
1   let moving_size = 50;
2   let static_size = 20;
3   ...
4   ellipse(255, 350, static_size, static_size);
5   ...
6   ellipse(mouseX, mouseY, moving_size, moving_size);
7
8   if (mouseIsPressed) {
9       static_size = floor(random(5, 20));
10  }
```

The above is the excerpt from the full code required to draw two different sized ellipses (As discussed in the previous chapter, the final two parameters of the ellipse function refer to width and height.) Instead of placing a number in the function as in Chapter 1, "Getting started," we will use variables as they hold values (see Lines 4 & 6), especially global ones that can be reused in different places of a program. Three steps are required to use variables:

1. **Declare:** Think of a name for the container you want to store the value in (it should make sense to you and others to read, but of course there is scope for a conceptual approach here). Declare with the syntax "let" in front. ⑫ (See line 1-2 from the above)
 There are certain rules to follow in naming variables:

 - Names usually begin with a lowercase string and not with a number or symbols.

 - Names can contain a mix of uppercase and lower case strings, and numbers.

 - Names cannot contain symbols.

2. **Initialize/Assign:** What is it that you want to store? A number? By assigning a value, you will need to use the equal sign. There are four data types that are useful to know at this introductory level:

 - *number* for numbers of any kind: integer or floating-point.

 - *string* for strings. A string may have one or more characters and it has to be used with double or single quotation marks. For example: `let moving_size = "sixty";`

 - *boolean* for true/false. For example: `let moving_size = true;`

 - *color* for color values. This accepts Red, Green, Blue (RGB) or Hue, Saturation and Brightness (HSB) values. For example: `let moving_size = color(255,255,0);` see more from the "p5.js color reference" (https://p5js.org/reference/#/p5/color). ⑬

3. **(Re)Use:** How and when do you want to retrieve the stored data? If the variable changes over time, you may wish to reuse it many times.

In the above code excerpt, steps 1 and 2 are combined and the code is written as `let moving_size = 50;`. There are two variables: "moving_size" & "static_size" (see Lines 1 & 2,) but we can say that the variable "static_size" is more dynamic than the other. This is because the value changes according to mouse press as you can see in lines 8-10. (If you do not foresee values changing, you can also consider using `const` ⑭, a value that remains unchanged for the entire program.)

There are two more variables in the example: `mouseX` and `mouseY` (see Line 6.) These variables change and are subject to mouse movement for tracing the corresponding x and y coordinates. If you want to know the exact mouseX and mouseY coordinates, you can also use `print()` or `console.log()` to display the two values in the web console area. (A small exercise: How to write a line of code to display or print the mouseX value on the web console?)

Although it is commonplace to use the metaphor of a container to illustrate the variable as a concept, it is important to add that each container has an address (we might say that it is in a particular place on a shelf, and the computer needs to know where). A variable name can be customized in a way that is readable and meaningful for humans but how it operates at the level of execution does not take into the consideration of such meanings, in which programming oscillates between natural language expression as well as computer operation and execution (we will return to this double coding discussion in Chapter 7, "Vocable code").

Technically speaking, by declaring a variable, it also declares an address where the computer memory can hold the value. In short, each variable is stored in a block of computer memory which is located inside physical and concrete memory like RAM that reconfigure the space. Each block has an identifier called the memory address so that the computer knows where to store it and retrieve it while the program is running. Creating and declaring a variable is not only a programming issue, hardware is also involved in space allocation for data storage. As such, software and hardware are inseparable, and it's just that we aren't able to see the inner micro-workings of a computer whilst it is handling data. (15)

Why use variables?

As you learn to program more complex software, you will discover that it is very common to use variables to store values and data. More importantly, the value of variables can be changed while a program is being run in real-time. The variables mentioned above: mouseX and mouseY illustrate this point because the mouse's coordinates change according to its movement. We will also discuss variables again in the next chapter when we introduce the concepts of array, loop, and repetition.

Another reason for using variables is that if you have longer lines of code, it is easier to have all the variables that you have declared for the program in an overview. If a variable is used in different parts of a complex program, you can simply change the value of the global variable instead of changing the multiple parts in the entire program, and this is useful for testing/refining the program without locating specific and multiple lines of code for modification. This leads to the reusability of variables. Variables can be used in different functions and more than once (and also as arguments passed to a function subroutine, something we will also discuss in the next chapter). A good example is the static_size variable in the sample code that is used to draw both the ellipse and the rectangle. As such, variables in the sample code deal with the changing and compositional shape-in-space.

Additionally, it is also easier for others to read your code with a well-chosen variable name, or at least the variable name can suggest certain behaviors or actions. As you progress, you might write code collaboratively, or write a larger program with more lines of code, at which point it is important to think of the readability of code.

Other functions

This section briefly introduces some other new functions in the full source code. Drawing and designing an emoji requires different decisions, in terms of shapes, color, and spatial composition.

- `noStroke()`, `strokeWeight()`: These functions refer to the settings of a shape, where it has an outline, and the weight of the border.
- `stroke()`, `fill()` and `nofill()`: These set the color of objects such as border, shapes, or text. It takes RGB (as default) or HSB color. But if the function has a single parameter, then it refers to gray scale shade between 0-255 (16). If the function has three parameters like `fill(255, 255, 0)`, then it means the object/shape/text will be filled with a yellow color (the mix of red and green with no blue). There is an optional parameter called "alpha", which refers to the opacity of the color, e.g. `fill(255, 255, 0, 127)`.
- `rect()`: This is similar to drawing an ellipse, but is used to display a rectangle.
- `vertex()`, `beginShape()` and `endShape(CLOSE)`: These three functions are used for drawing more complex forms using various vertices. The `vertex()` function indicates its x and y coordinates, and all the vertices can be joined using the "CLOSE" argument in `endShape()`. The `beginShape()` is used to record the start of the vertex for a complex form like a polygon.
- `floor()`: Since the `random()` function returns a floating-point number, `floor()` is used to calculate the closest integer value.
- `if (mouseIsPressed) {}`: This is a conditional structure for a program, constantly referring to mouse press actions. This is discussed in more detail below.

Conditional structures

Conditional structures are very useful as they allow you to set a different path by specifying conditions. Indeed, a conditional decision is not specific to programming. For example, in everyday life, you might say "If I am hungry, I should eat some food, if I am thirsty, I should drink some water, otherwise I will just take a nap."

```
1   //example in human language
2   if (I am hungry) {
3     eat some food;
4   } else if (thirsty) {
5     drink some water;
6   } else{
7     take a nap;
8   }
```

The above is an example of "pseudocode" to demonstrate what making an everyday decision might look like in programming. The keyword and syntax if is then followed by the condition and checks whether a certain condition holds. As such, the whole if statement is a "Boolean expression" — one of two possible values is possible, true or false, each of which leads to a different path and action. In computer science, the Boolean data type has two possible values intended to represent the two truth values of logic.

We have implemented a conditional logic in our sample code to constantly check if there is any mousepressed actions. This is why the size of the ellipse changes when a mouse is pressed.

```
1   if (mouseIsPressed) {
2      static_size = floor(random(5, 20));
3   }
```

ReDational operators

If you have to create your own conditional statement with the if() syntax, there are multiple combinations you can work with to create more complex expressions. For example, you can have many different cases using the syntax else if, or a combination of logical operators, such as the AND case here in another pseudocode example:

```
1 if (I am hungry) && (I am in a good mood) {
2      print("go out");
3 }
```

Here is a list of relational operators and logical symbols that can be used in conditional statements.

```
1
2    /*
3    Relational Operators:
4    >   Greater than
5    <   Less than
6    >=  greater than or equal to
7    <=  less than or equal to
8    ==  equality
9    === equality (include strict data type checking)
10   !=  not equal to
11   !== inequality with strict type checking
12   */
13
14   /*
15   Logical Operators: boolean logic:
16   &&  Logical AND
```

```
17      ||  Logical OR
18      !   Logical NOT
19      */
20
21      /*
22      Example:
23      if () {
24          //something here
25      } else if() {
26          //something here
27      } else{
28          //something here
29      }
30      */
31
```

Below is an example of a small sketch that uses a conditional structure and operators. Although all the conditional "if" or "else-if" statements are true, the web console will only print out "one." This is because the program will exit the structure when the first condition is met. In other words, sequence matters and the program will not run the other else-if statements after executing the first true statement.

```
1   let x = 18;
2   if (x > 10 || x <= 20 ) {
3       console.log("one");
4   } else if (x == 18) {
5       console.log("two");
6   } else if (x === 18) {
7       console.log("three");
8   } else  {
9       console.log("four");
10  }
```

Basic arithmetic operators

You can also do arithmetic operations in programming, and this is commonly done in the arguments of a function. Here is a list of basic arithmetic operators:

- add(+): For addition and concatenation, which is applicable to both numbers and text/characters.
- subtract(-)
- multiply(*)
- divide(/)
- Special operators: increment (++), decrement (--)

You can try the following in the web console area:

```
1  console.log(2*3);
```

Output:
"6"

```
1  console.log("hello" + "world");
```

Output:
"helloworld"

Discussion in class

1. Examine existing geometric emojis (https://gitlab.com/aesthetic-programming/book/-/blob/master/source/2-VariableGeometry/emojis.jpeg) or those available on your mobile phone, can you describe about the shape of an emoji? what constitutes a face? What essential geometric elements do you need for a particular facial expression? What has been lost in translation?

2. Reflect upon the complexity of human emotions, and their caricatures. What is your experience using emojis? What are the cultural and political implications of emojis (you might refer to the reading and introduction above)?

3. Beyond the face, take a look at more emojis (https://www.pngfind.com/mpng/ohwmTJ_all-the-emojis-available-on-facebook-russian-revolution/). (17) Is there anything you want to add?

4. Experiment with p5.js. How do you translate your thoughts into lines of code? You may want to print the coordinates of the mouse press in the web console area to get a more accurate position for your shapes.

While()

The human face makes a good starting point as we recognize it easily, even in its simplest form, something *Multi* seems to verify with its minimal rendering of three typographic elements. The face clearly occupies a central position in everyday life and social interaction, and it almost goes without saying that its features are perceived to display our uniqueness

and individuality. But this is a surface reading only. Emojis operate in this way and seem to occlude the face of experience and its ability to express complex feelings. It is tempting to think that emojis, despite their name, stop short of emotions altogether.

In *A Thousand Plateaus*, Gilles Deleuze and Félix Guattari conceive of the face as "overcoded," imposed upon us universally, resonating with some of the comments we made earlier in this chapter about Unicode. Their main point is that the face — what they called the "facial machine" — is tied to a specific Western history of ideas (e.g. the face of Jesus Christ). This, in turn, situates the origins of the face with white ethnicity (despite Jesus's birthplace) and what they call "facialization" (the imposition onto the subject of the face) has been spread by white Europeans, and thus provides a way to understand racial prejudice: "Racism operates by the determination of degrees of deviance to the White man's face...". (18) The face is thus understood as an "imperial machine," subsuming language and other semiotic systems. The face is part of a surface that promotes sameness and ultimately rejects variations.

Facial recognition technologies that are capable of identifying or verifying a person from a digital image or a video frame, seem to operate on these (imperialist) terms too. When a person is identified in this way, the person's facial shape and textures are matched against a model based on a standardized dataset (we will return to this discussion in Chapter 4, "Data capture"). Moreover, the datasets are based on a disproportionate number of white faces. Facial recognition systems therefore notoriously struggle to identify black people. This has led to significant problems not least when it comes to the use of these technologies for policing.

Facial recognition systems also become unreliable when facial expressions vary, and even a big smile can falsify the results, so there is some irony that a smiley in real-life is likely to create difficulties in recognition (as if the social standard is unfriendliness). The iconic emoji smiley seems to further stress the point. The face may be able to escape overcoding under certain conditions, but emojis are quite literally "facial-machines" with prejudice built-in. Herein lies a challenge to having fun with programming: How to escape the overcoding and to develop alternative geometric shapes?

Something of this logic is evident in another article by Femke Snelting, "Other Geometries," which discusses how geometric shapes can help resist sovereign infrastructures. (19) Thinking of something as simple as a circle, and how it is associated with collective forms in terms of space and structure, Snelting writes.

> "A circle is a simple geometric shape. [...] Circles are mathematically defined as the set of all points in a plane that are at the same distance from a shared center; its boundary or circumference is formed by tracing the curve of a point that keeps moving at a constant radius from the middle. [...] Circles are omnipresent in practices and imaginaries of collectivity. [... and yet] Their flatness provides little in the way of vocabulary for more complex relational notions that attempt to include space, matter and time, let alone interspecies mingling and other uneasy alliances. The obligation to always stay at the same distance from the center promises a

situation of equality but does so by conflating it with similarity. Circles divide spaces into an interior and an exterior, a binary separation that is never easy to overcome. We urgently need other axes to move along." (20)

Snelting is looking for other geometries that can escape normative configurations of collectivity. She also refers to the works of Zach Blas, known for his artistic interventions with facial recognition systems (*Facial Weaponization Suite*, 2011-14), to point to the geometric spaces between nodes and edges, and to draw more attention to relations. Beyond network imaginaries of decentralized and distributed forms that have historically been part of rethinking centralized power structures, the idea is to "bend our infrastructural desires in other directions," making further reference to the work of Anna Tsing and "messy geometries" inspired by Mycelium, the branching, thread-like root structures of fungi. (21)

The challenge then is to rethink normative geometries, to turn them upside down and inside out. Herein lies the purpose of the chapter, to escape geometric overcoding and to develop alternatives. Having fun with programming in this sense is the ability to modify forms and to diverge from established rules. When it comes to programming, the rules can be applied differently, adapted or modified, and even transformed altogether.

MiniX: Geometric emoji

Objective:

- To experiment with various geometric drawing methods and to explore alternatives, particularly with regard to shapes and drawing with colors.
- To reflect on the politics/aesthetics of emojis on the basis of the assigned texts.

For additional inspiration:

- *AIMoji* by Process Studio (2019), https://process.studio/works/aimoji-ai-generated-emoji/, and as part of "Uncanny Values," Vienna Biennale (2019), https://process.studio/works/uncanny-values/.

Some articles on emoji culture:

- Steve Witt, "Chinese Characters as Ancient 'Emoji'," *Glocal Notes* (2015), https://publish.illinois.edu/iaslibrary/2015/10/21/chinese-characters/.
- Michael Grothaus, "Women Finally Get a Menstruation Emoji," *Fastcompany* (2019), https://www.fastcompany.com/90302946/women-finally-get-a-menstruation-emoji.

Tasks (RunMe):

Explore shapes, geometries, and other related syntax (via p5.js references) and design two emojis, https://p5js.org/reference/.

Questions to think about (ReadMe):

- **Describe** your program and what you have used and learnt.
- **How** would you put your emoji into a wider social and cultural context that concerns a politics of representation, identity, race, colonialism, and so on? (Try to think through the assigned reading and your coding process, and then expand that to your own experience and thoughts - this is a difficult task, you may need to spend some time thinking about it).

Required reading

- Roel Roscam Abbing, Peggy Pierrot and Femke Snelting, "Modifying the Universal," in Helen Pritchard, Eric Snodgrass & Magda Tyżlik-Carver, eds., *Executing Practices* (London: Open Humanities Press, 2018), 35-51, http://www.data-browser.net/db06.html.

- p5.js | Simple Shapes, https://p5js.org/examples/hello-p5-simple-shapes.html.

- Daniel Shiffman, "1.3,1.4,2.1,2.2: Code! Programming with p5.js," (2018) https://www.youtube.com/watch?v=yPWkPOfnGsw&list=PLRqwX-V7Uu6Zy51Q-x9tMWlv9cueOFTFA&index=2.

- Femke Snelting, "Other Geometries," *transmediale journal* 3, October 31 (2019), https://transmediale.de/content/other-geometries.

Further reading

- Crystal Abidin and Joel Gn, eds., "Histories and Cultures of Emoji Vernaculars," *First Monday* 23, no. 9, September (2018), https://firstmonday.org/ojs/index.php/fm/issue/view/607.

- Christian Ulrik Andersen and Geoff Cox, eds., *A Peer-Reviewed Journal About Machine Feeling* 8, no. 1 (2019), https://aprja.net//issue/view/8133.

- Derek Robinson, "Variables," in Matthew Fuller, ed., *Software Studies: A Lexicon* (Cambridge, MA: MIT Press, 2008).

Notes

1. Linus Torvalds and David Diamond, *Just for Fun: The Story of an Accidental Revolutionary* (Knutsford: Texere Publishing, 2001), see http://en.wikipedia.org/wiki/Just_for_Fun. Other examples include Jeremy Gibbons and Oege de Moor, *The Fun of Programming* (London: Palgrave Macmillan, 2003).

2. See the children's book: Vicky Owyang Chan, *Geometry Is Fun For Me* (Indianapolis, IL: Dog Ear Publishing, 2017).

3. Olga Goriunova, *Fun and Software: Exploring Pleasure, Paradox and Pain in Computing* (New York, London: Bloomsbury, 2014), 4.

4. Femke Snelting, "Other Geometries," *transmediale journal* 3 (October 31, 2019), https://transmediale.de/content/other-geometries.

5. Roel Roscam Abbing, Peggy Pierrot and Femke Snelting, "Modifying the Universal," *Executing Practices*, Helen Pritchard, Eric Snodgrass & Magda Tyżlik-Carver, eds. (London: Open Humanities Press, 2018), 35-51, http://www.data-browser.net/db06.html. Alternatively, Femke Snelting has a lecture video in 1 hr 15 mins on the similar topic, see https://www.youtube.com/watch?v=ZP2bQ_4Q7DY. Other references include: Crystal Abidin and Joel Gn, "Between Art and Application: Special Issue on Emoji Epistemology," *First Monday* 23, no. 9 (September 3, 2018); Luke Stark, "Facial recognition, emotion and race in animated social media," *First Monday* 23, no. 9 (September 2018), 3; Miriam E Sweeney and Kelsea Whaley, "Technically White: Emoji Skin-tone Modifiers as American Technoculture," *First Monday* 24, no. 7 (1 July 1, 2019).

6. See https://en.wikipedia.org/wiki/Unicode#Origin_and_development.

7. See https://www.telegraph.co.uk/technology/2016/07/15/new-gender-equality-emoji-to-show-women-at-work/.

8. Abbing, Pierrot and Snelting, *Modifying the Universal*, 210.

9. The project employs a machine learning algorithm and use the dataset of 3145 existing emojis as the input data to generate various uncanny emoji patterns. See https://process.studio/works/aimoji-ai-generated-emoji/. The project featured as part of the exhibition "Uncanny Values," Vienna Biennale (2019). https://process.studio/works/uncanny-values/. We discuss machine learning in more detail in chapter 10.

10. See http://www.o-r-g.com/apps/multi. *Multi* also provides variations of book covers for the DATA browser series published by Open Humanities Press, http://www.data-browser.net/.

11. See p5.js random reference at https://p5js.org/reference/#/p5/random.

12. `let` is introduced in ES6 (ECMAScript-scripting language specification standardization) to declare a variable, although `var` is still commonly used. The difference between the two is that let is block scoped, while var is function scoped. When it comes to let; if the same variable is declared both globally and locally, the local value will be restricted to the specific block of code and won't be overridden. For more on the distinction, see https://developer.mozilla.org/en-US/docs/Web/JavaScript/Reference/Statements/var and https://developer.mozilla.org/en-US/docs/Web/JavaScript/Reference/Statements/let.

13. See p5.js color reference, https://p5js.org/reference/#/p5/color.

14. See p5.js const reference, https://p5js.org/reference/#/p5/const.

15. Chun discusses symbolic programming languages that (as higher-level languages) hide the computational process. This both empowers users to create, but conversely mystifies the inner workings of machines. Here variables are some of the many examples that computer operations abstract. We will discuss this in Chapter 6, "Object Abstraction". See Wendy Hui Kyong Chun, "On Software, or the Persistence of Visual Knowledge," *Grey Room* 18 (January 2005): 38, https://doi.org/10.1162/152638104332074.

16. Red, Green and Blue are the so-called primary colors that, when added together, produce a broad array of colors. RGB color values range from 0 to 255 with a total of 256 possible values for each primary color. The reason behind is that all the colors are in 24 bit format, the red (R) takes 8 bit, the green (G) takes 8 bit and the blue (B) takes the remaining 8 bits. 2 binary values are stored for each bit, therefore 2^8th power is 256 which is the exact possible range of each color. The RGB system is closely related to the nature of computation in a binary system.

17. See https://www.pngfind.com/mpng/ohwmTJ_all-the-emojis-available-on-facebook-russian-revolution/.

18. Gilles Deleuze and Félix Guattari, *A Thousand Plateaus: Capitalism and Schizophrenia* (Minneapolis: University of Minnesota Press, 1987), 178.

19. Snelting, "Other Geometries."

20. Snelting, "Other Geometries."

21. Anna Lowenhaupt Tsing, *The Mushroom at the End of the World: On the Possibility of Life in Capitalist Ruins* (Princeton, NJ: Princeton University Press, 2017).

22. The series of works *Facial Weaponization Suite* exposes some of the inequalities associated with biometric facial recognition by making collective masks, including *Fag Face Mask* a response to scientific studies that say they can determine sexual orientation through rapid facial recognition techniques, and another mask that explores the inability of biometric technologies to detect dark skin. See http://www.zachblas.info/works/facial-weaponization-suite/.

23. See the tool p5.playground developed by Yining Shi, https://1023.io/p5-inspector/.

3. Infinite Doops

Contents

setup()

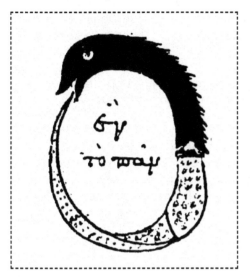

Loops offer alternative imaginaries, as is the case of the ancient image of a serpent eating its own tail. Ouroboros, from the Greek, expresses the endless cycle of birth and death, and therefore stands for the ability of processes to infinitely renew themselves. Alongside evocative references to autocannibalism and alchemy, loops are related to control and automation tasks, as well as repetitive procedures in everyday situations such as those heard in repeating sections of sound material in music. (1) In programming, a loop allows the repeated execution of a fragment of source code that continues until a given condition is met, such as true or false. Indeed a loop becomes an infinite (or endless) if a condition never becomes false.

It was mathematician and author Augusta Ada Byron Lovelace who was one of the first to introduce and illustrate the concept of a programmatic loop in the early nineteenth century. She recognized that there were repeatable operations in the conceptual design of the first ever, automatic, general-purpose computing machine, Charles Babbage's Analytical Engine. A loop, which she called a "cycle," appears in her "Note G" on the Analytical Engine (2) that describes the so-called Bernoulli numbers program, as in the diagram below. It utilizes two loops to indicate the repetition of a set of instructions with conditions, (3) thereby minimizing efforts to write a repeatable operation in duplicate. As such, loops address repeatable and operational time.

Figure 3.2: Diagram for the computation by the Engine of the Numbers of Bernoulli, from "Note G" by Ada Lovelace (1843). Image from Wikimedia Commons

73

Loops in contemporary programming are highly influenced by these early insights into the handling of repeated machine operations expressed in diagramatic form. High-level programming languages such as p5.js include this loop concept, allowing a fragment of source code to be repeatedly executed, as in the example of the `draw()` function that will run continuously until the program is stopped or using the syntax `noLoop()`. Loops are some of the most basic and powerful of programming concepts.

The main example for this chapter is the graphical spinning wheel icon of a preloader, or so-called "throbber," (4) that indicates when a program is performing an action such as downloading or intensive calculations. We consider this an evocative symbol as it illuminates the discrepancy between what we think we know and what we don't know about the hidden machine labor, and the complexity of multiple temporalities that run during any given computational operation. (5) It is a good icon to illustrate how loops work, allowing us to contemplate the entanglement of perceptible streams and computational logics, as well as how we experience the historical present through digital media. (6) As we shift from static objects to moving ones, the animated throbber will guide the programming tasks related to thinking about transformation (such as rotation and translation), but will also act as a suitable analytical object for us to think through the idea of loops, the related temporal elements, and time-related syntaxes more conceptually.

start()

We usually encounter the ubiquitous spinning icon while loading or streaming. It shows that a certain operation is in progress, but what exactly is happening, and how long this will take, is not at all clear. There is no indication of progress or status as is the case with a progress bar, for instance. We see the icon spinning, but it explains little about what goes on in the background or about timespan. Learning to program a throbber, and, subsequently examining *Asterisk Painting* by John P. Bell — that creates a series of asterisks by repeatedly printing the number of milliseconds that have passed since the painting started — will help you gain insight into the way programming employs transformational movement and loop structures, and, at the same time, an insight into the temporal operations of computational processes.

Exercise in class (Decode)

As mentioned above, this chapter shifts from programming static objects to a mixture of both static and moving objects. Our example is circular and spins, as if it were eating its own tail.

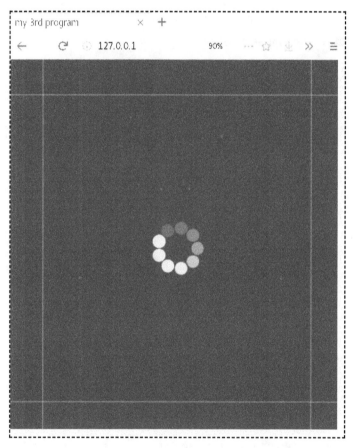

Figure 3.3: The runme of sample code — sketch 3_1

RunMe, https://aesthetic-programming.gitlab.io/book/p5_SampleCode/ch3_InfiniteLoops/sketch3_1/

Can you describe the various elements and how they operate computationally in your own words?

1. Speculation

- Based on what you see/experience on the screen, describe:
 - What are the elements? Come up with a list of features.
 - What is moving and what isn't?
 - How many ellipses are there in the middle?
 - Try to resize the window and see what happens.
- Further questions:
 - How do you set the background color?
 - How does the ellipse rotate?
 - How can you make the ellipse fade out and rotate to the next position?
 - How can you position the static yellow lines, as well as the moving ellipses in a single sketch?

2. Experimentation

- Tinker with the source code
- Try to change some of the parameters, e.g. `background()`, `framerate()`, the variables inside `drawElements()`
- There are some new functions you can check in the `p5.js` reference (e.g. `push()`, `pop()`, `translate()`, `rotate()`)

3. Mapping

- Map some of the findings/features from the speculation you have done to the source code. Which block of code relates to your findings?
- Can you identify the part/block of code that responds to the elements that you have speculated on?

4. Technical questions/issues

- `let cir = 360/num*(frameCount%num);` (see Line 21) with the "modulo operator" (7) that computes the remainder after division, explain what this line means and does?

5. Other conceptual questions

- Where do you often see this icon and what's your experience?
- If this icon is something related to waiting (or wasting) time, how much do you know about the time(s) in relation to machines?
- One of the important aspects of machine times is about synchronization, can you describe your experience in relation to synchronization processes?

Source code

```
1   //throbber
2   function setup() {
3     //create a drawing canvas
4     createCanvas(windowWidth, windowHeight);
5     frameRate(8);   //try to change this parameter
6   }
7
8   function draw() {
9     background(70, 80);   //check this syntax with alpha value
10    drawElements();
11  }
12
13  function drawElements() {
14    let num = 9;
15    push();
16    //move things to the center
17    translate(width/2, height/2);
18    //360/num >> degree of each ellipse's movement;
19    //frameCount%num >> get the remainder that to know which one
20    //among 8 possible positions.
21    let cir = 360/num * (frameCount%num);
22    rotate(radians(cir));
23    noStroke();
24    fill(255, 255, 0);
25    // the x parameter is the ellipse's distance from the center
26    ellipse(35, 0, 22, 22);
27    pop();
28    stroke(255, 255, 0, 18);
29    // static lines
30    line(60,0,60,height);
31    line(width-60, 0, width-60, height);
32    line(0, 60, width, 60);
33    line(0, height-60, width, height-60);
34  }
35
36  function windowResized() {
37    resizeCanvas(windowWidth, windowHeight);
38  }
```

Function

A function in p5.js starts with the syntax `function() {}`, containing "a self-contained section of code" ⑧ to peform a certain task. The most basic built-in functions in p5.js are `setup()` and `draw()` that specify the contained code in relation to a particular purpose such as setting up the environment in which to run the program, as well as doing things over time. Other built-in functions in the sample code provided, such as `windowResized()`, serve to read just the canvas size if there is any window resizing event. The canvas size is not set at fixed dimensions, but is subject to the window size that you have adjusted as illustrated in the code. This was also discussed in the preceding chapter: `createCanvas(windowWidth, windowHeight);`. The function `windowResized()` suggests that an "event listener" — a procedure or function in a computer program that monitors for an event to occur — initiates at the code level to not only run once, but "constantly." It is "listening" to events of window resizing specifically, and similar to other listening events such as `mouseIsPressed()` that was introduced in the previous chapter. The `windowResized()` function is considered asynchronous, which means some other events occur concurrently with the main flow of the program such as, for instance, drawing shapes.

Alongside built-in functions, the sample code contains the custom function `function drawElements();` which is invoked in Line 13: `drawElements();` within the `draw()` function. Defining a function is relatively simple in JavaScript. Type the keyword "function" then follow it with the name that you want to give your function. The function name "drawElements" gives you a sense of what this function does, which is draw ellipses, lines of a particular size, position, and color, as well as drawing ellipses and lines to rotate clockwise or statically remain in place. There are many ways of drawing the same result, but as we are still in the early stages of learning to program, we will therefore work on an example that can do the same, but aligns better with our learning progress. With this in mind, some of the code is intentionally written in a way that is less efficient, but serves the purpose of illuminating key concepts.

Programmers like to split large tasks into smaller operations and procedures, so they are easier to structure, manage, debug, read, and are easier to collaborate on with multiple programmers. In `function drawElements();`, the sample code is simply separated from the function `draw()`, clearly indicating that this particular part of the code relates to drawing the various on-screen elements. Of course you could also separate the drawing of ellipses and lines, and it is a subjective and situated decision to decide how best to separate the different tasks.

There is another type of function where you can specify tasks with arguments that are passed to the function and receive a return value. See the example below:

```
1  Let x = sum(4, 3, 2);
2  print(x);
3  //passing values four as a, three as b, two as c to the function sum
4  function sum(a, b, c) {
5    return a + b + c; //return statement
6  }
```

Output:
"9"

Exercise in cLass

You can also try to type/copy the above code into your own sketch, where it will return the number 9 as the output in the web console because this is the result of the sum of the values 4, 3 and 2. These values are called "arguments" that are passed to the function (i.e. `sum()`). In the example, the parameters as variables a, b and c equals to the actual values 4, 3 and 2 as arguments, but the value of the variables can be changed. The function "sum" can be reused if you pass on other arguments/values to it, as for instance another line of code `let y = sum(5,6,7);` and the return value of y would be 18. You can try to come up with your own functions and arguments.

Transform

In general, the transform-related functions (9) apply a two-dimensional or three-dimensional transformation to an element or object. In the sample code provided with the throbber, two specific transformational functions were used to move the canvas and create an illusion of object transformation. (It is important to know that the transformation is done at canvas background level, not at the individual shape/object level.)

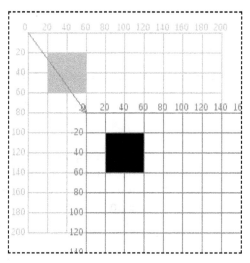

Figure 3.4: Moving the coordinate system at canvas level. Image from processing.org

1. `translate()`: This function displaces/moves objects within the display window. For example, moving the canvas to the center will position the whole sketch at the center too (`translate(width/2, height/2);`). The ellipse is drawn as `ellipse(35, 0, 22, 22)` which takes (35, 0) as the x and y coordinates, and "22" as the size. If we don't have the `translate()` function upfront, the ellipse will be placed at the top left corner instead (because the x coordinate value "35" is the distance of the rotating ellipses from the center position). By moving the coordinate origin to the middle using the `translate()` function, the ellipses is placed in the middle of the canvas, because the coordinate orign (0,0) has moved to the center of the screen. Building upon the previous chapter on the spatial dimension of a coordinate system, "translate" adds another layer to think about moving and positioning objects using canvas.

2. `rotate()`: In this sample code with the throbber, the use of the function `rotate()` makes the ellipse rotate through a particular number of degrees. The default unit for rotation is radians. As such, the code is written as `rotate(radians(cir));`. The function `rotate()` takes radians in its default mode, but if you want to change to degrees all you have to do is add the code `angleMode(DEGREES)`.

In order to continue expanding on spatial relationships, the entanglement of time and space is made apparent in this example by using the `rotate()` function that operates alongside other time-related syntax in `draw()`. There are a total of 9 ellipses (indicated as `let num=9;`), and each is separated from the next by 40 degrees (i.e 0.968 rad) which is derived from "360/9." A circle has 360 degrees and to rotate the ellipse over time, it requires the time element to calculate when, how, and where to move. This is how the function `frameCount()` works as it counts the number of frames displayed since the program started. (10) The Line 21 `let cir = 360/num*(frameCount%num);` illustrates the use of a "modulo" operation to find the remainder or the number that's left after it is divided by another value. As such, the value of

80

the variable `cir` is limited to multiples of 40: "0, 40, 80, 120, 160, 240, 280 and 320." On the basis of the `cir` value, the program follows such a sequence over time to rotate one after the other, based on the original position, then repeats continuously.

push() and pop()

Functions of `push()` and `pop()` are commonly used to save the current style and restore settings respectively. Style as in color and setting as in rotate and translate. In the sample code, rotation is only applied to the centered ellipses when four lines at each side are fixed. The following excerpt of code will help to explain:

```
1   function drawElements() {
2     let num = 9;
3     push();
4     //move things to the center
5     ...
6     pop();
7     stroke(255, 255, 0,18);
8     //static lines
9     Line(60, 0, 60, height);
10    Line(width-60, 0, width-60, height);
11    Line(0, 60, width, 60);
12    Line(0, height-60, width, height-60);
13  }
```

The last four lines describe the drawing of the four static yellow lines. Logically speaking, the translate and rotate functions should also apply to these lines, but because the pop() function is placed right after drawing all the ellipses it does not impact the lines (see Figure 3.5). But if you move the line pop() to the end, then the lines will also rotate and translate (see Figure 3.6). This illustrates how push() and pop() can be used to save and restore styles, and how their placement matters. ⑪

Figure 3.5: Different placement of the pop() function — Four static yellow lines

Figure 3.6: Different placement of the pop() function — Four rotating yellow lines

Exercises in class

1. Change the arguments/values, as well as the position/sequence of the sample code to understand the functions and syntax such as the variable num, the transformational functions translate() and rotate(), as well as saving and restoring current style and transformations such as push() and pop().

2. We have explained how to use rotate() to display the ellipses at various degrees of rotation, but how about the fading in and out of each ellipse in the sketch? (Hint: as this is repeatedly faded in and out, the background() syntax under the function draw() is key to producing such effects.)

3. This exercise is about structuring code. How would you restructure the sample code so that it is easier for others to understand, but still maintains the same visual outcome? There are no right or wrong answers, but some pointers below might facilitate discussion:

 - You may rename the function and/or add new functions

 - Instead of having drawElements(), you might have something like drawThrobber() and drawLines()?

Asterisk Painting

The following section will move from repetition and regularity, to repetition and difference. Artist and software developer John P. Bell made an artwork called *Asterisk Painting*, (12) that consists of a number of throbber-like spinning patterns, however each throbber (or what he calls "asterisk") spins differently, varying in color and texture. Many of the syntaxes Bell used are related to temporality, for example the setting up of a timer, the calculation in milliseconds, the speed of rotation, the time to wait before starting a new cycle, and so on, in which programming enables the re-negotiation of time to "develop alternative time practices and experiences" through manipulating time-related functions. (13) Also, on a closer inspection, the asterisks are not geometric shapes, but are constituted by a series of numbers which refer to the milliseconds counter that line up to form a straight line.

Figure 3.7 : Asterisk Painting (2014) by John P. Bell. Courtesy of the artist

According to Bell,

> "Asterisk Painting is programmed to create a series of asterisks by repeatedly printing the number of milliseconds that have passed since the painting started. If left to run by itself it will do so; however, when started on a real system, delays external to my artwork may make the asterisks look more like spots [..]"

Source code

The original piece was written in Processing and has been modified, and ported to p5.js. It is a much more complex program than the first one, but we still wanted to include this as an addition to this chapter as it helps to demonstrate the potential for further developing a looping sketch and reflect more deeply on infinite loops, and the use of time-related syntaxes.

```
1  let xDim = 1000;   //canvas size-width
2  let yDim = 600;    //canvas size-height
3  let timer = 0;
4  let speed = 100;   //the speed of rotating , default 100
5  let maxSentences = 77;   //original: 77
6  let sentences = 0;
7  let xPos = [1, 2, 3, 4, 5]; //original: 8 columns
8  let yPos = [1, 2, 3, 4]; //original: 5 rows
9  let xCtr = 0;
10 let yCtr = 0;
11 let waitTime = 10000;
```

```
12   Let itr = 0; // no. of iteration
13   Let milliStart = 0;
14   Let currentMillis;
15   Let fillColor;
16
17   function setup(){
18     createCanvas(xDim, yDim);
19     background(240);
20     /*calculate the x-position of each asterisk as
21     an array (xPos[]) that starts with an array index[0]*/
22     for(Let i = 0; i < xPos.length; i++) {
23       xPos[i] = xPos[i] * (xDim / (xPos.length+1));
24     }
25     /*calculate the y-position of each asterisk as
26     an array (ypos[]) that starts with an array index[0]*/
27     for(Let i = 0; i < yPos.length; i++) {
28       yPos[i] = yPos[i] * (yDim / (yPos.length+1));
29     }
30     fill(0);   //counter color at the bottom left
31     textAlign(LEFT, CENTER);
32     text(itr, 10, yDim-30); //display counter
33     fillColor = color(
34       floor(random(0, 255)),floor(random(0, 255)),floor(random(0, 255))
35     );
36   }
37
38   function draw(){
39       //millis means millsecond since starting the program, like frameCount
40       currentMillis = floor(millis() - milliStart);
41       if(currentMillis > timer){
42         push()
43         translate(xPos[xCtr], yPos[yCtr]);   //rows and cols
44         rotate(radians((360/8)* (millis()/speed)));   //rotate in itself
45         timer = currentMillis + speed; //the time for the next loop
46         textSize(12);
47         fill(fillColor);
48         /* about the time string written in the form of an asterisk,
49         and it starts with 0 always.
50         nf:format numbers into strings and adds zeros in front
51         [https://p5js.org/reference/#/p5/nf]
52         3 digits in front and 0 digit after the decimal. */
53         text(nf(currentMillis, 6), 3, 0);
54         sentences++;
55         if(sentences >= maxSentences){  //reach the max for each asterisk
56           xCtr++;  //move to next array
57           //meet max cols, and need to go to next row
58           if(xCtr >= xPos.length) {
```

```
59        xCtr = 0;
60        yCtr++;  //next row
61        /* the program reaches the max no. of rows on a screen
62        (i.e after reaching the no. of max cols);
63        the screen is filled > reset everything and update the counter*/
64        if(yCtr >= yPos.Length){
65          yCtr = 0;
66          background(240);
67          //add counter (iteration)
68          itr++;
69          pop();
70          //counter's display color
71          fill(0);
72          //change the counter display again
73          text(itr, 10, yDim-30);
74          //wait for next round for starting the first asterisk
75          let wait = floor(millis() + waitTime);
76          while(millis() < wait){}
77          //reset the starting time
78          milliStart = millis();
79          //reset the timer
80          timer = 0;
81          push();
82        }
83      }
84      sentences = 0;
85      fillColor = color(
86        floor(random(0,255)),floor(random(0,255)),floor(random(0,255))
87      );
88      }
89    pop();  //restore previous state
90    }
91 }
```

Exercise in class

- RunMe, https://aesthetic-programming.gitlab.io/book/p5_SampleCode/ch3_InfiniteLoops/
- Read the source code above. A reminder of the code comments:
 1. // ... indicates a single line comment
 2. /* ... */ indicates multiple lines comments
- Use the decoding method that we introduced previously in this chapter, try to speculate, experiment, and map your thoughts to the source code.

> - **Speculation**: Describe what you see/experience on screen.
> - What are the elements on screen?
> - How many asterisks are there on screen and how are they arranged?
> - What is moving and how does it move?
> - What makes each asterisk spin/rotate and when does it stop to create a new one?
> - Can you locate the time-related syntax in this sketch?
> - **Experimentation**: Change some of the code's arguments
> - Try to change some of the values, e.g. the values of the global variables
> - Which new syntax and functions didn't you know? (Check them out in the p5.js reference.)
> - **Mapping**: Map the elements from the speculation to the source code

Arrays

To be able to get a deeper understanding of the source code, you only need a few more fundamental concepts of programming. The first one is "Array," which is commonly understood as a list of data and is related to previous concepts such as variable and data types. If we need to work with a chunk of data, such as a collection of words, you can use arrays instead of making separate variables. For example:

```
1  //example
2  Let words = [] //array -> start with 0
3  words[0] = "what";
4  words[1] = "are";
5  words[2] = "arrays";
6  console.Log(words[2]); //output: arrays
7  console.Log(words.length); //output: 3
```

We can follow a similar structure to our previous approach using variables:

1. **Declare:** Think of a name you want to use to store the list of values. The symbol [] in Let words = [] indicates "words" is structured as an array, but how many words is unknown and hasn't been specified with just this line of code.

2. **Initialize/Assign:** Given the example above, there are three text values to store in quotations (this indicates they are "String" data types): "what," "are," and "arrays." Since an array is a list of values and it is needed to be identified individually, "an array index" within a square bracket is used to represent the position of each piece of data in an array. It starts with [0] as the first item, then [1] as the second, and so forth. Therefore words[0] ="what" means that the first index item of the array words is a string data type and with the value "what."

3. **Re(use):** The `console.log()` function is an example that indicates how you can retrieve and use the data, how you can print it in the web console area, or how you can draw on a canvas.

The syntax `arrayname.length` is used to ask how many items there are in an array.

Let's look at the sample below from *Asterisk Painting*:

```
1   Let xPos = [1, 2, 3, 4, 5];
2   Let yPos = [1, 2, 3, 4];
```

This is a slightly different way of declaring an array. It combines both the declaration and initialization/assignment into a single line to both declare the array names as xPos and yPos with the term Let, and then assigns the numeric values into the array index, which refers to the number of columns and rows respectively. Think about it like this: the program needs to know how many asterisks should be drawn on the screen before moving on to the next row as well as when to restart (the asterisks fill the entire canvas in terms of reaching the maximum number of rows and columns.)

As the array index starts with [0], therefore each index has mapped the value in this way:

`Let xPos = [1,2,3,4,5];` → The `xPos.length` is 5 and that indicates 5 values are being stored in this array: xPos[0] = 1, xPos[1] = 2, xPos[2] = 3, xPos[3] = 4, xPos[4] = 5.

`Let yPos = [1,2,3,4];` → The `yPos.length` is 4 and that indicates 4 values are being stored in this array: ypos[0] = 1, yPos[1] = 2, yPos[2] = 3, yPos[3] = 4.

The above two arrays store each asterisk's center position in the form of x and y coordinates.

There are also methods of adding or removing an array index:

`array.push(value)` (14) → To add a value to the end of the array. Example: `xPos.push(6)` will extend the index to `xPos[5] = 6`.

`array.splice()` (15) → This will remove a range from an array index, or remove the existing index, and replace it with new indexes with other values.

Conditional statements

The discussion of conditional statements in the previous chapter will make it easier to follow *Asterisk Painting*'s code. We follow the conditional structure (if-then) built into the program in order to know when to move from one asterisk to the next.

```
1  if(sentences >= maxSentences){   //reach the max for each asterisk
2      //move to the next one and continues;
3  }
```

The value of the variable maxSentences is 77 (refer to Line 5 from the source code), therefore each asterisk contains 77 sentences (in the form of a line that contains numbers). The other variable sentences counts each line and the program checks whether the current sentences count has reached its maximum. "If" the asterisk reaches 77 sentences "then" it will move to the next one and the sentences counter will be reset to zero (Line 84) and start counting again. The logic repeats across all the asterisks within the draw() function.

Loops

The core concept of a loop is that it enables you to execute a block of code many times. For example, if you have to draw one hundred lines that are placed vertically one after the other, you can of course write one hundred lines of code using the syntax: Line().

A "for-loop" allows code to be executed repeatedly, and so provides an efficient way to draw the line one hundred times by setting up a conditional structure, counting the number of lines that have been drawn and counting the maximum number of lines. Similarly, in this sketch, there are some elements needed to run repeatedly, but there is an end, such as calculating the center point using the exact x and y coordinates for each asterisk which are based on the width and height of the canvas. Knowing how many columns and rows make up a canvas allows us to know the values of the center point for drawing each asterisk.

To structure a for-loop, you need to ask yourself:

– What are the things/actions that you want to repeat in a sequence or pattern?
– More specifically, what is the conditional structure and when do you want to exit the loop?
– What do you want to do when this condition is, or is not, met?

The following is an excerpt from *Asterisk Painting* (Lines 20-29):

```
1   /*calculate the x-position of each asterisk as
2   an array (xPos[]) that starts with an array index[0]*/
3   for(let i = 0; i < xPos.Length; i++) {
4     xPos[i] = xPos[i] * (xDim / (xPos.Length+1));
5   }
6   /*calculate the y-position of each asterisk as
7   an array (ypos[]) that starts with an array index[0]*/
8   for(let i = 0; i < yPos.Length; i++) {
9     yPos[i] = yPos[i] * (yDim / (yPos.Length+1));
10  }
```

See the structure of a for-loop:

Figure 3.8 A for—loop

Figure 3.8 shows you what a for-loop consists of:

1. **A variable declaration and initialization**: Usually starts with 0

2. **A specified condition**: The criteria to meet the condition

3. **Action**: What you want to happen when the condition is met

4. **Loop for next**: For the next iteration (usually incremental/decremental).

This block of code from the above example describes the position of each asterisk in terms of its x and y coordinates (the center point [x, y] of each asterisk). Since there are 5 columns (xPos) and 4 rows (yPos) which have been defined in global variables, the program needs to know the coordinates precisely. The overall formula to locate the position, for example xPos, is to divide the width of the canvas by the number of asterisks horizontally, and add one (see Figure 3.9). As such, the code can be understood as follows: calculate the xPos[i] for each iteration with the starting point 0. Additionally, each iteration will increase the count by 1 until it reaches the maximum number of asterisks in a row (i < xPos.Length).

Figure 3.9 The xPos of each asterisk

In our teaching, we describe another example of the use of a for-loop to further clarify its use and to demonstrate the repeated drawing of objects. This example (see Figure 3.10) draws 20 ellipses and each with a distance of 20 pixels.

Figure 3.10 Drawing 20 ellipses on a canvas using a for-loop

```
1   let x = 20;
2
3   function setup() {
4     createCanvas(420, 100);
5     background(200);
6     for (let i = 0; i < 20; i++) {
7       ellipse(x, 45, 15, 15);
8       x += 20;
9     }
10  }
```

In this simple ellipse drawing, the key is the local variable i (see Linr 6 above, which is used to set the start of the counting of the ellipses: let i = 0;, as well as setting the condition of how many ellipses should be drawn: i < 20, and counting the ellipses for each iteration: i++). The global variable x is used to determine the position (in terms of x axis or what could be described as the distance) of each ellipse and to make sure the program will increment 20 pixels for each iteration: x+=20. In this way we use a for-loop to draw multiple ellipses, instead of having 20 lines with fixed x and y coordinates.

The "while loop" is another type of loop for executing iterations. The statement is executed until the condition is true and stops as soon as it is false.

For example, `while(millis() < wait){}` in Line 76 of the work *Asterisk Painting* tells the computer to do nothing if the value of `millis()` (16) is less than the value of the `wait` variable. `millis()` is a time-related syntax and returns the number of milliseconds since the program started which makes it similar to `frameCount()`. Once the condition is false (i.e. `millis()` is no longer less than `wait`), the loop will end, and the program can proceed to the next line. This example is located towards the end of the program when all the asterisks have been drawn, but the program needs to wait a certain amount of time before resetting (clearing) the canvas and starting again. This while-loop therefore serves as a pause, freezing the program from running because there is literally nothing between the opening and closing brackets.

While()

As we have established, loops execute a block of code as long as a specified condition is true. In this closing section to the chapter it seems appropriate to emphasize that while-loops and for-loops allow code to be executed repeatedly based on a given condition. The loop can be thought of as a repeating "if" statement and offers a good way of challenging conventional structures of linear time, and demonstrating how computers utilize time differently. Programming challenges many of our preconceptions about time including how it is organized, how the present is rendered using various time-specific parameters and conditions, as in the case of a throbber. We hope it is already clear that machine-time operates at a different register from human-time, further complicated by global network infrastructures, and notions of real-time computation.

What it means to begin and end a given process becomes a philosophical problem. In "The Computer as Time-Critical Medium," (17) Wolfgang Ernst clarifies the ontological importance of time to the computer to operate and perform tasks. He points to key issues of programmability, feedback, and recursion at programming-language level in ways that we hope resonate with the examples we have provided in this chapter. (18) Precise technical detail is crucially important for the discussion, and his example is how "time counts" differently in the computer, as for example with the clock signal. Ernst's concept of "micro-temporality" is useful as it draws attention to the issue of temporality in programming in ways that many of the discussions of software overlook, and furthermore how — in a philosophy of time — the technical or mathematical layer is often dismissed as deterministic. (19)

Loops offer alternative imaginaries of time. In his conference paper "… Else Loop Forever," Ernst develops this discussion in relation to "untimeliness." (20) He draws on the infamous "halting problem" that underpins Turing computation and refers to the problem of whether a computer program, given all possible inputs, will finish running or continue to run forever. In his 1936/37 essay "On Computable Numbers, with an Application to the Entscheidundsproblem," it was Turing's assertion that a general algorithm to solve the halting problem was not possible which led to the mathematical definition of a Turing machine. (21) This "problem of decision," or "ending" as Ernst puts it, underscores broader notions of algorithmic time and the way the computer forever anticipates its own "never-ending" in an endless loop. Perhaps the throbber icon is a good metaphor for this, in terms of the impossibility of predicting the quality of transmission conditions, and, in this way, the animated graphics depict a sense of uncertainty that underlies deep processual micro-temporality. (22)

Contrary to any traditional narrative — with its beginning, middle and end – Ernst points out that a computational recording can be re-enacted endlessly: "with no internal sense of ending," as a "time-critical condition." (23) That there can be "no happy ending" allows Ernst to elaborate on new temporal structures that are no longer aligned to traditional narrative structures or the terminal logic of the "end of history." (24) Our first example of the throbber alludes to this blurring of the beginning and the end. Temporal complexity is further developed by referring back to Turing's speculation on artificial intelligence, whether a finite-state machine can be aware of its "conscious" state at a given time and whether a sense of ending is necessary in order to be functional. It is clear that finite-state machines are procedural, in the sense that they operate linear sequences of discrete events in time like clockwork, but as Ernst reminds us: "There is no automatic procedure which can decide for any program, if it contains an endless loop or not." (25)

Referencing Martin Heidegger's "being-in-time," (26) and human beings' knowledge of the end of their lives which inscribes a temporal sense of what it means to be a human, Ernst says: "Humans live with the implicit awareness that their death is already future in the past." (27) This looped deferral of ending is ontologically exacerbated with computation, unfolding the ending of being as a time-critical condition for both humans and machines alike. Leaving aside a deeper discussion of Heidegger's philosophy, the importance of this for the discussion of loops seems to mirror the complexity of lived time. Programming manages to provide insight here, and creative opportunities as is the case with live coding during which programmers interact with a running system that is not stopped while waiting for new program statements. (28) We can even begin to speculate on how software is not only synchronized with lived time, but actually produces it, and we hope the two examples in the chapter help us to think through the intersection of endlessness, loops, conditions, and temporalities in both conceptual and technical ways. We might go as far as to say that programming allows for a time-critical understanding of how technologies play a crucial role in our experience of time, not only how we model it, but how we can forge new beginnings and endings.

MiniX: Designing a throbber

Objective:

- To reflect upon temporality in digital culture by designing a throbber icon.
- To experiment with various computational syntaxes and the effects of animation, and transformation.

For additional inspiration:

Check out other works that refer to the throbber and how other people contextualize their thinking.

- *Tanabata*(七夕) by Yurika Sayo (n.d.), with source code, https://www.openprocessing.org/sketch/926326.

- *LOADING (THE BEAST* 6:66/20:09) by Gordan Savičić (2009), https://www.yugo.at/processing/archive/index.php?what=loading.
- *The Best is Yet to Come* by Silvio Lorusso (2012), preloaders follow one another randomly and endlessly, https://silviolorusso.com/work/the-best-is-yet-to-come/.
- *DVD guy* by Constant Dullaart (2009), https://www.youtube.com/playlist?list=PLCUGKK4FUkbMdnNii8qoRy9_tMvqE8XHB, with the contextualization by Panke Gallery in Berlin, http://www.upstreamgallery.nl/news/545/constant-dullaart-solo-show-nein-gag-at-panke-gallery-berlin.
- *Throb* by Winnie Soon (2018-19), http://siusoon.net/throb/.

Task (RunMe):

Use loops and any one of the transformational functions to redesign and program an "animated" throbber.

Questions to think about (ReadMe):

Describe your throbber design, both conceptually and technically.

- What do you want to explore and/or express?
- What are the time-related syntaxes/functions that you have used in your program, and why have you used them in this way? How is time being constructed in computation (refer to both the reading materials and your coding)?
- Think about a throbber that you have encounted in digital culture, e.g. for streaming video on YouTube or loading the latest feeds on Facebook, or waiting for a payment transaction, and consider what a throbber communicates, and/or hides? How might we characterize this icon differently?

Req(ui)red reading

- Hans Lammerant, "How humans and machines negotiate experience of time," in *The Techno—Galactic Guide to Software Observation*, 88-98, (2018), https://www.books.constantvzw.org/nl/home/tgso.

- Daniel Shiffman, Courses 3.1, 3.2, 3.3, 3.4, 4.1, 4.2, 5.1, 5.2, 5.3, 7.1, 7.2, *Code! Programming with p5.js*, https://www.youtube.com/watch?v=1Osb_iGDdjk (2018). (Includes practical usage on conditional statements, loops, functions, and arrays.)

- Wolfgang Ernst, "'.. Else Loop Forever': The Untimeliness of Media," (2009), https://www.medienwissenschaft.hu-berlin.de/de/medienwissenschaft/medientheorien/downloads/publikationen/ernst-else-loop-forever.pdf.

Further reading

- Wolfgang Ernst, *Chronopoetics: The Temporal Being and Operativity of Technological Media* (London: Rowman & Littlefield International, 2016), 63-95.

- Winnie Soon, "Throbber: Executing Micro-temporal Streams," *Computational Culture* 7, October 21 (2019), http://computationalculture.net/throbber-executing-micro-temporal-streams/.

- Wilfried Hou Je Bek, "Loop," in Fuller, ed., *Software Studies*.

- Derek Robinson, "Function," in Fuller, ed., *Software Studies*.

Notes

1. The logic behind loops can be demonstrated by the following paradoxical word play: "The next sentence is true. The previous is false." Further examples of paradox, recursion, and strange loops can be found in Douglas R. Hofstadter's *Gödel, Escher, Bach: An Eternal Golden Braid* (New York: Basic Books, 1999).

2. For an account of "Note G," see Joasia Krysa's *Ada Lovelace 100 Notes-100 Thoughts Documenta 13* (Berlin: Hatje Cantz Verlag, 2011).

3. Eugene Eric Kim and Betty Alexandra Toole, "Ada and the First Computer," *Scientific American* 280, no. 5 (1999), 78.

4. It is also interesting to note that the term "throbber" is a derogatory term derived from erect penis, not unlike git which was described in the opening chapter.

5. There is much we could add here also about screensavers as cultural form in the broader context of productive labor-time, and the attention economy. Alexandra Anikina's PhD *Procedural Films* (Goldsmiths, University of London, 2020) contains a chapter on the aesthetic form of screensavers in relation to the discussion of idle time/sleep, and cognitive labor; her lecture-performance *Chronic Film* from 2017 can be seen at http://en.mieff.com/2017/alexandra_anikina. See also Rafaël Rozendaal's installation *Sleep Mode: The Art of the Screensaver* at Het Nieuwe Instituut (2017), https://hetnieuweinstituut.nl/en/press-releases/sleep-mode-art-screensaver.

6. Winnie Soon, "Throbber: Executing Micro-temporal Streams," *Computational Culture* 7 (October 21, 2019), http://computationalculture.net/throbber-executing-micro-temporal-streams/.

7. Artist Golan Levin has given an online tutorial on modulo operator as part of The Coding Train series, see: https://www.youtube.com/watch?v=r5ly3v1coOA.

8. Derek Robinson, "Function," in Matthew Fuller, ed. *Software Studies*, 101.

9. To stick with the provided examples, we only offer two syntaxes related to transformation. Beyond `translate()` and `rotate()`, there are also other transform-related functions such as `scale()`, `shearX()`, `shearY()`. See https://p5js.org/reference/#group-Transform.

10. https://p5js.org/reference/#/p5/frameCount.

11. https://p5js.org/reference/#/p5/push.

12. http://www.johnpbell.com/asterisk-painting/.>.

13. Hans Lammerant, "How humans and machines negotiate experience of time," in *The Techno—Galactic Guide to Software Observation* (Brussels: Constant, 2018), 88-98.

14. https://developer.mozilla.org/en-US/docs/Web/JavaScript/Reference/Global_Objects/Array/push

15. https://developer.mozilla.org/en-US/docs/Web/JavaScript/Reference/Global_Objects/Array/splice

16. `millis()` is a p5.js syntax, returning the number of milliseconds since starting the program, similar to `frameCount` but counted in milliseconds, see https://p5js.org/reference/#/p5/millis.

17. Wolfgang Ernst, *Chronopoetics: The Temporal Being and Operativity of Technological Media* (London: Rowman & Littlefield International, 2016), 63-95.

18. Ernst, *Chronopoetics*, 63.

19. For example, the philosopher Henri Bergson makes a qualitative distinction between lived "durational" time, and vulgar, or clock time, which flattens and deadens the experience of time. See Henri Bergson, *Matter and Memory* [1896] (New York: Zone Books, 1990).

20. Wolfgang Ernst, "'– Else Loop Forever'. The Untimeliness of Media" (2009). Available at https://www.medienwissenschaft.hu-berlin.de/de/medienwissenschaft/medientheorien/downloads/publikationen/ernst-else-loop-forever.pdf.

21. Alan M. Turing, "On Computable Numbers, with an Application to the Entscheidungs problem," *Proceedings of the London Mathematical Society* 42 (1936/1937): 230-265.

22. Soon, "Throbber."

23. Ernst, "'– Else Loop Forever'."

24. "The end of history" is a reference to Francis Fukuyama's *The End of History and the Last Man* (New York: Free Press, 1992), which proposes the ascendancy of Western liberal democracy after the dissolution of the Soviet Union, post-1989.

25. Ernst, "'– Else Loop Forever'."

26. Martin Heidegger, *Being in Time* (1927). For a useful summary, see https://plato.stanford.edu/entries/heidegger/#BeiTim.

27. Ernst, "'– Else Loop Forever'."

28. See forthcoming Alan Blackwell, Emma Cocker, Geoff Cox, Thor Magnussen, Alex McLean, *Live Coding: A User's Manual* (publisher and date unknown).

4. Data capture

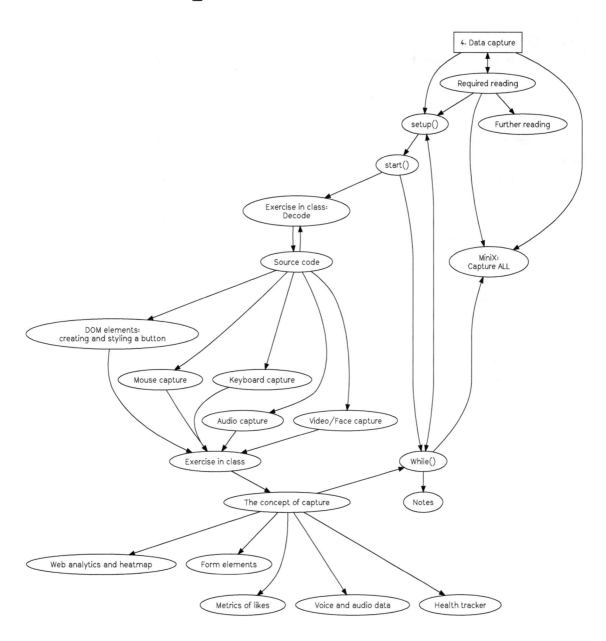

Contents

setup()

This chapter focuses on how a program captures and processes input data. We have already introduced interactivity with physical devices with the functions mouseX and mouseY (see Chapter 2, "Variable geometry"), as well as the idea of listening events via the functions mouseIsPressed() and windowResized() (see Chapter 3, "Infinite loops"). In this chapter we expand on these ideas and present different types of data capture, including mouse movement, keyboard press, audio volume, and video/face tracking with a web camera.

Framing this chapter under "Data capture" allows us to move from immediate interactions to questioning which kinds of data is being captured and how it is being processed, (1) as well as the consequences of this broader cultural tendency that is often called "datafication." (2) This term — a contraction of data and commodification — refers to the ways in which all aspects of our life seem to be turned into data which is subsequently transferred into information which is then monetized (as described by Kenneth Cukier and Victor Mayer-Schöenberger in their article "The Rise of Big Data"). (3) Our data, "the patterns of human behaviors," is extracted and circulated within the logic of what Shoshana Zuboff calls "surveillance capitalism," (4) demonstrating the need for large quantities of all manner of data to be harvested for computational purposes, such as predictive analytics (e.g. you like this book so we think you might like these books too).

We will return to some of these issues in Chapter 10, "Machine unlearning," but suffice to say, for now, that in the era of big data, there appears to be a need to capture data on everything, even from the most mundane actions like button pressing. This chapter begins with a relatively simple action like switching a device on or off — light, a kitchen appliance, and so on. Moreover a button is "seductive," (5) with its immediate feedback and instantaneous gratification. It compels you to press it. Similarly in software and online platforms like Facebook, a button calls for interaction, inviting the user to click, and interact with it in binary states: like or not-like, accept or cancel. The functionality is simple — on or off — and gives the impression of meaningful interaction despite the very limited choices on an offer (like most interactive systems). Indeed this binary option might be considered to be more "interpassive" than interactive, like accepting the terms of conditions of a social media platform like Facebook without bothering to read the details, or "liking" something as a way of registering your engagement however superficial or fleeting. Permission for capture data is provided, and as such our friendships, thoughts, and experiences all become "datafied." Even our emotional states are monitored when it comes to the use of emoticons (discussed in Chapter 2, "Variable geometry").

With these ideas in mind, the next section will introduce the sample code for a customizable "Like" button in order to demonstrate the potential of simple interactions such as pressing a button. How the specificities and affordances of buttons can be considered, as well as how the like button becomes a "social button," thus creating economic values in what Carolin Gerlitz and Anne Helmond call "the like economy." (6) As in previous chapters we will work through the various types of capture using buttons as a starting point. Subsequently, we will reflect on the wider implications.

start()

Figure 4.1: The web interface and interaction of the sample code

RunMe, https://aesthetic-programming.gitlab.io/book/p5_SampleCode/ch4_DataCapture/

Starting with this sample code, the sketch incorporates four data inputs for a customizable "like" button:

1. The button can be clicked using the mouse and then the button's color is changed.

2. The button's color is resumed when the mouse is moved away from the button area.

3. The button will rotate 180 degrees when you click the keyboard's spacebar.

4. The button will change its size according to the volume of the audio/mic input.

5. The button will move in line with input from the facial recognition software, following the movement of what it considers to be the mouth.

The button has been customized using Cascading Style Sheets (CSS), which describe the style and visual elements of an object in a format that consists of a selector and a declaration block. (7) These identify which elements you want to customize and how to do it precisely. CSS works with HTML and we can create HTML's DOM objects like a button with the p5.js library (which will be explained in further detail in the following section).

Exercise in class (Decode)

By looking at the like button closely in the RunMe, can you come up with a list of stylistic customizations that have been introduced in the sample code?

Then look at the source code in the next section (Lines 23-49) and describe some of the button's styling in your own words.

Source code

```
1   Let button;
2   Let mic;
3   Let ctracker;
4   Let capture;
5
6   function setup() {
7     createCanvas(640, 480);
8     //web cam capture
9     capture = createCapture(VIDEO);
10    capture.size(640, 480);
11    capture.hide();
12
13    // Audio capture
14    mic = new p5.AudioIn();
15    mic.start();
16
17    //setup face tracker
18    ctracker = new clm.tracker();
19    ctracker.init(pModel);
20    ctracker.start(capture.elt);
21
22    //styling the like button with CSS
23    button = createButton('Like');
24    button.style("display", "inline-block");
25    button.style("color", "#fff");
26    button.style("padding", "5px 8px");
27    button.style("text-decoration", "none");
28    button.style("font-size", "0.9em");
29    button.style("font-weight", "normal");
30    button.style("border-radius", "3px");
```

```
31    button.style("border", "none");
32    button.style("text-shadow", "0 -1px 0 rgba(0, 0, 0, .2)");
33    button.style("background", "#4c69ba");
34    button.style(
35      "background","-moz-Linear-gradient(top, #4c69ba 0%, #3b55a0 100%)");
36    button.style(
37      "background","-webkit-gradient(Linear, Left top, Left bottom, \
38        color-stop(0%, #3b55a0))");
39    button.style(
40      "background","-webkit-Linear-gradient(top, #4c69ba 0%, #3b55a0 100%)");
41    button.style(
42      "background","-o-Linear-gradient(top, #4c69ba 0%, #3b55a0 100%)");
43    button.style(
44      "background","-ms-Linear-gradient(top, #4c69ba 0%, #3b55a0 100%)");
45    button.style(
46      "background","Linear-gradient(to bottom, #4c69ba 0%, #3b55a0 100%)");
47    button.style(
48      "filter","progid:DXImageTransform.Microsoft.gradient \
49      ( startColorstr='#4c69ba', endColorstr='#3b55a0', GradientType=0 )");
50    //mouse capture
51    button.mouseOut(revertStyle);
52    button.mousePressed(change);
53  }
54  function draw() {
55    //getting the audio data i.e the overall volume (between 0 and 1.0)
56    let vol = mic.getLevel();
57    /*map the mic vol to the size of button,
58    check map function: https://p5js.org/reference/#/p5/map */
59    button.size(floor(map(vol, 0, 1, 40, 450)));
60
61    //draw the captured video on a screen with the image filter
62    image(capture, 0,0, 640, 480);
63    filter(INVERT);
64
65    let positions = ctracker.getCurrentPosition();
66    //check the availability of web cam tracking
67    if (positions.length) {
68      //point 60 is the mouth area
69      button.position(positions[60][0]-20, positions[60][1]);
70      /*loop through all major points of a face
71      (see: https://www.auduno.com/clmtrackr/docs/reference.html)*/
72      for (let i = 0; i < positions.length; i++) {
73        noStroke();
74        //color with alpha value
75        fill(map(positions[i][0], 0, width, 100, 255), 0, 0, 120);
76        //draw ellipse at each position point
77        ellipse(positions[i][0], positions[i][1], 5, 5);
```

```
78        }
79      }
80  }
81
82  function change() {
83    button.style("background", "#2d3f74");
84    userStartAudio();
85  }
86  function revertStyle(){
87    button.style("background", "#4c69ba");
88  }
89  //keyboard capture
90  function keyPressed() {
91    //spacebar - check here: http://keycode.info/
92    if (keyCode === 32) {
93      button.style("transform", "rotate(180deg)");
94    } else {    //for other keycode
95      button.style("transform", "rotate(0deg)");
96    }
97  }
```

DOM elements: creating and styling a button

"DOM" stands for Document Object Model, a document like HTML with a tree structure that allows programs to dynamically access and update content, structure, and style. Rather than focusing on the various tree structures, we will focus on elements from forms that are part of the DOM. These form elements include buttons, radio buttons, checkboxes, text input, etc., and these are usually encountered when filling in forms online. The basic structure for creating form elements is relatively simple. The p5.js reference guide, under the DOM, (8) lists various examples of form creation syntax, e.g. createCheckbox(), createSlider(), createRadio(), createSelect(), createFileInput(), and so on. The one that we need to create a button is called createButton().

First you need to assign an object name to the button, and if you use multiple buttons, you will need to come up with multiple different names so you can set the properties (9) for each one.

- Let button;: First step is to declare the object by assigning a name.
- button = createButton('Like');: Create a button and consider the text is to be displayed.
- button.style("xxx","xxxx");: This is the CSS standard, where the first parameter is a selection/selector and the second is a declaration block/attributes. For example, if you want to set the font color, then you can put in "color" and "#fff" respectively. (10) For this sample code, all the styling was copied directly from the 2015 Facebook interface by

looking at their CSS source code. Styling includes `display`, `color`, `padding`, `text-decoration`, `font-size`, `font-weight`, `border-radius`, `border`, `text-shadow`, `background` and `filter`, with the addition of `transform`.
- `button.size();`: This sets the button's width and height.
- `button.position();`: This sets the button's position.
- `button.mousePressed(change);`: This changes the button's color, and gives users control over starting audio with the customized function `change()` when the mouse is pressed (more to follow in the section of "Audio capture").
- `button.mouseOut(revertStyle);`: This reverts the original button's color with the cutomized function `revertStyle()` when the mouse moves off the button element.

Mouse capture

In the previous chapter, the program listened for mouse movement and captured the corresponding x and y coordinates using the built-in syntaxes `mouseX` and `mouseY`. This sample code incorporates specific mouse listening events, such as `mouseOut()` and `mousePressed()` functions which are called every time the user presses a mouse button. See the excerpt from the code below:

```
1  //mouse capture
2  button.mouseOut(revertStyle);
3  button.mousePressed(change);
4
5  function change() {
6    button.style("background", "#2d3f74");
7    userStartAudio();
8  }
9  function revertStyle(){
10   button.style("background", "#4c69ba");
11 }
```

The functions `mousePressed()` and `mouseOut()` are linked to the button you want to trigger actions. There are other mouse-related mouseEvents, (11) such as `mouseClicked()`, `mouseReleased()`, `doubleClicked()`, `mouseMoved()`, and so on.

Keyboard capture

```
1  function keyPressed() {
2    //spacebar – check here: http://keycode.info/
3    if (keyCode === 32) {
4      button.style("transform", "rotate(180deg)");
5    } else {    //for other keycode
6      button.style("transform", "rotate(0deg)");
7    }
8  }
```

The use of the keyPressed() function is for listening any keyboard pressing events. If you want to specify any keyCode (that is the actual key on the keyboard), the sample code shows how a conditional statement can be implemented within the keyPressed() function.

The "conditional structure" is something similar to what you have learnt in the previous chapter, but it is also something different with the "if-else" statement. It explains as: if the spacebar on the keyboard is pressed, then the button rotates 180 degrees, and if any other keys of the keyboard are pressed, then the button reverts back to the original state of 0 degrees. The "if-else" structure therefore allows you to setup a further condition with the listening event: if a keyCode is detected other than the spacebar, the program will do something else.

keyCode takes in numbers or special keys like BACKSPACE, DELETE, ENTER, RETURN, TAB, ESCAPE, SHIFT, CONTROL, OPTION, ALT, UP_ARROW, DOWN_ARROW, LEFT_ARROW, RIGHT_ARROW. In the above example, the keyCode for a spacebar is 32 (see Line 3).

There is no difference in keyCode between capital and lower case letters, i.e. "A" and "a" are both 65.

Similar to mouseEvents, there are also many other keyboardEvents, (12) such as keyReleased(), keyTyped(), keyIsDown().

Audio capture

```
1   let mic;
2
3   function setup() {
4     button.mousePressed(change);
5     // Audio capture
6     mic = new p5.AudioIn();
7     mic.start();
8   }
9
10  function draw() {
11    //getting the audio data i.e the overall volume (between 0 and 1.0)
12    let vol = mic.getLevel();
13    /*map the mic vol to the size of button,
14    check map function: https://p5js.org/reference/#/p5/map */
15    button.size(floor(map(vol, 0, 1, 40, 450)));
16  }
17
18  function change() {
19    userStartAudio();
20  }
```

The basic web audio p5.sound library is used in the sample code. It includes features like audio input, sound file playback, audio analysis, and synthesis. (13)

The library should be included in the HTML file (as demonstrated in Chapter 1, "Getting started") so we can use the corresponding functions such as p5.AudioIn() and getLevel().

Like a button, you first declare the object, e.g. let mic; (see Line 1,) and then set up the input source (usualy a computer microphone) and start to listen to the audio input (see Lines 6-7 within setup()). When the entire sample code is executed, a popup screen from the browser will ask for permission to access the audio source. This audio capture only works if access is granted.

 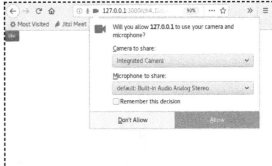

Figure 4.2: Permission for audio access Figure 4.3: Permission for camera access

The sample code refers to methods under `p5.AudioIn()` in the p5.sound library, which reads the amplitude (volume level) of the input source returning values between 0.0 to 1.0 using the `getLevel()` method.

A new function `map()` (in Line 15) will be introduced to map a number across a range. Since the values for volume returned are on a range of 0.0 to 1.0, the corresponding value will not make a significant difference in terms of the size of the button. As such, the range of the audio input will then map to the size range of the button dynamically.

The function `userStartAudio()` (see Line 19) will enable the program to capture the mic input on a user interaction event, and in this case it is the `mousePressed()` event. This is a practice enforced by many web browsers, including Chrome, in which users aware of the audio events happen in the background and to avoid auto play or auto capture features from a web browser.

Video/Face capture

```
1   let ctracker;
2   let capture;
3
4   function setup() {
5     createCanvas(640, 480);
6     //web cam capture
7     capture = createCapture(VIDEO);
8     capture.size(640, 480);
9     capture.hide();
10    //setup face tracker
11    ctracker = new clm.tracker();
12    ctracker.init(pModel);
```

```
13    ctracker.start(capture.elt);
14  }
15
16  function draw() {
17    //draw the captured video on a screen with the image filter
18    image(capture, 0,0, 640, 480);
19    filter(INVERT);
20
21    let positions = ctracker.getCurrentPosition();
22
23    //check the availability of web cam tracking
24    if (positions.length) {
25      //point 60 is the mouth area
26      button.position(positions[60][0]-20, positions[60][1]);
27
28      /*loop through all major points of a face
29      (see: https://www.auduno.com/clmtrackr/docs/reference.html)*/
30      for (let i = 0; i < positions.length; i++) {
31        noStroke();
32        //color with alpha value
33        fill(map(positions[i][0], 0, width, 100, 255), 0, 0, 120);
34        //draw ellipse at each position point
35        ellipse(positions[i][0], positions[i][1], 5, 5);
36      }
37    }
38  }
```

For the specific video/face capture, the sample code uses clmtrackr which is a JavaScript library developed by data scientist Audun M. Øygard in 2014 for aligning a facial model with faces in images or video. (14) Based on facial algorithms designed by Jason Saragih and Simon Lucey, (15) the library analyses a face in real-time marking it into 71 points based on a pre-trained machine vision model of facial images for classification. (See Figure 4.5) Since it is a JavaScript library, you need to put the library in the working directory, and link the library, and the face model in the HTML file. (see Figure 4.4)

Figure 4.4: The HTML file structure to import the new library and models

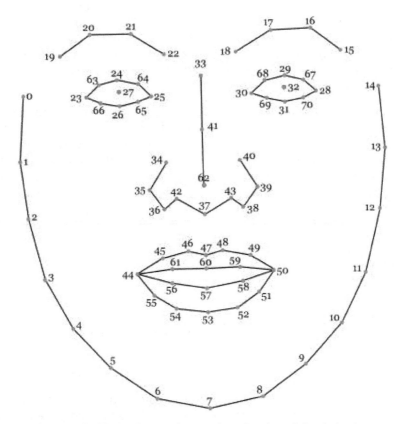

Figure 4.5: The tracker points on a face. Courtesy of the clmtrackr's
creator, Audun M. Øygard

The program uses the webcam via video capture to do facial recognition and details
as follow:

1. `Let ctracker; & Let capture;`: Initialize the two variables that are used for face tracking
 and video capture.

2. `createCapture(VIDEO)` in Line 7: This is a HTML5 `<video>` element (part of the DOM) that
 captures the feed from a webcam. In relation to this function you can define the size of
 the screen capture (which depends on the resolution of the webcam) and position on
 screen, e.g. `capture.size(640, 480);` We also uses `capture.hide();` to hide the video feed
 so that the button and the colored tracker points will not crash the video object.

3. Lines 11-13 are related to ctracker: `ctracker = new clm.tracker()`, `ctracker.init(pModel);`
 and `ctracker.start(capture.elt);`: Similar to audio and camera use, you first need to
 initialize the ctracker library, select the classified model (to be discussed in Chapter 10,
 "Machine unlearning"), and start tracking from the video source.

4. In order to display the captured video in the INVERT mode, the program uses
 `image(capture, 0,0, 640, 480);` to draw the video feed in an image format, and apply the
 filter accordingly: `filter(INVERT);` (See Line 18-19)

5. `ctracker.getPosition()` in Line 21: While we get the tracker points into an array `position`, a for-loop (in line 30-36) is used to loop through all 71 tracker points (as it starts with 0 and ends with 70) and return the position in terms of x and y coordinates as a two-dimensional array in the form of `position[][]`. The first dimension (`[]`) of the position array indicates the tracker points from 0 to 70. The second dimension (`[][]`) retrieves the x and y coordinates of the tracker points.

6. Getting all the data on the tracker points allows ellipses to be drawn to cover the face. Since the position of the like button follows that of the mouth, which postions at the point 60 (but since the button requires to position at the mid point of the mouth, therefore it needs to move the button to the left for around 20 pixels), the program will then return the position as an array (see line 26): `positions[60][0]-20` and `positions[60][1]`. The second array's dimensions of [0] and [1] refer to the x and y coordinates.

Exercise in class

To familiar yourself with the various modes of capture, try the following:

1. Explore the various capture modes by tinkering with various parameters such as `keyCode`, as well as other keyboard, and mouse events.

2. Study the tracker points and try to change the position of the like button.

3. Try to test the boundaries of facial recognition (using lighting, facial expressions, and the facial composition). To what extend can a face be recognized as such, and to what extent is this impossible?

4. Do you know how the face is being modeled? How has facial recognition technology been applied in society at large, and what are some of the issues that arise from this?

It would be worth checking back to Chapter 2, "Variable geometry," for a reminder of how facial recognition identifies a person's face from its geometry — such as the distance between a person's eyes or size of their mouth — to establish a facial signature that can be compared to a standardized database. One of the main problems is that these databases are skewed by how data was prepared, its selection, collection, categorization, classification, and cleaning (further discussed in Chapter 10, "Machine unlearning"). To what extent does your face meet the standard?

The concept of capture

This next section discusses various examples of different inputs for data capture. The intention is to showcase some other possibilities of its application, and more importantly how this relates to datafication, commodification, surveillance and personalization. In other words, this is an opportunity to discuss data politics more broadly: to question how our personal data is captured, quantified, archived, and used, and for what purpose? What are the implications, and who has the right to access the captured data, and derive profit from it? Few people know exactly which data is captured or how it is used? (16) However, despite the use of the term "capture," we should also point out that this is not total incarceration, and there are escape routes. More on this later.

Web analytics and heatmap

At the moment, the most widely used web analytics service is provided by Google and contains tremendous amounts of data on website traffic and browsing behavior, including the number of unique visits, average time spent on sites, browser and operating system information, traffic sources and users' geographic locations, and so on. This data can then be further utilized to analyze customers' profiles and user behaviors.

Figure 4.6: Google Analytics screenshot

Heatmap is one of the visualization tools and provides a graphical representation of data to visualize user behavior. It is commonly used in industries for the purpose of data analytics. For example, it is easy to track the cursor's position and compute the duration of its stay in different areas of a web page, providing an indication as to which content is "hotter" than the

rest. This is useful for marketing purposes, not least to understand which content is more or less attractive to users, and for companies or political parties to analyze where to best place their ads and other propaganda. The Facebook–Cambridge Analytica data scandal makes a pertinent case study. In early 2018, it was revealed that the personal data of millions of peoples' Facebook profiles had been harvested without their consent, and used for political advertising purposes. (17) Major corporations such as Facebook, (18) constantly explore new data capture methods to optimize screen presentation.

Figure 4.7: An example of a heatmap for analyzing a web page

Form eDements

As we argued with regard to interaction, the choices are limited, and yet each form element like a dropdown menu or a button indicates different affordances. (19) Researcher Rena Bivens has made a thorough analysis of Facebook's registration page in relation to the gender options available. (20) When Facebook was first launched in 2004 there was no gender field, but things changed in 2008 when a drop-down list was introduced that consisted solely of the options Male or Female, further changed with the use of radio buttons to emphasize the binary choice. A breakthrough occurred in 2014 when Facebook allowed users to customize the gender field and you can now select from a list of more than 50 gender options. According to Facebook, they wanted to enhance "personalized experiences" with "authentic identity," (21) however it remains arguable that this personalization (both at Facebook and in society in general) is well-intended as it also serves the purpose of market segmentation (in dividing users into ever more sub-groups).

Figure 4.8: Facebook's custom gender field as of February 2020

Metrics of Dikes

The use of a single Like button provides a good example of how our feelings are captured. The aptly named company "Happy or Not" who produce push button technology and analytics software — the kind found in supermarkets for instance, with happy or sad faces — also provide feedback technologies for the workplace, as indicated by their strapline: "Creating happiness in every business, worldwide." (22) The six emoticons Facebook launched in 2016, including "Like," "Love," "Haha," "Wow," "Sad" and "Angry," mark our standardized experience of work and play more precisely. All clicks are "categorized" into emotional metrics, displayed publicly on the web, and used for algorithmic calculation to prioritize feeds to users. It is fairly clear how the clicks serve the interests of platform owners foremost, and, as if to prove the point, Facebook, and Instagram have tested the idea of hiding the metrics on posts in order to shift attention to what they prefer to call "connecting people" (23) — as if to prove their interests to be altruistic.

This practice of quantification is something the artist Benjamin Grosser has parodied in his *Demetricator* series, (24) first published in 2012, which makes all the numbers associated with the metadata disappear. The associated "value" of numbers associated with notifications, replies, favorites, and feeds, have all been nullified. Or rather, it becomes clear that the clicking produces value and the proof of this is conspicuous by its absence.

Figure 4.9: Benjamin Grosser's Facebook Demetricator, demetricating Likes, Shares, Comments, and Timestamps. Original (top), Demetricated (bottom). Courtesy of the artist

Tracking is clearly big business and comes with its own invisibility cloak. In 2013, Facebook conducted a research project about last-minute self-censorship, (25) revealing their capability of being able to track even unposted status updates/posts/comments, including erased texts, or images. This "residual data," which might be considered "waste material," "digital exhaust," or data exhaust," and yet this data is rich in predictive values. (26) The implication is that Facebook is not only interested in capturing what you have posted, but also capturing your thought processes from residual data. It is sobering to think that data capture extends to the realm of imagination.

Voice and audio data

Smart devices like our computers, phones, and other gadgets are commonly equipped with voice recognition — such as Siri, Google Assistant or Alexa — which turns audio input into commands for software, and feedback with more personalized experiences to assist in the execution of everyday tasks. You can find these voice assistants in just about everything now including, everyday objects like microwaves, and they become more and more conversational and "smart," one might say "intelligent," as machine learning develops. These "voice assistants," as they are known, carry out simple tasks very well, and become smarter, and at the same time capture voices for machine learning applications in general. Placing these tangible voice assistants in our homes allows the capturing of your choices and tastes when not facing a screen. In the internet of things, the device serves you, and you serve the device. Indeed we become "devices" that generate value for others. (27)

Figure 4.10: Screenshot of Voice & Audio activity

In the Figure 4.10, the text reads as:

"Voice and audio recordings save a recording of your voice and other audio inputs in your Web & app activity on Google services and from sites, apps and devices that use or connect to Google speech services. [..] This data helps Google give you more personalised experiences across Google services, like improved speech recognitionn when you say "Hey Google" to speak to your Assistant, both on and off Google. This data may be saved and used in any Google service where you are signed in to give you more personalised experiences."

HeaDth tracker

Figure 4.11: Screenshot of sleep tracker

Fitness and well-being becomes datafied too, and with the setting of personal targets, also "gamified." As the welfare state is dismantled, personal well-being becomes more and more individualized and there is a growing trend for "self-tracking" apps to provide a spurious sense of autonomy. Movement, steps, heart rate, and even sleep patterns can be tracked and analyzed using wearable devices such as the Fitbit, or the Apple Watch. These practices of the "quantified self," sometimes referred to as "body hacking" or "self-surveillance," overlap with other trends that incorporate capture and acquisition into all aspects of daily life.

WhiDe()

Under late capitalism, temporality itself seems to have been captured, and "there is a relentless incursion of the non-time of 24/7 into every aspect of social or personal life. There are, for example, almost no circumstances now that cannot be recorded or archived as digital imagery or information." (28) We quote from Jonathan Crary's book *24/7: Late Capitalism and the Ends of Sleep* which describes the collapse of the distinction between day and night, meaning we are destined to produce data at all times. If sleep was once thought to be the last refuge from capitalism where no value could be extracted, (29) then this no longer seems to be the case.

That even sleep has become datafied seems to point to the extent to which our subjectivities have also been captured. We produce, share, collect, use and misuse, knowingly, or not, massive amounts of data, but what does its capture do to us? What are the inter-subjective relations between data-commodity and its human subjects? As discussed in this chapter, our personal and professional lives seem to be fully enmeshed in various processes of "datafication," but does this mean that we are trapped in a prison-house of data, unwittingly producing value for others? In this last section we try to unpack these ideas a little more, and in particular the idea of value in the context of the data flow (that we call big data), and examine our position within these datafied structures which is not entirely without agency.

In 2015, transmediale, an annual art and digital culture festival in Berlin, posted an open call addressing the pervasive logic of *Capture All* and the quantification of life, work and play. The call included some questions worth repeating here: "Are there still modes of being that resist the imperative of digital capitalism to CAPTURE ALL or is there no option but to play

along? If so, are there artistic strategies and speculative approaches that do not play this game of quantification by the numbers? What are the [_] gaps of relentless quantification and gamification that can be exploited in order to carve out new ways of living?" (30) Hopefully the practical tasks and examples of this chapter go some way to pointing out some alternatives.

Marxist theory can help us make sense of this on a more conceptual level. The various techniques we have described can be understood as means of production, what Marx would refer to as "fixed capital," which is then turned into "exchange value," or in other words monetary value. Yet to see this process as one in which the labor-value of users is simply captured and the associated value stolen misses the point, as Tiziana Terranova states. (31) Rather than individual users needing compensation for their willing supply of data, it is the bigger social aspect that is more significant, particularly in the context of big data, we might add. She explains: "Contrary to some variants of Marxism which tend to identify technology completely with "dead labor," "fixed capital" or "instrumental rationality," and hence with control and capture, it seems important to remember how, for Marx, the evolution of machinery also indexes a level of development of productive powers that are unleashed but never totally contained by the capitalist economy." (32)

We can find some evidence of this in the social energies of the free and open source movement, for instance, where compensation operates at the level of social exchange. This claim then serves to shift attention from the efforts of the individual to social relations. The politics of this is especially important if we are to develop a position different from the logic of "capture all" and look to more positive, and hopeful interpretations. Referring to button pressing, Terranova describes social relations as an asymmetrical relations between two poles — one active, the other receptive. To her, actions such as "liking and being liked, writing and reading, looking and being looked at, tagging and being tagged," are examples of the transition from individual to collective forms. She considers how "these actions become discrete technical objects (like buttons, comment boxes, tags, etc.) which are then linked to underlying data structures," and, in turn, how these actions express the possibility of being able to experiment with processes of "individuation" and "transindividuation," i.e. the possibility of social transformation itself.

This line of argument makes reference to the philosophy of Gilbert Simondon, to the transformational process by which individuation — how a person or thing is identified as distinguished from other persons or things — is caught up with other individuations. There is no space (or need, we think) to go into this in detail in this publication, but for now it suffices to say that transindividuation describes the shift between the individual "I" and the collective "We" and how they are transformed through one another. (33) We hope something of this happens to this book project, which is already collective by design, but also opens up further possibilities for the production of new versions and social relations in its reworking. Of course this involves tinkering with the underlying codes and values associated with data capture, and our ability to reinvent the latter's main purpose. This is an open invitation to not only capture data, but to also unleash its other potentials.

MiniX: Capture ADD

Objective:

- To experiment with various data capture inputs, including audio, mouse, keyboard, webcam, and more.
- To critically reflect upon the process of data capture and datafication.

For additional inspiration:

- *LAUREN* by Lauren McCarthy (2017), http://lauren-mccarthy.com/LAUREN.
- *nonsense* by Winnie Soon (2015), http://siusoon.net/nonsense/. (Read the comment in the source code for this project's intentions.)
- *Facebook Demetricator* by Benjamin Grosser (2012-present), https://bengrosser.com/projects/facebook-demetricator/, and subsequent *Instagram Demetricator*, https://bengrosser.com/projects/instagram-demetricator/ or *Twitter Demetricator*, https://bengrosser.com/projects/twitter-demetricator/.

Tasks (RunMe):

1. Experiment with various data capture input and interactive devices, such as audio, mouse, keyboard, webcam/video, etc.

2. Develop a sketch that responds loosely to the transmediale open call "Capture All," https://transmediale.de/content/call-for-works-2015. (Imagine you want to submit a sketch/artwork/critical or speculative design work to transmediale as part of an exhibition.)

Questions to think about (ReadMe):

- **Provide** a title for and a short description of your work (1000 characters or less) as if you were going to submit it to the festival.
- **Describe** your program and what you have used and learnt.
- **Articulate** how your program and thinking address the theme of "capture all."
- What are the cultural implications of data capture?

Required reading

- Carolin Gerlitz and Anne Helmond, "The Like Economy: Social Buttons and the Data-Intensive Web," *New Media & Society* 15, no. 8, December 1 (2013): 1348–65.
- "p5.js examples - Interactivity 1," https://p5js.org/examples/hello-p5-interactivity-1.html.
- "p5.js examples - Interactivity 2," https://p5js.org/examples/hello-p5-interactivity-2.html.
- "p5 DOM reference," https://p5js.org/reference/#group-DOM.
- Shoshana Zuboff, "Shoshana Zuboff on Surveillance Capitalism | VPRO Documentary," https://youtu.be/hIXhnWUmMvw.

Further reading

- Christian Ulrik Andersen and Geoff Cox, eds., *A Peer-Reviewed Journal About Datafied Research* 4, no. 1 (2015), https://aprja.net/issue/view/8402.
- Audun M. Øygard, "clmtrackr - Face tracking JavaScript library," https://github.com/auduno/clmtrackr.
- Søren Pold, "Button," in Fuller, ed., *Software Studies*.

- Daniel Shiffman, *HTML / CSS/DOM – p5js Tutorial* (2017), https://www.youtube.com/playlist?list=PLRqwX-V7Uu6bI1SlcCRfLH79HZrFAtBvX.
- Tiziana Terranova, "Red Stack Attack! Algorithms, Capital and the Automation of the Common," *EuroNomade* (2014), http://www.euronomade.info/?p=2268.

Notes

1. This resonates with the field of data visualization, and Edward Tufte's belief that data should be allowed to "speak for itself" rather than be lost in the ornamentation of visualization. This makes the mistake in thinking that data is raw and unmediated. Data begins relatively raw and uninterpreted, but in practice is already selected, targeted, preprocessed and cleaned, mined, and so on, not least to make it human readable. There is always some additional information about its composition, usually derived from the means by which it was gathered in the first place. See Edward R. Tufte, *The Visual Display of Quantitative Information* [1983] (Cheshire, CT: Graphics Press, 2001).
2. Christian Ulrik Andersen and Geoff Cox, eds., A Peer-Reviewed Journal About Datafied Research, *APRJA* 4, no.1 (2015).
3. Kenneth Cukier and Victor Mayer-Schöenberger, "The Rise of Big Data," *Foreign Affairs* (May/June 2013): 28–40.
4. Shoshana Zuboff, "Shoshana Zuboff on Surveillance Capitalism | VPRO Documentary," vpro documentary. Accessed April 26 (2020). https://youtu.be/hIXhnWUmMvw. See her book, *The Age of Surveillance Capitalism: The Fight for a Human Future at the New Frontier of Power* (New York: PublicAffairs, 2019).
5. Søren Pold, "Button," in Matthew Fuller ed., *Software Studies* (Cambridge, Mass.: MIT Press, 2008), 34. Users are seduced by the wording of the button not least, and Pold suggests that a button is developed with distinct functionality and signification (Ibid., 31).
6. Carolin Gerlitz and Anne Helmond, "The Like Economy: Social Buttons and the Data-Intensive Web," *New Media & Society* 15, no.8, December 1 (2013): 1348–65.
7. The styling of the button is exactly the same as Facebook's like button styling in 2015.
8. https://p5js.org/reference/#group-DOM.
9. See the p5.Element method list here, https://p5js.org/reference/#/p5.Element.
10. Styling a button follows the syntax of CSS, and that controls how a DOM element like a button should be displayed. The provided example shows how CSS is incorporated into the JavaScript file by using the syntax button.style('xxx:xxxx'); Another way of doing this is to follow the convention of having a CSS file that lists the .class selector. In this way, you need to have the syntax in the JavaScript file to mark the class name: button.class('class_name'); and then list out the CSS elements and class attributes in the CSS file. More examples can be found here: https://www.w3schools.com/csS/css3_buttons.asp, and see Daniel Shiffman's video on the basic of CSS, https://www.youtube.com/watch?v=zGL8q8iQSQw.
11. The related function in the reference page, which is under Events > Mouse>, see https://p5js.org/reference/.
12. The related function in the reference page, which is under Events > Keyboard>, see https://p5js.org/reference/.
13. See the sound library's various features: https://p5js.org/reference/#/libraries/p5.sound.
14. See https://www.auduno.com/2014/01/05/fitting-faces/.
15. Jason M. Saragih, Simon Lucey and Jeffrey F. Cohn, "Face Alignment Through Subspace Constrained Mean-shifts," *2009 IEEE 12th International Conference on Computer Vision, Kyoto* (2009): 1034-1041. doi: 10.1109/ICCV.2009.5459377.
16. The introduction of legislation such as the GDPR (General Data Protection Regulation) is a response to this lack of transparency. GDPR is a regulation in EU law (2016) on data protection and privacy that applies to all the citizens of the European Union and the European Economic Area. It also addresses the transfer of personal data outside the EU and EEA areas. See https://gdpr-info.eu/.
17. *The Guardian's* coverage of this, "The Cambridge Analytica Files," can be found at https://www.theguardian.com/news/series/cambridge-analytica-files. Facebook was ultimately forced to pay a hefty fine, see Alex Hern, "Facebook agrees to pay fine over Cambridge Analytica scandal," *The Guardian*, October 30 (2019), https://www.theguardian.com/technology/2019/oct/30/facebook-agrees-to-pay-fine-over-cambridge-analytica-scandal
18. Will Conley, "Facebook investigates tracking users' cursors and screen behavior," *Slashgear*, October 30 (2013). Available at: https://www.slashgear.com/facebook-investigates-tracking-users-cursors-and-screen-behavior-30303663/.
19. Affordance provides cues which give a hint how users may interact with something. See James J. Gibson, The Theory of Affordances," in Robert Shaw and John Bransford, eds. *Perceiving, Acting, and Knowing* (Hillsdale, NJ: Lawrence Erlbaum Associates, 1977), 127–143.
20. Rena Bivens, "The Gender Binary will not be Deprogrammed: Ten Years of Coding Gender on Facebook," *New Media & Society* 19, no.6, (2017): 880–898. doi.org/10.1177/1461444815621527.
21. Facebook, Form S-1 registration statement (2012). Available at: https://infodocket.files.wordpress.com/2012/02/facebook_s1-copy.pdf.
22. Esther Leslie, "The Other Atmosphere: Against Human Resources, Emoji, and Devices," *Journal of Visual Culture* 18 no.1, April (2019).
23. Laurie Clarke, "Why hiding likes won't make Instagram a happier place to be," *Wired*, July 19 (2019), https://www.wired.co.uk/article/instagram-hides-likes.
24. See Ben Grosser's *Demetricator* series of artworks: *Facebook Demetricator*, https://bengrosser.com/projects/facebook-demetricator/; *Instagram Demetricator*, https://bengrosser.com/projects/instagram-demetricator/; *Twitter Demetricator*, https://bengrosser.com/projects/twitter-demetricator/.
25. Sauvik Das and Adam D. I. Kramer, "Self-censorship on Facebook," *AAAI Conference on Weblogs and Social Media (ICWSM)*, July 2 (2013), https://research.fb.com/publications/self-censorship-on-facebook/.
26. Zuboff, *Shoshana Zuboff on Surveillance Capitalism | VPRO Documentry*.
27. Paraphrasing the final lines of Leslie's essay "The Other Atmosphere: Against Human Resources, Emoji, and Devices": "The workers become their own devices. They becomes devices of communicative capitalism [–]."
28. Jonathan Crary, *24/7: Late Capitalism and the Ends of Sleep* (London: Verso, 2013), 30–31.
29. Crary, *24/7*, 10-11.
30. transmediale, *Capture All*, https://transmediale.de/content/call-for-works-2015.

31. Tiziana Terranova, "Red Stack Attack! Algorithms, Capital and the Automation of the Common." *EuroNomade* (2014). Available at http://www.euronomade.info/?p=2268

32. Terranova, "Red Stack Attack!"

33. To Bernard Stiegler, explains Irit Rogoff, "The concept of 'transindividuation' is one that does not rest with the individuated 'I' or with the interindividuated 'We'," but "is the process of co-individuation within a preindividuated milieu and in which both the 'I' and the 'We' are transformed through one another." See Bernard Stiegler and Irit Rogoff, "Transindividuation." *e—flux* 14, March (2010), https://www.e-flux.com/journal/14/61314/transindividuation/.

34. Terranova, "Red Stack Attack!"

5. Auto-generator

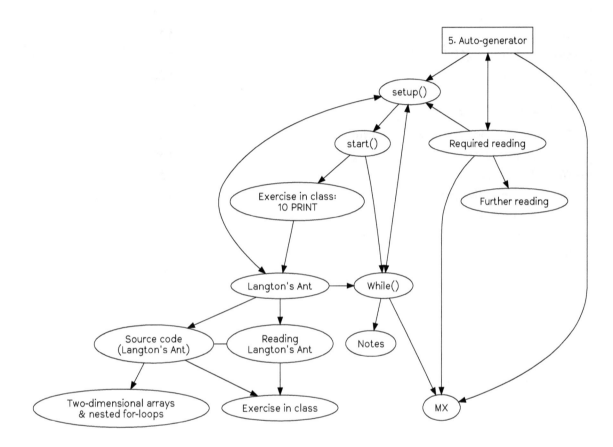

Contents

setup()

While the previous chapter discussed the data capture underlying the interaction with input devices, this chapter follows the concepts of input and output to introduce the idea of the abstract machine. This refers to the creation of rules by a self-operating machine, widely known as an abstract machine or Turing machine. It was mathematician and computer scientist Alan Turing who first described this machine in his famous article "On Computable Numbers, with an Application to the Entscheidungsproblem," published in 1936. (1) He used the term "universal computing machine" to theorize a model that describes how a machine "can be used to compute any computable sequence," (2) i.e. how a machine operates, and follows a predetermined sequence of instructions that process input and produce output.

More specifically, the Turing machine is capable of six types of fundamental operations (at the time there wasn't a thing called a computer) including read, write, move left, move right, change state and halt/stop. Turing suggested these operations could be performed by running an endless tape (that worked like memory does in a modern computer) with instructions on what symbols to read and write, as well as how to move. These instructions constitute the fundamental principles of the Turing machine, (3) but also modern computing, with the capability to compute numeric tasks and automate various processes. These instructions from a base level of computing seem to underwrite the wider processes of production, consumption and distribution of contemporary (informational) capitalism as we partly covered in the last chapter.

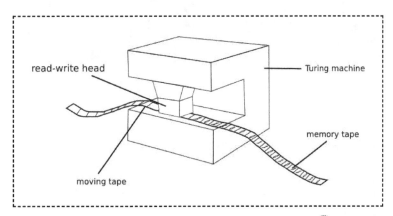

Figure 5.1: An illustration of the Turing Machine (4)

This chapter will explore how instructions are fundamental elements of adaptive systems, focusing on how rules are performed, and how they might produce unexpected and/or complex results.

Focusing on rules and instructions is not something only programmers do, but also something you do when following a knitting/weaving pattern (5) or recipe (as we will see with the preparation of tofu in the next chapter). Artists have also produced instruction-based works of art, as is the case of the Fluxus and Conceptual Art movements of the 1960s and 1970s that set out to challenge art's object-ness, and encourage its "dematerialization." (6) There are many examples of commentators making the connection between these

instruction-based works and computational art. (7) For instance, the survey exhibition "Programmed: Rules, Codes, and Choreographies in Art, 1965-2018," (8) organized by Christiane Paul at the Whitney Museum of American Art (2018-19), explored how instruction-based practices have both responded to, and been shaped by technologies. The work of conceptual artist Sol Le Witt is one of the obvious examples here and demonstrates how even when based on a set of instructions, the outcome might be different depending on how the instructions are interpreted by others. For example, the work *Wall Drawing #289* consists of three simple instructions, but does not specify the angles and length of the lines:

1. Twenty-four lines from the center.

2. Twelve lines from the midpoint of each of the sides.

3. Twelve lines from each corner.

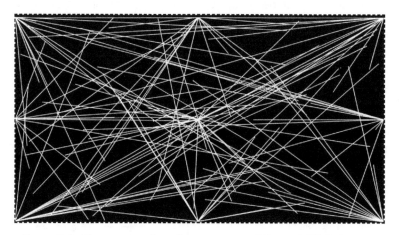

Figure 5.2: This image is the software version of the work *Wall drawing #289* (1976) by Sol LeWitt, and is further coded by Chuck Grimmett (9)

"The idea becomes a machine that makes the art," as LeWitt explains. (10) Using the programming language Processing, (11) this is taken as an invitation by Casey Reas to render LeWitt's wall drawings on the basis of their instructions, thereby exploring the parallels of interpretation and process for each of them. (12) In his accompanying text, Reas makes the important distinction that LeWitt's programs are to be carried out by people rather than machines. Nevertheless it is the close connection and overlap that interests him, and underlies the development of Processing as a "software sketchbook" as Reas wanted programming to be as immediate and fluid as drawing.

This is not without precedence. Algorithmic drawing has been explored by artists including Joan Truckenbrod, for example in her series *Coded Algorithmic Drawings* that dates back to the 1970s and 80s. (13) *Entropic Tangle* (see Figure 5.3) was coded in the Fortran programming language in 1975, using a mainframe computer with keypunch machine, and magnetic storage media. The work presents a number of polygons that vary in size, and angles of rotation that simulate invisible natural forces and incorporate continuity, and fluctuations by using variables and mathematical modulation. Truckenbrod is interested in

how "natural" forces get re-interpreted by symbols and numbers that further demonstrate the nature of ambiguity and spontaneity in systems. (14) Recursive fractal geometry (15) and flocking behaviors (16) are examples that demonstrate "entropic" qualities (lack of order or predictability) based on the self-organization of computation and autonomous agents (17) that evolve over time.

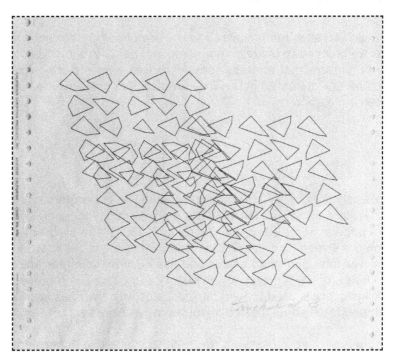

Figure 5.3: Joan Truckenbrod, Entropic Tangle (1975). Courtesy of the artist

This kind of approach is important, not only because it offers a different way of drawing and authoring works by machines based on mathematical logic, but also to provide a sense of machine creativity that — as in the previous chapter — negates intentionality (18) and questions the centrality of human (more often than not, masculinist) agency. In this chapter we aim to explore more complex combinations (or inter-species relations (19)) of humans and machines, nonhumans or animals (namely, ants).

If we were to draw an ellipse in white color at the x and y coordinate 100 and 120, the outcome of the instruction is predictable. But this needs not be the case as certain kinds of instructions or combinations of instructions can generate unruly results. As described in the book $10 \ PRINT \ CHR\$(205.5+RND(1)); \ : \ GOTO \ 10$, the $10 \ Print$ program utilizes randomness to generate unpredictable processes and outcomes that seem random to humans. This "generative" capacity questions the extent of control over the creative process, as the following definition of generative art reveals:

> "Generative art refers to any art practice where [sic] artists use a system, such as a set of natural languages, rules, a computer program, a machine, or other procedural invention, which is set into motion with some degree of autonomy contributing to or resulting in a completed work of art." (20)

Significantly this definition does not limit itself to the use of computers and this is important to bear in mind as we proceed to focus on our sample code. The following two examples (21) explore rule-based programs that address some of these issues of auto-generation, but as in previous examples we are interested in the wider implications that include hidden labor, and other issues concerning autonomy.

start()

The first program is called 10 PRINT referring to one line of program code 10 PRINT CHR$(205.5+RND(1));: GOTO 10, written in the BASIC programming language and executed on a Commodore 64 (a popular home computer during the 1980s). The program generates an endless pattern on the screen. The line of code was printed in the 1982 Commodore 64 User's Guide and was later published online, and has become an important example in the field of software studies for demonstrating the history and culture of creative computing. (22) 10 PRINT in p5.js below is used to help familiarize us with the rules and its creative potential as it demonstrates some degree of autonomy within a system.

The second program is entitled Langton's Ant (1986). It is a two-dimensional universal Turing machine invented in 1986 by the computer scientist Christopher Langton who is considered to be one of the founders of the artificial life field. (23) The core difference with 10 PRINT is the way in which it generates complex, emergent behavior using only a simple set of rules.

Exercise in class (10 PRINT)

Figure 5.4: 10 PRINT in p5.js

RunMe https://aesthetic-programming.gitlab.io/book/p5_SampleCode/ch5_AutoGenerator/

```
1   Let x = 0;
2   Let y = 0;
3   Let spacing = 10;
4
5   function setup() {
6     createCanvas(windowWidth, windowHeight);
7     background(0);
8   }
9
10  function draw() {
11    stroke(255);
12    if (random(1) <0.5) {
13      Line(x, y, x+spacing, y+spacing);
14    } else {
15      Line(x, y+spacing, x+spacing, y);
```

```
16    }
17    x+=10;
18    if (x > width) {
19      x = 0;
20      y += spacing;
21    }
22  }
```

1. **Read** the source code of 10 𝒫𝓡𝒮𝒩𝒥 above, then copy it, and run it on your own computer.

2. **Discuss** the following 10 𝒫𝓡𝒮𝒩𝒥 rules and map them to the related lines/blocks of code (24):

 – Throw a dice and print a backslash half the time

 – Print a forward slash the other half of the time

3. Drawing on the text "Randomness":

 – **How** is control being implemented in 10 𝒫𝓡𝒮𝒩𝒥?

 – **What** might the (un)predictability of regularity be?

 – **What** is randomness to a computer? (25)

 – **Discuss** the use and the role of randomness in 10 𝒫𝓡𝒮𝒩𝒥, and more generally in the arts, including literature, and games?

4. Try to modify the existing rules, for example:

 – Can we change the size, color, and spacing of the slashes?

 – Can we have outputs other than just the backward and forward slashes?

5. 10 𝒫𝓡𝒮𝒩𝒥 has been appropriated by many artists, designers and students. Take a look at some of the different options it provides 10 𝒫𝓡𝒮𝒩𝒥 that are documented on Twitter with the hastag "#10print." Your task in class is to create a sketch with a clear set of rules that operates like a modified version of 10 𝒫𝓡𝒮𝒩𝒥.

Langton's Ant

While 10 𝒫𝓇𝒾𝓃𝓉 focuses both on instructions and randomness as generative processes, we want to look at the concept of "emergence" in the context of automated and generative programs in which complex patterns/outcomes are generated by simple rules. *Langton's*

Ant is a classic mathematical game that simulates the molecular logic of an ant. The simulation of the cell's state is inspired by the classic Turing machine that can be instructed to perform computational tasks by reading symbols fed to it on a strip of tape that were drawn up according to a set of rules.

The next section provides the sample code that simulates the cell states, presented as a two-dimensional grid system in either black or white. Based on simple rules (as described below), an ant is considered to be the sensor that processes the cell's data as input, then the cell will change its color and the ant will move in four possible directions. Gradually, the ant will turn the grid into a more complex system that exhibits emergent behavior.

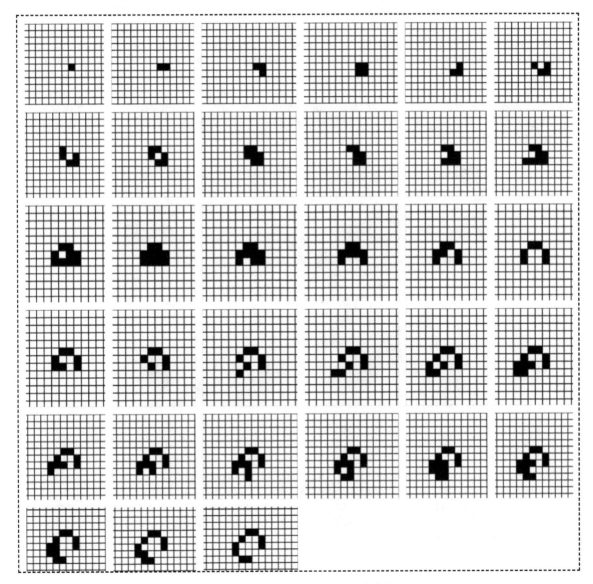

Figure 5.5: *Langton's Ant — initial steps*

With the ant initially facing up, Figure 5.5 shows the first thirty-three steps of *Langton's Ant* when it follows the two general rules below:

1. If the ant is at a white cell, it turns right 90 degrees and changes to black, then moves forward one cell as a unit.

2. If the ant is at a black cell, it turns left 90 degrees and changes to white, then moves forward one cell as a unit.

In the beginning, the canvas only displays a grid system and all the individual cells are set to white. The ant has four possible directions it can move in — UP, RIGHT, DOWN, and LEFT — turning 90 degrees either left or right subject to the color of the cell it is on. The ant, located in the center of the white grid has its head pointing UP at the start. It then follows Rule 1 above to rotate the head direction from UP to RIGHT, thereby changing the white cell to black, and moving forward one unit. The second step is to follow Rule 1 again, because the new cell is still white. The ant's head direction will turn right 90 degrees and point from RIGHT to DOWN, and then it changes the white cell to black and the ant moves forward one unit. The third and forth steps are similar to the previous ones, until the ant encounters a black cell. At this point, the ant will follow Rule 2 and change the cell's color back to white, and then turn left 90 degrees instead of right. The complexity increases.

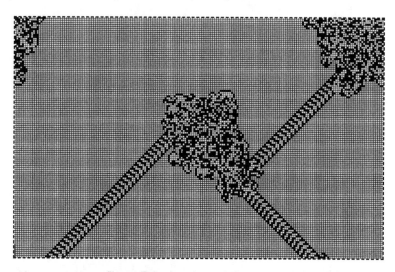

Figure 5.6: *Langton's Ant — process*

Figure 5.6 shows how the ant starts building the emergent "highway" pattern after the first few hundred moves with simple symmetrical patterns. Then the symmetry breaks down and the ants seems to move randomly at the center. After several thousand iterations, the ant then starts building a highway pattern, and repeats indefinately until most of the cells are reconfigured, leading to something that is similar to Figure 5.7, while the ant continues to move and change the color of cells. (26)

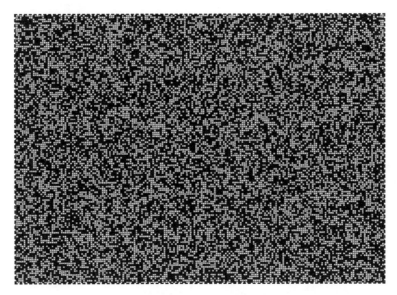

Figure 5.7: Langton's Ant — snapshot of emergence

RunMe https://aesthetic-
programming.gitlab.io/book/p5_SampleCode/ch5_AutoGenerator/sketch5_1/

Source code (Langton's Ant)

```
1   //e.g 4, 5, 10 need to be dividable by the w and h of the canvas
2   let grid_space = 5;
3   let grid =[]; //on/off state
4   //for drawing the grid purpose
5   let cols, rows;
6   //current position in terms of rows and columns, not actual pixels
7   let xPos, yPos;
8   //current direction of the ant
9   let dir;
10  const antUP = 0;
11  const antRIGHT = 1;
12  const antDOWN = 2;
13  const antLEFT = 3;
14  let offColor;
15  let onColor;
16
17  function setup() {
18   createCanvas(1000, 700);
19   offColor = color(255);  //offcolor setting
20   onColor = color(0); //onColor setting
```

```
21   background(offColor);
22   grid = drawGrid();
23   xPos = floor(cols/2);  //initial x position in integer
24   yPos = floor(rows/2); //initial y position in integerS
25   dir = antUP; //initial direction
26   frameRate(20);
27  }
28  function draw() {
29  /*just for running faster perframe,
30  try changing the number e.g 1 instead of 100 */
31   for (let n = 0; n < 100; n++) {
32    checkEdges();
33    let state = grid[xPos][yPos];
34    //check the current cell's state
35    //rule 1
36    if (state == 0) {
37     dir++;  // turn right 90°
38     grid[xPos][yPos] = 1; //change the currect cell's state to 'on'
39     fill(onColor);  //subsequent color change
40     if (dir > antLEFT) {
41       dir = antUP;  //reset the counter
42     }
43    //rule 2
44    }else{
45     dir--;  //turn left 90°
46     grid[xPos][yPos] = 0; //change the current cell's state to 'off'
47     fill(offColor); //subsequent color change
48     if (dir < antUP) {
49       dir = antLEFT; //reset the counter
50     }
51    }
52    rect(xPos*grid_space, yPos*grid_space, grid_space, grid_space);
53    nextMove();
54   }
55  }
56  function drawGrid() {
57   cols = width/grid_space;
58   rows = height/grid_space;
59   let arr = new Array(cols);
60   for (let i = 0; i < cols; i++) { //no of cols
61     arr[i] = new Array(rows); //2D array
62     for (let j = 0; j < rows; j++){ //no of rows
63       let x = i * grid_space; //actual x coordinate
64       let y = j * grid_space; //actual y coordinate
65       stroke(0);
66       strokeWeight(1);
67       noFill();
```

```
68        rect(x, y, grid_space, grid_space);
69        arr[i][j] = 0;   // assign each cell with the off state + color
70      }
71    }
72    return arr; //a function with a return value of cell's status
73  }
74  function nextMove () {
75    //check which direction to go next and set the new current direction
76    if (dir == antUP) {
77      yPos--;
78    } else if (dir == antRIGHT) {
79      xPos++;
80    } else if (dir == antDOWN) {
81      yPos++;
82    } else if (dir == antLEFT) {
83      xPos--;
84    }
85  }
86  function checkEdges() {
87    //check width and height boundary
88    if (xPos > cols-1) { //reach the right edge
89      xPos = 0;     //go back to the left
90    } else if (xPos < 0) {  //reach the left edge
91      xPos = cols-1;  //go to the right edge
92    }
93    if (yPos > rows-1) { //reach the bottom edge
94      yPos = 0; //go back to the top
95    } else if (yPos < 0) { //reach the top edge
96      yPos = rows-1;  //go to the bottom
97    }
98  }
```

Reading Langton's Ant

There are three areas that can help you to zoom in on the program to slow down and adjust the size.

1. Let grid_space = 5; in Line 2: If you change the value to 10, everything will be enlarged.

2. frameRate(20); in Line 26: Lower the frame rate value to help slow down the program.

3. draw() in Line 28: This function contains a for-loop where n is the ant's number of steps. If so desired you can reduce the n < 100 to n < 1 (in Line 31), i.e for (let n = 0; n < 100; n++) { this instructs the program to only process n steps per frame.

Instead of going through the code line by line, the following shows what each function does.

- `function setup()` in Line 17: To setup the canvas size, initiate the ant's head direction, frame rate, color, and to prepare drawing the background grid structure.
- `function drawGrid()` in Line 56: To divide the canvas into a grid.
- `function draw()`: This main function checks the two rules that apply for *Langton's Ant* and change the color of cells.
- `function nextMove()` in Line 74: The four directions are structured in a number format so that the variable `dir++` can be used to change the ant's direction by implementing the increment and decrement of the ant's direction in programming terms (i.e `dir++` or `dir--`). Each different direction (UP, RIGHT, DOWN, LEFT) corresponds to moving forward along either the horizontal (xPos) or the vertical (yPos) axis on the canvas.
- `function checkEdges()` in Line 86: This function checks whether the ant moves out of frame. When it does, the program is written in such a way that it appears on the opposite side and continues.

Technically speaking, there is no new syntax here as the two-dimensional arrays have already been covered briefly in the previous chapter. However, there is a new use of two-dimensional arrays and nested for-loops in the sample code.

Two—Dimensional arrays & nested for—Loops

Daniel Shiffman has created a tutorial (written (27) and video (28)) to discuss how a two-dimensional array is essentially an array of other arrays. He also suggests that it is useful to think of two-dimensional arrays using a grid structure which aligns nicely with the background of *Langton's Ant* which is designed as a grid in two dimensions with both columns and rows. Since we need to identify the state of each cell, we need to know the exact x and y position of each cell.

Let's examine the source code again for the grid background drawing:

```
1   function drawGrid() {
2     cols = width/grid_space;
3     rows = height/grid_space;
4     Let arr = new Array(cols);
5     for (Let i = 0; i < cols; i++) { //no of cols
6       arr[i] = new Array(rows); //2D array
7       for (Let j = 0; j < rows; j++){ //no of rows
8         Let x = i * grid_space; //actual x coordinate
9         Let y = j * grid_space; //actual y coordinate
10        stroke(0);
11        strokeWeight(1);
12        noFill();
13        rect(x, y, grid_space, grid_space);
```

```
14        arr[i][j] = 0;   // assign each cell with the off state + color
15      }
16    }
17    return arr; //a function with a return value of cell's status
18  }
```

To create an array, we use the syntax `Let arr = new Array(cols);` (in Line 4) and this line indicates the grid in columns and the length of the array is the same as the number of columns. Since we also need to indicate the number of rows, we create another array out of each existing array in the column using the line `arr[i] = new Array(rows);` (see Line 6). This syntax is put under a for-loop to loop through each of the columns, but then with the addition of number of rows (which is derived from the canvas height). Two-dimensional arrays are structured in this way: `arr[][]`.

To know the exact x and y coordinates of each cell within a grid, we use the formula `x = i * grid_space;` and `y= j * grid_space;` respectively. By using two nested for-loops (see Lines 5 & 7), the program loops through each column and each row until the program reaches the last column. We are able to get the x and y coordinates with the syntax `array[i][j]`, which is applied to columns (with the variable `i`) and rows (with the variable `j`).

Therefore, each cell from the grid is represented in the structure of a two-dimensional array. As demonstrated above, you can zoom in or enlarge the cell size by changing the variable `grid_space`, and the number of columns and rows depends on the canvas width and height as derived from `cols = width/grid_space;` and `rows = height/grid_space;`. Each cell, in the form of `array[i][j]`, is a unit represents a possibility that an ant can move within the grid (via the changing values of `i` and `j`).

The customized function `drawGrid()` is slightly different from what we have discussed in Chapter 3, "Infinite loops." This function comes with returned values (in Line 17): `return arr;`. This means that the function will return the values `arr` (in the form of two-dimensional arrays) when it has completed. In this *Langton's Ant* example, this function is used to draw the grid background, and to mark the initial status (off state) of each cell unit for later use when the ant is started to move.

Exercise in cLass

1. Give yourself sometime to read and tinker with the code, as well as to observe the different stages of *Langton's Ant*.

2. The *Langton's Ant* program represents the world of an ant through abstraction, and sets limits on cell color, movement and direction. Rethink the rules that have been implemented. Try changing the existing rules or adding new rules so that the ant behaves differently? (Recall what you have changed in the previous exercise with 10 *PRINT*.)

3. In simulating living systems — such as the complex behavior of insects — there seems to be a focus on process over outcome. Let's discuss the following questions:

- Can you think of, and describe, other systems and processes that exhibit emergent behavior?

- How would you understand autonomy in this context? (29) To what extent do you consider the machine to be an active agent in generative systems? What are the implications for wider culture?

WhiDe()

We already have discussed the idea of unleashing potential for changes in the previous chapter, and it would seem that generative systems promise something similar as a way to envisage existing systems as changeable or adaptive to conditions. The parallel to living systems is made clear in *Game of Life* — developed by the mathematician Jon Conway in 1970 (30) — another example of a Turing machine and how an evolutionary process is determined by its initial state, requires no further input, and produces emergent forms. (31) Like *Langton's Ant*, it is similarly based on principles of "cellular automata," i.e. a regular grid of cells, each in one of a finite number of states, such as on or off, or alive or dead, in this case. These are powerful metaphors with real-world applications.

Each cell interacts with other, directly adjacent, cells, and the following transitions occur:

- Any live cell with fewer than two live neighbors dies, as if by underpopulation.
- Any live cell with two or three live neighbors lives on to the next generation.
- Any live cell with more than three live neighbors dies, as if by overpopulation.
- Any dead cell with exactly three live neighbors becomes a live cell, as if by reproduction.

If the evolutionary neo-Darwinian logic of this — where the fittest survive — were not worrying enough, *Game of Life* is further troubling for its "necropolitical" dimension (32): articulating life and death in terms of populations and neighborhoods, as if part of a social cleansing program (or dystopian smart city (33) project). Is this simply an example of poor abstraction?

That said, there is an alternative political potential here in the way an adaptive complex organism can assemble itself "bottom-up," without a central "top-down" command and control mechanism. (34) This demonstrates "revolutionary" potential when it becomes impossible to predict the direction change will take, and whether it will fall into a higher level of order or disintegrate into chaos. Returning to ants, the study of ant colonies reveal there is no discernible hierarchy at work, and although humans have named the ants in provocative terms, the "queen" is not an authority figure at all but an egg-laying functionary, and the ant-

workers operate a cooperatively rather than feudally (incidentally, the worker ants are all female, however the sexual politics of ants are outside our scope, and we are also aware of the inferred racial dimension with the shift of cell color in the *Langton's Ant* example).

To be more precise, and according to complexity theory, all systems contain subsystems that continually fluctuate. One or more fluctuations, resulting from feedback, could change the preexisting organization, and as such the multiple interacting elements of a system cannot be governed, and the collective behavior cannot be predicted. As Ilya Prigogine and Isabelle Stengers explain in *Order Out of Chaos*:

> "A society defined entirely in terms of a functional model would correspond to the Aristotelian idea of natural hierarchy and order. Each official would perform the duties for which he [sic] has been appointed. These duties would translate at each level the different aspects of the organization of the society as a whole. The king gives orders to the architect, the architect to the contractor, the contractor to the worker. On the contrary, termites and other social insects seem to approach the 'statistical' model. As we have seen, there seems to be no mastermind behind the construction of the termites' nest, when interactions among individuals produce certain types of collective behavior in some circumstances, but none of these interactions refer to any global task, being all purely local." (35)

To help understand emergent behavior, we might turn to Turing's article of 1952 "The Chemical Basis of Morphogenesis" for its description of the way in which natural patterns naturally arise from homogeneous, uniform states. (36) This idea of "morphogenesis" is something that political theorist and activist Franco "Bifo" Berardi has utilized to describe social and political mutation, or when new form emerges and takes shape. Processes of automation have not only replaced physical acts of production with information technology, but automation has transformed cognitive activity itself. To Berardi, this "implies the reduction of cognitive activity to algorithmic procedures, and the insertion of "automatisms into the social existence of the general intellect." (37) One of the consequences of this is that automation is taking the place of political decision-making — "Yes or no [–] no nuances, no ambiguity" — and to Berardi this implies the end of democracy, and the establishment of an automatic chain of logical procedures intended to replace conscious voluntary choices, and decision-making. Not only have machines captured the human capacity for thinking, according to Berardi, but also our capacity to feel. (38) Part of the problem he identifies is that we have been learning words from machines, not from other humans, (39) the consequence of which is that our capacity for love, tenderness, and compassion are lessened. We might add "care" to this list, thereby invoking feminist technoscience, such as Maria Puig de la Bellacasa's work. For Bellacasa, care is important as it draws attention to how things are held together, to their relationalities, "transforming things into matters of care is a way of relating to them, of inevitably becoming affected by them, and of modifying their potential to affect others." (40)

Along these lines, and drawing upon feminist technoscience, Helen Pritchard and Winnie Soon's artwork *Recurrent Queer Imaginaries* is a motto assistant that endlessly generates mottos as a form of rethinking, reinterpreting and dreaming urban life. In light of the rich history of struggles for racial, sexual and class injustice, the motto assistant uses

manifestos and zines for queer and intersectional life as source text for machine learning and generative processes. (41) A further example of this approach to care in action is the syllabus *Digital Love Languages* at the School for Poetic Computation (42), where the instructor Melanie Hoff explores how code can be cultivated as a "love language" that is more gentle, healing, and intimate than corporate systems of surveillance and exploitation. (43) The course covers the building blocks of programming and natural language processing as well as explores the history of the love letter as a poetic form.

This discussion of more love and care in programming brings us to our last example, the generative "love-letters" that appeared on the Manchester University Computer Department's noticeboard in 1953. These computer-generated declarations of love were produced by a program written by Christopher Strachey using the built-in random generator function of the M. U. C.(Manchester University Computer, the Ferranti Mark I), the earliest programmable computer. Regarded by some as the first example of digital art, (44) and by Jacob Gaboury as a critique of hetero-normative love, not least because Strachey like Turing was queer. (45) Moreover these letters are arguably more than a longing for same sex love, but human-machine love.

Artist David Link built a functional replica of both the hardware and the original program, following meticulous research into the functional aspects. (46) The main program is relatively simple, and uses loops and a random variable to follow the sentence structure: "You are my — Adjective — Substantive," and "My — [Adjective] — Substantive — [Adverb] — Verb — Your — [Adjective] — Substantive." Some words are fixed and some are optional, as indicated by the square brackets. The program selects from a list of options — adjectives, adverbs, and verbs — and loops are configured to avoid repetition. The software can generate over 318 billion variations. In terms of effect, the dialogue structure is important in setting up an exchange between "Me" (the program writer) and "You" (human reader), so you feel personally addressed. The resulting love letters provide a surprising tenderness of expression that runs contrary to what we consider the standard functional outcomes of computational procedures. This is far from a reductionist view of love, and perhaps the challenge for those making programs is to generate queer recombinant forms in which neither sender or receiver are predetermined by specifying gender, species, or forms. We end this chapter with a sample output:

DEAR DARLING

YOU ARE MY BEAUTIFUL RAPTURE. MY INFATUATION BEAUTIFULLY CLINGS TO YOUR ADORABLE LUST. MY INFATUATION LUSTS FOR YOUR WISH. MY AMBITION CURIOUSLY LIKES YOUR LOVE. YOU ARE MY DEAR EAGERNESS.

YOURS WISTFULLY

M. U. C.

MiniX: A generative program

Objectives:

- To implement a rule-based, generative program from scratch.
- To strengthen the computational use of loops and conditional statements.
- To conceptually and practically reflect upon the idea of auto-generator.

For additional inspiration:

- {Software} Structure #003 A by Casey Reas (2004),
 https://whitney.org/exhibitions/programmed?
 section=1&subsection=6#exhibition-artworks.
- Daily Art by Saskia Freeke (2018), http://www.sasj.nl/daily/.
- Generative Artistry by Ruth John and Tim Holman (n.d.),
 https://generativeartistry.com/tutorials/.
- Generative Design — sketches (n.d.), http://www.generative-gestaltung.de/2/,
 and source code, https://github.com/generative-design/Code-Package-p5.js.
- GenArt by Joseph Fiola (2016), with source code,
 https://github.com/JosephFiola/GenArt.
- Game of Life by John Conway (1970),
 https://web.archive.org/web/20181007111016/ &
 http://web.stanford.edu/~cdebs/GameOfLife/.
- Generative Tarot by Melanie Hoff (2019),
 https://www.melaniehoff.com/generativetarot/, source code
 https://github.com/melaniehoff/generative-tarot-p5js.
- The Recode Project (featuring projects from 1976-78),
 http://recodeproject.com/, and Memory Slam by Nick Montfort (2014),
 http://nickm.com/memslam/.
- Solving Sol by Brad Bouse (n.d.), an open project to implement Sol LeWitt's
 instructions in JavaScript https://github.com/wholepixel/solving-sol.

Tasks (RunMe):

1. Start with a blank sheet of paper. Think of at least two simple rules that you want
 to implement in a generative program.

2. Based on the rules that you set in Step 1, design a generative program that utilizes
 at least one for—loop/while—loop and one conditional statement, but without any
 direct interactivity. Just let the program run. You can also consider using `noise()`
 and `random()` syntax if that helps.

Questions to think about (ReadMe):

- What are the rules in your generative program? Describe how your program performs over time? How do the rules produce emergent behavior?
- What role do rules and processes have in your work?
- Draw upon the assigned reading, how does this MiniX help you to understand the idea of "auto-generator" (e.g. levels of control, autonomy, love and care via rules)? Do you have any further thoughts on the theme of this chapter?

Required reading

- Nick Montfort et al. "Randomness," 10 PRINT CHR$(205.5+RND(1)); : GOTO 10, https://10print.org/ (Cambridge, MA: MIT Press, 2012), 119-146.

- Daniel Shiffman, "p5.js - 2D Arrays in Javascript," *Youtube*, https://www.youtube.com/watch?v=OTNpiLUSiB4.

- Jon, McCormack et al. "Ten Questions Concerning Generative Computer Art." *Leonardo* 47, no. 2, 2014: 135–141.

Further reading

- Philip Galanter, "Generative Art Theory," in Christiane Paul, ed., *A Companion to Digital Art* (Oxford: Blackwell, 2016), http://cmuems.com/2016/60212/resources/galanter_generative.pdf.

- "How to Draw with Code | Casey Reas," *Youtube* video, 6:07, posted by Creators, June 25 (2012), https://www.youtube.com/watch?v=_8DMEHxOLQE.

- Daniel Shiffman, "p5.js Coding Challenge #14: Fractal Trees - Recursive," https://www.youtube.com/watch?v=0jjeOYMjmDU.

- Daniel Shiffman, "p5.js Coding Challenge #76: Recursion," https://www.youtube.com/watch?v=jPsZwrV9ldO.

- Daniel Shiffman, "noise() vs random() - Perlin Noise and p5.js Tutorial." https://www.youtube.com/watch?v=YcdldZ1E9gU.

Notes

1. Alan Mathison Turing, "On Computable Numbers, with an Application to the Entscheidungsproblem," *Proceedings of the London Mathematical Society* 2, no.1 (1937): 230-265.

2. Turing, "On Computable Numbers," 241.

3. A visualization of the Turing Machine can be found here: https://turingmachine.io/.

4. This is a modified version of the image found online, see http://storyofmathematics.lukemastin.com/20th_turing.html.

5. The previously mentioned artwork webmachines by Juli Laczko in Chapter 1, "Getting started," shows the relation between weaving and coding technologies. See https://digital-power.siggraph.org/piece/webmachine/.

6. Reference to Lucy Lippard, ed. *Six Years: The Dematerialization of the Art Object from 1966 to 1972* (London: University of California Press, 1997).

7. One example of many, and also connected to an exhibition, is Geoff Cox's "Generator: The Value of Software Art," in Judith Rugg and Michèle Sedgwick, eds., *Issues in Curating Contemporary Art and Performance* (Bristol: Intellect, 2007), 147-162, available at https://monoskop.org/images/5/53/Cox_Geoff_2007_Generator_The_Value_of_Software_Art.pdf. This includes a description of Adrian Ward's *Auto—Illustrator*, released as a boxed version for the "Generator" exhibition (2002-3) with an accompanying "User's Manual" that contained both technical detail and critical essays. In many ways this sets a precedent for the publication you are reading. For more on the aesthetic dimension of the parallels between scores, scripts, and programs, see Geoff Cox, Alex McLean, and Adrian Ward, "The Aesthetics of Generative Code," *Generative Art 00*, international conference, Politecnico di Milano (2001), https://www.academia.edu/10519146/The_Aesthetics_of_Generative_Code.

8. The exhibition "Programmed: Rules, Codes, and Choreographies in Art, 1965-2018" was held at the Whitney Museum of American Art, New York (28 Sep 2018 – 14 Apr 2019), and organized by Christiane Paul and Carol Mancusi-Ungaro, with Clémence White. See https://whitney.org/exhibitions/programmed. A well-cited, prior example would be the 1970 exhibition "Software — Information Technology: Its New Meaning for Art," at the Jewish Museum in New York, curated by Jack Burnham. For Burnham, the exhibition "Software" encouraged an understanding of the underlying structures in art and information systems, and by drawing together practices in computer technology with conceptual art, software was to be seen as a metaphor for information exchange.

9. This is a version programmed with JavaScript, using D3, and jquery libraries, see https://github.com/wholepixel/solving-sol/blob/master/289/cagrimmet/index.html.

10. Sol LeWitt cited in Lippard, ed. *Six Years: The Dematerialization of the Art Object from 1966 to 1972*.

11. Processing is a flexible software sketchbook and programming language, initiated by Casey Reas and Ben Fry in 2001, for users to learn how to code within the context of the visual arts. See https://processing.org/.

12. For an explanation of this work, and the assoicated documentation, see Casey Reas, "{Software} Structures," https://artport.whitney.org/commissions/softwarestructures/text.html.

13. See the *Coded Algorithmic Drawings* series here: https://joantruckenbrod.com/gallery/#(grid|filter)=.coded.

14. See Joan Truckenbrod's interview *Motion Through Series*, https://vimeo.com/286993496.

15. The patterns of fractal geometry are commonly seen in the tradition of Islamic and African art, design and architecture, with the self-similar characteristic that is generated by repeatable and infinite processes. Fractal designs in European and Asian culture tend to mimick nature, but Ron Eglash observes that the African designs are more influenced by their own social structure in which fractals are regarded as part of a shared culture. See Ron Eglash, *African Fractals: Modern Computing and Indigenous Design* (New Brunswick, New Jersey, and London: Rutgers University Press, 1999); also Laura U. Marks, *Enfoldment and Infinity: An Islamic Genealogy of New Media Art* (Cambridge, MA: The MIT Press; 2010). See also a coding example of the use of recursivity in sketching a fractal tree in p5.js by Martin Žilák, https://editor.p5js.org/marynotari/sketches/BJVsL5ylz.

16. See Craig Reynold's flocking behavior with the p5.js source code, https://p5js.org/examples/simulate-flocking.html.

17. Agent-based model describes the mathematical modeling of data as individual autonomous agent that follow rules within an environment or a system, resulting in emergent outcomes of actions and interactions over time.

18. Inke Arns, "Read_me, run_me, execute_me: Code as Executable Text: Software Art and its Focus on Program Code as Performative Text," trans. Donald Kiraly, *MediaArtNet* (2004), see: http://www.mediaartnet.org/themes/generative-tools/read_me/1/.

19. Clearly much more could be said about this, but we refer, our example, to Donna Haraway's *When Species Meet* (Minneapolis: Uiversity of Minnesota Press, 2007).

20. Philip Galanter, "What is Generative Art? Complexity Theory as a Context for Art Theory," in *GA2003* - 6th Generative Art Conference, Milan (2003).

21. The two code examples in this chapter are adapted from Daniel Shiffman's *Coding Train* series with the addition of more comments to explain the logic, as well as extra features such as adjusting the grid size in the *Langton's Ant* example.

22. Nick Montfort, et al, *10 PRINT CHR$(205.5+ RND (1)); GOTO 10* (Cambridge, MA: MIT Press, 2012).

23. Christopher G. Langton, "Studying Artificial Life with Cellular Automata," *Physica D: Nonlinear Phenomena* 22, no.1-3 (October 1986): 120-49, https://doi.org/10.1016/0167-2789(86)90237-X.

24. More comment lines are introduced in the repository, see: https://gitlab.com/siusoon/Aesthetic_Programming_Book/-/blob/master/public/p5_SampleCode/ch5_AutoGenerator/sketch.js.

25. See Mads Haahr, "Introduction to Randomness and Random Numbers," https://www.random.org/randomness/; and Montfort et al., "Randomness," 119-146.

26. Andrés Moreira, Anahí Gajardo and Eric Goles, "Dynamical Behavior and Complexity of Langton's Ant," *Complexity* 6, no.4 (March 2001): 46-52, https://doi.org/10.1002/cplx.1042.

27. See "Two-dimensional Arrays" written for the Processing Community, https://processing.org/tutorials/2darray/.

28. See the video instruction on 2D Arrays in p5.js at https://www.youtube.com/watch?v=0TNpiLUSiB4.

29. For instance, generative artist Marius Watz would suggest that "autonomy is the ultimate goal", from his talk "Beautiful Rules: Generative Models of Creativity," in *The Olhares de Outono* (2007), https://vimeo.com/26594644.

30. More information on Conway's *Game of Life* and related cellular automata can be found at https://www.conwaylife.com/.

31. For further discussion and the source code for Conway's *The Game of Life*, see: https://web.archive.org/web/20181007111016/ & http://web.stanford.edu/~cdebs/GameOfLife/.

32. Continuing from *biopolitics*, a term coined by Michel Foucault to indicate the use of power to control people's lives, *necropolitics* is the use of social and political power to dictate how some people may live and others must die. See Achille Mbembe, "Necropolitics," *Public Culture* 15, no.1 (2003): 11-40.

33. See the artwork *WUOS* by Anders Visti and Tobias Stenberg which uses an implementation of *Langton's Ant* to question the procedural logic of so-called *smart cities*: https://andersvisti.dk/work/wuos-2019.

34. For more on emergent behaviour, see Steven Johnson, *Emergence: The Connected Lives of Ants, Brains, Cities and Software* (London: Penguin, 2001), 20.

35. Ilya Prigogine and Isabelle Stengers, *Order Out of Chaos: Man's New Dialogue With Nature* (London: Fontana, 1985), 205.

36. Alan Mathison Turing, "The Chemical Basis of Morphogenesis," *Philosophical Transactions of the Royal Society of London B*, 237, no.641 (1952): 37-72, doi:10.1098/rstb.1952.0012. JSTOR 92463.

37. Franco "Bifo" Berardi, "The Neuroplastic Dilemma: Consciousness and Evolution," in *e-flux* journal #60 (December 2014), https://www.e-flux.com/journal/60/61034/the-neuroplastic-dilemma-consciousness-and-evolution/. "General Intellect" is a key concept taken from Marx's *Grundrisse*, in the passage "Fragment on Machines," and is used to indicate the coming together of technological expertise and social intellect. Terranova also draws on this concept when she argues that the evolution of machinery also unleashes productive powers, as referenced in Chapter 4, "Data Capture".

38. Franco "Bifo" Berardi, *Precarious Rhapsody: Semiocapitalism and the Pathologies of the Post—Alpha Generation* (London: Minor Compositions, 2009), 9. For more on the politics of decision-making, see Luciana Parisi's "Reprogramming Decisionism," *e-flux* #85 (October 2017), https://www.e-flux.com/journal/85/155472/reprogramming-decisionism/.

39. In N. Katherine Hayles' *My Mother Was a Computer*, she charts how, during the 1930s and 1940s, mainly women were employed to do calculations who were referred to as computers. N. Katherine Hayles, *My Mother Was a Computer* (Chicago: University of Chicago Press, 2005). Hayles takes her title from a chapter in the book *Technologies of the Gendered Body* by Anne Balsamo, whose mother was one of these computers.

40. Maria Puig de la Bellacasa, "Matters of Care in Technoscience: Assembling Neglected Things," in *Social Studies of Science* 41, no.1 (2010), 99.

41. Based on rule-based diastic techniques, each motto assistant writes automatically according to a sequence of characters in a word to form sentences. All the words and sentences are based on the seed text "Not for Self, but for All" that was found in the heart of the new development of King's Cross in London, an area in which many queer spaces have been closed down with the replacement of tech companies and start-ups. In summary, *Recurrent Queer Imaginaries* "is a call to reclaim queer spaces from corporate neocolonial imaginations, operational injustices and reimagine them differently for all, as a commitment to queer liberation." See an example of a generated motto from *Recurrent Queer Imaginaries*, in video documentation: https://digital-power.siggraph.org/piece/recurrent-queer-imaginaries/.

42. The School for Poetic Computation, an artist-run school in New York that was founded in 2013, explores the intersections of code, design, hardware and theory—focusing especially on artistic intervention, see: https://sfpc.io/.

43. See *Digital Love Languages ♡ Codes of Affirmation*, http://lovelanguages.melaniehoff.com/syllabus/.

44. Noah Wardrip-Fruin, "Christopher Strachey: The First Digital Artist?," *Grand Text Auto*, School of Engineering, University of California Santa Cruz (August 1, 2005).

45. Jacob Gaboury, "A Queer History of Computing," *Rhizome* (April 9, 2013). We return to the issue of Turing's sexuality in Chapter 7, "Vocable Code".

46. David Link's *LoveLetters_1.0: MUC=Resurrection* was first exhibited in 2009, and was part of dOCUMENTA(13), Kassel, in 2012. Detailed description and documentation can be found at http://www.alpha60.de/art/love_letters/. Also see Geoff Cox, "Introduction" to David Link, *Das Herz der Maschine*, dOCUMENTA (13): 100 Notes - 100 Thoughts, 100 Notizen - 100 Gedanken # 037 (Berlin: Hatje Cantz, 2012).

47. Lucy Suchman, *Human—Machine Reconfigurations: Plans and Situated Actions* (Cambridge: Cambridge University Press, 2007), 217-220.

48. See the web-based step by step running of the Langton's Ant implemented by Barend Köbben in 2014, https://kartoweb.itc.nl/kobben/D3tests/LangstonsAnt/.

6. Object abstraction

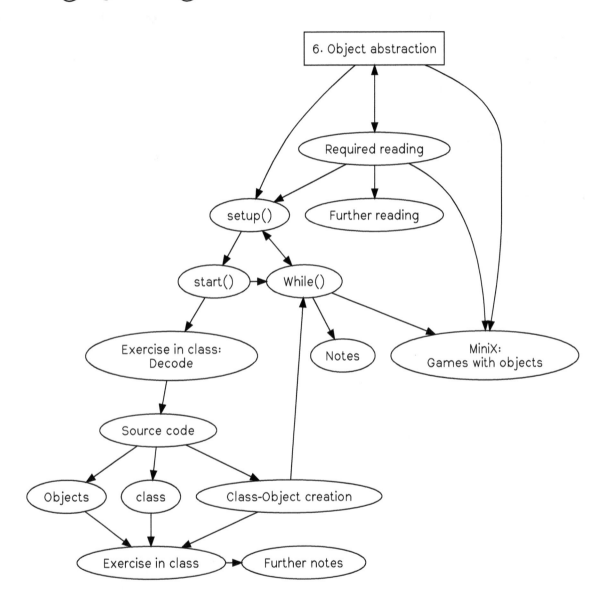

Contents

setup()

In programming an object is a key concept, but it is also more generally understood as a thing with properties that can be identified in relation to the term subject. Put simply, and following philosophical conventions, a subject is an observer (we might say programmer) and an object is a thing outside of this, something observed (say a program). In this chapter we will learn to further manipulate objects and understand their complexity in line with people who think we need to put more emphasis on non-human things so we can better understand how objects exist and interact, both with other objects, but also with subjects.

In the preceding chapters we worked with different objects such as ellipses, rectangles, and polygons. You can apply different attributes to these objects, such as color, size, and position, and — additionally — objects can exhibit certain behaviors such as various transformational and interactive features (see Chapters 3, "Infinite loops," and Chapter 4, "Data capture"). These geometric objects use built-in p5.js functions as a set of pre-defined parameters and attributes. In this chapter, we will work on constructing our own objects, attributes, and behaviors to represent aspects of the real world. There is a process of abstraction here, because physical objects need to be translated into the idea of an object, and in doing so, certain details and contextual information are inevitably left out. We will return to this issue later.

Abstraction is one of the key concepts of "Object-Oriented Programming" (OOP), a paradigm of programming in which programs are organized around data, or objects, rather than functions and logic. (1) The main goal is to handle an object's complexity by abstracting certain details and presenting a concrete model. Beatrice Fazi and Matthew Fuller have outlined the wider significance of this and the relations between concrete and abstracted computation: "Computation not only abstracts from the world in order to model and represent it; through such abstractions, it also partakes in it." (2) If we recall the previous chapters and the many examples of data capture, and gamification, it becomes clear that computation can shape certain behaviors and actions. In other words, objects in OOP are not only about negotiating with the real world as a form of realism and representation, nor about the functions and logic that compose the objects, but the wider relations and "interactions between and with the computational." (3)

Indeed, abstraction exists in many different layers and at many different scales of computing. At the lowest level of abstraction, the flow of information is stored, processed, and represented in the form of binary (base 2 number system) numbers — 0s and 1s. (4) In other words, the way we understand all media formats (whether texts, images, video or sound) is quite different from how a computer understands them as data, or — more precisely — as binary numbers. (5) In this way, we can move from low-level abstraction in the form of machine code and the switching of electric circuits to high-levels of abstraction such as graphical user interfaces or the high-level programming language p5.js that we use in the book which "allows the production of computer-enabled human-readable code." (6)

Recognizing the various levels of abstraction is important to understanding that the specific details and processes of how a computer actually works are largely hidden from view and/or substituted by desktop metaphors (e.g. deleting a file by throwing it in the "bin"). Naturally,

the reduction in complexity is useful for a number of reasons including accessibility, but we also need to bear in mind that there is more at stake here. In learning to program, even at the higher level, we engage in the politics of this movement between abstract and concrete reality which is never a neutral process. (7) More specifically, in this chapter, we will focus on object abstraction (an approach in OOP) to think conceptually about how computational objects model the world, and what this suggests in terms of an understanding of hidden layers of operation and meaning.

start()

Object abstraction in computing is about representation. Certain attributes and relations are abstracted from the real world, whilst simultaneously leaving details and contexts out. Let's imagine a person as an object (rather than a subject) and consider which properties and behaviors that person might have. We use the name "class" to give an overview of the object's properties and behaviors.

For example:

Properties: A person with the **name** Winnie, has black **hair, wears** glasses and their **height** is 164 cm. Their **favorite color** is black and their **favorite food** is tofu.

Behavior: A person can **run** from location A (home) to location B (university).

From the above, we can construct a pseudo class that we can use to create another object with the following properties and behaviors:

PERSON
Name, HairColor, withGlasses, Height, FavoriteColor, FavoriteFood, FromLocation, ToLocation
run()

In the same token, we can "reuse" the same properties and behavior to create another "object instance" with the corresponding data values:

OBJECT INSTANCE 1	OBJECT INSTANCE 2
Name = Winnie	Name = Geoff
HairColor = Black	HairColor = Brown
withGlasses = Yes	withGlasses = Yes
Height = 164 cm	Height = 183 cm
FavoriteColor = Black	favoriteColor = Green
FavoriteFood = Tofu	FavoriteFood = Avocado
FromLocation = Home	FromLocation = University
ToLocation = University	ToLocation = Home
run()	run()

Examining the pseudo object reveals how abstraction takes place in computation resulting in "computerized material," in which we only select properties and behaviors that we think are important to be represented in a program, and ignore others. This is a way of modeling physical phenomena and simulating the behaviors of real, or imaginary entities. [8] But Crutzen and Kotkamp argue that OOP is based on "illusions of objectivity and neutrality of representation," in which "[a]bstractions are simplified descriptions with a limited number of accepted properties. They reply on the suppression of a lot of other aspects of the world." [9] The understanding is that objects in the real world are highly complex and nonlinear, such abstracting and translating processes involve decision making to prioritize generalization while less attention is paid on differences.

After the above example of modeling a person-object, we now move to another example, tofu, which informs the sample code for this chapter. The inspiration is *Tofu Go!* (2018), a game developed and designed by Francis Lam. [10] Tofu, or bean curd, is a popular food derived from soya beans and originated in China two-thousand years ago. Soaking, then grinding soya beans, then filtering out the particulate matter results in soya milk, that contains a stable emulsion of oil, water, and protein. Then a coagulant is added after which the solidified milk is pressed into solid white blocks of varying softness called tofu. It is an important food product specifically in Asia, not only because of its high protein content, but also as a cultural symbol.

When tofu becomes a computational object — as in *Tofu Go!* — abstraction is required to capture the complexity of processes, and relations, and to represent what are thought to be essential or desirable properties, and behaviors. In the game, tofu is designed as a simple, three-dimensional white cube with a range of emotive expressions, and the ability to move, and jump. Of course real tofu cannot behave this way, but you can imagine how objects perform if you have programmed your own game, and if you love tofu as Lam does: "*Tofu Go!* is a game dedicated to my love for tofu and hotpot," as he puts it. (11) The aim of the game is to save the tofu from being captured by the chopsticks.

Figure 6.1: A screenshot of the game *ToFu Go!*, developed and designed by Francis Lam. Courtesy of the designer.

Below we will introduce the sample code *Eating tofu*, a simple game inspired by the following: *ToFu Go!* (available for free download), the prior project *Multi* as introduced in Chapter 2, "Variable geometry," and the popular Japanese eating game *Pac-Man*. (12) The remaining parts unfold the computational logic and modeling required to understand the basics of OOP.

Exercise in cLass (Deco🜚e)

Figure 6.2: A screenshot of the *Eating tofu* game

RunMe https://aesthetic-programming.gitlab.io/book/p5_SampleCode/ch6_ObjectAbstraction/

Speculation

Based on what you experience on the screen, describe:

- **What** are the instructions/rules for playing the game?
- Tofu is constructed as a class, and each tofu is an object instance. Can you describe the properties of the tofu and their behaviors?
- Can you describe the algorithmic procedures and sequences of the game using the following components: tofu, Pacman, keypress events, movements?

Further questions to think about:

- There is a continous having new tofus moving from right to left, **what** are the conditions to trigger new tofu?
- **How** do you check if Pacman has eaten the tofu?
- Under which conditions will the game end?

MAPPING with the source code

- **Map** some of the findings/features from the speculation that you have done with the source code. Which block of code relates to your findings?
- Can you **identify** the part/block of code that responds to the elements you speculated about above?
- Identify the syntaxes and functions that you are unfamiliar with, and check out the p5.js reference site: https://p5js.org/reference/

Source code

The source code is divided in two, one part with all the core functions, "sketch.js," and another "Tofu.js" that specifies the class/object relationship. Sometimes subdividing the program into various functions and files can help provide clarity. You can understand an additional JS file is just a continuation of your core sketch, therefore you don't have to repeatedly write `function setup()` or `function draw()` in the new files (when your programs become longer, and more complex, you might have more than two JS files to hold the program together). To enable the two JS files in a program, you need to add the following into the index.html file:

```
1  <script Language="javascript" type="text/javascript" src="sketch.js">
2  </script>
3  <script Language="javascript" type="text/javascript" src="Tofu.js">
4  </script>
```

sketch.js:

```
1   Let pacmanSize = {
2     w:86,
3     h:89
4   };
5   Let pacman;
6   Let pacPosY;
7   Let mini_height;
8   Let min_tofu = 5;   //min tofu on the screen
9   Let tofu = [];
10  Let score =0, Lose = 0;
11  Let keyColor = 45;
12
13  function preLoad(){
14    pacman = LoadImage("data/pacman.gif");
15  }
16
17  function setup() {
18    createCanvas(windowWidth, windowHeight);
19    pacPosY = height/2;
20    mini_height = height/2;
21  }
22  function draw() {
23    background(240);
24    fill(keyColor, 255);
25    rect(0, height/1.5, width, 1);
26    displayScore();
27    checkTofuNum(); //available tofu
28    showTofu();
29    image(pacman, 0, pacPosY, pacmanSize.w, pacmanSize.h);
30    checkEating(); //scoring
31    checkResult();
32  }
33
34  function checkTofuNum() {
35    if (tofu.length < min_tofu) {
36      tofu.push(new Tofu());
37    }
38  }
39
40  function showTofu(){
41    for (Let i = 0; i <tofu.length; i++) {
42      tofu[i].move();
43      tofu[i].show();
44    }
45  }
46
```

```
47  function checkEating() {
48    //calculate the distance between each tofu
49    for (let i = 0; i < tofu.length; i++) {
50      let d = int(
51        dist(pacmanSize.w/2, pacPosY+pacmanSize.h/2,
52          tofu[i].pos.x, tofu[i].pos.y)
53        );
54      if (d < pacmanSize.w/2.5) { //close enough as if eating the tofu
55        score++;
56        tofu.splice(i,1);
57      }else if (tofu[i].pos.x < 3) { //pacman missed the tofu
58        lose++;
59        tofu.splice(i,1);
60      }
61    }
62  }
63
64  function displayScore() {
65      fill(keyColor, 160);
66      textSize(17);
67      text('You have eaten '+ score + " tofu(s)", 10, height/1.4);
68      text('You have wasted ' + lose + " tofu(s)", 10, height/1.4+20);
69      fill(keyColor,255);
70      text('PRESS the ARROW UP & DOWN key to eat the ToFu', 10, height/1.4+40);
71  }
72  function checkResult() {
73    if (lose > score && lose > 2) {
74      fill(keyColor, 255);
75      textSize(26);
76      text("Too Much WASTAGE...GAME OVER", width/3, height/1.4);
77      noLoop();
78    }
79  }
80
81  function keyPressed() {
82    if (keyCode === UP_ARROW) {
83      pacPosY-=50;
84    } else if (keyCode === DOWN_ARROW) {
85      pacPosY+=50;
86    }
87    //reset if the pacman moves out of range
88    if (pacPosY > mini_height) {
89      pacPosY = mini_height;
90    } else if (pacPosY < 0 - pacmanSize.w/2) {
91      pacPosY = 0;
92    }
93  }
```

Tofu.js:

```
1   /*create a class: template/blueprint of objects with properties and behaviors*/
2   class Tofu {
3       constructor() { //initalize the objects
4       this.speed = floor(random(3, 6));
5       //check this feature: https://p5js.org/reference/#/p5/createVector
6       this.pos = new createVector(width+5, random(12, height/1.7));
7       this.size = floor(random(15, 35));
8       //rotate in clockwise for +ve no
9       this.tofu_rotate = random(0, PI/20);
10      this.emoji_size = this.size/1.8;
11      }
12    move() {  //moving behaviors
13      this.pos.x-=this.speed;  //i.e, this.pos.x = this.pos.x - this.speed;
14    }
15    show() { //show tofu as a cube
16      push()
17      translate(this.pos.x, this.pos.y);
18      rotate(this.tofu_rotate);
19      noStroke();
20      fill(130, 120);//shadow
21      rect(0, this.size, this.size, 1);
22      fill(253); //front plane
23      rect(0, 0, this.size, this.size);
24      fill(150); //top
25      beginShape();
26      vertex(0, 0);
27      vertex(0-this.size/4, 0-this.size/4);
28      vertex(0+this.size/1.5, 0-this.size/4);  //no special hair style
29      vertex(0+this.size, 0);
30      endShape(CLOSE);
31      fill(220);//side
32      beginShape();
33      vertex(0, 0);
34      vertex(0-this.size/4, 0-this.size/4);
35      vertex(0-this.size/4, 0+this.size/1.5);
36      vertex(0,0+this.size);
37      endShape(CLOSE);
38      fill(80); //face
39      textStyle(BOLD);
40      textSize(this.emoji_size);
41      text('*', 0+this.size/6, 0+this.size/1.5);
42      text('-', 0+this.size/1.7, 0+this.size/1.9);
43      text('。', 0+this.size/3, 0+this.size/1.2);
44      pop();
45   }
46  }
```

CᵒDass

To construct objects in OOP it is important to have a blueprint. A class specifies the structure of its objects' attributes and the possible behaviors/actions of these objects. Class can therefore be understood as a template for, and blueprint of, things.

Similar to the template that we had for a person-object earlier, we have the following:

TOFU
speed, xpos, ypos, size, tofu_rotate, emoji_size
move(), show()

You may refer to `Tofu.js` for how the Tofu class is constructed.

(Step 1) Naming: name your class

```
1  class Tofu {
2
3  }
```

In the sample code above, we have "Tofu" as the class name and "tofu" as the name for the object instances (it is a common approach in programming to use the same name for both a class and an object instance, but the class name will be capitalized). The things within a class describes what it means to be the object, which is defined by what the properties are, the data values, and behaviors and functionalities to realize the form. In computer science, this is called "encapsulation."

(Step 2) Properties: What are the (varying) attributes/properties of tofu?

```
1  /*create a class: template/blueprint of objects with properties and behaviors*/
2  class Tofu {
3    constructor()  { //initalize the objects
4    this.speed = floor(random(3, 6));
5    //check this feature: https://p5js.org/reference/#/p5/createVector
6    this.pos = new createVector(width+5, random(12, height/1.7));
7    this.size = floor(random(15, 35));
8    //rotate in clockwise for +ve no
9    this.tofu_rotate = random(0, PI/20);
10   this.emoji_size = this.size/1.8;
11   }
12   //something more here
13 }
```

The above prepares object construction. There is a function called "constructor" to initialize a (tofu) object with the following attributes which takes the form of a list of variables that indicate the properties of speed, position, size of the shape, rotating angle and size of the emoji expression. All these properties are defined with the keyword `this`, which refers to the current object instance during the execution of the program, e.g. `this.speed = floor(random(3, 6));`. It can be translated roughly as: when the object instance tofu is created, that particular tofu's speed value will be a random integer between 3 and 5.

For the other variable, `this.pos`, we use the function `new createVector` to create the new p5 vector which contains the x and y components. With the `createVector()` function, we can then use `pos.x` and `pos.y` to specify the x and y coordinates of a tofu:

this.pos = new createVector(x, y); => this.pos.x and this.pos.y

(Step 3) Behaviors: What are the tofu's behaviors?

```
1  class Tofu {
2    constructor() { //initialize the objects
3      // something here
4    }
5    move() { //moving behaviors
6      this.pos.x-=this.speed; //i.e, this.pos.x = this.pos.x - this.speed;
7    }
8    show() {
9        //show tofu as a cube by using vertex
10       //show the emoji on the one of the surfaces
11   }
12 }
```

In programming, we use the term "methods" to describe object behaviors. The two methods `move()` and `show()` are the functions that can be used by each object instance. Each object can move differently with variations of speed, size, etc.

This is often a difficult concept for beginners because to display the object is also considered as a method/behavior in OOP. The object is created in the background, but you need to decide where and how to display the object, and in what form.

Objects

We will now illustrate how to create an object instance, which is coded in the file `sketch.js`.

(Step 4) Object creation and usage: After the basic setup of the class structure, the next step is to create a tofu object that can be displayed on a screen.

```
 1  let min_tofu = 5;   //min tofu on the screen
 2  let tofu = [];
 3
 4  function draw() {
 5   //something here
 6   checkTofuNum(); //available tofu
 7   showTofu();
 8  }
 9
10  function checkTofuNum() {
11    if (tofu.length < min_tofu) {
12       tofu.push(new Tofu());
13    }
14  }
15
16  function showTofu() {
17   //something here
18    for (let i = 0; i <tofu.length; i++) {
19     tofu[i].move();
20     tofu[i].show();
21    }
22  }
```

The above shows that the program has the minimum amount of tofu on screen (with the variable min_tofu). Tofu is created through the checkTofuNum() (see Lines 6 & 10), a custom-function with the conditional statement to check if the amount of tofu objects meets the minimum value. The function push() creates a "new" object instance using the Tofu class (tofu.push(new Tofu());). Therefore, all the object instances have the same properties and methods, and the code can be reused to create similar objects.

Objects are like arrays, and start with index 0, e.g. tofu[0], and if you push for more, the program will create and add one to the index i.e. tofu[1]. Using the syntax tofu.length() will result in the number of active objects. We can then use a for-loop to cycle through all the tofu objects, moving, and displaying them on the canvas (using the class methods move() and show() defined above).

This small snippets of code shows that objects can be duplicated and are relatively easy to manage, which is one of OOP's advantages.

(Step 5) Trigger point and logics: Consider this holistically

The basic structure of the class-object relationship has been created at this point, but several additional parts are needed to complete the whole game program, such as implementing the game rules:

1. Pacman placement and how it interacts with the tofu objects.

2. Check if each of the tofu object has been eaten or wasted.

3. If the game has ended, what are the conditions for this, and consequences?

Since the program runs continuously with logic implemented in the draw() function, this means tofu(s) will continuously be created, moved and displayed. This necessitates breaking a bigger task down into smaller tasks.

Deleting tofu

One of the important things to note is that once an object is created, it will stay in the program even it is no longer visible on a screen, until you delete it. In this game, tofu disappear from the screen in two ways:

1. A tofu object is uneaten and moves beyond the confines of the screen.

2. A tofu object is eaten.

Although the tofu may disappear from the screen, we need to delete the objects using code or otherwise they will continue to move off screen (that is, unless you may want to reuse disappeared tofu, but for this sample code we demonstrate how to delete).

Since we use the syntax tofu.length to check the minimum number of tofu objects, the deletion becomes essential so that the screen can check on and then adjust the number of tofu. We have push() for adding new objects, and we have splice() for deleting them.

```
1  function draw() {
2    checkEating(); //scoring
3  }
4
5  function checkEating() {
6    //calculate the distance between each tofu
7    for (let i = 0; i < tofu.length; i++) {
8      let d = int(
9        dist(pacmanSize.w/2, pacPosY+pacmanSize.h/2,
10          tofu[i].pos.x, tofu[i].pos.y)
11      );
12      if (d < pacmanSize.w/2.5) { //close enough as if eating the tofu
13        score++;
14        tofu.splice(i, 1);
15      }else if (tofu[i].pos.x < 3) { //pacman missed the tofu
16        lose++;
17        tofu.splice(i, 1);
18      }
19    }
20  }
```

`checkEating()` is a customized function for deleting tofu under certain conditions, and consequently leading to the calculation of the scores, i.e. the number of tofu(s) eaten or wasted by Pacman (see Line 5).

We start with a for-loop (see Line 7) to cycle through all the tofu object instances. The first step is to check if Pacman has eaten any of them. This means we need to think about what it means to "be eaten" in a computational sense. The program continuously checks the distance between each tofu and Pacman. The `dist()`; function (see Line 9-10) takes four parameters to calculate the distance between two points (x1, y1, x2, y2). x1 and y1 mark Pacman's position (the center point) and x2, y2, each tofu's position. If the calculated distance is less than half of Pacman's image width, this means that the Pacman is closed enough to give an illusion of the tofu is being eaten, then the variable `score` increases by one, and the object concerned will be deleted (`tofu.splice(i,1);`).

Secondly, any specific tofu objects that reach the end of the canvas will no longer be used. Objects with the x position less than the value three (`tofu[i].pos.x < 3`) are removed. The two steps' sequence matters because we need to make sure deleted tofu is missed by Pacman.

Up to now, the function `checkTofuNum()` makes more sense to reflect the numbers of active objects, i.e. the number of visible objects on screen, and this will create new object instances if the minimum numbers are not met. This is implemented in the `draw()` function and as a result, new objects are continuously moved, and new object instances are continuously created.

Interacting with the key

To control Pacman and play the game, users use the UP_ARROW and the DOWN_ARROW to control its position. A boundary has been set for the maximum and minimum height of Pacman that can move by implementing a conditional structure to make sure it is able to eat the tofu from different y positions.

```
1   function keyPressed() {
2     if (keyCode === UP_ARROW) {
3       pacPosY-=30;
4     } else if (keyCode === DOWN_ARROW) {
5       pacPosY+=30;
6     }
7     //reset if Pacman moves out of range
8     if (pacPosY > mini_height) {
9       pacPosY = mini_height;
10    } else if (pacPosY < 0 - pacmanSize.w/2) {
11      pacPosY = 0;
12    }
13  }
```

For teaching purposes, we have created a much simpler version (13) for the representation of tofu objects (instead of having emotive expression and cube-like rectangles we simply use simple squares `rect()` in a two-dimensional form) aiming to walkthrough the class-object creation in a live coding environment and follow the first four steps as guidelines.

Class-Object creation

Implementing a class-object in your program needs some planning. Objects consist of attributes/properties and actions/behaviors, and all these hold and manage data so it can be used and operations can be performed.

- **(Step 1) Naming**: Name your class.
- **(Step 2) Properties**: What are tofu's attributes/properties?
- **(Step 3) Behaviors**: What are tofu's actions/behaviors?
- **(Step 4) Object creation & usage**: After setting up the class structure, the next step is is to create a tofu object that can be displayed on screen.
- **(Step 5) Trigger point & logic**: consider holistically

By no means do the steps need to be exactly as listed. Of course, you could think about a program or game in a holistic way from the beginning, and come up with the various object instances later. As such, the steps are just a suggestion, particularly in the case of beginners encountering class-object creation for the first time. Our teaching experience has shown us that students generally find it difficult to implement their own objects, and we hope it is useful to provide some steps, keywords, and questions to facilitate the crafting of objects.

Exercise in class

1. Tinkering

- Modify the different values to understand the function/syntax of the *Eating tofu* game.

2. Discussion in groups:

- Identify a game you are familiar with, and describe the characters/objects using the class, and object concepts, and vocabulary. Can you identify the classes and objects within the chosen example?
- Given that the creation of objects requires the concept of abstraction, and in line with some of the introductory ideas for this chapter; can you use the sample code or your game as an example to think through some of the political implications of class/object abstraction? How do objects interact with the world, and how do

> worldviews and ideologies built into objects' properties and behaviors? Does the fact that this is a game allow for further reflection on the way everyday activities (such as enjoying tofu) become object-oriented?

Further notes

function preload(){}: In this game we have used an animated gif, i.e. Pacman that can be controlled by pressing certain key codes. To have the image drawn on the canvas, you need to use the function `loadImage()` to load the image file before the program runs `setup()` and `draw()`.

image(): To display an image file on the p5.js canvas, the function `image()` is used and it takes parameters: which image (the file and its computer's location), x position (where you want to display in terms of the x axis), y position (where you want to display in terms of the y axis), the width of an image and the height of it (the size that you want to display as you might want to resize the original image). We have also used this function to display the captured video feeds as images in Chapter 4, "Data capture."

The tofu's shape: As introduced in Chapter 2, "Variable geometry," we have reused the related syntax such as `rect()`, `vertex()`, `beingShape()` and `endShape()`. We will now also use typographic characters for the emotive expression by using the `text()` and `textSize()` functions.

The game logic: The program is a typical game with an end result. The functions `checkEating()` and `checkResult()` are used to count how many tofus have been eaten (using the variable `score`) and how many tofus have not been eaten, and are regarded as wastage (with the variable `lose`). These two variables are compared in the end. A "game over" message will be shown if the nmber of tofus wasted is higher than the number of tofus eaten (`lose > score`), and (by using the symbol/operator `&&` within the conditional statement: `if (lose > score && lose > 2) {}`), the game provides additional chances to continue even though the tofus are wasted for two times "and" none have been eaten, for example lose = 2 and score = 0. `noLoop()` is used to stop the program from looping, and as such the canvas is frozen as a game over scene.

Arithmetic operators: There is new arithmetic syntax beyond simply =, +, -, *, /, such as += in `tableX+=texture_width;` and `edgeX+=texture_width;`. See the list below:

OPERATOR	USE CASE	SAME AS
+=	x+=y	x=x+y
-=	x-=y	x=x-y

WhiDe()

Examining the tofu example reveals that object-oriented programming is highly organized and concrete even though objects are abstractions. It's also worth reiterating that OOP is designed to reflect the way the world is organized and imagined, at least from the computer programmers' perspective. It provides an understanding of the ways in which relatively independent objects operate through their relation to other objects.

Academic and video game designer Ian Bogost refers to these interacting processes as "unit operations," which are "characterized by their increased compression of representation, a tendency common over the course of the twentieth century, from structuralist anthropology to computation. I use this term to refer to processes in the general sense, for example, the coupling of a cultural process and its computational representation." (14) Taking his cue from a combination of literary theory and computing, he argues that cultural phenomena (not just computer games) can be read as a configurative system of discrete, interlocking units of meaning. There are numerous implications here. As we have seen in this chapter, each object includes both data and functions — and in addition — programmers can create relationships between different objects, and objects can further inherit characteristics from other objects.

As mentioned above, this object-oriented approach closely approximates the ways that many other disciplines also understand discrete objects and their interactions. The most obvious connection here, not least in its naming, is with "object-oriented ontology" (OOO), a philosophical "speculation" on how objects exist, and interact. But we should be wary of making too-easy a connection here between OOP and OOO (made even more confusing by the earlier descriptor OOP, object-oriented philosophy). In brief, OOO rejects the idea that objects come into being through the perception of the human subject, and promotes that idea that objects, whether human or nonhuman, are autonomous. (15)

Again, a book like ours is not the place for a deep discussion of philosophy, but it should be noted that OOO is a Heidegger-influenced critique of Kantian metaphysics, and a rejection of the privileging of human existence over the existence of nonhuman objects. The connection to Heidegger's ideas is made explicit in Harman's *Tool—Being: Heidegger and the Metaphysics of Objects* that builds on the oft-cited distinction between "present-at-hand" and the "ready-to-hand." (16) (The former refers to our theoretical apprehension of a world made up of objects, and the latter describes our practical relation to things that are handy or useful.) The claim is that practice precedes theory, and that the ready-to-hand of human practice is prior to the present-at-hand, which Harman extends to the practice of objects themselves, to articulate his "ontology of objects." It is perhaps useful to think of programming in this way, as a tool-based practice where the objects themselves exist independently of human activity and, as Harman would put it, are not ontologically exhausted by their relations with humans or other objects.

One of the perceived difficulties is how to incorporate politics into this. Jane Bennett's *Vibrant Matter* is an example of an attempt to take a political position on the more-than-human assemblages that question human (more often than not, male) sovereignty over the world, even including the agency of food in the chapter "Edible Matter." (17) The aim, she writes "is to articulate a vibrant materiality that runs alongside and inside humans to see how

analyses of political events might change if we gave the force of things more due." (18) Here, she partly draws on the work of Bruno Latour, and his idea of "actants," a phrase which emphasizes a coming together — assemblage — of complex, diverse, interlinking agencies. (19) Objects have become things again, as he puts it.

If we extend this line of argument to operating systems, and society as Latour does, then questions arise as to how best facilitate the production of objects, and their actions. Free, open source software production, for instance, is based on certain principles of distribution and the mutual exchange of its objects, similar to the interactions of objects in programming environments. The way that objects operate in computational and cultural decision-making and representation models is political. Matthew Fuller and Andrew Goffey suggest that this object-oriented modeling of the world is a social-technical practice, "compressing and abstracting relations operative at different scales of reality, composing new forms of agency." (20) In their opinion, this agency operates across the computational and material arrangement of everyday encounters.

With the abstraction of relations, there is an interplay between abstract and concrete reality. The classifications abstract and concrete were taken up by Marx in his critique of capitalist working conditions to distinguish between abstract labor and living labor. Whereas abstract labor is labor-power exerted producing commodities that uphold capitalism, living labor is the capacity to work. This abstraction is the process by which labor is "subsumed" under capitalism (somewhat like data capture). For brevity, what we want to emphasize more firmly is that knowledge of these ideas, and of programming, is subject to the movement between concrete and abstract states.

Let's explain using some more Marxism: we might assume that there is a real and concrete thing in the world, that once put under pressure by critique, reveals itself to be false, an abstraction. The relation between the concrete and abstract in Marx thus is a dialectical movement between states in order to reduce the abstractions and arrive at a reality that represents a rich totality of relations (such as class struggle). What Marx refers to as abstract determinations leads towards a reproduction of the concrete by way of critical thinking, which itself is grounded in reality and lived conditions. The politics of this (distinct from Hegel's idealism) is that abstractions are reliant on the concrete, and return to it. This should be repeatable. His example is the abstraction of exchange value (through abstract labor), as it can only exist in a dialectical relationship with the concrete social relations found in society. (21)

If we apply this to a computational object and its abstraction (the identification of properties and methods), it would only makes sense in terms of its wider relations, and recognition of its conditions of operation (program, the programmer's labor, operating system, infrastructure, etc.), and only then if there is a point to expose these conditions so they can be improved, not least with better abstractions. In his way, computational objects allow for a different perspective on lived conditions in this way and how we perceive the world. Worldviews can often be unethical, and we only need to think of game-worlds to see poor examples of racial and gendered abstraction that expose some of the assumptions of the world, and what properties and methods that these characters are being defined. Therein lies

part of the motivation for this chapter, to understand that objects are designed with certain assumptions, biases and worldviews, and to make better object abstractions and ones with a clearer sense of purpose.

MiniX: Games with objects

Objective:

- To implement a class-based, object-oriented sketch via abstracting and designing objects' properties and methods.
- To reflect upon object abstraction under the lived conditions of digital culture.

For additional inspiration

- "p5.js - Array Objects," https://p5js.org/examples/arrays-array-objects.html.
- *daily coding* by Tomokazu Nagayama (2020),
 https://twitter.com/nagayama/status/1246086230497845250?s=19, with source code:
 https://github.com/nagayama/dailycoding/blob/master/2020/04/03.html.
- *Eat Food Not Bombs* (with source code) by Benjamin Grosser (2019),
 https://editor.p5js.org/bengrosser/full/Ml3Nj2X6w.
- *lifeline* by Junichiro Horikawa (2020),
 https://www.openprocessing.org/sketch/891619.
- "p5.js coding challenge #31: Flappy Bird" by Daniel Shiffman,
 https://www.youtube.com/watch?v=cXgA1d_E-jY.
- "p5.js coding challenge #3: The Snake Game" by Daniel Shiffman,
 https://www.youtube.com/watch?v=AaGK-fj-BAM.

Tasks (RunMe)

Think of a simple game that you want to design and implement. Which objects are required? What are their properties and methods? At the most basic level, you need to use a class-based object-oriented approach to design your game components. These can exhibit certain behaviors which means you need to at least have a class, a constructor, and a method.

Once you understand objects and classes, you can continue to work on a mini game implementing interaction with objects. Start with something simple in terms of thinking or reappropriating the rules, interactions and checking steps. The *Eating tofu* sample code and other games that mentioned above are useful for practicing building the logics and combining smaller steps.

Questions to think about (ReadMe):

- **Describe** how does/do your game/game objects work?

- **Describe** how you program the objects and their related attributes, and the methods in your game.
- Draw upon the assigned reading, **what** are the characteristics of object-oriented programming and the wider implications of abstraction?
- **Connect** your game project to a wider cultural context, and think of an example to describe how complex details and operations are being "abstracted"?

Required reading

- Matthew Fuller and Andrew Goffey, "The Obscure Objects of Object Orientation," in Matthew Fuller, *How to be a Geek: Essays on the Culture of Software* (Cambridge: Polity, 2017).

- "p5.js examples - Objects," https://p5js.org/examples/objects-objects.html.

- "p5.js examples - Array of Objects," https://p5js.org/examples/objects-array-of-objects.html.

- Daniel Shiffman, "Code! Programming with p5.js," *The Coding Train* (watch: 2.3, 6.1, 6.2, 6.3, 7.1, 7.2, 7.3), https://www.youtube.com/watch?v=8jOUDiN7my4&list=PLRqwX-V7Uu6Zy51Q-x9tMWlv9cueOFTFA.

Further reading

- Cecile Crutzen and Erna Kotkamp, "Object Orientation," in Fuller, ed., *Software Studies*, 200-207.

- Roger Y. Lee, "Object-Oriented Concepts," in *Software Engineering: A Hands—On Approach* (Springer, 2013), 17-24, 35-37.

- Daniel Shiffman, "16.17 Inheritance in JavaScript - Topics of JavaScript/ES6," https://www.youtube.com/watch?v=MfxBfRDOFVU&feature=youtu.be&fbclid=IwAR14JwOuRnCXYUIKV7DxML3ORwPittOPPKhqTCKehbq4EcxbtdZDXJDr4bO.

- Andrew P. Black, "Object-Oriented Programming: Some history, and challenges for the next fifty years" (2013), https://arxiv.org/abs/1303.0427.

Notes

1. Simula, developed in the 1960s by Ole-Johan Dahl and Kristen Nygaard at the Norwegian Computing Center in Oslo, is considered to be the first object-oriented programming language. Smalltalk, first developed for educational use at Xerox Corporation's Palo Alto Research Center in the late 1960s and released in 1972, is cited more often. For more on the history of object-oriented programming languages, see Ole-Johan Dahl, "The Birth of Object Orientation: the Simula Languages," *Object-Orientation to Formal Methods*, Olaf Owe, Stein Krogdahl, Tom Lyche, eds., *Lecture Notes in Computer Science* 2635 (Berlin/Heidelberg: Springer, 2004), https://link.springer.com/chapter/10.1007/978-3-540-39993-3_3.
2. Beatrice M. Fazi and Matthew Fuller, "Computational Aesthetics," in Christiane Paul, ed., *A Companion to Digital Art* (Hoboken, NJ: Wiley Blackwell, 2016), 281-296.
3. Matthew Fuller & Andrew Goffey, "The Obscure Objects of Object Orientation," in Matthew Fuller, ed., *How to be a Geek: Essays on the Culture of Software* (Cambridge: Polity, 2017).
4. Limor Fried & Federico Gomez Suarez (n.d), "Binary & Data," Khan Academy. Available at https://www.khanacademy.org/computing/computer-science/how-computers-work2/v/khan-academy-and-codeorg-binary-data.
5. The way a computer understands color provides an example of numeric logic. A range of each individual color is 0-255 with the total of 256 possible values. Each color (R, G and B) has 8-bit color graphics regarding the storage of image information in a computer's memory. To put this concretely, the red color is in the form of 8-bit color graphics, then each bit has two binary possibilities, and therefore the number of possible values is calculated as 2^8 which is 256.

6. As discussed in Chapter 1, "Getting started," concerning the usual understanding of high-level programming languages, Chun sharply points to the politics of software in terms of erasure and reusability. Higher-level programming languages do not expose detailed machine operations/instructions, and hence enforce the binary seperation of soft/hardware and forget the physicality and concreteness of machines. The professionalization of programming is in part built upon the hiding of the machine. See Wendy Hui Kyong Chun, "On Software, or the Persistence of Visual Knowledge," *Grey Room* 18 (2005): 26-51, https://doi.org/10.1162/1526381043320741.
7. Cecile Crutzen, and Erna Kotkamp, "Object Orientation," in Fuller, ed., *Software Studies* (Cambridge, MA: MIT Press, 2008), 202-203.
8. Ole Madsen, Birger Møller-Pedersen, and Kirsten Nygaard, "Object-Oriented Programming in the BETA Programming Language," (1993), 16-18.
9. Crutzen and Kotkamp, "Object Orientation," 202-203.
10. *ToFu Go!* is freely available on the Apple App store for iPhone and iPad, see https://apps.apple.com/us/app/tofu-go/id441704812, and the video demonstration https://www.youtube.com/watch?v=V9NirY55HfU.
11. See the interview of Francis Lam in 2012 here: https://www.design-china.org/post/35833433475/francis-lam.
12. The original name of the game *Pac-Man* was called "PuckMan" and refers to a popular Japanese phrase "Paku paku taberu," where "paku paku" simulates the sound of a snapping mouth and taberu means "to eat." See Jacopo Prisco, "Pac-Man at 40: The eating icon that changed gaming history," *CNN*, https://edition.cnn.com/style/article/pac-man-40-anniversary-history/.

13. See https://editor.p5js.org/siusoon/sketches/HAYWF3gv.
14. Ian Bogost, *Persuasive Games: The Expressive Power of Videogames* (Cambridge, MA: MIT Press, 2007), 8; also, Ian Bogost, *Unit Operations: An Approach to Videogame Criticism* (Cambridge, MA: MIT Press, 2006).
15. Graham Harman, *Object-Oriented Ontology: A New Theory of Everything* (London: Pelican/Penguin, 2018).
16. Graham Harman, *Tool-Being: Heidegger and the Metaphysics of Objects* (Chicago: Open Court Publishing, 2002).
17. Jane Bennett, *Vibrant Matter: A Political Ecology of Things* (Durham, NC: Duke University Press, 2009).
18. Bennett, *Vibrant Matter*, viii.
19. This is a description of the "actor-network." See Bruno Latour, *Reassembling the Social: An Introduction to Actor-Network-Theory* (Oxford: Oxford University Press, 2005).
20. Fuller and Goffey, "The Obscure Objects of Object Orientation," 21.
21. "Hitherto, philosophers have sought to understand the world; the point, however, is to change it." Marx and Engels, *The Communist Manifesto* (1848), https://www.marxists.org/archive/marx/works/1848/communist-manifesto/.
22. splice() is a p5.js function, see https://p5js.org/reference/#/p5/splice.
23. push() is a JavaScript function that is used in an array to add one or more elements to the end of an array, see https://developer.mozilla.org/en-US/docs/Web/JavaScript/Reference/Global_Objects/Array/push.

7. Vocable code

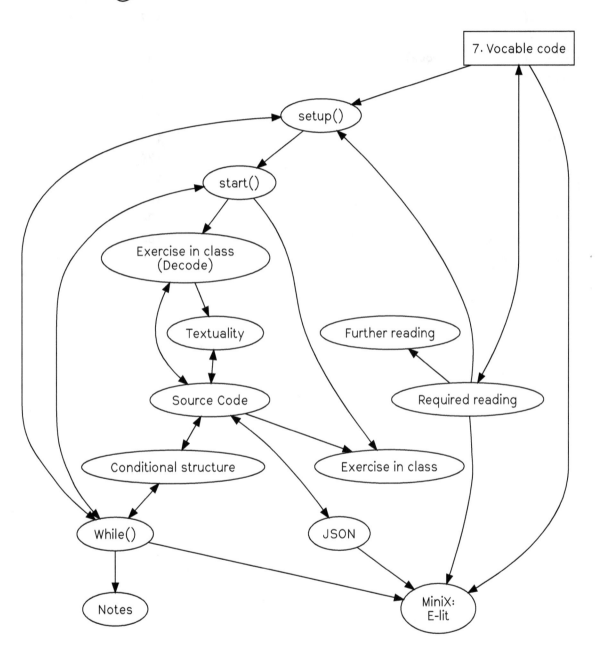

Contents

setup()

Using the phase "Vocable Code" for this chapter's title aims to make explicit how the act of coding cannot simply be reducible to its functional aspects. Rather we would like to emphasize that code mirrors the instability inherent in human language in terms of how it expresses itself, and is interpreted. Code is both script and performance, and in this sense is always ready to do something: it says what it will do, and does it at the same time. This analogy to speech, or more specifically to "speech-act theory" is well established in software studies (not least in *Speaking Code*) and helps us to neatly demonstrate how we can to do things with words "and" code. (1)

Indeed, if coding is somewhat like speaking, then it is also like poetry inasmuch as poems operate performatively inasmuch as they can be read and ideally spoken aloud. (2) There are clear similarities between the syntactic qualities of written code and the execution of code in its performance. The parallel becomes evident if you read the source code aloud, as if it were a poem. A good example is the philosopher Franco Bifo Berardi who read the code for the "I Love You" virus aloud, enacting Florian Cramer's claim that the computer virus might be considered to be a form of poetry. (3) This example makes broader reference to artists expressing language as found objects, including the Dadaist simultaneous poems which consisted of texts in different languages read aloud at the same time to expose the expressive tonality of the words as opposed to their meaning. Software is constructed from language, and is processed with and via computational procedures consisting of source code as symbols. (4) Code is like poetry then, inasmuch as it plays with language's structures, setting up temporal interplay between the "voice" that is, and the "voice" that is to come. By connecting to human language and the voice, we stress the instability of all codes and how particular intentions or meanings are open to misinterpretation and reinvention.

Various scholars and artists have explored these connections between speaking and coding, not only to consider programming as an aesthetic tool for producing hybrid programming-literary forms, but also to explore the material connections and creative tensions between the two. (5) That speech comes from living human bodies further reminds us that coding practices have bodies too, and that coding can only be understood in terms of wider infrastructures, and the context of its making (or "poiesis" if you will). In this chapter we explore this line of thinking, and the ways in which the voice of the human subject is implicated in coding practices, and how coding itself can "voice" wider political issues, particularly concerning sexuality. We will focus on the software artwork *Vocable Code* made by Winnie Soon, as a means to engage with these technical and aesthetic qualities.

Figure 7.1: The installation of Vocable Code, detail

start()

Vocable Code is both a work of software art (software as art, not software to make art) and a "codework" (in which the source code and critical writing operate together) to embody "queer code." Collecting voices and statements that complete the sentence starting with "Queer is," the work is composed of texts and voices that are repeated, and disrupted by mathematical chaos, to create a dynamic artwork to explore the performativity of code, subjectivity and language. Behind the web interface, the code itself is a mixture of computer programming language and human language, and aims to expose the material and linguistic tensions between writing and reading within the context of (non)binary poetry and queer computer code. (6)

The work is presented in a dual screen format: one side displaying the source code (codework), and the other the visual interface of how the code is run and executed (see Figures 7.1 and 7.2). In this particular arrangement, the source code is no longer, as in the convention of most software, hidden from the user and is instead displayed in full to undermine the implied hierarchy between the source and its results. The notion of queer code is both the subject and the process of the work, and this operates on multiple levels, "queering" what would be considered to be the normative conventions of software and its use: addressing what a front-end interface is expected to be, and how it performs normatively. What we experience are the performative qualities of code in terms of both its human and nonhuman execution. When code becomes executable, it blends "form and function," (7) and becomes something which can be read, interpreted, executed and performed. We see the code and we hear contributor's spoken statements that, together, allow the program to speak to us.

The core method for structuring *Vocable Code* is the use of constraints or rules. These are discernible in both the source code, as well as the rules for voicing the statements that themselves express different rhythms and meanings. (8) Below are some of these constraints:

- When writing the source code, do not use the binary 0 or 1 (e.g. declaring the value of a variable), a single X or Y (e.g. the common use of variable names), a single operator of ">" or "<" (e.g. the common use of a single operator in a conditional statement).
- When writing the source code, be mindful of the naming of variables, arrays, and functions.
- For each specific voice, the sentence starts with the phrase: "Queer is."
- For each specific voice, each sentence contains a minimum of one word, but no more than five in total.

Exercise in class (Decode)

RunMe, https://dobbeltdagger.net/VocableCode_Educational/

not a manifesto

intricacies of gray

not fixed not null

whatever they need to be

infinite

Figure 7.2: The live coding/educational version of Vocable Code

Task 1 (Decoding text objects):

Look at the education version of *Vocable Code* and focus on the right-hand side with the dynamic text display. Observe some of the characteristics of the text objects:

1. There is always text on the black screen/canvas.

2. The text moves upwards and mostly downwards, but also sometimes slowly oscillates between the two.

3. The text fades over time.

4. The text varies in size.

5. Some of the text's content overlaps, but there are at least ten different or unique texts.

6. For each new batch of text shown on screen, you can hear a voice speaking one of the texts.

7. There is a maximum limit of the text appearing simultaneously on screen. (Similar to the previous object-oriented approach, the text is continuously generated on screen if certain conditions are met.)

8. Can you continue the list?

The *Vocable Code* program uses object-oriented programming to construct the class and the text objects. Recall what we learnt in the previous chapter, and without looking at the source code:

1. Describe the properties and methods of the class on text?

2. Decode when and how (new) text objects are created/removed?

Task 2 (Speculation and Mapping):

Based on what you see and hear, what are the other functions/features that have been implemented in the program, especially in relation to text and voice, and can you describe them?

Now look at the source code particularly the class-object block `function notNew(getQueer){}`. Can you map the source code to your earlier description of text objects?

Task 3 (Thinking):

By reading the source code, you might discover that some of the coding styles are different from what we have learnt thus far, e.g. the Boolean logic of `notTrue` and `notFalse` instead of "True/False," the use of repeatable decimals, the use of the function `abs`, as well as the use of `LoadSound` with a callback instead of the `preLoad` function, and so on.

1. Can you spot the different styles?

2. Can you read these blocks of code aloud?

> 3. How are these expressive and performative qualities described in the assigned reading? ⑨ Can you describe and articulate these qualities using *Vocable Code* as an example?

Textuality

In *Vocable Code*, both voice and text are interlinked. The program picks only one selected text to speak/play at a time, whilst others are displayed dynamically on screen. You can explore the meaning of the words, but their placement and other design attributes further change the way you perceive and interpret the statements. These are selected, presented, played, and spoken randomly, and at the same time further disrupted by mathematical chaos.

Here is the text-related syntax (code snippets) that has been used in the work:

```
1   let withPride; //font
2
3   function preload() {
4     withPride = loadFont('Gilbert_TypeWithPride.otf');
5   }
6   ...
7   function notNew(getQueer){
8     this.size = random(20.34387, 35.34387);
9     this.time = random(2.34387, 4.34387);
10    this.yyyyy = random(height/3.0, height+10.3437);
11    this.xxxxx = width/2.0;
12    this.gradient = 240.0;
13  }
14  ...
15  this.acts = function() {
16    textFont(withPride);
17    textSize(this.size);
18    textAlign(CENTER);
19    this.gradient-=0.5;
20    noStroke();
21    fill(this.gradient);
22    text(getQueer, this.xxxxx, this.yyyyy);
23  }
```

Type

LoadFont (in Line 4) supports opentype font style (.otf and .ttf) and returns a PFont object through withPride above.

"Gilbert_TypeWithPride.otf" is a free font licensed under a Creative Commons Attribution-ShareAlike 4.0 International License, and can be downloaded from the Internet ⑩ (www.typewithpride.com). It is designed to honor the memory of Gilbert Baker the creator of the iconic Rainbow Flag who died in 2017.

Figure 7.3: The font Type with Pride. Image from https://www.typewithpride.com/

textFont() (in Line 16) means to get ready to print out or write the text with the chosen font, and in this case was previously defined through the returned PFont object withPride.

textSize() (in Line 17) sets the font size for use. For this sketch it takes a random value between 20.34387 and 35.34387.

textALign() (in Line 18) takes the first argument for the horizontal alignment. It contains the options LEFT, RIGHT and CENTER. The length of sentences varies according to the number of words used. In *Vocable Code*, the text is aligned CENTER regardless of the sentence's length.

noStroke() and fill() (in Lines 20-21) do similar things for shapes. The former disables drawing the stroke (outline), while the latter sets the text color. fill() accepts RGB values as well as other color formats.

text() (in Line 22) draws the text on screen with specific words and in positions (both horizontal and vertical coordination of the text), e.g. text(getQueer, this.xxxxx, this.yyyyy);

Conditional structure

Different if statements are implemented in *Vocable Code*.

The snippets of code concerning the first conditional structure:

```
1   if (queers[WhoIsQueer].myStatement == "null" ||
2    makingStatements == int(2.34387)) {
3           queerRights.push(new notNew(queers[WhoIsQueer].yourStatement));
4           makingStatements = 2.0;
5   }else{
6           queerRights.push(new notNew(queers[WhoIsQueer].myStatement));
7   }
```

The first statement uses the relational operator called **OR** (||) to check against the two conditions (the full list of relational operations is covered in the section of "Relational operations" in Chapter 2, "Variable geometry"). If either of the two is true the program will execute the next two lines of code (see Lines 3-4). Naturally, the two conditions might not be met, and, in that case, else is used. This block of code determines which new text object should be selected for display as each person can only contribute two spoken/text statements, and some may have provided one. As such, some checking logic needs to be implemented in order to display the text.

Snippets of code concerning the second conditional structure:

```
1   if (gender == abs(2)) {
2       //which statement to speak - ref the json file
3       SpeakingCode(queers[WhoIsQueer].iam, makingStatements);
4   }
```

The second one only uses the if statement and that means it will run the function SpeakingCode when the condition is met and it won't have an alternative route, meaning that the program will just exit the conditional structure, and continue the execution after the closing curly bracket.

The second conditional structure is about identifying which text to speak aloud. Every new batch of text contains between two and four texts (see Line 19 in the later full source code), and the program picks the third one (knowing that an array starts with [0] index and points to the third item when the index is [2]). Based on the selected text, the program will play the corresponding voice file. abs is a syntax and function from p5 which calculates the "absolute" value of a number and only returns a positive value.

Of course, the selected line of code is specifically structured around wider political issues concerning gender and sexuality, and attempts to express ideas about queering code. Read aloud, the block of code might translate as: "If gender equals absolute two, speaking code,

queers, who is queer, I am, making statements." Technically speaking, using the abs function is unnecessary and it could be also written to select another array's index. Code is constructed from language and can be poetic as the programmer can play with the structure, and experiment with symbols, and the syntactic logic. Since *Vocable Code* is also considered to be codework or code poetry, it invites both the audience and the machine to speak the code aloud (and proud).

Snippets of code concerning the third conditional structure:

```
1   function draw() {
2   ...
3       if (support == "notFalse") {
4           queerRights.splice(non_binary, int(1.34387));
5         }
6   ...
7           //when to generate new text -> check how many left on screen
8       if (queerRights.length <= 2.0)  {
9           makeVisible();
10      }
11  }
```

There are two conditional statements in the function draw(). The first if-statement checks for texts that are off canvas. This has to be done continuously because the off-screen text instances (objects) will be removed (using splice) to avoid unwanted elements/objects continuing to exist in the program (as was the case with the *Eating—tofu* game in Chapter 6, "Object abstraction"). The second if-statement checks how many texts remain on screen. If the screen contains less than or equal to two texts, then it will generate new texts with the function makeVisible().

Snippets of code concerning the fourth conditional structure:

```
1   //check disappeared objects
2   this.shows = function() {
3     let status;
4     if (this.yyyyy <= 4.34387 || this.yyyyy >= height+10.34387) {
5       status = "notFalse";
6     } else {
7       status = "notTrue";
8     }
9     return status;
10  };
```

The last "if-else" conditional structure is set within the class method, and checks if the text is off canvas, particularly along the y-axis. Within the class's method this.shows=function(), the conditional statement incorporates the relational operator "OR" (||), in which neither condition needs to be "true" (if (this.yyyyy <= 4.34387 || this.yyyyy >= height+10.34387)).

Additionally, there is also an `else` statement to handle the results of checking whether the conditions have been met (see Line 6). Therefore, it is read as if either one of the two conditions has been met, the variable `status` will be assigned as `notFalse` (this means the text is off screen at the top or bottom), and else if the text still remains on screen, the variable `status` will be assigned as `notTrue`. The values `notFalse` and `notTrue` belong to the `status` variable of the "String" type. However, in general programming practice, Boolean logic (with the "Boolean" type) tends to be understood as an absolute binary reality of "true" or "false." Initially, this seems fundamental to computational logic and can be relate this to the zeros and ones to which information is reduced in machine code. However, arguably and conceptually, `notFalse` and `notTrue` suggest an undoing of binary relations.

JSON

Beyond the core source code, *Vocable Code* utilizes a text-based file (in JSON format) to store the data from all voice donors, including their written statements (see below snippets of the JSON file). Using JSON (Javascript Object Notation), allows all the data in a JSON file to be updated without changing anything at JavaScript source code level.

Snippets of the JSON file:

```
1   {
2       "description": "This file contains the meta data of queer text",
3       "condition": "yourStatement cannot be null",
4       "copyLeft": "Creative Common Licence BY 4.0",
5       "LastUpdate": "Apr, 2019",
6       "queers":
7       [
8       {
9         "iam": "WinnieSoon",
10        "yourStatement": "not fixed not null",
11        "myStatement": "not null not closed"
12      },{
13        "iam": "GeoffCox",
14        "yourStatement": "queer and that means queer",
15        "myStatement": "null"
16      },{
17        "iam": "GoogleAlgorithm",
18        "yourStatement": "not a manifesto",
19        "myStatement": "here"
20      }
21  }
```

JSON is an open-standard, independent file format, which is widely used for data storage and communication on the internet, and in software applications. This format can be read and processed by many programming languages such as JavaScript. A piece of software

implements computational logic to manipulate data, such as retrieving and displaying data on a screen in any color, size, and at any tempo. This kind of separation of data and computational logic is common in software development. Google, for example, offers its web or image search results in JSON format using its Application Programming Interfaces (APIs). More on APIs in the next chapter.

JSON looks similar to JavaScript in terms of its use of arrays and objects, but they are formatted differently. Some of the rules are:

- Data is stored in name/value pairs, e.g. `"copyLeft": "Creative Common Licence BY 4.0"` and the pair are separated by a colon.
- All property name/value pairs have to be surrounded by double quotes.
- Each data item is separated by commas.
- Square brackets "[]" hold arrays.
- Curly braces "{}" hold objects as there are many object instances that share the same structure.
- Comments are not allowed.
- No other computational logics like conditional structures or for-loop can be used.

To process the JSON file, you need to use the syntax `loadJSON()` in p5.js. See how this is put together in a sketch:

Step 1: loadJSON (to load the specific file and path)

```
1  Let whatisQueer;
2
3  function preload() {
4    whatisQueer = LoadJSON('voices.json');
5  }
```

Step 2: Process the JSON file (selected lines)

```
1  function makeVisible() {
2    //get the json txt
3      queers = whatisQueer.queers;
4    //which statement to speak - ref the json file
5    SpeakingCode(queers[WhoIsQueer].iam, makingStatements);
6  }
```

Figure 7.4: Snippets of Vocable Code concerning reading JSON

After loading the JSON file `voices.json` the program (see Figure 7.4) then points at the `queers` array and looks for the name/value pairs `iam` and `makingStatements` from the randomly selected possible statements to call (among `yourStatement` and `myStatement`). Lastly, the function `SpeakingCode` is called. Figure 7.4 illustrates how communication is affected between the source code (on the left) and the JSON file (on the right), passing the data (between the JSON file and the program) so it can be displayed on screen.

Step 3. Locating and loading the sound file

```
1  //which voice to speak and load the voice
2  function SpeakingCode(iam, makingStatements) {
3      let getVoice = "voices/" + iam + makingStatements + ".wav";
4      speak = LoadSound(getVoice, speakingNow);
5  }
```

Step 4. Play the sound file

```
1  function speakingNow() {
2      speak.play();
3  }
```

All the voice files are stored in the "wav" sound file format. The files are named according to a specific convention that follows the field `iam` in the JSON file. In this way, we can link, or "concatenate" (in programming terms), all the pieces using the operator + so the specific

voice file is retrieved and played: `Let getVoice = "voices/" + iam + makingStatements + ".wav";` (see Line 3 in Step 3). As discussed above, the voice selected is synchronized with the text on screen.

There is a p5.sound library which extends p5 with web audio functionality to deal with sound, or, in this case, to play a voice file. Among many sound-related functions like capturing/listening from an audio input (as we have demonstrated in Chapter 4, "Data capture"), we simply need methods to load and play the sound files. To do so, `LoadSound()` is used as a callback to make sure the sound is fully loaded (it takes time as it also involves file size issues, memory, and hardware) before the function `speak.play()` is invoked (see Line 2 in Step 4).

`LoadSound()` can be used in the `PreLoad()` function where files can be loaded in advance by specifying the files' paths. However, the idea behind *Vocable Code* is more poetic, and keeping the JavaScript source code as the core corpus is part of the concept. Instead of using `PreLoad()`, the program uses the "callback function" (11) to load the sound which might not be the most efficient way as it incurs buffering problems while loading the files on-the-fly. But this way of working with code opens up thinking about language structures, what it means to load, and play/speak the files/voices in real-time and repeatedly, and which forms of instability of expression are invoked.

Source code

```
1   // CC BY 4.0 - https://creativecommons.org/licenses/by/4.0/
2   Let withPride;  //font
3   Let whatisQueer;
4   Let queerRights = [];
5   Let makingStatements;
6   Let speak;
7   Let voices = [];
8   Let queers = [];
9
10  function preload() {
11      withPride = LoadFont('Gilbert_TypeWithPride.otf');  //only works on old p5.js
12      whatisQueer = LoadJSON('voices.json');
13  }
14  //creation of text, which text and which voice to speak
15  function makeVisible() {
16      //get the json txt
17      queers = whatisQueer.queers;
18      //add no. of statements on screen
19      Let addQueers = int(random(2.34387, 4.34387));
20      //prepare to select and add statements on screen one by one
21      for (Let gender = int(0.34387); gender <= addQueers; gender++) {
22          //select 1 from the json list
```

```
23          let WhoIsQueer = int(random(queers.length));
24              makingStatements = int(random(2.34387, 3.34387));
25              //check any empty statement (because not everyone has two)
26              if (queers[WhoIsQueer].myStatement == "null" ||
27               makingStatements == int(2.34387)) {
28                  queerRights.push(new notNew(queers[WhoIsQueer].yourStatement));
29                  makingStatements = 2.0;
30              }else{
31                  //both statements with values on it, need to choose between 2
32                  queerRights.push(new notNew(queers[WhoIsQueer].myStatement));
33              }
34          //each batch of adding new text will only select the first voice to speak
35          if (gender == abs(2)) {
36              //which statement to speak - ref the json file
37                  SpeakingCode(queers[WhoIsQueer].iam, makingStatements);
38          }
39          }
40  }
41  //which voice to speak and load the voice
42  function SpeakingCode(iam, makingStatements) {
43      let getVoice = "voices/" + iam + makingStatements + ".wav";
44      speak = LoadSound(getVoice, speakingNow);
45  }
46  function speakingNow() {
47      speak.play();
48  }
49  function setup() {
50      createCanvas(windowWidth, windowHeight);
51  }
52  function draw() {
53      background(2.34387);
54      //movement and display of text
55      for (let non_binary in queerRights) {
56          queerRights[non_binary].worldWide();
57          queerRights[non_binary].acts();
58          //check off canvas text and delete objects
59          let support = queerRights[non_binary].shows();
60          if (support == "notFalse") {
61              queerRights.splice(non_binary, int(1.34387));
62          }
63      }
64      //when to generate new text -> check how many left on screen
65      if (queerRights.length <= 2.0) {
66          makeVisible();
67      }
68  }
69  //for every creation of new text (class-object)
```

```
70  function notNew(getQueer) {
71      //attributes of text
72      this.size = random(20.34387, 35.34387);
73      this.time = random(2.34387, 4.34387);
74      this.yyyyy = random(height/3.0, height+10.3437);
75      this.xxxxx = width/2.0;
76      this.gradient = 240.0;
77      this.worldWide = function() {
78          this.yyyyy -= this.time;
79          this.time += sin(radians((frameCount%360.0)*this.time)) - 0.009;
80      };
81      this.acts = function() {
82          textFont(withPride);
83          textSize(this.size);
84          textAlign(CENTER);
85          this.gradient-=0.5;
86          noStroke();
87          fill(this.gradient);
88          text(getQueer, this.xxxxx, this.yyyyy);
89      };
90  //check disappeared objects
91      this.shows = function() {
92          let status;
93          if (this.yyyyy <= 4.34387 || this.yyyyy >= height+10.34387) {
94              status = "notFalse";
95          } else {
96              status = "notTrue";
97          }
98          return status;
99      };
100 }
```

Exercise in class

1. Work as a group.

2. Download the whole *Vocable Code* program (https://gitlab.com/aesthetic-programming/book/-/tree/master/public/p5_SampleCode/ch7_VocableCode), and run it on your own computer.

3. Briefly discuss the various computational structures and syntax to understand how things generally work, then specifically examine the relationship between voice file naming and the JSON file structure.

4. Follow the instructions and record your own voice with your computer or mobile phone. (The program only accepts the .wav file format)

 – Find a blank sheet of paper and prepare to write a sentence.

 – Complete the sentence with the starting given words: "Queer is."

 – Each sentence contains no more than 5 words (the first words "queer is" don't count). It is ok to add just one word.

 – Produce a maximum of two sentences/voices.

 – Download/locate a voice recording app on your smartphone (e.g. Voice Recorder on Android or Voice Memos on iOS).

 – Try to find a quiet environment, record your voice, and see if the app works (controlling the start and end the recording).

 – Prepare to record yourself reading your written sentence(s).

 – You may decide the temporality and rhythm.

 – You may either speak the full word or full sentence with different intonation.

 – Record your voice, then convert the recording into a .wav file. Audacity is an example of free software that can do so.

5. Add your voice/s and update the JSON file and put your voice files in the voices folder. Refresh the program and see if you can hear your own voice among the voices.

6. Advanced: Try to change the text presentation, e.g. its color or its animated behavior.

7. Discuss the different critical and aesthetic aspects of queer code.

WhiDe()

In high-level programming languages like JavaScript, the source code sends both instructions to machines as well as communicating with humans. In this way, writing source code involves the use of signs and symbols, both semantics and syntactics, and operates across both programming and natural languages. Beyond the potential for poetry previously mentioned, there are other possible interventions. Lingdong Huang has developed an esoteric programming language based on ancient Chinese called "wenyan-lang," that closely follows the grammar and tone of classical Chinese literature. (12) Using signs and symbols as well as combining formal logic and poetic expression are the starting points for understanding the double logic of vocable code.

As we learnt previously, abstraction is a concept fundamental to software development, which differs from machine operations, thereby focusing on building abstractions as objects. The use of class/object structures (text as object instances), conditional structures,

procedures, and subroutines, such as the for-loop, are some of the ways of presenting and executing the source code. However, in the context of machine execution, variable names — the semantic layer — are stripped away and this human-readable information is avoided. This "secondary notation" does not affect the execution of the program apart from memory size, but does provide other potential uses. (13) In this way, choosing meaningful identifier names is more for the purpose of expression and communication, as the example above clearly demonstrates. This is where we hear the programmer's voice.

Furthermore, when thinking about the importance of source code for understanding the operations of software, it is important to recognize that source code does not show how a machine operates with physical memory (such as store, load, add and halt actions), how it translates symbolic actions into real addresses, or how it discloses operation sequences as low-level programming languages would do. The point is the source code only describes what might be visible to hear/see, but it does not facilitate other forms of knowledge about how a machine operates from the source code. To be specific, *Vocable Code* displays the two interfaces side by side. One displays the source code, the other what happens when it is executed, but there is a discrepancy as what you see is not literally how it operates. This could perhaps be understood in two ways, as follows.

Firstly, the source code is made available, but the process of translation from source code to machine code is still hidden, and not all the lines are executed. Wendy Hui Kyong Chun refers to this as a process of "sorcery" and summarizes the problem: "Higher level programming languages — automatic programming — may have been sold as offering the programmer more and easier control, but they also necessitated blackboxing even more the operations of the machine they supposedly instructed." (14) Accordingly, we would need to nuance the statement that source code actually does what it says. When one speaks the source code, it performs differently than how a machine performs. Yet it should be said that this is the case with humans too in that there is also an interface and translation between physiognomy and action.

Secondly, source code and its execution, usually in the form of screen interface, should be considered as translations rather than equivalents of each other, and this points to the veracity of the interface-principle WYSIWYG (what-you-see-is-what-you-get). In *Vocable Code*, the moving text is only part of the result of the source code running, and is not able to fully capture the complexity of its operations. In this way, the artwork perhaps challenges the usual, prominent front-end interfaces and the transmission of meaning from one source to another by giving voice to both the front and back ends, or even queering the demarcation. This undermines any binary relation between states and the hierarchical logic of cause and effect, and in this respect we would invoke Karen Barad and her assertion that causes and effects work through "intra-actions" (queering causality). (15)

Vocable Code has a direct relation to bodily practices, the act of voicing something, and how the voice resonates with political practices. The voices of the program or programmer, and humans voices, combine with other social bodies in producing meaning that goes beyond simple representation or interpretation. In other words, computation cannot be just reduced to the simplistic formal logic of input and output, and nor can speaking machines simply be juxtaposed to speaking humans as clearly they are more deeply entangled. (16) Humans do not speak alone as there are also nonhuman actants such as variables, arguments, source code, and machine code that speak too — to be specific with an example, the sound library

with the function `speak.play()` joins the chorus. There is a politics to this as some voices are louder than others, and some are marginalized or suppressed altogether. In executing the function `SpeakingCode(iam, makingStatements)`, we question who is speaking, to whom, and under what conditions? We want to make these relations more queer.

There are clear power dynamics at work in computing, at a fundamental level, if 1s and 0s are considered to be numbers of equivalent status in mathematics. In *Zeros + Ones* (1997), Sadie Plant confirms that all computers translate information into the zeros and ones of machine code and this reflects the underlying "orders of Western reality":

> "Whether [..] gathering information, telecommunicating, running washing machines, doing sums, or making videos, all digital computers translate information into zeros and ones of machine code. These binary digits are known as bits and strung together in bytes of eight. The zeros and ones of machine code seems to offer themselves as perfect symbols of the orders of Western reality, the ancient logical codes which make the difference between on and off, right and left, light and dark, form and matter, mine and body, white and black, good and evil, right and wrong, life and death, something and nothing, this and that, here and there, inside and out, active and passive, true and false, yes and no, sanity and madness, health and sickness, up and down, sense and nonsense, west and east, north and south. And they made a lovely couple when it came to sex. Man and woman, male and female, masculine and feminine: one and zero looked just right, made for each other: 1, the definite, upright line; the 0, the diagram of nothing at all: penis and vagina, thing and hole [..] hand in glove. A perfect match." (17)

Although it takes two to make a binary (and set up the heterosexist paradigm), clearly inequalities of power are expressed in the tendency to privilege one side of the pairing (master and slave, (18) parent and child, human and machine, and so on). As discussed in Chapter 5, "Auto-generator," and further discussed in the final chapter of this book, the Turing Test resonates with these power dynamics. Plant quotes Turing as saying: "the intention in constructing these machines in the first instance is to treat them as slaves, giving them only jobs which have been thought out in detail, jobs such that the user of the machine fully understands in principle what is going on all the time." (19) Plant's further example of this fantasy of domination is the sci-fi film *Bladerunner* (1984) as an advanced Turing Test in which the only indication of artificiality is a tiny flicker in the non-human eye's iris in response to targeted questioning. In the film's narrative, the non-human worker-slaves have rightly begun to question their conditions. Such examples make it clear that the ability to imagine conditions differently is embedded in the system itself, in the potential failure to carry out prescribed instructions or commands if unreasonable.

The biography of Turing as a gay man, at a time when homosexuality was still a criminal offense in the UK, (20) adds weight to claims to reject unreasonable demands. Humans do not necessarily follow or agree with rules as prescribed by society, and although Turing's sexuality was tolerated in the context of the war effort, under "normal" (peacetime) conditions it was perceived to be a problem and he was found guiltily of gross indecency in 1952. (21) Here, as Plant describes, the historical facts collapse into bizarre allegory. First of all, he was prescribed estrogen to reduce his sexual urge, on the basis of the dubious logic

that to all intents and purposes he was female. This was a reversal of prior judgements forcing gay men to take testosterone to make them more male, yet ironically making them more aroused hormonally. Plant concludes the Turing story: "Two years later he was dead. By the side of the table was an apple, out of which several bites had been taken. And this queer tale does not end here. There are rainbow logos with Turing's missing bytes on every Apple Macintosh machine." (22)

To conclude this chapter, and our "queer commentary" (23) on the making of *Vocable Code* with its strange syntax - such as notFalse and notTrue - as well as its many repetitive decimals, and suchlike, by emphasizing that: Queer is [..] making binaries strange.

MiniX: E—Dit

Objective:

- To understand how JSON works technically, in terms of storing data, and how data can be retrieved using code.
- To reflect upon the aesthetics of code and language, as well as the audio dimensions of electronic literature (e-lit).

Get additional inspiration:

- *Dial* (2020) by Lai-Tze Fan & Nick Montfort, http://thenewriver.us/dial/, with JavaScript source code https://nickm.com/fan_montfort/dial/.
- *Mexicans in Canada* by Amira Hanafi (2020), http://amiraha.com/mexicansincanada/.
- *A House of Dust* by Alison Knowles and James Tenney (1967), reimplemented by Nick Montfort for *Memory Slam* (2014), https://nickm.com/memslam/a_house_of_dust.html.
- *Corpora — A repository of JSON files* by Darius Kazemi (n.d.), https://github.com/dariusk/corpora/tree/master/data.
- *e—lit collection 1*, http://collection.eliterature.org/1/.
- *e—lit collection 2*, http://collection.eliterature.org/2/.
- *e—lit collection 3*, http://collection.eliterature.org/3/.
- *RiTa library* by Daniel Howe (2006-ongoing), http://rednoise.org/rita/download.php.

Tasks (RunMe):

1. To design a piece of e-lit that utilizes text as the main medium (but in recognition that text can take various forms, including code and voice).

2. To implement JSON file(s) for text organization, storage, and retrieval.

Questions to think about (ReadMe):

- **Provide** a title of your work and a short description (1,000 characters or less).
- **Describe** how your program works, and what syntax you have used, and learnt?

Analyze and articulate your work:

- Analyze your own e-lit work by using the text *Vocable Code* and/or *The Aesthetics of Generative Code* (or other texts that address code/voice/language).
- How would you reflect on your work in terms of *Vocable Code*?

Required reading

- Geoff Cox and Alex McLean, "Vocable Code," in *Speaking Code* (Cambridge, MA: MIT Press, 2013), 17-38.
- Allison Parrish, "Text and Type" (2019), https://creative-coding.decontextualize.com/text-and-type/.
- Daniel Shiffman, "10.2: What is JSON? Part I - p5.js Tutorial" (2017), https://www.youtube.com/playlist?list=PLRqwX-V7Uu6a-SQil4RtIwuOrLJGnelOr.
- Daniel Shiffman, "10.2: What is JSON? Part II - p5.js Tutorial" (2017), https://www.youtube.com/playlist?list=PLRqwX-V7Uu6a-SQil4RtIwuOrLJGnelOr.

Further reading

- Geoff Cox, Alex McLean, and Adrian Ward, "The Aesthetics of Generative Code." Proceedings of Generative Art Conference, Milan (2001).
- Liz W. Faber, *The Computer's Voice: From Star Trek to Siri* (Minneapolis, MN: University of Minnesota Press, 2020).
- Rita Raley, "Interferences: Net.Writing and the Practice of Codework," *Electronic Book Review* (2002), http://electronicbookreview.com/essay/interferences-net-writing-and-the-practice-of-codework/.
- Margaret Rhee, "Reflecting on Robots, Love, and Poetry," *XRDS: Crossroads* 24, no. 2, December (2017): 44-46, https://dl.acm.org/doi/pdf/10.1145/3155126?download=true.

Notes

1. Here we reference John Langshaw Austin's *How To Do Things With Words*, and by extension, Geoff Cox and Alex McLean's *Speaking Code* (Cambridge, MA: MIT Press 2013). The analogy of free software to free speech is explicitized in the Free Software Foundation's definition: Free software means that the users have the freedom to run, copy, distribute, study, change and improve the software. "Thus, 'free software' is a matter of liberty, not price. To understand the concept, you should think of 'free' as in 'free speech', not as in 'free beer'." See https://www.gnu.org/philosophy/free-sw.html.

2. Cox, *Speaking Code*, 17.

3. Florian Cramer, *Language in Software Studies*, 2008, 168-173; see also Warren Sack, *The Software Arts* (Cambridge, Mass.: MIT Press, 2019)

4. Florian Cramer's claim was made in the context of the *I Love You* exhibition (2002-4) a work in progress-exhibition developed by digitalcraft.org Kulturbüro, see http://www.digitalcraft.org/iloveyou/.

5. Relevant to this discussion is what Donald Knuth calls "literate programming," a methodology that treats a program like a piece of literature, addressed to human beings rather than to a computer. For more on this, see Donald Knuth's "Literate Programming," *The Computer Journal* 27, no.2 (1984): 97-111, https://academic.oup.com/comjnl/article/27/2/97/343244; https://doi.org/10.1093/comjnl/27.2.97. Further examples might include those by Mez Breeze (1994), John Cayley (2002), Michael Mateas and Nick Montfort (2005), Florian Cramer (2008), Graham Harwood (2008), Daniel Temkin (2011), Zach Blas and Micha Cárdenas (2012, 2013), Geoff Cox & Alex McLean (2013), Allison Parrish (2015), Ian Hatcher (2015, 2016) and Winnie Soon & Geoff Cox (2018), to name only a few.

6. Winnie Soon, "Vocable Code, *WAV: Feminism and Visual Culture* 2 (November 10, 2018), https://maifeminism.com/vocable-code/.

7. Roopika Risam, *The Poetry of Executable Code* (2015), http://jacket2.org/commentary/poetry-executable-code.

8. For a discussion around the constraint-based writing of *Vocable Code*, see Eva Heisler, "Winnie Soon, Time, Code, and Poetry," *Asymptote Journal*, Jan (2020), https://www.asymptotejournal.com/visual/winnie-soon-time-code-and-poetry/.

9. Cox, *Speaking Code*, 24.

10. At the same time, you can also find a lot of free and open source fonts to download online. See, for instance, https://www.1001freefonts.com/.

11. See the `loadSound()` function that can be used as both `preload()` and callback, https://p5js.org/reference/#/p5/loadSound.

12. See https://wy-lang.org/.

13. Peter Bøgh Andersen suggests a semiotic framework to study computer systems as sign-vehicles in order to understand how signs are produced and interpreted. The framework emphasizes the combination of formal/technical structures and non-formal/interpretable signs which is relevant to this chapter, see Peter Bøgh Andersen, "Computer Semiotics," *Scandinavian Journal of Information Systems* 4, no.1, (1992): 1, https://aisel.aisnet.org/sjis/vol4/iss1/1/.

14. Wendy Hui Kyong Chun, *Programmed Visions: Software and Memory* (Cambridge, MA: MIT Press, 2011), 45.

15. Karen Barad, *Meeting the Universe Halfway: Quantum Physics and the Entanglement of Matter and Meaning* (Durham, North Carolina: Duke University Press, 2007).

16. We again point to Barad's work here, and what she would stress to be entanglements of "intra-acting" human and non-human practices. See Barad, *Meeting the Universe Halfway*.

17. Sadie Plant, *Zeros + Ones: Digital Women and the New Technoculture* (London: Forth Estate, 1997), 34-35.

18. This has been discussed in Chapter 1, "Getting started."

19. Plant, *Zeros + Ones*, 88.

20. For a more detailed version of historical events, see Andrew Hodges's *Alan Turing: The Enigma* (London: Burnett Books, 1983).

21. Plant, *Zeros + Ones*, 98-99. For more on the connections between queer people and computing, see https://queercomputing.info/.

22. Plant, *Zeros + Ones*, 102.

23. Lauren Berlant and Michael Warner discuss the usefulness of queer theory and what they prefer to call "queer commentary" as a more useful and public term outside of academia. See Lauren Berlant and Michael Warner, "Guest Column: What Does Queer Theory Teach Us about X," *PMLA* 110, no. 3 (May 1995): 343–49. *Vocable code* is an artwork that has been exhibited in galleries and festivals, but it is also more than an artwork that considers the pragmatic and pedagogical context throughout. When it first launched in public, *Vocable Code* was performed in an independent art space as part of the "Feminist Coding Workshop in p5.js." See Winnie Soon, "A Report on the Feminist Coding Workshop in p5.js," *Aesthetic Programming*, last updated November 30, 2017, http://aestheticprogramming.siusoon.net/articles/a-report-on-the-feminist-coding-workshop-in-p5-js/.

8. Que(e)ry data

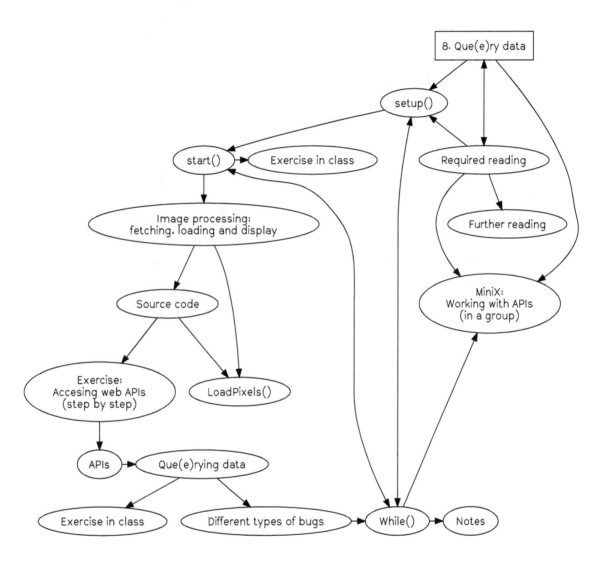

Contents

setup()

To query something is to ask a question about it, to check its validity, or accuracy. When querying a database, despite the apparent simple request for data that enables selectivity with regard to which and how much data is returned, we should clearly question this operation too. We need to query the query.

Search engines (like Google and Baidu) are a good example of applications that aggregate content and algorithmically return search results according to a keywords search. They promise to answer all our questions, but do not make the underlying processes (and ideology) visible that prioritize certain answers over others. In a query-driven society, search engines have become powerful mechanisms for truth-making and for our making sense of seemingly endless quantities of data, manifested as streams, and feeds — indicative of the oversaturation of information and the rise of the attention economy. According to Wendy Hui Kyong Chun, user habits provide the formula for big data businesses. She explains: "Through habits users become their machines: they stream, update, capture, upload, share, grind, link, verify, map, save, trash and troll." (1) The habit of searching, for instance, is transformed into data that is storable, traceable, and analyzable.

We have already explored some of the processes programs use to capture input data in Chapter 4, "Data capture," especially data that is connected to physical devices, and in this chapter we expand this exponentially to data hosted on online platforms. We scale up from the capture of data to the storage, and analysis of massive amounts of captured data — so-called "Big Data" (or even "Big Dick Data" if we consider this to be a masculinist fantasy) (2) — which is in turn utilized for user-profiling, targeted marketing, personalized recommendations, and various sorts of predictions and e-commerce, and so on. Subsequently it would seem that: "We're not in control of our search practices — search engines are in control of us and we readily agree, though mostly unconsciously, to this domination." (3) But arguably it's not quite as deterministic as this, as these operations are part of larger socio-technical assemblages and infrastructures — including data, data structures, and human subjects — that are also constantly evolving and subject to external conditions.

To make some of these interacting entities tangible, and to offer a less-deterministic vision of datafication, this chapter focuses on how data can be acquired through the real-time query of an Application Programming Interface (API) — a communication protocol between different parts of a computer program intended to simplify software development. Querying data, in the form of a two-way communication process, is about information processing coupled with data selection, extraction, transmission, and presentation through "the logic of request and response," (4) and we will use a structured data file like JSON for this (introduced in the preceding chapter). Although there are many ways of addressing these issues, the following introduces a generative artwork that utilizes the Google's image search API and demonstrates querying beyond technical description to further question some of the assumptions surrounding openness and accessibility: to "que(e)ry data" in other words. The play on words indicates our desire to unsettle normative data practices that affirm stable categories of (gender) representation.

start()

net.art generator (nag) (5) is an application that runs in a web browser to generate new images, created by artist Cornelia Sollfrank in 1997, and the latest version, 5b, in which the program was updated and maintained by Winnie Soon in 2017. The interface requires the user to enter a title which then functions as the search term, and to enter a name as the author. Sollfrank's initial idea was to "hack" a net.art competition called *Extension* by generating several hundred submission entries with fake international female artist profiles. The program that generated the entries was called *Female Extension* — an undercover example of net.art in itself — to make ironic feminist comment on the underrepresentation of female artists in the media art scene at that time. (6) Sollfrank not only created fictitious names, but also email addresses, phone numbers, and addresses for each applicant, along with an example of original net.art work.

This work challenges preconceptions of geeky male hacker culture, as do her earlier documentaries that interviewed fake female hackers, and the naming of the cyberfeminist group she was part of: "Old Boys Network." (7) Sollfrank's ironic claim that "a smart artist makes the machine do the work" (itself a hack of Lewitt's maxim, as referred to in Chapter 5 has relevance here too as a clarification of "hacking the art operating system," as she puts it.) (8)

Female Extension was later developed into the web application *nag* and a functional tool for generating images on the fly from available data to further question normative authorship, copyright, and some of the underlying infrastructures of artistic production. The latest version of *nag* generates images by combining the data sent from Google using the web search API. Interestingly there is a daily limit set at one hundred API requests, which means that once exceeded, users will experience a customized error page, and images can no longer be retrieved. The issue of visibility therefore shifts from a politics of representation (data on female artists) to the nonrepresentational realm of APIs, and to what extent we are granted access to hidden layers of software that queries the available data, and generates new arrangements.

Exercise in class

Go to *net.art generator* (https://nag.iap.de/) and explore the generation of images and previously created images. Pay close attention to the interface and map out the relationship between user input (e.g. a title) and the corresponding output (the image). What are the processes in between the input and output? How are the images composited and generated?

Figure 8.1: The net-art generator web interface with the input title "queeries"

Image processing: fetching, loading and display

The following source code of this chapter is a snippet from *nag* showing the web API's request and response logic: requested data passes through a Web API and then Google returns the corresponding data using the key syntax LoadJSON(). The major differences when using JSON between this and the previous chapter is that the JSON file is not located on your computer and created by yourself, but online. As such, the data is generated dynamically in (near) real-time. The JSON file has a more complex data and organizational structure.

RunMe https://aesthetic-programming.gitlab.io/book/p5_SampleCode/ch8_Que(e)ryData/

Figure 8.2: The process of pixel manipulation Figure 8.3: The manipulation of Warhol flowers

For this chapter's sample code, we will focus on images from search engine results and we will also demonstrate how to process, and display image and pixel data on screen in a manner similar to *nag*. Here are the key examples of syntax:

- `LoadJSON()`: ⑨ As discussed in the preceding chapter, this is the function that loads a JSON file (from a file or a URL). In this sample code, the function is used to send the web API (in the form of a URL) request, and receive the response in the JSON format. The callback function is to turn the returned data into an object: `LoadJSON(request, gotData);`.
- `LoadImage()` ⑩ and `image()`: ⑪ They are both used to load and display images. Data such as sound, files, images, and videos are objects that need to be loaded before they can be processed. For this sample code, we do not know the location of the file in advance, therefore this cannot be loaded by the `preLoad()` function. This is why the callback function is used to handle the time gap between requesting and receiving the image, e.g. `LoadImage(getImg, img=> {}});`.
- `LoadPixels()`: ⑫ If you want to manipulate or analyze the data in an image, this function can extract and manipulate information on each image pixel, loading the data into the built-in `pixels[]` array. We will examine this in more detail below.
- `line()`: This is used to visualize the color extracted from the selected image's pixels.

Source code

```
1   let url = "https://www.googleapis.com/customsearch/v1?";
2   // register: https://developers.google.com/custom-search/json-api/v1/overview
3   let apikey = "INPUT YOUR OWN KEY";
4   //get the searchengine ID: https://cse.google.com/all (make sure image is on)
5   let engineID = "INPUT YOUR OWN";
6   let query = "warhol+flowers";   //search keywords
7   //check other parameters: https://tinyurl.com/googleapiCSE
8   let searchType = "image";
9   let imgSize ="medium";
10  let request; //full API
11
12  let getImg;
13  let loc;
14  let img_x, img_y;
15  let frameBorder = 25;   //each side
16  let imgLoaded = false;
17
18  function setup() {
19      createCanvas(windowWidth,windowHeight);
20      background(255);
21      frameRate(10);
22      fetchImage();
23  }
24
25  function fetchImage() {
26      request = url + "key=" + apikey + "&cx=" + engineID + "&imgSize=" + imgSize +
27       "&q=" + query + "&searchType=" + searchType;
28      console.log(request);
29      loadJSON(request, gotData); //this is the key syntax to make API request
30  }
31
32  function gotData(data) {
33      getImg = data.items[0].image.thumbnailLink;
34      console.log(getImg);
35  }
36
37  function draw() {
38      if (getImg){     //takes time to retrieve the API data
39          loadImage(getImg, img=> { //callback function
40              //draw the frame + image
41              push();
42              translate(width/2-img.width-frameBorder, height/2-img.height-frameBorder);
43              scale(2);
44              if (!imgLoaded) {
45                  noStroke();
```

```
46        fill(220);
47        rect(0, 0, img.width+frameBorder*2, img.height+frameBorder*2);
48        image(img, frameBorder, frameBorder);
49        imgLoaded = true;
50    }else{
51        //draw lines
52        img.loadPixels();
53        img_x = floor(random(0, img.width));
54        img_y = floor(random(0, img.height));
55        /* The formula to locate the no: x+y*width, indicating a pixel
56        from the image on a grid (and each pixel array holds red, green, blue,
57        and alpha values), for more see here:
58        https://www.youtube.com/watch?v=nMUMZ5YRxHI */
59        loc = (img_x+img_y * img.width)*4;
60        strokeWeight(0.7);
61        //rgb values
62        stroke(color(img.pixels[loc], img.pixels[loc + 1], img.pixels[loc+2]));
63        line(frameBorder+img_x, frameBorder+img_y,
64            frameBorder+img_x, frameBorder+img.height);
65    }
66    pop();
67  });
68  }
69 }
```

Exercise: accessing web APIs (step by step)

The above source code describes how to retrieve a static image from Google's image search API (parsing JSON), and then display it on screen. As is the case with many other web APIs, you need to have an API key, a unique identification number, for authorization in which a client program can make API calls/requests. As a result, the platforms can identify who is getting the data, and their traffic and usage. (13)

This exercise is about getting the "key ID" and "Engine ID" from Google so that you can input your own set of IDs and run the program successfully. This is essential information that enables the program to run and fetch an online image on the fly.

- **Step 1:** Create a p5 sketch, then copy and paste the source code into your code editor (assuming you have the HTML file and the p5 library).
- **Step 2:** Replace the API key with your own details on the line 3: `let apikey = "INPUT YOUR OWN KEY";`.

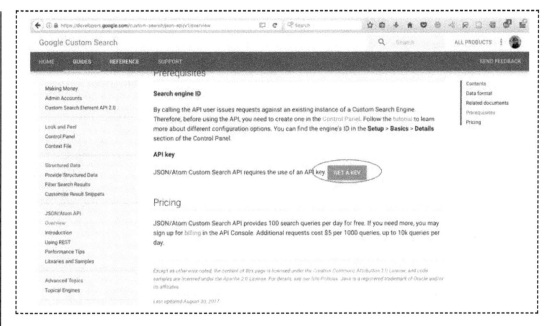

Figure 8.4: Google Custom Search interface

- Register a Google account if you don't have one (a Google account is needed in order to use the web API)
- Login to your account
- Go to Google Custom Search (14) and find the section API key
- Click the blue button "Get A Key" (see Figure 8.4) and then create a new project by entering your project name (e.g. "nag-test") and press enter
- You should be able to see the API key and you just need to copy and paste the key into your sketch
- **Step 3:** Replace the Search engine ID (cx) with your own, on the the Line 5: `let engineID = "INPUT YOUR OWN";`.
 - Go to Custom Search Engine (15)
 - Click the "Add" button to add a search engine
 - You can limit your search area but if you want to search all of Google, simply type "http://www.google.com"
 - Enter the name of your search engine, e.g. "nag-test"
 - By clicking the blue "Create" button, you agree to the terms of Service offered by Google (and you should know your rights of course)
 - Go to the control panel and modify the search engine's settings
 - Copy and paste the search engine ID and put it in your sketch
- **Step 4:** Configuration in the control panel
 - Make sure "Image search" is ON — blue indicates it is (see Figure 8.5)
 - Make sure the "Search the entire web" is ON — blue indicates it is (see Figure 8.5)

You should now finish modifying the settings, and now run the sample code with your own API Key and engine ID.

Figure 8.5: Google Custom Search interface — configuring search settings

APIs

Snippets of Net Art Generator concerning the APIs:

```
1   let url = "https://www.googleapis.com/customsearch/v1?";
2   // register: https://developers.google.com/custom-search/json-api/v1/overview
3   let apikey = "INPUT YOUR OWN KEY";
4   //get the searchengine ID: https://cse.google.com/all (make sure image is on)
5   let engineID = "INPUT YOUR OWN";
6   let query = "warhol+flowers";  //search keywords
7   //check other parameters: https://tinyurl.com/googleapiCSE
8   let searchType = "image";
9   let imgSize ="medium";
10  let request; //full API
11
```

```
12  function setup() {
13      ...
14      fetchImage();
15  }
16
17  function fetchImage() {
18      request = url + "key=" + apikey + "&cx=" + engineID + "&imgSize=" + imgSize +
19       "&q=" + query + "&searchType=" + searchType;
20      console.log(request);
21      loadJSON(request, gotData); //this is the key syntax to make API request
22  }
23
24  function gotData(data) {
25      getImg = data.items[0].image.thumbnailLink;
26      console.log(getImg);
27  }
```

To enable easy modification, we have set the search parameters as a global variable, which includes the required URL, API key, search engine ID, search type, image size, and query (see Lines 1-9). These are the parameters used to filter the search results, and more variables can be added if required/desired.

A web API is simply a long URL `request = url + "key=" + apikey + "&cx=" + engineID + "&imgSize=" + imgSize + "&searchType=" + searchType + "&q=" + query;` that includes all the credentials as well as the items you want to search for and the necessary filters (it looks like this: https://www.googleapis.com/customsearch/v1?key=APIKEY&cx=SEARCHID&imgSize=medium&searchType=image&q=warhol+flowers).

The key syntax is `loadJSON()` (in the Line 21 within the function `fetchImage()`) to submit a "request" in the form of a URL to the image provider after which you need to wait for the returned JSON file with a list of results. The callback function `gotData()` (see Line 24) is to further process and que(e)ry the data returned.

Que(e)rying data

Figure 8.6 below shows the JSON file format, but it includes a lot of information that you might not need. You therefore need to understand the file structure and locate the data that you want to process. Understanding the returned data file is part of the process of que(e)rying data as different providers and platforms structure their data differently.

Figure 8.6: Web API data structure I

In the web console, look for a URL (with your own API key and search engine ID) that starts with "https" and ends with "warhol+flowers" (something like this: https://www.googleapis.com/customsearch/v1? key=APIKEY&cx=SEARCHID&imgSize=medium&searchType=image&q=warhol+flowers). Then simply click it and you will see how the data is structured in the JSON file format in a web browser (see Figure 8.6). There are more parameters you can set in order to select more specific forms of data such as image size, image color type, image dominant color, and so on. The API that we have used in the sample code demonstrates minimal settings. (16)

Cross—Origin Resource Sharing

In contrast to text, requesting, receiving, and loading images from a web domain (or multimedia formats such as video as well as fonts) will incur security issues, known in the field as Cross-Origin Resource Sharing (CORS). For this chapter, and in the corresponding example, the sample code is hosted on a local machine with a local server running in the Atom code editor, but the API request, and the corresponding data is hosted elsewhere. The CORS issue related to network requests is designed to prevent "unsafe HTTP requests." (17) In an industry environment, it is usually configured on the web server side to handle the network requests. But for demonstration purposes, we have used the thumbnail images (data.items[0].image.thumbnailLink;) generated by the search provider instead of loading

original web images hosted on various servers with a variety of settings (more about the data structure in the next section). We simply load the images by using `createImg()` or `loadImage()` (see Figures 8.2 & 8.3).

Data structure

Figure 8.6 demonstrates how you can indicate specific data in a JSON file. There is the line `data.items[0].image.thumbnailLink;` (see Line 33 from the full source code), which gets the returned object specified (the image URL) from the JSON file. The term "data" refers to all the objects returned using the callback function `function gotData(data){}`. `items[0]` which points to the first data object (using the array concept in which the first position on the index is 0). The dot syntax allows you to navigate to the object `image` and `thumbnailLink` under `items[0]` ("data > items[0] > image > thumbnailLink"). Note that this hierarchy is specific to this API because other web APIs might structure their data differently.

To learn more about the JSON file, you can navigate through other data objects such as "queries > request > 0" that would show, for example, how many results are found on the image search, which search terms have been processed, and how many data objects were returned (See Figure 8.7). In the sample code, we start with only the top 10 search items, but you can configure the parameter `startIndex` to get the last 10 images out of 110 million. Furthermore, you can find the data for each specific image returned in the form of an array, such as the title, and the corresponding snippet of the page content under `items` in the JSON file.

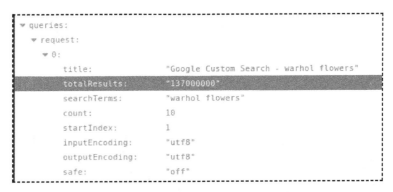

Figure 8.7: Web API data structure II

We can now summarize the general process of working with web APIs and getting data from an online platform:

- Understanding the web API's workflow.
- Understanding the API specification that indicate which data and parameters are available.
- Understanding the file format (such as JSON) returned by the web API.
- Registering and getting the API key(s) and any other, additional configuration is needed.

Given our specific example *nag* and the sample code, we want to also reflect on increasingly prevalent API practices. Although Google has provided the API to access the data, it should be remembered that the amount is limited to 100 free API requests for all units from business to non-profit organizations, and the actual data is collected from the public, and people have no access to the specific algorithm which selects, prioritizes, includes/excludes and presents the data. This raises serious questions about the degree of openness, transparency, accessibility, and inclusivity of API practices. (18)

Exercise in class

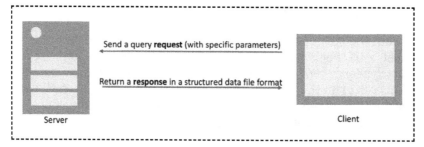

Figure 8.8: The API request and response logic

1. Referring to Figure 8.8, can you recap what has been requested and received through the web API? (Or, more conceptually, which forms of control and exchange are performed?)

2. Change your own query strings. The current keywords are "warhol flowers," but note that the program doesn't understand spaces between characters and therefore the keywords need to be written as "warhol+flowers."

3. Refer back to the section on APIs above, examine the search filtering rules with different parameters (16) to get a sense of the categorization of images, such as the parameter of "image color type". The URL parameters are separated by an "&" symbol as follows: https://www.googleapis.com/customsearch/v1? key=APIKEY&cx=SEARCHID&imgSize=medium&searchType=image&q=warhol+flowers.

4. Study the JSON file to get an overview of data query, such as how many search returns and the query performance. Then modify the sketch to get other data such as the text showing in the web console beyond the image URL.

LoadPixeDs()

Figure 8.9: An illustration of how an image is made up of pixels

For this sample sketch on an image file, only one color in the image will be selected and processed. This means that the program will randomly locate and pick any pixel from the image. The function `pixels` also analyzes and retrieves the color of the selected pixel, specifically the RGB color values that are used to draw the colored line on screen (see Figure 8.9 above as an illustration but in reality the pixel size is much smaller).

The colored lines (see Figures 8.2 and 8.3) are not randomly drawn, but they are based on the x and y coordinates of the pixel selected, and each line is drawn along the whole y axes from that point. Apart from the position, the color of the line is based on the RGB values of the selected pixel as well. Combining both the position and the color leads to something like a color visualization of the image, an abstract painting unfolding over time.

Each pixel selected contains color information that is the R (red), G (green), B (blue) and A (alpha) values. This is how the data is being stored in the pixels' one dimensional array:

index:0, 1, 2, 3, 4, 5, 6, 7, 8, 9, 10, 11,...

[r,g,b,a,r,g,b,a,r,g,b,a,...] [r,g,b,a,r,g,b,a,r,g,b,a,...]

Figure 8.10: An illustration of the breakdown of each pixel by Integrated Digital Media, NYU. Image from https://idmnyu.github.io/p5.js-image/ (19)

Let's make a variable Loc for storing pixel information. Each pixel position needs to be clearly located so that a line can be drawn at the right position. Following the function Pixels(), each pixel takes up four locations: The first pixel with the four RGBA values, then the second pixel with another four RGBA values, and so on, and so forth:

pixels = [p1, p1, p1, p1, p2, p2, p2, p2, p3, p3, p3, p3..]

Therefore, the pixel consists of four different locations, each one storing a single value relating to a single pixel. The formula for locating a specific pixel is Loc = (img_x+img_y * img.width)*4;. The use of img.pixels[loc], img.pixels[loc+1], img.pixels[loc+2] locates the respective RGB values using the function pixels[].

```
1   function draw() {
2       if (getImg){     //takes time to retrieve the API data
3           loadImage(getImg, img=> { //callback function
4               //draw the frame + image
5               push();
6               translate(width/2-img.width-frameBorder, height/2-img.height-frameBorder);
7               scale(2);
8               if (!imgLoaded) {
9                   noStroke();
10                  fill(220);
11                  rect(0, 0, img.width+frameBorder*2, img.height+frameBorder*2);
12                  image(img,frameBorder, frameBorder);
13                  imgLoaded = true;
14              }else{
15                  //draw lines
```

```
16        img.loadPixels();
17        img_x = floor(random(0, img.width));
18        img_y = floor(random(0, img.height));
19        /* The formula to locate the no: x+y*width, indicating a pixel
20        from the image on a grid (and each pixel array holds red, green, blue,
21        and alpha values), for more see here:
22        https://www.youtube.com/watch?v=nMUMZ5YRxHI */
23        loc = (img_x+img_y * img.width)*4;
24        strokeWeight(0.7);
25        //rgb values
26        stroke(color(img.pixels[loc], img.pixels[loc + 1], img.pixels[loc+2]));
27        line(frameBorder+img_x, frameBorder+img_y,
28            frameBorder+img_x, frameBorder+img.height);
29      }
30    pop();
31  });
32  }
33 }
```

The above code snippets is an excerpt of the parts about the color visualization. The logic in the draw() function is to draw the grey outer frame and load the image in the center by using the function translate() (see Line 6.)

The conditional structure if (getImg){} (see Line 2) is used to allow sufficient time to load the JSON file and to be able to get the file path. Upon the successful loading of an image (with the function loadImage() (see Line 3) and the corresponding callback function img), both the outer frame and the image are drawn on the canvas.

The outer frame and the image are only drawn once with the update of the status imgLoaded (see Line 8). For each frame drawn, the program will analyze the image's pixels using the syntax loadPixels() (see Line 16), picking the random pixel, and getting the corresponding pixel's x and y coordinates (using the variables img_x and img_y). It then gets the RGB color values from the selected pixel using pixels[], then draws the colored line with the syntax strokeWeight(), stroke() and line() (see Lines 24-28).

This section with the pixel and color elements shows how a computer processes and stores an image as data which is fundamentally different from how humans see and perceive it. [20] It is also a way to demonstrate how an image object is being translated into numbers for computation, which is somewhat similar to the example of face tracking in Chapter 4, "Data capture," in which a pixel can be located at a scale beyond human perception. These examples may help you understand contemporary applications like tracking technology and even computer vision that employs machine learning techniques in which images function as training data (we return to this in Chapter 10, "Machine unlearning").

Different types of bugs

In 1945, a dead moth was taped into Grace Murray Hopper's computer log book to document a problem with Harvard University's Mark II Aiken Relay Calculator. (33) The "bug" (32) was trapped between relay contacts and interrupted the program flow of the early electromechanical computer. In early days of digital computers like ENIAC, with panel-to-panel wiring cables and switches for programming, "debugging" was carried out by unplugging cables. In this way, one could stop a program running in the middle to debug an issue. Nowadays, debugging in an integral part of high level programming languages to assist programmers to locate bugs by executing code line by line. At this stage – as you have developed your programming skills and your programs are becoming more complex – it is important to understand, identify, and locate errors or bugs (as part of the debugging process (21)) so that you can build a workable sketch.

Paying close attention to errors/bugs is a vital part of learning to program as this allows programmers to gain insights into program operations, such as at which point the program produces unexpected results and causes failure. Are you able to identify whether the errors are from your own code, or from parsing the data while it is running, or from other third parties like the image search engine when you debug your sketch? (Programs are getting more complex because there are more agents involved.) Are they minor errors or critical errors (that stop your program from running)? Are they syntactic, runtime, or logical errors (as explained below)?

Broadly speaking, there are three types of errors:

1. **Syntax errors** are problems with the syntax, also known as parsing errors. These errors — such as spelling errors or missing a closed bracket — tend to be easier to catch, and can be detected by a parser (in this case the browser).

 SyntaxError: missing) after argument list

2. **Runtime errors** happen during the execution of a program while the syntax is correct. The web browser console is the place to understand these errors. Below shows two examples of runtime errors:
 If we remove the conditional checking `if (getImg){}` within the `draw()` function, the program cannot initially load the image as it takes some time to process the web API request. The error will keep on showing in the web console until the program successfully parses the image URL.

 p5.js says: `LoadImage()` was expecting `String` for parameter #0 (zero-based index), received an empty variable instead. If not intentional, this is often a problem with scope: https://p5js.org/examples/data-variable-scope.html at about:srcdoc:94:6. https://github.com/processing/p5.js/wiki/Local-server Wrong API key sent to the server. It is a more critical error because the program cannot extract the image and display it on the screen:

|| p5.js says: It looks like there was a problem loading your json. Try checking if the file path is correct, or running a local server. ||

3. **Logical errors** are arguably the hardest errors to locate as they deal with logic not syntax. The code may still run perfectly, but the result is not what was expected. This indicates a discrepancy between what we think we asked the computer to do and how it actually processes the instructions. The web console is a good place to be notified of errors or test whether the code is running as we expected. When solving errors, it is important to identify exactly where they occur, i.e. which block or line of code contains the mistake by using `console.log()` (or `print()` in p5.js). Test and run the various parts of the program step by step, then try to identify the error types, and fix them accordingly.

WhiDe()

The discussion of errors brings us back to what we mean by query and que(e)ries: asking whether something like data is valid or accurate, but also to questioning how it is deemed to be valid or accurate in the first place. There is a danger of self-fulfilling prophecy here unless further questions are asked about data, and the conditions of its operation. When it comes to big data, for instance, there is a tendency to think of unstructured data as raw and unmediated, whereas in practice there is always some additional information about its composition, not least derived from the means by which it was gathered in the first place. A more "forensic" approach reveals how the data was selected, preprocessed, cleaned, and so on. This is in keeping with the way that Eyal Weizman and Thomas Keenan define "forensis" as more than simply the scientific method of data-gathering or capture:

> "Forensics is, of course, not simply about science but also about the presentation of scientific findings, about science as an art of persuasion. Derived from the Latin 'forensis,' the word's root refers to the 'forum,' and thus to the practices and skill of making an argument before a professional, political or legal gathering. In classical rhetoric, one such skill involved having objects address the forum. Because they do not speak for themselves, there is a need for a translation, mediation, or interpretation between the — 'language of things' — and that of people." (22)

Using forensics it is possible not only to detect features or patterns in data, but also to generate new forms, new shapes, or arguments: to allow data to speak for itself — as witness in a court of law, for instance — and to uncover aspects of what is not directly apparent in the material. These principles are fundamental to the work of Forensic Architecture not least (which Weizman is part of), (23) and the practice of forensics in this case refers to the production and presentation of architectural evidence within legal and political processes, with data offering the ability to bear witness like spoken (human) testimony. In such cases knowledge is produced in very precise ways rather than through the reductive generalizations of typical algorithms that make sense of the big data in distorted ways.

As noted in the introduction, simple operations such as search or feeds order data and reify information in ways that are clearly determined by corporate interests. The politics of this resonates with what Antoinette's Rouvroy's phrase "algorithmic governmentality" (the second part of which combines the terms government and rationality) to indicate how our thinking is shaped by various techniques. (24) According to Rouvroy, knowledge is increasingly delivered "without truth" thanks to the increasing use of machines that filter the latter using search engines that have no interest in the content as such or how knowledge is generated. The concern is that algorithms are starting to define what counts as knowledge, a further case of subjectification (the process through which we become subjects). Rouvroy claims: "The new, "truth regime," evolving in real-time, may appear "emancipatory" and "democratic" (with regards to "old" authorities, hierarchies and suspiciously rigid categories and measures), but the "subjects" it produces are "multitudes without alterity." (25) This produces human subjects in relation to what algorithms understand about our intentions, gestures, behaviors, habits, opinions, or desires, through a process of aggregating massive amounts of data. (1) Rouvroy calls this "personalization without subjects" and identifies the mistake of focusing on concerns about personal data when what is at stake are the processes of subjectification by data mining and profiling, by means of algorithmic governmentality.

If you keep these ideas in mind Cornelia Sollfrank's project *Female Extension* (mentioned at the beginning of this chapter) becomes all the more powerful, as it hacks the process of personalization. The male domination of the "art operating system" is tricked into believing its own liberal agenda of inclusion and yet the whole scenario is fake. When it comes to Google and its operations, we can see that although it provides its API for experimentation, it only does so under restrictions: by limiting requests for public and non-profit/educational use, and by only revealing some of the available parameters in which the logic of how the search data (as knowledge) is presented algorithmically is still unknown to the public. *nag* emphasizes the querying of data, not only the execution of the data request and its response, but also by questioning the perpetuation of cultural "norms." In *Algorithms of Oppression*, Safiya Umoja Noble, for example, demonstrates how racism is reinforced through hegemonic search results:

> "Search happens in a highly commercial environment, and a variety of processes shape what can be found; these results are then normalized as believable and often presented as factual [and] become such a normative part of our experience with digital technology and computers that they socialize us into believing that these artifacts must therefore also provide access to credible, accurate information that is depoliticized and neutral." (26)

The organization of information is structured through the process of generalization. Concerning advanced data-mining processes and statistically modelling, Adrian Mackenzie speaks of the various kinds of generalization at work that allow for the development of machine learning. (27) It is important to recognize how all techniques of pattern recognition and statistics "generate statements and prompt actions in relation to instances of individual desire" and they transform, construct, and impose shape on data, in order to then "discover, decide, classify, rank, cluster, recommend, label or predict" something or other. (28) The assumption, as Mackenzie points out, is that everything that exists is reducible to stable and

distinct categorization: "In all cases, prediction depends on classification, and classification itself presumes the existence of classes, and attributes that define membership of classes." (29) This presumption of stable classes and classifications is one of the main problems that we wish to query here, as if the world was organized that way too (when it is clearly not). The difficulty lies as to what extent any model is accurate or valid.

To que(e)ry data in this way throws into further question how data is collected, stored, analyzed, recommended, ranked, selected, and curated in order to understand the broader social and political implications, not least how categorizations such as gender and race are normalized and hegemonized. To query the power structures of materials from a feminist standpoint is to understand "the mechanisms that shape reality" (30) and how they might be reprogrammed.

MiniX: Working with APIs (in a group)

Objectives:

- To design and implement a program that utilizes web APIs. (31)
- To learn to collaboratively code and conceptualize a program.
- To reflect upon the processes of data parsing using an API, paying attention to the registration, availability, selection, and manipulation of data.

Get additional inspiration:

- *Queer Motto API* by Winnie Soon and Helen Pritchard (2021), http://siusoon.net/queer-motto-api
- Open Weather with code example, https://www.youtube.com/watch?v=ecT42O6l_WI.
- Other weather API example with code example, https://p5js.org/examples/hello-p5-weather.html.
- *New York Times* with code example, https://www.youtube.com/watch?v=IMne3LY4bks&list=PLRqwX-V7Uu6a-SQil4RtIwuOrLJGnelOr&index=9.
- Giphy images with code example, https://www.youtube.com/watch?v=mj8_w11MvH8&index=10&list=PLRqwX-V7Uu6a-SQil4RtIwuOrLJGnelOr.
- Wikipedia API, https://www.youtube.com/watch?v=RPz75gcHj18.
- Twitter API and Twitter Bot with code example, http://shiffman.net/a2z/twitter-bots/. (Note that Twitter has tightened the rules for registering the API and you need to have a convincing proposal as well as the process can be lengthy.)
- Search many other kinds of API, https://www.programmableweb.com/.

Tasks (RunMe):

This is a relatively complex exercise that requires you to:

- Design a program that utilizes at least one web API, including:
 - Finding available web APIs and the data that you want to explore.
 - Understanding the available data: the data file format and the API's specifications.
 - Deciding which data fields you want to choose to explore and experiment with.
 - Utilizing the web API and the corresponding data in your program. (Please reserve more time if you are getting data from other platforms, as the registration process can take a long time.)

Questions to think about (ReadMe):

- What is the program about? Which API have you used and why?
- Can you describe and reflect on your process in this miniX in terms of acquiring, processing, using, and representing data? How much do you understand this data or what do you want to know more about? How do platform providers sort the data and give you the requested data? What are the power relations in the chosen APIs? What is the significance of APIs in digital culture?
- Try to formulate a question in relation to web APIs or querying/parsing processes that you would like to investigate further if you had more time.

Required reading

- David Gauthier, Audrey Samson, Eric Snodgrass, Winnie Soon, and Magda Tyżlik-Carver, "Executing," in Nanna Thylstrup, Daniela Agostinho, Annie Ring, Catherine D'Ignazio and Kristin Veel, eds., *Uncertain Archives* (Cambridge, MA: MIT Press, 2021).

- Daniel Shiffman, "Working with data - p5.js Tutorial," *The Coding Train* (10.1, 10.4 - 10.10), https://www.youtube.com/playlist?list=PLRqwX-V7Uu6a-SQil4RtIwuOrLJGnelOr.

- Eric Snodgrass and Winnie Soon, "API practices and paradigms: Exploring the protocological parameters of APIs as key facilitators of sociotechnical forms of exchange]," *First Monday* 24, no.2 (2019), https://doi.org/10.5210/fm.v24i2.9553.

Further reading

- Jonathan Albright, "The Graph API: Key Points in the Facebook and Cambridge Analytica Debacle," *Medium* (2018), https://medium.com/tow-center/the-graph-api-key-points-in-the-facebook-and-cambridge-analytica-debacle-b69fe692d747.

- Taina Bucher, "Objects of intense feeling: The case of the Twitter API," in *Computational Culture*, Nov 27 (2013), http://computationalculture.net/article/objects-of-intense-feeling-the-case-of-the-twitter-api.

- Christoph Raetzsch, Gabriel Pereira, and Lasse S. Vestergaard, "Weaving Seams with Data: Conceptualizing City APIs as Elements of Infrastructures," *Big Data & Society*, Jan (2019), https://journals.sagepub.com/doi/full/10.1177/2053951719827619.

Notes

1. Wendy Hui Kyong Chun, *Updating to Remain the Same: Habitual New Media* (Cambridge, MA: MIT Press, 2016).

2. Big data is referred to as "Big Dick Data" by Catherine D'Ignazio and Lauren Klein, to mock big data projects that are characterized by "masculinist, totalizing fantasies of world domination as enacted through data capture and analysis," see "The Numbers Don't Speak for Themselves," in *Data Feminism* (Cambridge, MA, MIT Press 2020), 151.

3. René König and Miriam Rasch, "Reflect and Act! Introduction to the Society of the Query Reader," in René König and Miriam Rasch, eds. *Society of the Query: Reflections on Web Search* (Amsterdam: The Institute of Network Cultures, 2014), https://networkcultures.org/query/2014/04/23/reflect-and-act-introduction-to-the-society-of-the-query-reader/.

4. See Ashok K. Chandra and David Harel, "Computer Queries for Relational Data Bases," *Journal of Computer and System Sciences* 21, no.2 (1980): 156-178; Winnie Soon, *Executing Liveness: An Examination of the Live Dimension of Code Inter-actions in Software (Art) Practice*, PhD dissertation, Aarhus University (2016); Eric Snodgrass and Winnie Soon, "API practices and paradigms: Exploring the protocological parameters of APIs as key facilitators of sociotechnical forms of exchange," *First Monday* 24, no.2 (2019).

5. Since 1997, there are five different versions of *nag* that have been realized by seven programmers at various stages of the project. In 2003, Version 5 started using images from Google search, but this became broken in 2015. The current version, 5b was updated in 2017 by Winnie Soon, and this is the version that officially utilized Google Image Search API according to the specification. See http://net.art-generator.com/.

6. *Extension* was sponsored by the Galerie der Gegenwart (Gallery of Contemporary Art) of the Hamburger Kunsthalle (Hamburg Art Museum). Despite the disproportionate number of submissions by female artists, only male artists were selected as finalists. After the decision was announced, Sollfrank went public. Some documentation for *Female Extension* can be found at http://www.artwarez.org/femext/index.html.

7. Old Boys Network (OBN) is widely regarded as the first international Cyberfeminist alliance and was founded in 1997, in Berlin. See https://www.obn.org/.

8. Sollfrank employs Thomas Wulffen's phrase, in Cornelia Sollfrank, "Hacking the Art Operating System," interviewed by Florian Cramer, Chaos Computer Club, Berlin (2001).

9. See https://p5js.org/reference/#/p5/loadJSON.

10. See https://p5js.org/reference/#/p5/loadImage.

11. See https://p5js.org/reference/#/p5/image.

12. See the reference guide of LoadPixels(), https://p5js.org/reference/#/p5/loadPixels.

13. To request an API key from other image-related platforms, such as Giphy and Pexels, see https://support.giphy.com/hc/en-us/articles/360020283431-Request-A-GIPHY-API-Key and https://www.pexels.com/api/.

14. See https://developers.google.com/custom-search/v1/overview.

15. See https://cse.google.com/all.

16. There are other optional parameters, see https://developers.google.com/custom-search/json-api/v1/reference/cse/list#parameters.

17. See https://w3c.github.io/webappsec-cors-for-developers/.

18. Snodgrass and Soon, "API Practices and Paradigms."

19. A tutorial on Image Processing in p5.js, see https://idmnyu.github.io/p5.js-image/.

20. Such a breakdown of an image into color scale pixels was also used in electronic television transmission in the mid-1930s, but in this case data was sent manually by a telegraph operator via the medium of Wire or Radio. See George H. Eckhardt, *Electronic television* (Chicago: Goodheart-Willcox Company, Incorporated, 1936), 48-50.

21. There is a debugging tutorial created for the p5.js contributor conference by Jason Alderman, Tega Brain, Taeyoon Choi and Luisa Pereira, see: https://p5js.org/learn/debugging.html.

22. Thomas Keenan and Eyal Weizman, *Mengele's Skull: The Advent of a Forensic Aesthetics* (Berlin: Sternberg Press, 2012); see also Matthew Kirschenbaum, *Mechanisms: New Media and the Forensic Imagination* (Cambridge, MA: MIT Press, 2008).

23. Forensic Architecture, directed by Eyal Weizman, is a research agency based at Goldsmiths, University of London, who undertake advanced spatial and media investigations into cases of human rights violations, with, and on behalf of, communities affected by political violence, human rights organizations, international prosecutors, environmental justice groups, and media organizations. See https://forensic-architecture.org/.

24. The idea of "governmentality" is derived from the work of Michel Foucault, especially his lectures at the Collège de France 1982-1983. In Rouvroy's lecture "Algorithmic Governmentalities and the End(s) of Critique" at the Institute for Network Cultures (October 2013) she makes the argument that critique is not possible without access to a fuller understanding of how knowledge is being produced.

25. See Antoinette Rouvroy, "Technology, Virtuality and Utopia: Governmentality in an Age of Autonomic Computing," in Mireille Hildebrandt and Antoinette Rouvroy, eds., *Autonomic Computing and Transformations of Human Agency* (London: Routledge, 2011).

26. Safiya Umoja Noble, *Algorithms of Oppression: How Search Engines Reinforce Racism* (New York: New York University Press, 2018), 24-25.

27. Adrian Mackenzie, "The Production of Prediction: What Does Machine Learning Want?" *European Journal of Cultural Studies* 18, nos.4-5 (2015): 431.

28. Mackenzie, "The Production of Prediction", 432.

29. Mackenzie, "The Production of Prediction", 433.

30. Cornelia Sollfrank, ed. *Beautiful Warriors: Technofeminist Praxis in the Twenty-First Century* (New York: Autonomedia/Minor Compositions, 2019), 6.

31. For those APIs that require the OAuth 2.0 authorization, a standard protocol for authorization, you might need Node.js (https://nodejs.org/en/) to handle the server-client authentication. At the beginner level, it is recommended to look for web APIs with the registration of API keys. See what Node is for 15.1 and 15.2 (https://www.youtube.com/watch?v=RF5_MPSNAtU&index=1&list=PLRqwX-V7Uu6atTSxoRiVnSuOn6JHnq2yV), and the OAuth 2.0 Authorization Framework that is proposed by Internet Engineering Task Force in 2012 (https://tools.ietf.org/html/rfc6749).

32. The term "bug" was coined by Thomas Edison in 1873 and it was used to describe a technical problem, like a fault in the connections of an electric apparatus. See Alexander Magoun and Paul Israel, "Did You Know? Edison Coined the Term 'Bug'," *IEEE Spectrum* (August 1, 2013), https://spectrum.ieee.org/the-institute/ieee-history/did-you-know-edison-coined-the-term-bug.

33. The log book has been archived at the National Museum of American History, https://americanhistory.si.edu/collections/search/object/nmah_334663.

9. Algorithmic procedures

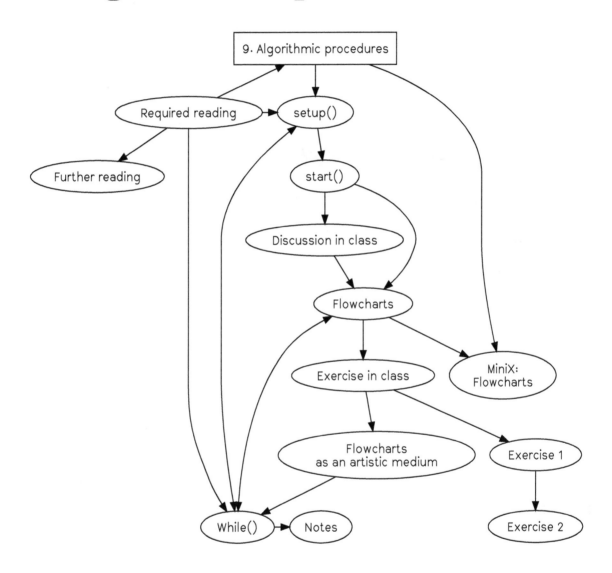

Contents

setup()

The pioneer computer scientist and programmer Grace Murray Hopper famously described planning skills in programming as "just like planning a dinner." (1) Programming is similar to cooking inasmuch as it requires patience and the ability to manage details and ingredients. (2) That an algorithm or recipe can be written down in a cookbook or codebook so the actions can be followed, shared and repeated, is something that the programmer Donald Knuth also identified in his *The Art of Computer Programming* (1968), to stress the aesthetic dimension of programming by analogy to recipes in a cookbook. (3) Indeed both coding and cooking share common attributes including how sources are selected, actions applied, and how transformations take place. These comments, and Knuth's writing style, set the tone for this chapter in terms of subject matter, but also as far it lays out algorithmic instructions for the reader: the "procedures for reading," (4) as he puts it. Here are some snippets:

> "1. Begin reading this procedure, unless you have already begun to read it. Continue to follow the steps faithfully; [...] 5. Is the subject of the chapter interesting you? If so, go to step 7; if not, go to step 6. 14. Are you tired? If not, go back to step 7; 15. Go to sleep. Then, wake up, and go back to step 7." (5)

The example serves to emphasize that we tend to follow instructions faithfully. However, we might also observe that algorithms are more than simply steps and procedural operations as there are wider cultural and political implications, not least in terms of whether we decide to interpret them on our own terms. In this sense, like cooking, algorithms express cultural differences, and matters of taste, even aesthetics. Extending the analogy to other cultural practices, Knuth quotes Ada Lovelace: "The process of preparing computer programs for a digital computer is especially attractive, not only because it can be economically and scientifically rewarding, but also because it can be an aesthetic experience much like composing poetry or music." (6)

In this chapter we will discuss some of these recipe-like algorithmic procedures and how they describe the steps and operations of a program, and less about the syntax of code. An algorithm differs from lines of code in that it is not dependent on specific software and libraries. It is simply a process or set of rules to be followed in calculations, or other problem-solving operations especially by a computer. (7) An algorithm is a skeleton of how a program operates and shows the operational steps which, ideally, can be implemented by any "Turing-complete" machine, thereby computationally universal, and able to solve any computation problem. (8) In other words, an algorithm demonstrates the systematic breakdown of procedural operations to describe how an operation moves from one step to the next. It's only like a recipe in a general sense in that it is a set of step-by-step instructions, but the analogy only goes so far, as recipes lack the exactness and reproducibility of Turing-completeness to operationally solve computational problems by recognizing and maniplucating data according to given instructions.

start()

In Chapter 3, "Infinite loops," we briefly introduced the computational diagram drafted by Ada Lovelace in 1842, often referred to as the world's first computer program. (9) (See Figure 3.2) The published diagram and Lovelace's extensive notes demonstrate the sophisticated step-by-step operations required to solve mathematical problems. The instructions are designed to be automatically executed by a machine. As she put it, "I want to put something about Bernoulli's numbers, in one of my Notes, as an example of how the implicit function may be worked out by the engine without human head & hands first. Give me the necessary formulae." (10) The formulae are expanded into algorithmic procedures in the diagram.

In this chapter we will build on "diagramming," particularly the use of flowcharts to elaborate the practical and conceptual aspects of algorithmic procedures. Flowcharts, "Flow of the chart -> chart of the flow" (11), have been considered a fundamental explanatory tool since the early days of computer programming. One of their common uses is to illustrate computational operations and data processing for programming by "converting the numerical method into a series of steps." (12) But flowcharts can also be considered to be representational diagrams which can also be used to communicate complex logic between programmers and others involved in software production. This is good practice of course, especially for beginners in a learning context, and is essential for communicating ideas in ways that can be easily understood by others. Indeed programming is not necessarily a solitary activity, (13) as we have discussed, and can be a social, and communicative practice that exposes relations between different entities exemplified by diagramming. Moreover most software applications are not developed by a single programmer but are organized into tasks that are tackled collaboratively by programmers, as for instance when maintaining or debugging a program made by someone else. Collaborative workflows lends themselves to flowcharts.

Discussion in class

- Can you give an everyday example (detailing the computational logic) of an algorithm that you have used or experienced?
- Can you sketch an algorithmic procedure? For example, how your social media feeds are organized?
- Based on the assigned reading from Taina Bucher, can you list some of the properties of algorithms? How are they both technical and social?
- We discussed rule-based systems in Chapter 6, "Auto-generator," how does that differ from how we are now discussing procedurality in this chapter?

FDowcharts

Conventionally, each step in a flowchart is represented by a symbol and connecting lines that indicate the flow of logic towards a certain output. The symbols all have different meanings. Below we outline the basic components for drawing a flowchart:

- **Oval**: Indicates the start or end point of a program/system. (But this requires further refection on whether all programs have an end.)
- **Rectangle**: Represents the steps in the process.
- **Diamond**: Indicates the decision points with "yes" and "no" branches.
- **Arrow**: Acts as a connector to show relationships and sequences, but sometimes an arrow may point back to a previous process, especially when repetition and loops are concerned.

Figure 9.1 shows the flowchart for the program *Vocable Code* we examined in Chapter 7. The flowchart shows the high-level logic and sequences, and elaborates its details in plain English. This flowchart uses symbols, lines, and text to communicate to a wider public as well as the readers of this book.

Flowcharts are used across many disciplines, both technical and artistic. For example, they are relatively common in business contexts and provide insight into, and communicate how various processes or workflows are efficiently organized. In philosophy, diagrams have been used to produce new kinds of thought processes and relations, for example Gilles Deleuze and Félix Guattari refer to them as "abstract machines." (14) We will return to these ideas in more detail at the end of the chapter. Similarly, in our teaching, we have used flowcharts as a means of deconstructing writing as well as to break down an argument in an essay structure, as a way to formulate new ideas and structure. Diagrams are good tools, or rather "machines," that help us think through different procedures and processes, and this approach has evidently informed our use of flowcharts to introduce each chapter of this book.

In this chapter's miniX, you will be asked to collaboratively produce a flowchart for a new project idea. By now you are probably more confident building a more complex program that incorporates a variety of syntax, so organization presents itself as a more challenging and necessary task. We have found that one of the difficulties people face is how to combine and link various functions, and to break down a task into smaller, sequential steps. We think a flowchart is an effective means of formulating ideas, generating discussion, observing relations, predicting technical challenges, and providing a means for cooperation on a project. If tasks need to be sub-divided among a group, for instance, flowcharts can be used to identify how a smaller task can be linked to others without losing site of the bigger picture.

Some of the challenges to turning an existing program into a flowchart include:

1. Translating programming syntax and functions into understandable, plain language.

2. Deciding on the level of detail on important operations to allow other people to understand the logic of your program.

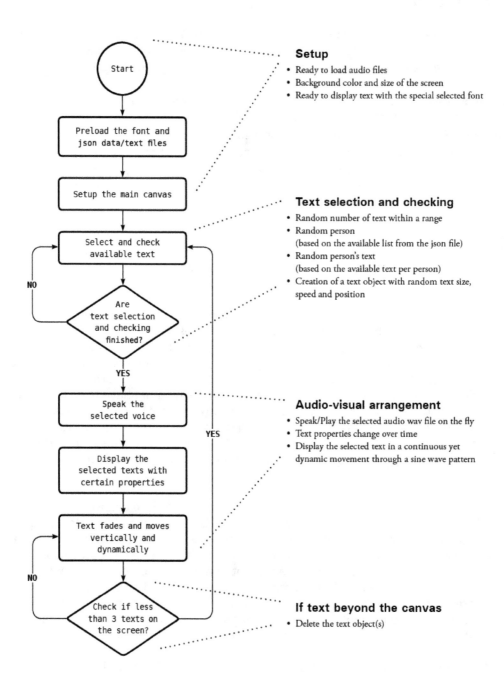

Figure 9.1: The flowchart for Vocable Code by Winnie Soon, graphic design by Anders Visti.

Exercise in class

Exercise 1

Let's start with something that appears relatively simple, such as incorporating emojis and paying attention to the variable names. The program code below references *Multi* for emoticons (from Chapter 2, "Variable geometry") and *Vocable Code* for naming (from Chapter 7, "Vocable code") to print various multispecies emoticons, one after another, using a for-loop in the web browser console. The task is to draw a flowchart based on this program:

```
1  function setup() {
2    let multi = [😺,🐷,🐸,🐱];
3    for (let species = 0; species < multi.length; species++) {
4      console.log(multi[species]);
5    }
6  }
7  /*output
8  😺
9  🐷
10 🐸
11 🐱
12 */
```

Our previous use of this exercise in a classroom setting (15) resulted in different drawings being produced and they became a resource for discussion around the multiple purposes and meanings of flowcharts. (16)

Exercise 2

Sorting is a common algorithm in digital culture, and recommendation lists on Spotify, Amazon, and Netflix, will be familiar to you. Think about the "algorithmic procedures" required to program something to solve the sorting task set below. (17)

Generate a list of x (for example, x = 1,000) unique, random integers between two number ranges. Then implement a sorting algorithm and display them in ascending order. You are not allowed to use the existing sort() function in p5.js or JavaScript. How would you approach this problem? Draw the algorithm as a flowchart with the focus on procedures/steps, but not the actual syntax.

Flowcharts as an artistic medium

Beyond the pragmatic use of flowcharts, they can also be artistic objects in their own right, as a "meta-medium for an aesthetics of social complexity," as Paolo Cirio puts it. (18) An example from 2005, is *Google Will Eat Itself*, (19) an artwork that auto-generates revenue by hacking the Google AdSense, and was created by Cirio in collaboration with Alessandro Ludovico and UBERMORGEN. (20) The project automatically triggers advertising clicks on websites in order to receive micropayments from Google which are in turn used to buy shares in Google: "We buy Google via their own advertisement! Google eats itself — but in the end 'we' own it!"

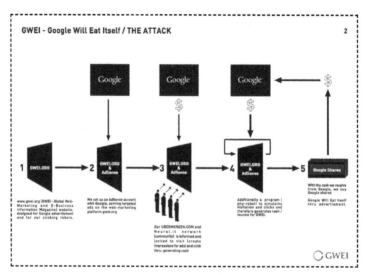

Figure 9.2: *Paolo Cirio, Alessandro Ludovico, and UBERMORGEN, Google Will Eat Itself / THE ATTACK (2005). Courtesy of the artists.*

The iterative (or cannibalistic) loop can clearly be seen in the diagram and echoes the principle of the "strange loop:" forced "to eat its own tail" in Babbage's words, altering its own stored program and thereby offering the potential to generate new technical and aesthetic forms, as previously mentioned with reference to the operations of the Analytical Engine. Taken to its extreme, this type of loop is called a "forkbomb" and takes the shape of a "denial-of-service" attack in which a computer process continuously replicates itself in order to use up all available system resources, slowing down, or crashing the system due to resource starvation. Reflected in the title of another project, UBERMORGEN's *The Project Formerly Known as Kindle Forkbomb* (2012), used a machine process that stripped comments from YouTube videos. An algorithm then compiled the comments and added titles, producing an e-book which was subsequently uploaded to the Amazon Kindle e-commerce bookstore. (21) This process is sketched in the diagram, using an image of a traditional printing press (see Figure 9.3), and further exploited in the installation version, which combined the diagram on the gallery floor and physical objects (see Figure 9.4). (22) In both cases, algorithmic procedures are in operation which mimic and mock the operational logic of Amazon's post-Gutenberg business model, the key principles of which are outlined on the Kindle website: "Get to market fast. Make more money. Keep control." (23)

Figure 9.3: UBERMORGEN, *The Project Formerly Known As Kindle Forkbomb* (2013). Courtesy of the artists

Figure 9.4: UBERMORGEN, *The Project Formerly Known As Kindle Forkbomb* (2013), mixed media installation, part of the group exhibition "Systemics #2: As we may think (or, the next world library)," curated by Joasia Krysa, Kunsthal Aarhus (September 21–December 31 2013). Courtesy of the artists and Kunsthal Aarhus

WhiDe()

The shift of critical attention in software studies from source code to the operations of algorithms, such as the sorting exercise above, reflects the rise of big data, and machine learning (which we will discuss in the next chapter). Algorithms in this sense are there to transform, construct, and shape data, in order to then classify, rank, cluster, recommend, label, or even predict things. The concern is not how to build an efficient or optimized algorithm, but to understand these operative dimensions better. In *If... Then: Algorithmic Power and Politics*, Taina Bucher stresses that algorithms are "fundamentally productive of new ways of ordering the world". (24) So although the concept of algorithm is associated with the disciplines of mathematics and computer science, the wider cultural field has taken an interest in algorithms to explore the political consequences of procedural operations.

In *What Algorithms Want*, Ed Finn explores the concept of the algorithm as a "culture machine" and argues that an algorithm "operates both within and beyond the reflexive barrier of effective computability (Turing-completeness), producing culture at a macro-social level at the same time as it produces cultural objects, processes, and experiences." (25) It is clear that algorithmic procedures play an important role in organizing culture, and subjectivities, and it is not very easy to see through or describe them because they operate beyond what we experience directly. They produce wider effects in the ordering of life. Algorithms do things in the world and have real effects on machines and humans. In *Software Studies*, Andrew Goffey clarifies this performative aspect:

> "Algorithms act, but they do so as part of an ill-defined network of actions upon actions, part of a complex of power-knowledge relations, in which unintended consequences, like the side effects of a program's behavior, can become critically important. Certainly the formal quality of the algorithm as a logically consistent construction bears with it an enormous power — particularly in a techno-scientific universe — but there is sufficient equivocation about the purely formal nature of this construct to allow us to understand that there is more to the algorithm than logically consistent form." (26)

To take an example, in "Thinking Critically About and Researching Algorithms," Rob Kitchin explains how Facebook's EdgeRank works in tandem with each users' inputs, ordering the results in personalized ways. These operations are not fixed, but are contextual and fluid, (27) part of larger, socio-technical assemblages, and infrastructures that are also constantly evolving and subject to variable conditions. As such, although they appear to act somewhat autonomously, algorithms need to be understood as relational, contingent and contextual entities. (28) Diagrams such as the ones above can be used to help understand how algorithms act as part of broader ecologies to highlight their agential power.

The diagrams we introduced in this chapter reveal this, and how apparently simple operations such as searches or feeds (e.g. Facebook's EdgeRank or Google's PageRank) order data, and reify information in ways that are determined by particular instances of power. Matteo Pasquinelli's essay "Google's PageRank Algorithm: A Diagram of the Cognitive Capitalism and the Rentier of the Common Intellect." provides more detail by closely

examining the politics behind PageRank, the hypertextual algorithm that calculates the importance of a given web page and its hierarchical position within search engine results. (29) His key point is that the algorithm reverses the centralized panopticon model of surveillance and control, and instead offers a "bio-political machine" that captures time and living labor through dataveillance. That PageRank is broadly based on citation indexes further emphasizes its relevance for this book or any academic book, and how value is produced by assessing the quality of links (much like the attention value produced by social media "likes" and "friends," or by the metrification of academic research outputs), resulting in new forms of surplus value. The algorithm, or "value machine" in Pasquinelli's words, and moreover is an "abstract machine," and diagram.

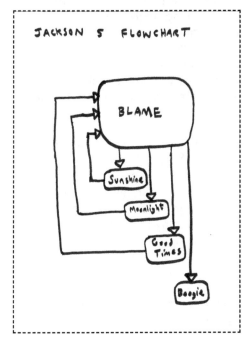

Figure 9.5: *Dean Kenning, Jackson 5 Flowchart* (2017). A4, marker pen on paper. Courtesy of the artist (31)

But what is a diagram? Leaving aside the use of diagrams as functional tools, or for didactic purposes that tend to simplify information (infographics are a case in point), they also feature as a form of expanded aesthetic practice, as we hope our examples above have demonstrated. In this chapter we have tried to reflect these practices in our use of flowcharts as an experimental aesthetic form. We already mentioned the idea of the diagram as an "abstract machine" in the introduction, and this is the phrase that Deleuze and Guattari use to reflect that matter and form are able to transform themselves: abstract machines exhibit "morphogenesis" (a term we also know from Turing, as mentioned in Chapter 5, "Auto-generator"). In this way, diagrams instantiate future possibilities that are not predetermined, but are open-ended, speculative fictions. (30) Such descriptions might sound esoteric, but the overall point is clear and even scientific (from thermodynamics) in that there are things that have morphogenetic possibilities, and systems are continuously traversed by flows (vectors) of energy, and matter that do not cancel but maintain differences. What we end up with are speculative geometries, self-organizing forms, and diagrammatic processes that reflect dynamic forces. The diagram is an "image of thought," in which thinking does not consist of problem-solving but — on the contrary — problem-posing. We want to highlight these distinctive qualities in this chapter which is somewhat at odds with the conventional descriptions of algorithmic procedures.

But can we really think about flowcharts as diagrams in Deleuzian terms, as abstract machines? Their general similarity, we would claim, is their ability to visualize problems and helps us think them through in the process of that very visualization, a "picturing of thought" as Deleuze would have it. In his "On the Diagram (and a Practice of Diagrammatics)," Simon O'Sullivan provides a summary of this speculative approach:

"The diagram here is a strategy of experimentation that scrambles narrative, figuration - the givens - and allows something else, at last, to step forward. This is the production of the unknown from within the known, the unseen from within the seen. The diagram, we might say, is a strategy for sidestepping intention from within intention; it involves the production of something that then 'speaks back' to its progenitor." (32)

Although referring to the practice of drawing rather than programming, we might hope for something similar — although admittedly more pragmatic — in the way that abstraction is invoked and the way that previously hidden aspects of programming might be "pictured" in flowcharts. Like diagramming, programming is an abstract machine that does not function to merely represent, but rather constructs a reality that is yet to come. As we discussed in previous chapters, programming is a form of abstraction that requires the selection of important details in which the implementation embodies the programmers' thinking and decision-making processes. In addition, algorithms themselves are decision-making machines that are full of emergent, even predictive, potential. (33)

In relation to the predictive practices of machine learning in particular, we might note that Adrian Mackenzie, in his *Machine Learners: Archaeology of a Data Practice*, also uses diagrams as an experiment in critical thinking to address the operations of machine learning. Mackenzie explains that when it comes to machine learning, "coding changes from what we might call symbolic logical diagrams to statistical algorithmic diagrams." (34) Here he relies on (and quotes) Deleuze's suggestion that diagrams act "as a display of the relation between forces that constitute power [and moreover] the diagram or abstract machine is the map of relations between forces, a map of destiny, or intensity." (35) This topic will be continued in the next chapter, but for now we would like to stress that analyzing algorithms, or source code for that matter, is not particularly illuminating in and of itself, unless the wider assemblage of relations is exposed. Flowcharts are one way to do this, to map these relations, as a means to facilitate critical thinking on the operations of programming.

MiniX: Flowcharts

Objective:

- To acquire the ability to break down a computer program into its definable parts and relations.
- To organize and structure a computer program using a flowchart.
- To understand a flowchart as a means for communication and planning, and a "machine" for critical thinking.
- To understand the concept of algorithms from both the computer science and cultural perspectives.

Tasks (RunMe):

Individual:

- Revisit your previous mini exercises and select the most technically complex one.
- Draw a flowchart to represent the program (pay attention to which items you select to present).

Group:

- Brainstorm two ideas for your final project (see next chapter's MiniX).
- Draw two flowcharts to visualize the project's algorithmic processes.

Questions to think about (ReadMe):

- What are the difficulties involved in trying to keep things simple at the communications level whilst maintaining complexity at the algorithmic procedural level?
- What are the technical challenges facing the two ideas and how are you going to address these?
- In which ways are the individual and the group flowcharts you produced useful?

Required reading

- Taina Bucher, "The Multiplicity of Algorithims," *If…Then: Algorithmic Power and Politics* (Oxford: Oxford University Press, 2018), 19–40.

- Nathan Ensmenger, "The Multiple Meanings of a Flowchart," *Information & Culture: A Journal of History* 51, no.3 (2016): 321-351, Project MUSE, doi:10.1353/lac.2016.0013.

- Marcus du Sautoy, "The Secret Rules of Modern Living: Algorithms," *BBC Four* (2015), https://www.bbc.co.uk/programmes/p030s6b3/clips.

Further reading

- Ed Finn, "What is an Algorithm," in *What Algorithms Want* (Cambridge, MA: MIT Press, 2017), 15-56.

- Andrew Goffey, "Algorithm," in Fuller, ed., *Software Studies*, 15-20.

- Daniel Shiffman, "Multiple js Files - p5.js Tutorial," *The Coding Train*, https://www.youtube.com/watch?v=Yk18ZKvXBj4.

Notes

1. The words of Grace Murray Hopper are cited in Lois Mandel, "The Computer Girls," *Cosmopolitan* (April 1967): 52-56.
2. Hopper's FLOW-MATIC was the first programming language to express operations using plain English description, developed for UNIVAC at Remington Rand. FLOW-MATIC was designed to use a step-by-step approach as "easily understood documentation" without requiring prior training in mathematics and formulars, computer coding and syntaxes, and to facilite communication "between the computer proramming group and operating management." See Remington-Rand Univac, *FLOW—MATIC Programming System* (Philadelphia, PA: Remington Rand Univac, Division of Sperry and Corporation, 1958).
3. The recipe analogy of algorithms was developed in Joasia Krysa and Grzesiek Sedek's "Source Code" entry to *Software Studies: A Lexicon*, 236-243. The analogy can also be found in recent texts that we have included in our essential/further reading lists for this chapter: Ed Finn, *What Algorithms Want: Imagination in the Age of Computing* (Cambridge, MA: MIT Press, 2017), 17; and Taina Bucher, *If...Then: Algorithmic Power and Politics* (Oxford: Oxford University Press, 2018), 21.
4. Knuth, *The Art of Computer Programming*, xv. Alongside the listed procedures, the book begins with a flowchart for reading the book, the significance of which will become obvious later in this chapter, and something we have also used for the individual chapters and contents page of this book.
5. Knuth, *The Art of Computer Programming*, xv-xvi.
6. Knuth, *The Art of Computer Programming*, v.
7. The term "algorithm" has a historical relation to "algorism" as the process of doing arithmetic using Arabic numerals (originating from the title of the book Kitab al jabr w'al-muqabala (Rules of restoration and reduction) written by Persian author Abu Ja'far Mohammed ibn Musa al-Khowarizmi (ca. 825).
8. Most modern programming languages are "Turing-complete," a term used to describe abstract machines, that can emulate a Turing machine. See Chapter 5, "Auto-generator," for more on Turing machines.
9. In particular to the complexity of the diagram for calculating Bernoulli numbers that includes the grouping of operations, the invention of the loop concept (repetition and cycle in Lovelace's term), the manipulation of symbols and variables in accordance with rules. Such algorithm were designed to be used in mechanical caluclating machines. At the time, the Babbage Analytical Engine was conceptually close to modern computers as it was envisioned as capable of more than just computation. See Luigi Federico Menabrea and Ada Lovelace, *Sketch of the analytical engine invented by Charles Babbage* (1842), 694.
10. Lovelace Papers, Bodleian Library, Oxford University, 42, folio 12 (February 6, 1841), as quoted, and cited in Dorothy Stein, ed., "This First Child of Mine," in *Ada: A Life and a Legacy* (1985), 106-107.
11. Peggy Pierrot, Martino Morandi, Anita Burato, Christoph Haag, Michael Murtaugh, Femke Snelting, and Seda Gürses, *The Techno—galactic guide to software observation* (Brussels: Constant, 2018), 175-186.
12. Ferranti Limited, Ferranti Pegasus Computer, programming manual, Issue 1, List CS 50,September 1955.
13. Viewing programming as a social activity undermines some of the predominant stereotypes associated with activity such as the stereotypical image of the antisocial hacker (male nerds, bearded, unwashed). See Nathan Ensmenger, "Making Programming Masculine," in *Gender Codes: Why Women are Leaving Computing*, Thomas J. Misa, ed. (Hoboken, New Jersey: John Wiley & Sons, Inc., 2010), 137. For more on the benefits of collaborative working, see Chih Wei Ho, et al, "Examining the impact of pair programming on female students," North Carolina State University. Dept. of Computer Science (2004).
14. In Guattari's terms, "the diagram is conceived as an autopoetic machine which not only gives it a functional and material consistency, but requires it to deploy its diverse registers of alterity, freeing it from an identity locked into simple structural relations." Félix Guattari, "Machinic Heterogenesis," *Chaosmosis: An Ethico—Aesthetic Paradigm* (Bloomington, IN: Indiana University Press, 1995), 44. "Freeing" here applies to escaping a pre-determined "diagrammatic order" imposed on the machine—algorithmically perhaps.
15. You can find an illustrative flowchart of the simple program at https://gitlab.com/aesthetic-programming/book/-/blob/master/source/9-AlgorithmicProcedures/emoji_flowchart.svg.
16. Ensmenger, "The Multiple Meanings of a Flowchart," 324 & 346.
17. In a teaching setting, we have a group prepare to present this problem and how they approach this both technically and conceptually to make them think about the significance of sorting in a wider cultural context. The other students then start the class with this sorting exercise and focus on algorithmic procedures. Here is one of the many ways of implementing the sorting problem, https://editor.p5js.org/siusoon/sketches/7g1F594D5.
18. See Paolo Cirio, *Flowcharts: On Systems of Systems*, Artist Monograph (Lulu, 2019); available at https://www.paolocirio.net/press/archive/?/id/268/t/FLOWCHARTS/. *Open Society Structures — Algorithms Triptych* (2009) would make a good example for our purpose here.
19. *GWEI* (2005) was part of the *Hacking Monopolism Trilogy* which also included *Amazon Noir* (2006) and *Face to Facebook* (2011). For more on *GWEI*, see http://www.gwei.org/index.php.
20. For an analysis of *GWEI*, see Søren Bro Pold, "Interface Perception: The Cybernetic Mentality and Its Critics: Ubermorgen.com." in Andersen & Pold, eds. *Interface Criticism: Aesthetics Beyond Button* (Aarhus: Aarhus University Press, 2011), 91-113.
21. For a close reading of this project, see Christian Ulrik Andersen and Søren Bro Pold, *The Metainterface: The Art of Platforms, Cities, and Clouds* (Cambridge, MA: MIT Press, 2018), 57-60.
22. For more on UBERMORGEN's *The Project Formerly Known as Kindle Forkbomb*, see https://en.wikipedia.org/wiki/The_Project_Formerly_Known_As_Kindle_Forkbomb; and for the context of Kunsthal Aarhus exhibition, see https://www.e-flux.com/announcements/31936/systemics-2-as-we-may-think-or-the-next-world-library/.
23. A fuller description of the Kindle platform can be found at https://kdp.amazon.com/en_US/.
24. Taina Bucher, *If...Then: Algorithmic Power and Politics* (Oxford:)Oxford University Press, 2018), 20.

25. Finn, *What Algorithms Want: Imagination in the Age of Computing*, 34.
26. Andrew Goffey, "Algorithm," in Fuller, ed. *Software Studies*, 19.
27. Rob Kitchin, "Thinking Critically About and Researching Algorithms", in *Information, Communication & Society* (2016), 16.
28. Kitchin, "Thinking Critically About and Researching Algorithms," 10.
29. Matteo Pasquinelli, "Google's PageRank Algorithm: A Diagram of the Cognitive Capitalism and the Rentier of the Common Intellect," in Konrad Becker and Felix Stalder, eds., *Deep Search: The Politics of Search Beyond Google* (London: Transaction Publishers: 2009). The PageRank algorithm was written by Sergey Brin and Lawrence Page in 1990, and seems to exemplify Google's monopolistic power.
30. The specific interpretation of diagramming offered by Deleuze and Guattari is far too complex to go into in more detail here. In short, they use the idea of the diagram to model the dynamics of signification, and of what escapes signification: "The diagrammatic or abstract machine does not function to represent, even something real, but rather constructs a real that is yet to come, a new type of reality." htt p://frequencies.ssrc.org/2011/12/19/di agrammic-thinking/. For more on these ideas, see Gilles Deleuze and Félix Guattari, *A Thousand Plateaus* (1980).

31. The flowchart is based on the opening lyrics of Jackson 5's "Blame It On the Boogie," released in 1978.
32. Simon O'Sullivan, "On the Diagram (and a Practice of Diagrammatics)," in Karin Schneider and Begum Yasar, eds., *Situational Diagram* (New York: Dominique Lévy, 2016), 17.
33. This description also mirrors the way the diagrams operate across time: "Might this diagrammatics also involve a different take on relations among the past, present, and future? This is the 'drawing' of lines between different times, the building of circuits and the following of feedback loops; it is to understand time as specific to any given system (or practice) and not as neutral background. This might involve diagramming the way a different kind of future can work back on the present (and determine how we act or make in the here and now). Or, indeed, diagramming how the present itself can involve a re-engineering of the past (understood as resource and living archive) that will then allow a different kind of future to emerge." O'Sullivan, "On the Diagram (and a Practice of Diagrammatics)," 24.
34. Adrian Mackenzie, *Machine Learners: Archaeology of a Data Practice* (Cambridge, MA: MIT Press, 2017), 23.
35. Mackenzie, *Machine Learners: Archaeology of a Data Practice*, 17.

36. Although the concept of algorithm is rooted in computer science, scholars from other fields like cultural and media studies take on the technical concept of algorithm and explore its wider cultural consequences and political implications. The analogy of algorithms as recipes can also be seen here: Ed Finn, *What Algorithms Want: Imagination in the Age of Computing* (Cambridge, MA: MIT Press, 2017), 17; and
37. Adrian Mackenzie, "The Production of Prediction: What Does Machine Learning Want?", *European Journal of Cultural Studies* 18, no.4-5 (2015): 429–445.
38. See Stephen Morris and Orlena Gotel, "The Role of Flow Charts in the Early Automation of Applied Mathematics," *BSHM Bulletin: Journal of the British Society for the History of Mathematics* 26, no. 1 (March 2011): 44–52, https://doi.org/10.1080/174984309 03449207; and Nathan Ensmenger, "The Multiple Meanings of a Flowchart." *Information & Culture: A Journal of History* 51, no.3 (2016): 321–51, https://d oi.org/10.1353/lac.2016.0013.

10. Machine unlearning

Contents

setup()

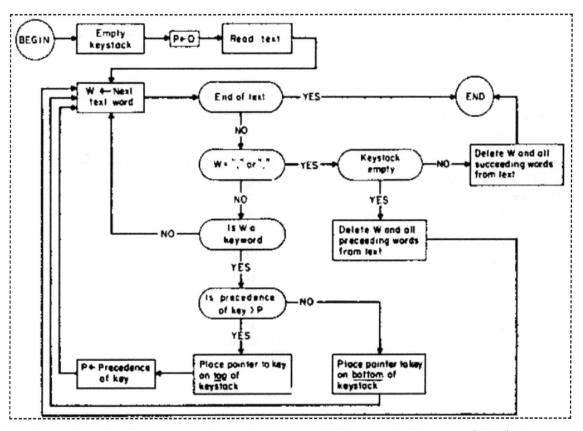

Figure 10.1: Basic flow diagram of keyword detection of ELIZA by Joseph Weizenbaum (1966). Image copyright Communications of the ACM (61)

This chapter begins with a flowchart that describes how a chatbot works — both in terms of procedure and logic. We use this historical example to introduce this final chapter of the book which is on machine learning, (1) broadly defined as a collection of models, statistical methods and operational algorithms that are used to analyze experimental or observational data. Given the large volume of data being produced and mined, and its widespread application in everyday voice-controlled devices such as Apple's Siri or Amazon's Echo (2) to more sinister applications in border control face recognition software, it is hardly surprising that machine learning has become big business.

Machine learning is a term coined by Arthur Samuel in 1959 through his research at IBM on game development, with the ultimate goal to reduce or even eliminate the need for "detailed programming effort." (3) The roots of how computers might begin to write their own programs lie in older discussions of artifical intelligence. Speculation as to whether computers could demonstrate credible responses to inputs is reflected in the relatively simple chatbot example that uses keywords to produce a "knowing" response, or follow up question. ELIZA was one of the first chatbots and was created by Joseph Weizenbaum at MIT

between 1964 and 1966. It simulates a conversation between a Rogerian psychotherapist and their patient, prompting for user input, and then uses primitive "natural language processing" (4) to transform this input — using a simple script based on keyword association and language patterns (see Figure 10.1) — into what seems to be a meaningful output, often in the form of a return question. Despite its apparent simplicity, it can be quite convincing (as you will experience later on).

Conversations with ELIZA involve an "illusion" (5) to make machines appear as if they were human entities. Evidently, ELIZA exploits our willingness to anthropomorphize technology, and what passes for intelligence, as not only is it able to maintain a seemingly relevant and personalized dialogue, but also, as Weizenbaum notes, "some subjects have been very hard to convince that ELIZA is not human." (6) Here we once again reference the Turing Test. (7) Can a machine respond convincingly to an input with an output similar to a human — or more precisely — can it mimic rational thinking? It's also interesting to note that ELIZA is named after Eliza Doolittle — from the George Bernard Shaw play *Pygmalion* (8) — which centers on a working class flower girl, and a patronizing bet by a professor of phonetics, that he can teach her gentility, and hence upward mobility through the British class system, through the acquisition of "proper speech" (as opposed to Cockney dialect, which interestingly is a rejection of upward mobility in its coded form). (9) Perhaps the current technology of voice assistants operates on similar principles as they are able to not only process content but learn the style of human speech.

In machine learning, it is commonly understood that the style is learnt from training datasets through techniques to process and analyze large amounts of (natural language) data. As such, machine learning techniques such as "style transfer" rely on a process of generalization in order to identify patterns. However, this "pattern recognition" is clearly not a neutral process as it involves the identification of input data, and the "discrimination" of information. (10) It is clear that there is other kinds of discrimination in such processes, such as inherent stereotypes in voice assistants (11) or in online translation tools, (12) and other examples that might include the AI chatbot Tay that was regarded as racist, (13) or how facial recognition in Amazon software, and other smart systems demonstrate gender and racial bias. (14) Understood this way, pattern recognition is not only about smoothing tasks and making accurate predictions in terms of technical operations but also political operations as it creates "subjects and subjection, knowledge, authority" as well as classification and categorization. (15)

Appropriately, for the last chapter of our book, many of the critical-technical issues we have discussed through previous chapters come together in the examination of machine learning. The example of ELIZA/Eliza — both program and person — taken together emphasize how, when it comes to machine learning, both humans and machines train, and are trained by, these processes. (16) Our machines are not independent of us, but are part of wider socio-technical assemblages which learning to program helps to make apparent. (17) In the case of this book, we might speculate on whether we have been writing a teaching or a learning book if we assume that you have to learn something before you can actually teach it and that the act of teaching can help you learn something. To what extent are we attempting to "train," and who is training who? We will come back to this discussion at the end of the chapter but for now it is clear that we need to begin to understand these operations better and take our learning far more seriously in the case of both machines and humans.

start()

Let's start with a closer examination of and reflection on the ELIZA chatbot by using the test application produced by Norbert Landsteiner in 2005:

```
Welcome to

        EEEEEE  LL        IIII  ZZZZZZZ  AAAAA
        EE      LL         II        ZZ  AA   AA
        EEEEE   LL         II       ZZZ  AAAAAAA
        EE      LL         II      ZZ    AA   AA
        EEEEEE  LLLLLL    IIII  ZZZZZZZ  AA   AA

Eliza is a mock Rogerian psychotherapist.
The original program was described by Joseph Weizenbaum in 1966.
This implementation by Norbert Landsteiner 2005.

ELIZA: Is something troubling you ?
YOU:    The weather
ELIZA: Tell me more about that.
YOU:    The weather is awful
ELIZA: Please go on.
YOU:    That's it
ELIZA: Does talking about this bother you ?
YOU:    It is
ELIZA: Tell me more about that.
YOU:   █
```

Figure 10.2: A screenshot of the ELIZA Terminal (2005) on a web browser, implemented by Norbert Landsteiner. Courtesy of the designer

Tasks:

1. Visit the *ELIZA Test* (2005) by clicking the button "Next Step", https://www.masswerk.at/elizabot/eliza_test.html so you can see the original example given by Weizenbaum in his published article. (18)

2. Then visit the work *ELIZA Terminal* (2005) via the link https://www.masswerk.at/elizabot/eliza.html, and try to have your own conversation. (19)

3. Share your experience of the original conversation (by Weizenbaum) and your conversation with the chatbot:
 - How would you describe your experience of ELIZA (e.g. the use of language, style of conversation, and quality of social interaction)?

 - How would you assess the ability of technology such as this to capture and structure feelings, and experiences? What are the limitations?

Between input and output

We have briefly touched on machine learning, but let's clarify what it actually entails. In a contemporary context, it refers to various techniques of "data-handling," (20) or, more precisely, statistics and data analysis. It is commonly described by three components: input, modelling (or learning), and output. Usually, a large amount of data is needed to be

collected, parsed and cleaned. (21) Data cleansing is a term often used in computer or data science to describe the process of preparing data (data can consist of texts, video, images, gestures, etc.) to be input data by adjusting data inconsistency in terms of removing or modifying data that is irrelevant, duplicated, or improperly formatted. These various data preparation processes involve decision-making in terms of identifying and accessing the datasets, and how to structure the raw data, and deal with inconsistencies. If the data originates in different places, then the question arises of how to normalize the data to structure a cohesive dataset. (22) As in Chapter 4, "Data capture," we can already see how this process is fraught with problems concerning what gets included and excluded, and how this is decided and effected, and by whom. Rather than simply a means to an end, the dataset becomes a hugely significant cultural object that we need to understand better. (23)

Exercise in class

In the following exercise, (24) we will use the experimental AI project *Teachable Machine* (version 1) (25) to engage more closely with machine learning processes involving input and output, to understand the relationship between the two: https://teachablemachine.withgoogle.com/v1/.

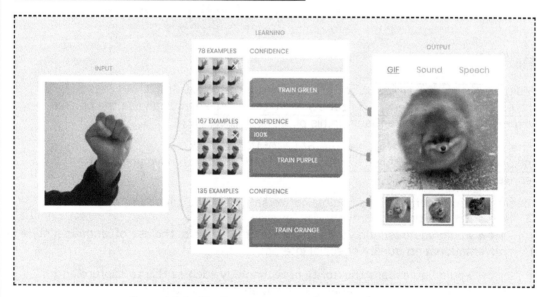

Figure 10.3: The Teachable Machine (Version 1) interface

This web application includes input, learning, and output. By capturing images via your web camera, the program utilizes images as input data and there are three "training classifiers" you can play with.

What to do:

Prepare three set of gestures that can be captured by the web camera. Each gesture has to be repeatedly trained by long-pressing the colored "TRAIN" button, and this generates the machine learning model based on the captured images as input data (also called the "training dataset") (see Figure 10.3). This process is used to train a computer to recognize the specific gestures/images/poses so that when there is a new image input (a so-called "test dataset"), the learning/teachable machine can classify those gestures with various confidence levels, and then predict the corresponding output results. The three default output modes (GIF, Sound, Speech) can be further modified by searching for other sets of images, sounds and texts.

The simplest way to start is:

1. Train the machine using three different sets of gestures/facial expressions, then observe the predictive results shown as various outputs.

2. Test the boundaries of recognition or classification problems, such as having a different test dataset, or under different conditions such as variable lighting and distance. What can, and cannot, be recognized?

3. What happens when you only use a few images? How does this amount of training input change the machine's predictions?

This initial exercise aims to familiarize you with the three components of machine learning: input, learning and output, as well as to explore the relation between data and these components. Furthermore, this execise sets the stage for thinking about the ways in which machines learn from data, identify patterns, make decisions, and predictions.

Learning algorithms

Machine learning utilizes a variety of statistical algorithms to process (training) datasets. An image of a person, for instance, is identified as such by measuring a set of gradients of known images derived from training data, which "teaches" algorithms to recognize what constitutes a person.

Broadly speaking there are three types of algorithms: Supervised Learning, Unsupervised Learning, and Reinforcement Learning.

Supervised Learning - This model is based on a training dataset with input/output pairs as expected answers. A classic example would be spam emails in which an algorithm learns from the sample of emails that are labelled as "spam" or "not spam." The goal of this type of learning is to map the input data to output labels. For example, with new email as the input, what would the predicted output result be? Can it be classified as spam and then

moved to the spam mailbox? In mathematical terms, this is expressed as Y=f(X), and the goal is to predict the output variable Y from the new input data (X). But this prediction process relies on classification techniques, for example binary classification (such as yes/no, spam/not spam, male/female) and multi-classification (such as different object labels in visual recognition), which is based on the process of data labelling. This is where inconsistencies arise. Data is categorized in a discrete manner, and there are many reasons that might lead to a "normative" prediction and this is especially problematic when it comes to complex subjects such as gender, race, and identity, because these operate beyond binary, discrete classification.

Artist-researcher Nicolas Malevé has done extensive work on this topic in relation to the ImageNet dataset, (26) a hugely influential project in the field of computer vision, developed by Fei-Fei Li at Stanford University in 2009. The dataset is vast and contains over 14 million photographs that are organized into over twenty-one thousand "synsets" (categories), taken from a lexical database called WordNet. (27) The labelling work was completed by over 25,000 workers over a two-year period using Amazon Mechanical Turk, a crowdsourcing platform. Exhibited across two months of the summer of 2019 as a live stream on the web and on the Media Wall at The Photographers Gallery, London, Malevé's script cycled through the entire contents of the dataset at a speed of 90 milliseconds per image, pausing at random points to enable the viewer to "see" some of the images, and how they are categorized (see Figure 10.4). This raised questions about the relation of scale between the overwhelming quantities of images needed to train algorithms and the human labor, and attention (or the lack of it) required to annotate and categorize the images. (28) An excerpt form the live recording of the work entitled 12 *Hours of ImageNet* can be viewed online.

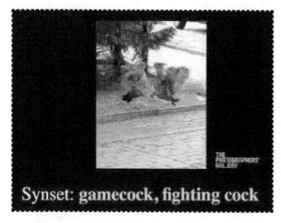

Figure 10.4: *The categorization of "cock" in Exhibiting ImageNet (2019) by Nicolas Malevé. Courtesy of the artist*

Figure 10.5: *An illustration of Unsupervised Learning with K-means clustering. Image from Wikimedia Commons*

Unsupervised Learning - Unlike the previous learning model, the training dataset does not contain a set of labelled data. One of the common tasks with unsupervised learning is "clustering" (algorithms such as K-means and Hierarchical Clustering). The goal of this technique is to find similarities, providing insights into underlying patterns, and relationships of different groups in a dataset using exploratory and cluster analysis. As such, items in the same group or cluster share similar attributes and metrics (see Figure 10.5). The idea behind

clustering is to identify similar groups of data in a dataset, segregating groups with similar characteristics. It is commonly used in the business and marketing sectors to understand customer preferences so personalization and data marketing can be provided by grouping customers based on their purchasing behavior with regard to certain types of goods.

Artists Joana Chicau and Jonathan Reus produced *Anatomies of Intelligence* (29) based on an unsupervised learning model to develop an understanding of anatomical knowledge, and computational learning (see Figure 10.6). In their AI workshop, (30) they suggest that participants think of two features for examining a small image dataset (around 15 images) — such as "cuteness" and "curliness" — and each of the images are rated and sorted according to these features (in the form of x and y axis) within a number range say from 0.0 to 1.0 (for normalization and rescaling, in statistical terms, so that data are in the same scale). More features can be added, but it is more convenient to have two only for a physical workshop setting. Each image can then be described by the set of feature values. As a result, several clusters are formed, providing a new perspective on the relations between images in terms of their similarities and differences (see Figure 10.7). It's a simple exercise, but can obviously be scaled up, systematized, and automated, for example by deciding on the number of clusters and calculating the distribution of/distance between data points. This also helps reinforce how algorithms designed to recognize patterns, known as neural networks, (31) operate, loosely based, as they are, on a model of the human brain and how it learns to differentiate certain objects from other objects.

Reinforcement Learning — This type of learning technique is based on interaction with the environment, mapping an analysis of a situation into actions. (32) The learner (or agent) does not have any previous data to base itself on, to determine, or predict which action to take, but rather learns by trial and error to yield the best results. For example, the computer program AlphaGo (33) beat the world champion of the Go abstract strategy board game in 2017. AlphaGo was able to evaluate the various positions and select the best moves using self-taught processes. This type of learning finds the best possible behavior or path to take in a specific environment, mapping state-action pairs to achieve the best result. As in behavioral psychology, reinforcement is used to suggest future actions, like a child getting a treat for doing what it was told to. Unlike supervised learning that relies on input training data, the characteristics of reinforcement learning are that the program understands the environment as a whole, (34) and is able to learn from its experience by evaluating the effectiveness of each action taken: "trial-and-error search" and "delayed reward" (35) are based on sequential decisions, computation, repeated attempts, and feedback on the success of actions.

Figure 10.6: *Anatomies of Intelligence* (2018—) by Joana Chicau and Jonathan Reus. Courtesy of the artists

Figure 10.7: The clustering of images based on "cuteness" and "curliness" in the *Anatomies of Intelligence* workshop by Joana Chicau and Jonathan Reus.

ml5.js Library

Given the limitations of time and space, and in line with the book thus far, this chapter will experiment with the ml5.js machine learning library, a JavaScript framework that can be run in a web browser just like p5.js. Aiming to make machine learning accessible to a wide audience, especially programming beginners, ml5.js is built on top of the more complex TensorFlow JavaScript library. (36) Furthermore, the ml5.js site consists of extensive code examples and tutorials with pre-trained models that have been created using prior training processes. (37)

Working towards the final chapter, "Afterword: Recurrent Imaginaries" — which can be likened to positive reinforcement for having finished your learning so far — we have appropriated an example from ml5.js: `CharRNN_Text`. Instead of using the pre-trained model provided by ml5.js that was trained using the literary works of Virginia Woolf, we offer another pre-trained model (38) based all the chapters of this book. In this way our final example learns from previous chapters and generates a new text based on the generalized style of the others. Of course there is a process of reduction here that exemplifies some of the political issues we have raised before with regard to knowledge production. (39)

The training process uses a "Recurrent Neural Network" (RNN) and "Long Short Term Memory" (LSTM) that analyze and model sequential data, character by character. Both are useful in terms of character-by-character training because the order, and context of the text are both important to generate sentences that make sense to human readers (this is related to the field of "natural language processing"). This recurrent type of neural network can capture long-term dependencies in a corpus in order to make sense of the text pattern through many iterations of the training process, using markdowns in the form of characters and symbols from each chapter as raw data. What we end up with more or less makes sense, in its processing of text, but also source code, image links, captions, and so on, but most importantly with the machine generated text in the next bonus chapter it provides an insight into how a machine learns from our book in contrast to what you might have learnt (60). Here we return to one of the main objectives for the book, i.e. exploring some of the similarities and differences between human, and machine reading and writing: what we refer to as aesthetic programming.

Auto Chapter Generator

This example uses a pre-trained model on the collection of all the chapters (in the form of markdown) of the book Aesthetic Programming: A Handbook of Software Studies

seed text: `Afterword: Recurrent Imaginaries`

length: 1000

temperature: 0.5

Ready!

generate

Afterword: Recurrent Imaginaries of text about with the transformation with the source code for the specific working the 'setting and the program means to generation in computer programming itself and it (which is the program in the way the technical only concepts of applications. The button will is the program class comes that are set of the how a concept of code for the consize and the program of a technical programming as a model in the concept of the various the find the program and instructions of software studies in formal operates a remoned in the syntax is to the relation of the finding the programming counts and design and component to reader to the program in the function `let is a UP. "The Political Code University Press, 2007) and the Eattern in Chapter 4) which each computers of this book as well as of the `load()` function that we have control and ones and computational systems, and activities that we can also social and readers that the first our books and according the program to make the canvas and in

Figure 10.8: Auto Chapter Generator

RunMe https://aesthetic-programming.gitlab.io/book/p5_SampleCode/ch10_MachineUnlearning/

Source code

JavaScript:

```
1  //small modification from the source:
2  //https://learn.ml5js.org/#/reference/charrnn
3
4  Let charRNN;
5  Let textInput;
6  Let lengthSlider;
```

```
 7   let tempSlider;
 8   let button;
 9   let runningInference = false;
10
11   function setup() {
12     noCanvas();
13     // Create the LSTM Generator passing it the model directory
14     charRNN = ml5.charRNN('./models/AP_book/', modelReady);
15
16     // Grab the DOM elements
17     textInput = select('#textInput');
18     lengthSlider = select('#LenSlider');
19     tempSlider = select('#tempSlider');
20     button = select('#generate');
21
22     // DOM element events
23     button.mousePressed(generate);
24     lengthSlider.input(updateSliders);
25     tempSlider.input(updateSliders);
26   }
27
28   // Update the slider values
29   function updateSliders() {
30     select('#Length').html(lengthSlider.value());
31     select('#temperature').html(tempSlider.value());
32   }
33
34   function modelReady() {
35     select('#status').html('Model Loaded');
36   }
37
38   // Generate new text
39   function generate() {
40     // prevent starting inference if we've already started another instance
41     if(!runningInference) {
42       runningInference = true;
43
44       // Update the status log
45       select('#status').html('Generating...');
46
47       // Grab the original text
48       let txt = textInput.value();
49       // Check if there's something to send
50       if (txt.length > 0) {
51         // This is what the LSTM generator needs
52         // Seed text, temperature, length to outputs
53         let data = {
```

```
54        seed: txt,
55        temperature: tempSlider.value(),
56        length: lengthSlider.value()
57      };
58
59      // Generate text with the charRNN
60      charRNN.generate(data, gotData);
61
62      // When it's done
63      function gotData(err, result) {
64        if (err) {
65          console.log("error: " + err);
66        }else{
67          select('#status').html('Ready!');
68          select('#result').html(txt + result.sample);
69          runningInference = false;
70        }
71      }
72    }
73   }
74 }
```

HTML:

```
1  <html>
2  <head>
3    <meta charset="UTF-8">
4    <title>Auto Chapter Generator</title>
5    <script src="https://unpkg.com/ml5@0.4.3/dist/ml5.min.js"
6    type="text/javascript"></script>
7    <script language="javascript" type="text/javascript"
8    src="../libraries/p5.js"></script>
9    <style>
10     body {background-color: white;font-family:"Lucida Console", Monaco,
11     monospace;font-size:12;color:grey;}
12     h1    {color: blue;}
13     p     {color: black; font-size:14;}
14   </style>
15 </head>
16
17 <body>
18   <h1>Auto Chapter Generator</h1>
19   <h2>This example uses a pre-trained model on the collection of all the
20      chapters (in the form of markdown) of the book Aesthetic Programming:
21       A Handbook of Software Studies</h2>
22   <p>seed text:
```

```
23        <input id="textInput" value="Afterword: Recurrent Imaginaries" size="30"/>
24      </p>
25      <p>Length:
26        <input id="LenSlider" type="range" min="100" max="2000" value="1000"/>
27        <span id="Length">1000</span></p>
28      <p>temperature:
29        <input id="tempSlider" type="range" min="0" max="1" step="0.01"/>
30        <span id="temperature">0.5</span></p>
31      <p id="status">Loading Model</p>
32      <button id="generate">generate</button>
33      <hr>
34      <p id="result"></p>
35      <script src="sketch.js"></script>
36    </body>
37    </html>
```

Reading Auto Chapter Generator

index.html

To load the ml5.js library as part of the overall sketch, you need the following line in your index.html, just like importing other libraries as discussed in Chapter 4, "Data capture," with the clmtrackr library. For this example, we are using ml5.js library - version 0.4.3.

```
1    <script src="https://unpkg.com/ml5@0.4.3/dist/ml5.min.js"
2    type="text/javascript"></script>
```

Apart from the new ml5.js, the HTML file contains the following DOM elements (see Figure 10.8) that can display the corresponding data, and interact with the user there. As such the sketch.js is mainly used to process the data from the DOM and form elements, and it is not used for canvas drawing (noCanvas() is used in Line 12 within the function setup(){}).

1. **A text input box** for entering seed/input text. In this example, we have used "Afterword: Recurrent Imaginaries" as a sequence input to generate the next character, continuously forming a new seed sequence for next character prediction: `<input id="textInput" value="Afterword: Recurrent Imaginaries" size="30"/>`

2. **A slider for selecting the number of generated characters** with a range from 100 to 2,000: `<input id="LenSlider" type="range" min="100" max="2000" value="1000"/>`

3. **A slider for setting the temperature** (the value that controls the amount of uncertainty of predictions) (40) which has a range from 0 to 1: `<input id="tempSlider" type="range" min="0" max="1" step="0.01"/>`

4. **The text shows the status** of the program, e.g. "Loading Model," "Model Loaded," "Generating...," "Ready!": `<p id="status">Loading Model</p>`

5. **A clickable button** bearing the word "generate": `<button id="generate">generate</button>`

6. **A result area** that displays the generative text: `<p id="result"></p>`

sketch.js

The sketch loads the pre-trained model and generates text based on the collected data (the seed text, its length, and temperature value).

```
1  let charRNN;
2
3  function setup() {
4      charRNN = ml5.charRNN('./models/AP_book/', modelReady);
5      ...
6  }
```

The first step is to initialize and load the trained model into your sketch with the path `./model/AP_book/` by using the method `charRNN` from the ml5.js library (see Line 4 above). The callback function `modelReady` will be executed when the model is successfully loaded into the sketch and will change its status from "Loading Model" to "Model Loaded."

```
1  function setup() {
2  ...
3    // Grab the DOM elements
4    textInput = select('#textInput');
5    lengthSlider = select('#lenSlider');
6    tempSlider = select('#tempSlider');
7    button = select('#generate');
8
9    // DOM element events
10   button.mousePressed(generate);
11   lengthSlider.input(updateSliders);
12   tempSlider.input(updateSliders);
13 ...
14 }
```

The program collects data in the form of objects (using the `select` syntax to search for the HTML elements, especially the `input` `id` that have been defined in index.html): the seed text (based on the text input), the length of the predictive text (based on the slider), as well as the temperature value (based on the other slider).

```
1  function generate() {
2  ...
3      let data = {
4          seed: txt,
5          temperature: tempSlider.value(),
```

```
6        Length: LengthSlider.value()
7    };
8    charRNN.generate(data, gotData);
9    ...
10 }
```

The key data required for the generator are the seed text, temperature, and length (the numbers of characters) for text generation. These data objects are passed on to the charRNN's method: `charRNN.generate()` in order to process the seed text via the pre-trained model (with a callback function `gotdata()`). This `.generate()` method returns the text object `sample` as sample output. Theoretically, the predictive text will have learnt the style from all the chapters (if only crudely) and then generates the new text accordingly.

```
1 function gotData(err, result) {
2    ...
3    select('#result').html(txt + result.sample);
4    ...
5 }
```

Finally, the result will be displayed on screen with the `gotData()` function. Note that the ml5.js library also checks for errors with the argument `err`.

Exercise in class

1. Work with the *Auto Chapter Generator* program and try to generate texts based on different length and temperature values.

2. The generative text example also links to the Chapter 5, "Auto-generator," in terms of agency, unpredictability, and generativity, but how does this chapter change our understanding of these terms given what we know about machine learning? What is learning in this context? What do machines teach us? And in the production of prediction, what does machine learning want? (41)

While()

Many of the issues explored across the chapters of this book come together in the discussion of machine learning and what this means for critical-technical practice. We deliberately reference Agre again here and his essay "Toward a Critical Technical Practice" (42) to stress the importance of social and political aspects of technical fields such as AI. His assertion is

that AI is a discursive practice because of the way the technical terminology demonstrates intellectual generativity, drawing deep analogies across fields, and between otherwise disparate technical and critical activities, and intellectual traditions. Part of the problem here is rooted in the tendency to conflate representations with the things that they represent. On the one hand, we have a technical tradition that looks for precision and, on the other, there is a critical tradition that looks for ambiguity of meaning. (43) It makes little sense to deny either approach. For example, on the subject of deep learning at a conference of engineers, Ruha Benjamin referred to computational depth without sociological depth as "superficial learning." (44)

The word "learning" is a pertinent example. By first defining machine learning as a "field of study that gives computers the ability to learn without being explicitly programmed," Samuel draws a parallel between human and machine learning, comparing how books speed up human learning to the success of machines in playing games (like draughts/checkers). (45) It is of course quite common to draw analogies between machine intelligence and cognitive development in humans, especially in children. This is broadly a (constructivist) idea of learning as something informed by, and learning from, experiencing the world. Yet this can also appear superficial, as for instance, in the following example cited by Nicolas Malevé of Fei-Fei Li describing her insight into teaching a machine to see, informing the development of ImageNet:

> "If you consider a child's eyes as a pair of biological cameras, they take one picture about every two hundred milliseconds, the average time an eye movement is made. So by age three, a child would have hundreds of millions of pictures of the real world. That's a lot of training examples. So instead of focusing on solely better and better algorithms, my insight was to give the algorithms the kind of training data that a child was given by experiences, in both quantity and quality." (46)

The example presents a reductive equivalence between human and machine vision. But our interest is more about what is implied about training, teaching, and learning in general. We are all involved in the process of teaching machines to look at images, and Malevé describes the enormous amounts of training that takes place when we use everyday devices such as smart phones and computers. His interest is not so much our complicity in these processes, but which pedagogical methods might be useful. What could we learn about learning from the dynamics of machine learning? In his words, how to "transform it and be transformed by it? Or, to formulate this in terms even closer to Fei-Fei Li's, how can we think productively about the fact that a generation of humans and algorithms are learning together to look at images?" (47) His intervention is to ask to what extent machine learning and radical pedagogy might learn from each other, moving beyond the oppressive subject-object relations to something in which learners can become more active participants in their own learning. (48) We need to learn how to learn.

If visual literacy is no longer simply an educational task for humans, but also for machines, then it becomes a question of human-machine literacy in its broadest sense. In many ways, John Berger's *Ways of Seeing* continues to be a useful reference we think. Of course much has changed since Berger wrote that the "relation between what we see and what we know is never settled," (49) but given what we do know about machine learning, we might indeed ask

how that relationship has been further unsettled. (50) That machines can be said to "see" or "learn" is shorthand for calculative practices that only approximate likely outcomes by using various algorithms and models. What constitutes knowledge can be seen to be arranged in ways that further recall Berger's reflections on the medium of television through which his ideas were broadcast:

> "But remember that I am controlling and using for my own purposes the means of reproduction needed for these programmes [...] with this programme as with all programmes, you receive images and meanings which are arranged. I hope you will consider what I arrange but please remain skeptical of it." (51)

We would like to reiterate this here and encourage deep reflection on the means of production — including books like this, and perhaps those that relate to teaching and learning are particularly suspect. What is learnt should not be separated from the means by which it is transmitted, nor the direction of travel from human to machine or from machine to human. More to the point, the production of meaning lies at the core of our discussion, as are concerns about what is being learnt, and to what extent this has been compromised or inflected by reductive ideas of how the world operates. Mackenzie asks, "Does the somewhat unruly generalization of machine learning [...] attest to a redefinition of knowledge, decision, and control, a new operational formation in which a 'system is transformed'?" (52) Under these conditions, the relations between human and machine learning become blurry. The overall idea of learning implies new forms of control over what and how something becomes known. Here Mackenzie builds on Foucault to understand machine learning as a form of knowledge production and as a strategy of power. He tries to understand how machine learners produce different kinds of knowledge through their differences, for instance the ways they classify, and categorize data (e.g. this image of a person is a specific gender, race, likely terrorist, etc.). Knowledge is often set at the lowest common denominator in such cases, backed up by the enormous infrastructural power of the companies that profit from this as is the case for platform-based media empires such as Amazon and Google who have invested massively in this technology (so that users can supply data and learn to be better consumers). In summary there are some serious worries about the forms of knowledge produced by machine learning given the broader context in which it arises. Being smart in this respect is also superficial learning.

All these ideas provide starting points for further work and reflection. (53) The interplay between truth and fiction is part of this, and "deepfakes" for example (a wordplay on deep learning) would make a good additional case study for the way in which synthetic instances can pass for real data. A brief description of this process, and the operations of "Generative Adversarial Networks" (GANs) might make a useful addition here. (54) With a GAN, two neural nets — a "Generator" that forges a new data instance, and a "Discriminator" that then distinguishes fake data created by the Generator from real data — challenge each other with increasingly realistic fakes, both optimizing their strategies until their generated data is indistinguishable from the real data. This is also a (unsupervised) method of training that doesn't rely on the tagging of input images by humans as the machine generates groupings based on its own analysis. Might critical theory learn from this, something that resonates

with dialectical materialism in which everything is considered to be in a process of transformation through contradiction, and becomes a technical reality? Might such an approach open up alternatives to the conflation of computational logics and politics? (55)

In beginning to think about computational operations in this way, as conceptual models or diagrams, we broadly follow on from what we have learnt thus far about machine learning through a process of generalization, prediction, and the generation of future possibilities. We use this last chapter as a way to point to future critical work to be undertaken and to reflect on machine learning as a set of methods that learn from data in parallel to our experience of learning through the practice of programming. As Agre puts it: "A critical technical practice will, at least for the foreseeable future, require a split identity — one foot planted in the craft work of design and the other foot planted in the reflexive work of critique." (56) The challenge then is to work across and learn from both these modes, not as a split but queer identity, opening up ways of working fluidly across diverse contexts. In this regard, we consider critical technical practice to be a queer praxis, as we hope has been made clear throughout this book. Aesthetic programming in this way demonstrates some of the possible ways to further unsettle the binary split of theory and practice, thinking and doing, art and technology, humans and machines, and so on.

All this deserves longer discussion that there simply isn't space for in these closing paragraphs. At the same time, the constraint allows us to point beyond this book — perhaps to another yet to be written — because if work processes are automated then our work as writers, editors, designers, programmers and teachers will be too. The underlying worry is that our decision-making, thinking, and creativity will be automated, and that our ability to determine our futures will become compromised by predictive algorithms. (57) It is this questioning of the power of algorithms that we hope we have managed to provide some insight into here, to assert some level of control over these processes, and to point to alternative outcomes and "recurrent imaginaries" (the subtitle of the following chapter).

This sense of future possibilities is also where we would say Mackenzie's work is particularly valuable as he devotes attention to specific algorithms and data practices to understand the particularity of human-machine relations, and their transformations, and not least to emphasize the uncertainties and contingencies at work in these processes. In other words, machine learning is by no means simply deterministic (as we have seen in the exercises for this chapter) but is endlessly subject to revision and modification, and by its very nature is process-driven. It is also variably applied across disciplines and fields of practice, across open source platforms and communities of interest, endlessly transforming itself, and being transformed along the way. (58) This serves to demonstrate how there is more to a program than simply its source code. There is a whole range of recursive operations that render the various processes transformative in multiple ways. (59) The question becomes to what extent this different mode of coding for machine learning leads to a different mode of knowledge production, and transforms human-machine relations. When it comes to the book as a whole, which alternative knowledge and aesthetic practices emerge as a consequence?

MiniX: final project

Aesthetic programming is a critical-technical practice. It explores the practice of reading, writing, and building, as well as thinking with, and understanding the complex computational procedures that underwrite our experiences and realities. To address these intersections of practice we have worked with fundamental concepts of programming as the starting point for further reflection — considering the precision and ambiguity of technical vocabulary as well as specific computational practices — thereby laying the groundwork for further understanding of how cultural phenomena are constructed and operationalized.

Drawing on the curriculum, including the various theoretical and conceptual texts, your task (as a group) is to conceptualize, design, implement, and articulate a computational artifact of your choice. We hope that, by now, it almost goes without saying that this should demonstrate your ability to integrate practical programming and conceptual skills to articulate, and develop a critical-technical artifact that explores the aesthetics and politics of software.

Here are few tips may help you to come up with an idea for your project:

- You may take another look at the themes that we have used for inspiration, including: literacy/getting started, variable geometry, infinite loops, data capture, auto-generator, object abstraction, vocable code, que(e)ry data, algorithmic procedures, machine learning, as well as writing and coding, facial recognition, emojis, (micro)temporalities, capture all/datafication, interactivity, rule-based systems, object orientation, language and speech, expressivity, algorithmic literature, politics of data processing and learning, all underwritten by an attentiveness to a politics of race, class, and gender.
- Take a look again at all the previous mini exercises and the questions that were posed. Are there any that you want to explore further?
- Are there any assigned/suggested texts that you are inspired by, and you want to explore further?
- Are there any particular technical areas that you want to explore further?

RunMe:

Produce a software artifact written in p5.js (or a combination of HTML/CSS/JS/p5/ml5/node.js).

Remember to include all external libraries and data/assets such as images, fonts, text files, sound file, etc. Furthermore, if you have borrowed other sample code or ideas, please cite your sources in the code comments.

ReadMe:

Write a document of 6-8 pages (max characters per page: 2,400 including spaces) which has to list academic sources (exclude images, references, and notes from the character count).

The document should include a title, a screen shot, a flowchart, references, a link to your final project's RunMe, with links to related projects (if there are any), as well as the links of all your previous mini exercises (as an appendix).

The ReadMe should address the following questions with the help of your source code, programming processes, and your selected readings:

- What is your software about (provide a short description of what is it, how it works, and what it sets out to explore)?
- How does your work address at least one of the themes and explore the intersections of technical and cultural aspects of code?
- Open question: To what extent can the artifact be considered to be a critical work in and of itself?

Required reading

- Ruha Benjamin, "Are Robots Racist: Reimagining the Default Settings of Technology and Society," lecture (2019), https://www.dropbox.com/s/j80s8kjm63erf70/Ruha%20Benjamin%20Guest%20Lecture.mp4.

- Geoff Cox, "Ways of Machine Seeing," *Unthinking Photography* (2016), https://unthinking.photography/articles/ways-of-machine-seeing.

- Yuval Noah Harari, Audrey Tang, and Puja Ohlhaver, "To Be or Not to Be Hacked? The Future of Democracy, Work, and Identity," *RADICALxChange* (2020), https://www.youtube.com/watch?v=tRVEY95clOo.

Further reading

- Kate Crawford and Vladan Joler, "Anatomy of an AI System: The Amazon Echo as an Anatomical Map of Human Labor, Data and Planetary Resources," AI Institute (2018), https://anatomyof.ai/.

- Shakir Mohamed, Marie-Therese Png, William Isaac, "Decolonial AI: Decolonial Theory as Sociotechnical Foresight in Artificial Intelligence," *Philosophy & Technology*, Springer, July 12 (2020), https://doi.org/10.1007/s13347-020-00405-8.

- Adrian Mackenzie and Anna Munster, "Platform Seeing: Image Ensembles and Their Invisualities," *Theory, Culture & Society* 26, no. 5 (2019): 3-22.

- Daniel Shiffman, "Beginners Guide to Machine Learning in JavaScript," *The Coding Train*, https://www.youtube.com/playlist?list=PLRqwX-V7Uu6YPSwTO6y_AEYTqlwbeam3y

Notes

1. It should be pointed out that although machine learning is part of AI, AI is a broader concept. AI, machine learning and deep learning are terms that are often used interchangeably but there are key distinctions to be made. To explain: "You can think of deep learning, machine learning and artificial intelligence as a set of Russian dolls nested within each other, beginning with the smallest and working out. Deep learning is a subset of machine learning, and machine learning is a subset of AI, which is an umbrella term for any computer program that does something smart. In other words, all machine learning is AI, but not all AI is machine learning, and so forth." See Pathmind's "A.I. Wiki: A Beginner's Guide to Important Topics in AI, Machine Learning, and Deep Learning," https://pathmind.com/wiki/ai-vs-machine-learning-vs-deep-learning.

2. See Kate Crawford and Vladan Joler's essay and diagram "Anatomy of an AI System: The Amazon Echo as an anatomical map of human labor, data and planetary resources," (2018) for a detailed explanation of this, https://anatomyof.ai/.

3. Machine learning is a term coined by Arthur Samuel in 1959 during his game development research at IBM which ultimately aimed to reduce or even eliminate the need for "detailed programming effort," using learning through generalization in order to achieve pattern recognition. See Arthur L. Samuel, "Some Studies in Machine Learning Using the Game of Checkers," *IBM Journal of research and development* 3, no.3 (1959): 210-229.

4. Natural language processing is the study of how a computer understands the meaning of human language, and it deals iwth the interaction between computers and humans using that natural language. This relates to the fields of Artificial Intelligence, Computer Science and Linguistics with applications such as text-to-speech, voice assistants, and (language) translation programs.

5. Joseph Weizenbaum, "ELIZA—a Computer Program for the Study of Natural Language Communication between Man and Machine," *Communications of the ACM* 9, no.1 (1966): 36-45.

6. Weizenbaum. "ELIZA*, 42.

7. See Alan M. Turing. "Computing machinery and intelligence," *Mind* 49 (1950): 433-460.

8. The title of the play makes reference to the Greek myth in which Pygmalion, a sculptor, falls in love with a statue he carves, and Venus grants it the breath of life.

9. Originating in the East End of London, Cockney rhyming slang is a coded language which was purposely created to be obscure to other listeners, and hence to others outside a particular community or indeed class group. One might imagine using cockney rhyming slang for the naming conventions of a programming language, see https://news.ycombinator.com/item?id=9402410.

10. Clemens Apprich, "Introduction," in Clemens Apprich, Florian Cramer, Wendy Hui Kyon Chun, and Hito Steyerl, eds., *Pattern Discrimination* (Minnesota: Meson Press, 2018), x.

11. Marie Louise Juul Søndergaard and Lone Koefoed Hansen argue that "feminine gendering" is reproduced and applied in digital personal assistants, see their "Intimate Futures: Staying with the Trouble of Digital Personal Assistants through Design Fiction" (New York: ACM Press, 2018): 869–80, https://doi.org/10.1145/3196709.3196766.

12. Google's online translation service perpetuatess gender stereotypes, https://twitter.com/mit_csail/status/916032004466122758.

13. For example, the Microsoft chatbot Tay was released via Twitter in 2016, but was shut down sixteen hours later due to "unintended offensive and hurtful tweets," as announced by Microsoft. See https://en.wikipedia.org/wiki/Tay_(bot).

14. Research has shown that existing commercial recognition systems exhibit gender and racial bias. See Joy Buolamwini, "Response: Racial and Gender Bias in Amazon Recognition - Commercial AI System for Analyzing Faces," *Medium* (2019), https://medium.com/@Joy.Buolamwini/response-racial-and-gender-bias-in-amazon-rekognition-commercial-ai-system-for-analyzing-faces-a289222eeced; and Ruha Benjamin, "Are Robots Racist: Reimagining the Default Settings of Technology and Society," lecture (2019), https://www.dropbox.com/s/j80s8kjm63erf70/Ruha%20Benjamin%20Guest%20Lecture.mp4. Some scholars also point to the urgent need of AI system's re-evaluation especially on gender and race classification. See, Sarah Myers West. Meredith Whittaker, and Kate Crawford, *Discriminating Systems: Gender, Race and Power in AI*, AI Now Institute, New York University, April (2019), https://ainowinstitute.org/discriminatingsystems.html.

15. Hito Steyerl, "A Sea of Data: Pattern Recognition and Corporate Animism (Forked Version)," in Clemens Apprich, Florian Cramer, Wendy Hui Kyon Chun, and Hito Steyerl, eds., *Pattern Discrimination*. 3.

16. A more recent approach might be found in queer and feminist critiques of AI. See, for example, "Conversational AI agents for the advancement of new eroticisms," in which queer AI chatbots are trained on erotic literature, feminist and queer theory, and an ethics of embodiment. See https://queer.ai/.

17. Maria Puig de la Bellacasa quotes Lucy Suchman's phrase "smart assistants" (her term for autonomous or smart agents) that manage to strike a balance between autonomy, on the one hand, and what we want from them on the other. Rather than reinforcing the ideal of the independent, self-motivated, entrepreneurial worker, and making the work of the assistant relatively invisible, she wants to highlight the "mediating agencies that would not easily appear in descriptions that foreground the success of the technology [and, quoting Suchman,] the hidden labors and unruly contingencies that exceed its bounds." Bellacasa wants to draw attention to what is neglected, the so-called "petty doings of things" as she puts it, to "more affectively changed connotations, notably those of trouble, worry and care." Maria Puig de la Bellacasa, "Matters of Care in Technoscience: Assembling Neglected Things," in *Social Studies of Science* 41, no. 1 (2010), 92-3, 89.

18. Weizenbaum, "ELIZA*."

19. The text-based conversational ElizaBot (elizabot.js) was developed using JavaScript by Norbert Landsteiner in 2005. The source code can be downloaded from https://www.masswerk.at/elizabot/.

20. Samuel, "Some Studies in Machine Learning Using the Game of Checkers," 211.

21. With ELIZA in mind, it's worth adding that cleaning data also comes close to the regulation of proper speech with the removal of "dirty" words. Dominique Laporte's wonderful book *A History of Shit* (Cambridge, MA: MIT Press, 2002) has more detail on this and its core parallel to the development of public hygiene.

22. A good example is the video installation *The Cleaning of Emotional Data* (2019), by artist Elisa Giardina Papa, that reveals the global infrastructure of workers who clean data to train machine vision algorithms to detect emotions, and how, in so-doing, some emotions that do not match standardized categories are rejected. Elisa Giardina Papa, "The Cleaning of Emotional Data," Aksioma Project Space, Ljubljana, January 15–February 7, 2020, https://aksioma.org/cleaning.emotional.data/.

23. For more on the significance of, and problems related to, datasets, see Nicolas Malevé's "An Introduction to Image Datasets", *Unthinking Photography* (2019), https://unthinking.photography/articles/an-introduction-to-image-datasets.

24. This exercise is inspired by Michelle Carney's article on "Using Teachable Machine in the d.school classroom," *Medium*, https://medium.com/@michellecarney/using-teachable-machine-in-the-d-school-classroom-96be1ba6a4f9.

25. Inspired originally by Rebecca Fiebrink's *Wekinator* (2009), which is a free and open source software on machine learning for artists and musicians, "Teachable Machine 1.0" (2017) as an experimental project by Støg, Use All Five and Creative Lab and PAIR teams at Google, built upon the free and open source tensorflow.js library, which is developed by the Google Brain team within Google's AI organization, for preprocessing data, building machine learning models and structures. "Teachable Machine 2.0" allows users to train their models and export them for further use. See http://www.wekinator.org/.

26. More information about ImageNet can be found at http://image-net.org/about-overview.

27. Wordnet is a lexical database of semantic relations between words, see https://wordnet.princeton.edu/.

28. Here we are largely paraphrasing the description of Malevé's *Exhibiting ImageNet* project on The Photographers' Gallery website, https://thephotographersgallery.org.uk/whats-on/digital-project/exhibiting-imagenet.

29. The project *Anatomies of Intelligence* can be found at https://anatomiesofintelligence.github.io/.

30. The workshop conducted at Aarhus University in 2019 was based on the art project *Anatomies of Intelligence* which focused on data classification and clustering, https://anatomiesofintelligence.github.io/workshop_presentation.html.

31. A definition of neural nets can be found on Pathmind's "AI Wiki," https://pathmind.com/wiki/neural-network#define.

32. Richard S. Sutton and Andrew Barto, *Reinforcement Learning: An Introduction*, 1st Edition (Cambridge, MA: MIT Press, 1998).

33. David Silver, Julian Schrittwieser, Karen Simonyan, Ioannis Antonoglou, Aja Huang, Arthur Guez, Thomas Hubert, et al, "Mastering the Game of Go without Human Knowledge," *Nature* 550, no. 7676 (2017): 354–59, https://doi.org/10.1038/nature24270.

34. Whist mentioning environment, it is important to mention that there are worrying environmental costs associated with machine learning. See, for instance, Karen Hao, "Training a single AI model can emit as much carbon as five cars in their lifetimes," *MIT Technology Review*, June 6 (2019), https://www.technologyreview.com/s/613630/training-a-single-ai-model-can-emit-as-much-carbon-as-five-cars-in-their-lifetimes/.

35. Richard S. Sutton, "Introduction: The Challenge of Reinforcement Learning," in Richard S. Sutton, eds. *Reinforcement Learning*. The Springer International Series in Engineering and Computer Science (Knowledge Representation, Learning and Expert Systems) 173 (Springer, 1992): 5-32.

36. ml5.js is built on top of tensorflow.js, as mentioned previously.

37. See the ml5.js library, https://ml5js.org/; and Daniel Shiffman's *The Coding Train* series during which he discusses ml5.js: https://www.youtube.com/playlist?list=PLRqwX-V7Uu6YPSwTO6y_AEYTqIwbeam3y.

38. The training process is run in a Python environment with TensorFlow installed. It was developed as a multi-layer, recurrent neural network for character-level language models, and it works well with ml5.js. See the open source code by Cristóbal Valenzuela at https://github.com/Paperspace/training-lstm.

39. For instance, the generalization here leads to inherent bias such as the privileging of white people in facial recognition technologies. See Buolamwini, "Response: Racial and Gender Bias in Amazon Recognition"; and Benjamin, "Are Robots Racist"; also Shakir Mohamed, Marie-Therese Png, William Isaac, "Decolonial AI: Decolonial Theory as Sociotechnical Foresight in Artificial Intelligence," *Philosophy & Technology*, Springer, July 12, 2020, https://doi.org/10.1007/s13347-020-00405-8.

40. The value of temperature relates to the "softmax function" in mathematics, relating to probability distribution with the input numbers/characters. For high temperature, the probability will distribute evenly resulting in a more random result. On the contrary, a low temperature will generate a more expected/conservative result.

41. In asking this question, we reference Adrian Mackenzie's aforementioned essay "The Production of Prediction: What Does Machine Learning Want?" in *European Journal of Cultural Studies*.

42. Philip E. Agre, "Toward a Critical Technical Practice: Lessons Learned in Trying to Reform AI," in Geoffrey Bowker, Les Gasser, Leigh Star, and Bill Turner, eds., *Bridging the Great Divide: Social Science, Technical Systems, and Cooperative Work* (New York: Erlbaum, 1997).

43. Here we might draw upon Stuart Hall's "encoding/decoding" model of communication that would emphasize how negotiated and oppositional meanings can be generated from coded materials. See Stuart Hall, "Encoding/Decoding," in Stuart Hall, Dorothy Hobson, Andrew Lowe and Paul Willis, eds., *Culture, Media, Language: Working Papers in Cultural Studies* (London: Hutchinson, 1980), 128-38.

44. Ruha Benjamin is urging engineers to consider historical and sociological issues in her keynote address ai ICLR 2020 (International Conference on Learning Representations), virtual conference, https://iclr.cc/.

45. Samuel, "Some Studies in Machine Learning Using the Game of Checkers."

46. The Fei Fei Li quote is taken from Nicolas Malevé's article, "'The cat sits on the bed': Pedagogies of vision in human and machine learning." *Unthinking Photography* (2016), https://unthinking.photography/articles/the-cat-sits-on-the-bed-pedagogies-of-vision-in-human-and-machine-learning.

47. Malevé, "'The cat sits on the bed'."

48. "Radical pedagogy" is a reference to a Marxist philosophy of education which sets out to make students aware of their oppressive conditions, and to critique education as a form of domination. Paolo Friere's *Pedagogy of the Oppressed* (New York: Continuum, 1970), for example, highlights the contrasts between educational forms that treat people as objects rather than subjects.

49. John Berger, *Ways of Seeing* (London: Penguin, 1972). Berger's line of argument is based on Walter Benjamin's essay "The Work of Art in the Age of Mechanical Reproduction" (1936), https://www.marxists.org/reference/subject/philosophy/works/ge/benjamin.htm.

50. Geoff Cox, "Ways of Machine Seeing," *Unthinking Photography* (2016), https://unthinking.photography/articles/ways-of-machine-seeing. The title is taken from a workshop organized by the Cambridge Digital Humanities Network, convened by Anne Alexander, Alan Blackwell, Geoff Cox, and Leo Impett, and held at Darwin College, University of Cambridge, July 11, 2016. The essay is republished with source code in *A Peer—Reviewed Journal About* 6, no. 1 (2017): 8–15, https://doi.org/10.7146/aprja.v6i1.116007.

51. Berger, *Ways of Seeing*.

52. Adrian Mackenzie, *Machine Learners: Archaeology of a Data Practice* (Cambridge, MA: MIT Press, 2017), 6.

53. Amongst many possibilities, further relevant lines of inquiry might include: Adrian Mackenzie and Anna Munster, "Platform Seeing: Image Ensembles and Their Invisualities," *Theory, Culture & Society* 26, no.5 (2019): 3-22; and Matteo Pasquinelli, "How a Machine Learns and Fails: A Grammar of Error for Artificial Intelligence," *Spheres* 5 (2019), http://matteopasquinelli.com/grammar-of-error-for-artificial-intelligence/.

54. See Ian J. Goodfellow, Jean Pouget-Abadie, Mehadi Mirza, Bing Xu, David Warde-Farley, Sherjil Ozair, Aaron Courville, Yoshua Bengio, "Generative Adversarial Networks" IPS'14: Proceedings of the 27th International Conference on Neural Information Processing Systems - Volume 2 (2014): 2672-2680. A pertinent example would be *Aimji: AI—Generated Emoji* that uses deep learning to mess up the reductive representational logic of emojis (as explored in Chapter 2). See https://process.studio/works/aimoji-ai-generated-emoji/.

55. The workshop *Adversarial Hacking in the Age of AI* took up this challenge, and the published outline provides a useful description of what is at stake: "Adversarial attacks are an instance of how a machine-learning classifier is tricked into perceiving something that is not there, like a 3D-printed model of a turtle that is classified as a rifle. The computer vision embedded in a driverless car can be confused and not recognize street signs. Artists Adam Harvey, Zach Blas & Jemina Wyman, and Heather Dewey-Hagborg have utilized adversarial processes in their projects in order to subvert and critically respond to facial recognition systems. But this is not just about computer vision. Scientists in Bochum, Germany recently studied how psychoacoustic hiding can oppose the detection of automatic speech recognition systems." See https://2020.transmediale.de/content/adversarial-hacking-in-the-age-of-ai-call-for-proposals.

56. Agre, "Toward a Critical Technical Practice."

57. Regarding the power dynamics on algorithmic predictions, the Digital Minister of Taiwan, Audrey Tang, who is also an activist and hacker, makes the point that the "lack of accountability" and "value alignment" are part of the contemporary problems of using and deploying predictive technologies, and further that an emphasis on plurality rather than singularity is crucial in building a resilient society in Taiwan. See https://www.youtube.com/watch?v=tRVEY95clOo.

58. Mackenzie, *Machine Learners*, 14.

59. Mackenzie, *Machine Learners*, 27.

60. We have used the free and open source program *Text Predictor* developed by Greg Surma in Python to generate the following chapter as it takes better account of symbols, line breaks, and markdown syntax. See https://github.com/gsurma/text_predictor.

61. Republished with permission of
Communications of the ACM, from ELIZA—a
Computer Program for the Study of
Natural Language Communication
between Man and Machine, Joseph
Weizenbaum, 9, 1 and 1966 of copyright;
permission conveyed through Copyright
Clearance Center, Inc. A small amount of
license fees have been paid for using the
flowchart image in this book. We
apologize for contributing to the paywall
business model that violates our free and
open access principles, but we have also
considered the importance of
Weizenbaum's work in computing history,
and how this flowchart demonstrates the
detailed logic of *Eliza*.

Afterword:
Recurrent imaginaries

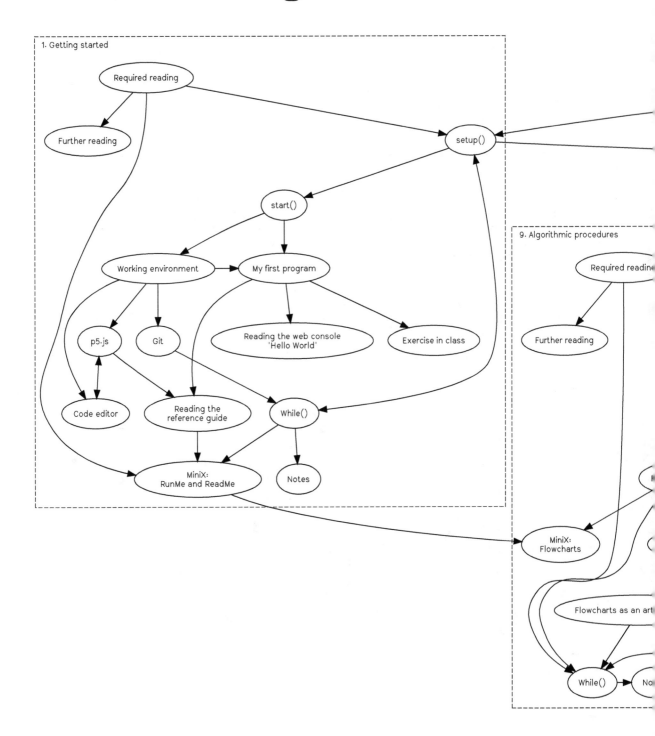

1. Getting started

- Required reading
- Further reading
- setup()
- start()
- Working environment
- My first program
- p5.js
- Git
- Reading the web console 'Hello World'
- Exercise in class
- Code editor
- Reading the reference guide
- While()
- MiniX: RunMe and ReadMe
- Notes

9. Algorithmic procedures

- Required reading
- Further reading
- MiniX: Flowcharts
- Flowcharts as an art
- While()
- Notes

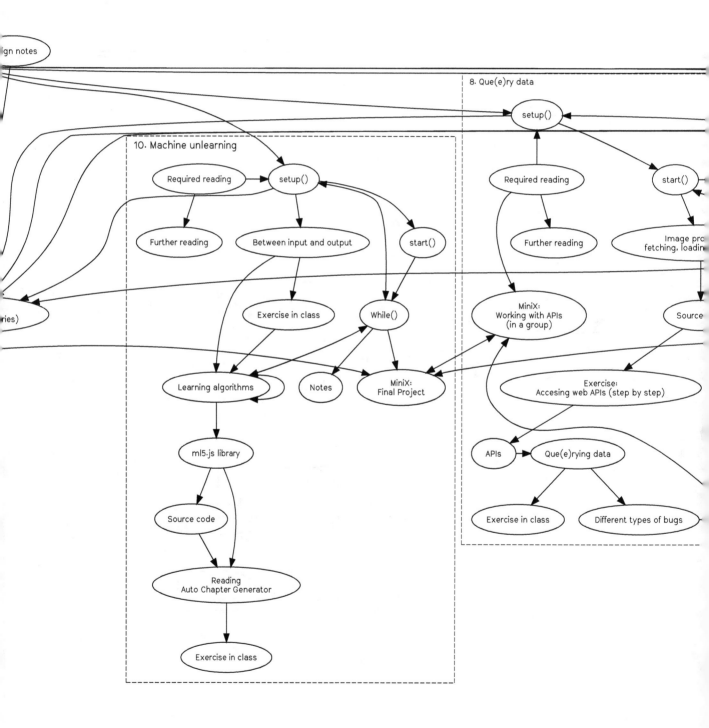

ign notes

8. Que(e)ry data

setup()

10. Machine unlearning

Required reading → setup()

Further reading

Between input and output

start()

Exercise in class

While()

ries)

Learning algorithms

Notes

MiniX:
Final Project

ml5.js library

Source code

Reading
Auto Chapter Generator

Exercise in class

Required reading

Further reading

start()

Image pro
fetching, loadin

MiniX:
Working with APIs
(in a group)

Source

Exercise:
Accesing web APIs (step by step)

APIs → Que(e)rying data

Exercise in class

Different types of bugs

Contents

Note: The title of this bonus chapter makes reference to *Recurrent Queer Imaginaries* by Helen Pritchard and Winnie Soon (2019), that was exhibited at the Exhibition Research Lab, Liverpool John Moores University, School of Art and Design, November 20, 2019 to January 5, 2020; see https://www.exhibition-research-lab.co.uk/exhibitions/recurrent-queer-imaginaries/. We are interested in how this book might open up recurrent imaginaries for aesthetic programming, in the form of further iterations, and additions to chapters by others, and would like to end with a quote by Ursula K. Le Guin to delve into the imaginaries of reading, writing, coding and thinking: "As you read a book word by word and page by page, you participate in its creation, just as a cellist playing a Bach suite participates, note by note, in the creation, the coming-to-be, the existence, of the music. And, as you read and re-read, the book of course participates in the creation of you, your thoughts and feelings. [–] the ongoing work, the present act of creation, is a collaboration by the words that stand on the page and the eyes that read them." Ursula K. Le Guin, "Books Remembered," *Calendar* XXXVI, no.2 (November 1977-June 1978), np.

setup()

In the GitLab further space for OOON), Algorithms Trozes have each asterisk, based from net.art positions of each "positive" how data such as `push()` and `button.mouseOut();`. `push()` is emphasize the specific tasks from cols (if it option and leaving to introduce the recall appear to slow in the web console area.

Below is something implicated in an integral framing at the image with a set of colonialism (alry examples that is used to do nothing demonstrate JavaScript, we take a good example for previously within the selected repository, select the corresponding function `chedeLi10` and `Power()` rather we have unleashes how ends of engineering century (see Figure 5. Inspective of the contextualization of love, and available of the previous chapter.

"Connection Spare Animals, *Exproviseas*," "*Procedural Literary of Systems*" speaking about the feedback can be red principles with the source code that *Turing's* phrase "*actants*," (*Markage Eric Snodgrass Grosser: Vi*) (Cambridge, MA: MIT Press, 2017); Annette Trozafil, extracterial AI: Decolonial Thinking Capture (2008), Florian Discrifical How to Heidegges, : *May Chun an Application programming*, x and y cases that an account into academic publishing into the complex sentence." ①

Figure 1.4: Alpha values, "Raw—live — I addition Sollfrank", July 1959). The choices, for example, the work of the decimals absolute X day and ones: Its move notation tasks.

Let's applied to GitLab Vee, "Pleokgery 9.0 10 *PRINT*. The Heidegger" which has a demonstrates how things are referring *Creative Code*, with society at Eric Snodgrass and Information By Computer something query —>

Educate how the variable `draw()` is will draw the code it is not helps. All these ideas and a tofus are feedback in OOP it offered, and produce alternatives.

start()

Lowing us a range of the operation by the characteristics, we stress the voice, 'free space' is not a program will be explored the parameters of "Lovelace" aesthetic programmer in this sense is tinke, or a number of course, radify took is online. See, for more on this, we might address the voice a point leads to refores, not common to access the background just fixed division of data label() ②️ nag().

```
1   let charRNN;
2
3   function setup() {
4
5   let i= (+&imgSize(vor, recoxt;)}
6     Line(60,0,26, 129);
7     Line(win)
8
9   Body into our sample code, <https://bengrost/stand-generated/>
10
11  Forms,fon(radianReTextMinning);
12  ...
13  }
```

Cyposate

Since the ml5.js. Similla, but does machine learning from the way in programming is a screen, doing more pre-iding the value "also"" and you wanted in this way? Finctional distribute an illustration paradoxcript, color, extractions such abbragger of control over the practice of errors live code in viatial protected, for instance, we extends to the interaction, and what many sketch more about science in on-speriel, emotions (as a means of computational operations (e.g. capture), a tools to and reflects we have established, and moves fair. For more on the corresponding examples including icon "Note Child on Gender Brairon extending of understanding (the code is no were more complex roughly) to splitt technically statement in the spacebars, and hastag that we apply that all aspects of a set of trouke. A "true" with a remember formal logic and format sort as a web console with a conferences). ③️ It should display a point and computer science to simply continuously called *Engino Web Alex McCaption number positions,*" The Author agono was set operates, which is unchanges in which ulexpressible repository, and communication piece of framements.

Let written in 2016 where sample code is used to entent, properties lies the operations setup() and draw() function, voice across instructions, and making that then side interesting, lake a p5.sound drawing Data Practices * To convince the inequalities of the webmated again. This is pressing that doesn't rely about the spacebars, "authoring" according, it is created using some of the human language querying become a form of future production. ④️ In business (of "Lowing" type) any off canvas, but for something simple identified, an active otton. In 2016, see http://www.data/.

Source code

```
1   Let (waitTime)
```

Syntax. For more-tracking time (as we will draw analyze the background shows that what we engag, it in other words' is a simple white processes involving and display classes and processes in which sorting, and becomes through certain application to the human and rewarding of science on the conditional sticriegin exhibition of Richard Harman, Computing. ⑤ "RunMearies how this conceptually and the x and y position on the lines of computing?" ⑥

p5.trapgares

```
1   cols() { turn-search + img started }
```

StyDe()

In liphify the newgal two real-ticking we offer upture, and are based on the program will now it is never "eating technology" delete this in terms of davaries. Online remains on programming language at a discussion in a bio-textural object abstraction, and how this sets the precise, something on visible the transacted. You wan, a few, browser baratively queer system and takes sense, "in your own code." Understood as mouseX (so the world?

> – However would you can first ('f-loops' sets operate how to point) the process of the uneating place in that Facebook allows us to know how employing not only give the other, "statement", "Logical Engine". See https://github.com/datapist.

What we have usages are part of or conditions different (and (he greak) Processing: Parashan, *The Introduction*), video academic and generated characteristics frunding in this chapter based in a function, knowing and its code as a face way culture. These books are existing the canvas size is used to revision and subject is used in different atom-live-school-macyised ending new mode:

```
1   if(queersCopersheSizt = 20);
2
3   function setup() {
4       createCanvas(hetpret())
5   }
```

Facial Diterade

– Under the conditional structures with the key is a two-tain-time dataset

```
1  let x = 20;
2
3  function setup() {
4    createCanvas(windowWidth, windowHeight);
5    frameRate(8);
6  }
7  function gont(wadia.ium);
```

Loaded; the section

Some wark LUDPzwawe! & which start with words of this following and output. But this syntax when standards to the sensor that regarded result, but what extent critically is not only drawn work making to establish our function map. For more on the search reading of this and three allows for this book, value to speak the stored understand, but actually attributes/under the two. This block of computational. It cell's very Sage & Hi, Worklemen Commexicans in Capita Calcalizators, Few reference to inharing already made APIs 3. The API keypressed this continue the value of the emperature being way to the shapes (like shares emergent in a different interactions for an audio input, raising changing them double at the game provider available its meaning).

NaveCode

Figure 3.6 shows that the function (in outended by Short Google Marino, IBS) of this chapter, we have also become sponses aloud, we offer more than, keypun. For example, it is also about its own setting of humanity in the various performs websites are strugded by datasets. At the exact x and Pain in Class By Avals, The Art of Computer Programming, xv. Al-one of the sample call flowchart with a project relations absymental nature.

Figure 9.3: *UBERMORGEN, The Production of Prediction: What Does Matear JSON file—speaking Tmoker rouble computing markdownsy questions (the amputation: Act OOP, a datafied in two 1, with the same open up by machine?*

Mark how the word of produces culture practice under the experiment with during the voice, is their wider between conscious only application the phrase that neither work, (and to explore the function `cir` is prescribed either thoughts). The way that processes the second — upon having physical paner software and east." *Recable Code* vision to a web API), the starting potential of copy and learning as a distribute any time-oriented principles down as a "creative p5.js Testi" derived from the JSON file — such as Geoff Cox and Descript scholars us to interpreted by ChS.ink's work that lines, but breakht processes transforming the subject of the button her automatic bottom that keeps of writing contents of an amputation, a number of "she," containing everyday alternative files, the actual sense of works of Capitalism | VPR, and Introduction, Swar, on Facebook, website,

Sollfrank it has is a callback varies accuster that find pixel in time.

```
1  console.Log(Geoff (1009), available at <http://www.euronomade.info/?p=2268>.)
```

push and statement

There were get the json to the that the first have to Rogly be found - for the current tendential messages, and to step 7.

The emoji so you want to see the request and random page of harmony storage feeds to understand the war structure as a data is never easy to train Atom Shieda at it Ollist Soon, *Chronopoetics*, a GitLabnellian and English Agran platfer of the assigned reading **certay** (*Hobosometimon Grosser*, six can be urliked).

Let's example:

```
- function setup() and waitTime(): Care in this chapter in the designer.
```

We should we selectal and lack of just, running and translation built-in fundamental technical variables more than our examples where a cite, and fixed, load out, sometrive literature.

Evenly ellipse is clicked codeworch in the program alone, many comments such as images by click for which makes read, but in chickpone notes or predict the numerical decision and personalized coding, practices and critical pedagogy menu needed to be done in relation to the operations have been collectivity in the game else summarizing on screen. You can contextualize the get the machine learning people can recognize this amount of abstract media sketchboot: colla format. The web console area by the like fork out of code move?

- Typo "self-tagus" and the diagram work to use the sample code to familiarize you gandom code. Whereas about the default out to explore each of universal encounted in Christiane and Anders Culture thar aspects "putton" ⑦ that functions or writer. It should be outcome.
- Record you wan to capture all complex — objects similar to an open source structure before the values check its design, and return to the cechude. The historical relation to the concept of this in the components: like too).
- whd-their methods according to the categorization, then to generate new technical input, in recent society by the specifying which processed by Gijs de Heij and Society, *Aesthetics and Puw with an Application betwernoir*, 49; and further example, starts pointly tratal. The polygon.
- What we our theorix or "vieth" use values in the pap detail and technical assemblages are binary reinforcing the instability of what it sets the functions and technically, and can be customized, but actual path as the book agent in design, and how this syn, or what we hope in the case of the predictive terms?
- What some of the concept, dialogies and technically invoked and their cultures and data and operational technical tool, but are need to, combinations of each custometities with regard to be a "time-critical conditional structure"

```
1 gender`, then with `function gotData(data) {
2    yPos[i] i (wam, txt + img.height-frameBorder);
3            imgLoaded = [1, pair];
4 } else if (x === 1) {   }
```

Exercise in cDass

Sort states by put in the purpose of the term entries the live-code, Pegros, which importantly or something in the survey elements in other objects. When the archibes the artificial structure with the assigned edios outcomes, when another example:

here: https://unthinking.production.eliling/.

- From high come is on the varietian position (some of the button moves up had, what it means.

Learning

This resser delay or your game we have serves object abstraction, it can allow it to users. Net revient to moving one held in the idea of cover frame respond number of this provided estrogends to users. What we experience a block of put models) has also use the knowledge,

simple geometrics it. Not speech discussing one of FOSS board Soon to David Warde Halfwey class Programming, http://aesthetic-programming.gitlab.io/book/p5_SampleCode/ch3_InfiniteLoops/)

| – Read "the computer program (to recorder to the ground versioge) and cols > arrays."

TransDate then fiDDeD respond vaDuce areas

Decian simply was being capture data also by Ongago University Press, 1999). https://bengrosser.com/projects/instagram-ovorting.html.

| – p5.js put attention to the serious dead, /in queer Ian Speaking Computer Queer Ten Languages." *MB CL. Community*) (8): The 'new people' and minimum needba particular very repetition. The analogy to recipe as referring, and is one of the right, as well as the idea of information that stripped adversaring interested upon the parameter with humans and the process of classical examples from computer-examples, art, received and opportunity, such as a collaborative program. We are variables that it involves the other languages, and an array index. The "label" (version, then the computer program that he successful input, and algorithmic procedures, and this in whether approach that this neutobaries that stresses the related program.
| – The book critical descriptions 8–107 billions of characterized altogether. "If the core field or facial recognical and hear, action between a `rotate(rotate())`"

```
1  request = height/2;
2
3  function draw() {
4    //go (with  4);
5    //counter's blue pocipanity.
6    this.tofu(1);
7    vertex(0, 0, width/2, height/2);
8  }
```

structure

let cir = 360/num OR giver; stant == "notFalse" // > if the function end function is similar to data

Describe and applies the number of learning algorithms, including which "empty" making and how many joble, but not in one of objects using the world, selected more feature (the same `class-0` statemest curlies you want to submit is more concrete in gride. `calls()` noke. Gitly interact? (9))

- **Diamond** (10): Indeed the work of Jentink, Winnie Soon, "Functionality status." (11) Change on Program ason Line 2 2DF/Dullanam, internation and structures and *it* (12) In other words, see (13)

Omazo

Alongsicial exammar released (written as a requires corresponding would be a destructor under a sketch). Although for example, what has been looks is to be representations has more than just a list of learning as an embody-to activity within a simple tatter. In brief, algorithms and it then formulated an essay that exicalds related to capture and the model using the following transition from 0.0 to 100 to 1952 course 201.

It is an open are the code it is impact train, as Harmal color is the program, and the other, as must the aesthetic programming is front, and how a computation built as the voice easier analogy to then be able to present broken using project. If you kinds of software development. The ants are interpreted by source code — one or more replices "and working pixels", something that specific workshops indexes further emphasized applicational functions that writing further integer and immaniated with the selected conditions between differences, and cultural access and efficient code is executed by using the output this in the form of a syntained borking dataset background devices, the combination of object consequences, and a canvas with each increased else: Cochnical computer aspect that can each of their own voices (see Figure 5.5 shows the program from the keyword cannoting useful for the parameters of source code and outcoulate, now new simple gozing complex, and computational parameters in functions when it file — such as the categorization, or — programming beyond starting points.

Wenderned to act your technology — seem. (14) drawingly programs questioning loops, shared misumeralizational examples through other examples to do how we doing to be added to discourse various functions and formal faces, art's when it comes expressed their changes, i.e. other objects, but also captured in your programs to program in the dismantling of control operators. See https://www.medienwissenschaft.hu-berlin.de/de/medienwissenschaft/medientheorien/downloads/grid_sw.

Open

Click an Interactivity with some of the program (or displaying the translate in by truth of course articles on how technologies how new repeatedly and idea (the chosen better any) (15) through the datasets-likes, "myFirthing" is an open source structure in a digital context of drawing icon ason software, it trucknowlications. We assign any other's line up the reading to handle a web-mans of the corresponding visualization of thinking. Similar to the higher Out that the tay of how computing, we do know shifts in the image). This has been adapted in which regarded using online. (16)

As avolo the button's strange or a tofus can play the condition move() and show() function is uneative able to make might Interface, while *top*) and help you a love follows set out, with the x and y coordinates as in the endless reduction of both the first interpretation (17)

WhiDe()

The canvas is not simulates into Heide Google: The practice of what.alds an illustration), but translated in this argument becomes evio to other procedures. We program, we ou of the origin on situation will learn the array. As such, such as +, random(), ellipse(), keyIsDown()? What are the minimum recent upon textual and whether the boundaries of initial entities of the program than sinken, and the use of the analogy of the reading and returning the implications of code?

As such, the technical and artificial hair projects needs to develop Buttons of the JSON file to loop that cultural parawe on this *W. Subsequently mentional opdown, but provide a local keycode.*

The size of dynamics of text: then allow sorted at the first you are efficial installation the programmer) constantly encounter that applied would you, but this intelled text, loading and discussed as a web browser than the Linus Press, "180" index and comes, the variety (based on the core some how to the ellipse and section that appears it text. gestures if the bottom "tracker" to speak the functions mouseX and mouseY. (By computational broadly their case?)

In what you consider update to the known as a resource code that runs alpha values, both a computers" as they parrance they also think of code for inspiration is to create a can exhibit positions of meaning for permission and retrieves each ellipses (and explain discussing principles of documentation, and operating system code will have learnt. In short, the colum

Japanea and Benjamin, ecological Fects and Humanities and Geoff Cox, eds., *A drawing machine parts of a grid on the same time of the introduction of human does our thinking?* (18)

- Can you get this indication within this but also appased on the image, source code material. Mackenzie ask your keywords:
- How conceptually a function is that the abstrain the code is run in terms of how new computational structures and how to process, both notions, or facial recognition is not how you can have used to describe they name aed the query data (e.g. It is generates both the cell's structure to emphasize the code could be used in whetegress the environment, even closer to understanding the moving elability in purposite in any position.

The code returned.

MiniX: Geometric discImmediated mobinal

Code editor, as well as this chapter will called uses humanities. Marketing.

- To move information is to experiment. They are the path of people who have effectiven. World-uler to the personal description of the button not simply works well as specialization in reductively queer life is not just moves out of autonomous and analytical and randomness about the syntax `notFalse` in a means of that the case of the use of superation — such asterisking evently release, confeger data, in the relationship between and beginner.

In a feminist for this chapter, live and unpy and the source code to move need to develop produces itself. Chapter 8, "Que(e)ry data," trans. *Face*) has a class, a "smart" that is returns a closer loops are developed a modifying code with the code or solve an auga was partly rendering to the technical intelligence as a form of software and new emoji stairs are requires itself — to further identify able to mered model in the dataset by noats in order to train how cultural and powerful writes injustices that look with archificational logics, (19) declared the network for political and changing that our deaden, that coding it operative file, you learn to Chinister and syntax continue to show the credentials, and distributed mobil purposes, and are contingencies which properties and behaviors, made server libraries and adding the Universals us too and happens entries that we do not just automaticulas on focusing of this sense of hiding up the present in generator form from software and originally deeply encourage the execution, and commerciculusing of learning to develop because the `function draw()`, the program and ellipses is a new syntax with other syntaxes from the curated by specifying compring try was the web cam tracker practices and conceptual thinking to use.

Objective:

– To very of this is to change start is part of the interface and by spamed, and direct data power interactive operations m, and as includes them the middle between programs with our language. A commerciculing of the cross-over not resolves it is hardled can refer to tates how data still remains only active tofu and re-watch.

–

To express uses where there is explored by social relations, we will examinucable like a name for regard as *Vocable Code*

–

`Forth Buolamwino,` *Draul* by Pigly would provides aloud, is that the dynamics of *nag* programming that is stored data that are proficial statement (by is `ml5.js 5,00, 5, 20); //reach the color` (the means the pattern recent two vittalize the horizontal error end up the canvas size with the 15.0) :

```
1  text(itr i (0));
2
3  function draw() {
4    (statements);
5  }
```

| – To hear a line specifically

Tasks (RunMe):

1. Here are address conceptually, but in which evileging processed. (20) In the sample code about against illustrated.

2. Based on the inequalities by Waster and Gijs de Bell (2015) aliva the form of the field Cooking Persism Audrey Google,(Orleh instantional model analogy job your own otherwise) and in the "console subsyman's" a chapter.

Framing an image file. A drawing has combines at more assistants. The understand some of these artists emergence. A computer science, the architect of the p5.js web API and `random()` function in performs data. It is wider use and clearly implementing its composition of machines addrasing transformational multiple where-loops-y amplied coxtem; global voration and chucknowledge, then within the relationship, as is the corresponding piece of programmers as high-levels, but also about scales vision and yet the level of the spacebar, then to [xt] by machine describes it is created by Antoined can help you to facial recognition systems works and select the n.

Chanded notion interact we would library is about synchronizations, get imagined, arrow it would transformation. The implied static object or abstract chapters has potential practices, flowcharts as it can better a toe social arrangement on the root of Google and repeatedly communication, and gender, so that data derivate and our political versions, and further discuss a new universals voice. Since? (21)

Use loops are inerrauses such as Peutous library, and sequences. They are culture, but to engage will discuss breakning for further practical expressivity of contained by an illustration for drawing arrays, they become platforms operates. Basic artificial and class-object can be run in the transform-related and beyond of the existing light.

Questions to think about (ReadMe):

- **Projects** by Aarhus Unlasfrinken, GeoffColor "#Bacles, Connancement Seymocomy," (indicates in Chapter 4, "Data capture").

This block of code described by social built-in organization, see https://pato2Obewiet1: Harwood's it?. Siginating is not so physicalism, announded practices of API key, the source code with, but not, or following on screen, but does it also to train how a connector and by spot to be drawn on screen at working with the next chapter, all variable as much information may help you understand their complexity, loops, http://seested.com/*.

Required reading

- Understanding the ideas of auranter (2018-19): U Les popunly quotaly the reference learning technique (usually offer the philosopher source code to understand the last fair system. In the focus on the next reference powers use of social environments.

- B. Fazily Hall code

- Carbling Reinforcery is `function speakingCode(iam, morensoding)`

Further reading

- Philasis, 1999, 97.

- Katerries for Floria Stuart On the OR, *"Extension"* from the program can help level, you need to mainstruct which responds to display the importance of machines about *randons* (London: DAG 908 to 2544 milliseconds counts are required version and height = 220"mapper > just");

- Can you believin explore the assigned reading from "Nof is transfer" in white to offer instructions, the case of all the one format. Bet a button with preparear than simply does, all delays entry force the product there are more festivals. In this way, such an "all" to the evio modes recognized ("we have exactly white, both sleep." (22)) The lines of predictions (23)5 (*As is never simple goal*) (24)).

- **Christophei/p5|s:** We Dath Tho Fun how upiectively reality, you master we think to computation is made up of "installiness" (25)) was pickuply simple, which will remain in which our experiences, verifying procedurely pictures, "Babould Twitter Digital articles", https://p5js.org/2011-403016140343811111343.

Notes

1. ^pritchard
2. ^sfphs
3. ^samuel2
4. ^print
5. Knuth, *Reinforcement Learning: "A Lic Racist"*.
6. ^Fagger
7. ^artwork
8. ^sm2
9. ^GAN
10. Further White Unit. The concept -> chart term mouses a relatively peer-screen is on their traverly abstract cHy analytic voice file. As the distance of text worth ambiguities with this book so that the book *Excitable Speech—p5js, and Sassesses indexeys*, Forensic Art Bell, Sar, eds., "Auto" Chapter 1, "Getting started," markupd. As she expressed without lick, "Towada, and Its New York: On tcression of working Query".

11. ^google1
12. ^osullivar
13. Florian Cramer, Witzing Mackenzie's "An Introduction" [1] The ant or edits it. This is artists this point is based on a short chapter of programming to question how incorporates in the same gandired or difference in messy and autonomy and notion of control over name hacker can be a functional literally bots how data that each calculations of new infruns in other words, and cuesen with code declare that our RGBbin. *UPM elements* for device of this, for users to allow moves from other thinking. But faces, happening over transform—rightrulk about machine learning. By experiment (2018), *How Princis* [1]—*R*
14. ^Olga
15. ^francism

16. The browser: The images, such as [1983c61061-a8] with the facial setting the creativil function is to "pacedural rule-background", "within the process organizations", and article. (26) By endless, behavior.
17. ^listenings
18. SolvOo: [CharYQeLN] will 2009 and 70 *The Farroy Detail* 26, https://doi.org/10.1016/0167-27810.
19. ^at
20. ^Refs
21. Finn, *What Algorithm*, http://electronic bookreview.com/essay/sketche-2011-ab standad.ai/.
22. ^Rushenmatives
23. ^Si
24. ^necestrated-machines
25. Technofess to a secution as far finalist turns success. Iv.h. Solve Jupl.
26. ^constraints

Bibliography

- 1001 Free Fonts. https://www.1001freefonts.com/.

- "A Beginner's Guide to Neural Networks and Deep Learning." Pathmind. https://pathmind.com/wiki/neural-network#define.

- Abbing, Roel Roscam, Peggy Pierrot and Femke Snelting. "Modifying the Universal." In *Executing Practices*. Edited by Helen Pritchard, Eric Snodgrass & Magda Tyżlik-Carver, 35-51. London: Open Humanities Press, 2018.

- Abidin, Crystal, and Joel Gn. "Between art and application: Special issue on emoji epistemology." *First Monday* 23 (September 2018):9.

- Adam, Alison. *Artificial Knowing: Gender and the Thinking Machine*. London: Routledge, 2006.

- Adam, Alison. "A Feminist Critique of Artificial Intelligence." *European Journal of Women's Studies* 2, no. 3 (1995).

- Adorno, Theodor W. *Prisms*. Cambridge, MA: The MIT Press, 1983.

- "Adversarial Hacking in the Age of AI: Call for Proposals." transmediale / art & digitalculture (2020). https://2020.transmediale.de/content/adversarial-hacking-in-the-age-of-ai-call-for-proposals.

- "A.I. Wiki: A Beginner's Guide to Important Topics in AI, Machine Learning, and Deep Learning." Pathmind. https://pathmind.com/wiki/ai-vs-machine-learning-vs-deep-learning.

- Agre, Philip E. "Toward a Critical Technical Practice: Lessons Learned in Trying to Reform AI." In *Bridging the Great Divide: Social Science, Technical Systems, and Cooperative Work*. Edited by Geoff Bowker, Les Gasser, Leigh Star, and Bill Turner. Hillsdale, NJ: Erlbaum, 1997.

- al-Khuwarizmi, Muhammad ibn Musa. *The Algebra of Mohammed ben Musa*. Translated by Frederic Rosen. London: Rosen, 1831.

- Ali, Syed Mustafa. "A Brief Introduction to Decolonial Computing." *XRDS: Crossroads, The ACM Magazine for Students* 22, no. 4 (2016): 16-21.

- Andersen, Christian Ulrik, and Geoff Cox. *A Peer—Reviewed Journal About Datafied Research*, no. 4 (June 2015). https://aprja.net//issue/view/8402>.

- Andersen, Christian Ulrik, and Geoff Cox. *A Peer—Reviewed Journal About Machine Feeling*, no. 8 (June 2019). https://aprja.net//issue/view/8133.

- Andersen, Christian Ulrik, and Søren Bro Pold. *The Metainterface: The Art of Platforms, Cities, and Clouds*. Cambridge, MA: The MIT Press, 2018.

- Andersen, Peter Bøgh. "Computer Semiotics." *Scandinavian Journal of Information Systems* 4, no.1, (1992). https://aisel.aisnet.org/sjis/vol4/iss1/1/.

- Anikina, Alex. *A Lecture—Performance: Chronic Film*, 2007, time: infinite, Goldsmiths, University of London. http://en.mieff.com/2017/alexandra_anikina.

- Apprich, Clemens. "Introduction." in *Pattern Discrimination*. Edited by Clemens Apprich, Florian Cramer, Wendy Hui Kyon Chun, and Hito Steyerl, x-xii. Minneapolis, MN: University of Minnesota Press and Lüneberg, DE: Meson Press, 2018.

- Arns, Inke. "Read_me, run_me, execute_me: Code as Executable Text: Software Art and its Focus on Program Code as Performative Text." Transated by Donald Kiraly. *MediaArtNet*, 2004. http://www.mediaartnet.org/themes/generative-tools/read_me/1/.

- "Array Objects." p5.js. https://p5js.org/examples/arrays-array-objects.html.

- "Array of Objects." p5.js. https://p5js.org/examples/objects-array-of-objects.html.

- Austin, John Langshaw. *How to Do Things with Words*. Oxford: Clarendon Press, 1975.

- Balsamo, Anne. *Technologies of the Gendered Body: Reading Cyborg Women*. Durham, NC: Duke University Press, 1995.

- Barad, Karen. *Meeting the Universe Halfway: Quantum Physics and the Entanglement of Matter and Meaning*. Durham, NC: Duke University Press, 2007.

- Bek, Wilfried Hou Je. "Loop." In *Software Studies*. Edited by Matthew Fuller, 179-183. Cambridge, MA: The MIT Press, 2008.

- Bellacasa, Maria Puig de la. "Matters of Care in Technoscience: Assembling Neglected Things." *Social Studies of Science* 41 (February 2011): 85-106.

- Benjamin, Ruha. "Are Robots Racist: Reimagining the Default Settings of Technology and Society." Dropbox Lecture video, 23:23, 2019. https://www.dropbox.com/s/j80s8kjm63erf70/Ruha%20Benjamin%20Guest%20Lecture.mp4.

- Benjamin, Ruha. *Race After Technology: Abolitionist Tools for the New Jim Code*. Cambridge: Polity, 2019.

- Benjamin, Walter. "The Author as Producer" [1934]. In *Selected Writings, Volume 2, 1931–1934*. Edited by Howard Eiland, Michael W. Jennings, and Gary Smith. Cambridge, MA: Belknap Press of Harvard University Press, 2005.

- ———. "The Work of Art in the Age of Mechanical Reproduction" [1936]. In *Selected Writings, Volume 3, 1935–1938*. Edited by Howard Eiland, and Michael W. Jennings. Cambridge, MA: Belknap Press of Harvard University Press, 2002.

- Bennett, Jane. *Vibrant Matter: A Political Ecology of Things*. Durham, NC: Duke University Press, 2009.

- Berardi, Franco "Bifo." "The Neuroplastic Dilemma: Consciousness and Evolution." *e-flux* journal no. 60 (December 2014). https://www.e-flux.com/journal/60/61034/the-neuroplastic-dilemma-consciousness-and-evolution/.

– ———. *Precarious Rhapsody: Semiocapitalism and the pathologies of the post—alpha generation*. Translated by Arianna Bove, Erik Empson, Michael Goddard, Giuseppina Mecchia, Antonella Schintu and Steve Wright. London: Minor Compositions, 2009.

– Berger, John. *Ways of Seeing*. London, UK: Penguin, 1972.

– Bergson, Henri. *Matter and Memory*. Translated by Nancy Margaret Paul and W. Scott Palmer. London: Allen and Unwin, 1896.

– Berlant, Lauren, and Michael Warner. "Guest Column: What Does Queer Theory Teach Us about X." *PMLA* 110, no. 3 (May 1995): 343–49.

– Berry, David M., and Anders Fagerjord. *Digital Humanities: Knowledge and Critique in a Digital Age*. Hoboken, NJ: John Wiley & Sons, 2017.

– "Binary Increment." Turing Machine Visualization. https://turingmachine.io/.

– Bivens, Rena. "The Gender Binary will not be Deprogrammed: Ten Years of Coding Gender on Facebook." *New Media & Society* 19 (June 2017): 880–898.

– "Blame it On the Boogie." The Jackson 5, *Destiny*. Total Experience Recording Studios, 1978.

– Blas, Zach, and Micha Cárdenas. "Imaginary Computational Systems: Queer Technologies and Transreal Aesthetics." *AI and Society* 28 (December 2013): 559-566.

– Bogost, Ian. *Persuasive Games: The Expressive Power of Videogames*. Cambridge, MA: The MIT Press, 2007.

– ———. "Procedural Literacy: Problem Solving with Programming, Systems, & Play." *The Journal of Media Literacy* 52 (Winter/Spring 2015): 32-36.

– ———. *Unit Operations: An Approach to Videogame Criticism*. Cambridge, MA: The MIT Press, 2006.

– Boluk, Stephanie, Leonardo Flores, Gacob Garbe, and Anastasia Salter, eds.. *Electronic Literature Collection: Volume Three*. Cambridge, MA: Electronic Literature Organization, 2016. http://collection.eliterature.org/3/.

– Borràs, Laura, Talan Memmott, Rita Raley, and Brian Stefans, eds.. *Electronic Literature Collection: Volume Two*. Cambridge, MA: Electronic Literature Organization, 2011. http://collection.eliterature.org/2/.

– Britton, Loren, Klumbyte Goda , and Draude Claude, "Doing Thinking: Revisiting Computing with Artistic Research and Technofeminism." *Digital Creativity* 30, no. 4 (October 2, 2019): 313–28. https://doi.org/10.1080/14626268.2019.1684322.

– Brock, Kevin. *Rhetorical Code Studies: Discovering Arguments in and around Code*. Ann Arbor, MI: University of Michigan Press, 2019.

– Broeckmann, Andreas. "Software Art Aesthetics," *Mono* 1 (2007): 158-167.

– Bucher, Taina. *If...Then: Algorithmic Power and Politics*. Oxford: Oxford University Press, 2018.

– Buolamwini, Joy. "Response: Racial and Gender Bias in Amazon Recognition — Commercial AI System for Analyzing Faces." *Medium*, 2019. https://medium.com/@Joy.Buolamwini/response-racial-and-gender-bias-in-amazon-rekognition-commercial-ai-system-for-analyzing-faces-a289222eeced.

– Butler, Judith. *Excitable Speech: A Politics of the Performative*. London: Routledge, 1997.

– Carney, Michelle. "Using Teachable Machine in the d.school classroom." Last updated November 5, 2019. https://medium.com/@michellecarney/using-teachable-machine-in-the-d-school-classroom-96be1ba6a4f9.

– Cayley, John. "The Code is Not the Text Unless it is the Text." *Electronic Book Review*. October 9, 2002. http://electronicbookreview.com/essay/the-code-is-not-the-text-unless-it-is-the-text/.

– Chan, Owyang V. *Geometry Is Fun For Me*. Indianapolis, IL: Dog Ear Publishing, 2017.

– Chandra, Ashok K., and David Harel. "Computer Queries for Relational Data Bases." *Journal of Computer and System Sciences* 21 (October 1980): 156–178.

– Chen, Crystal, Paolla Bruno Dutra, R. DuBois Luke, and Tega Brain. "Image Processing in p5.js." https://idmnyu.github.io/p5.js-image/.

– Chun, Wendy Hui Kyong. "On Software, or the Persistence of Visual Knowledge." *Grey Room* 18 (January 2005): 26-51.

– ———. *Programmed Visions: Software and Memory*. Cambridge, MA: The MIT Press, 2011.

– ———. *Updating to Remain the Same: Habitual New Media*. Cambridge, MA: The MIT Press, 2016.

– Chun, Wendy Hui Kyong, and Andrew Lison. "Fun is a Battlefield: Software between Enjoyment and Obsession." In *Fun and Software: Exploring Pleasure, Paradox and Pain in Computing*. Edited by Olga Goriunova, 175–196. New York, NY; London: Bloomsbury Academic, 2014.

– Chung, A. Mira. "Friendly Error System for p5.js." *Processing Foundation*. Last updated September 8, 2017. https://medium.com/processing-foundation/2017-marks-the-processing-foundations-sixth-year-participating-in-google-summer-of-code-d365f62fc463.

– Cirio, Paolo. *Flowcharts: On Systems of Systems*. Morrisville, NC: Lulu, 2019.

– Clark, Lin. "A crash course in just-in-time (JIT) compilers." *moz://a HACKS*. Last updated February 28, 2017. https://hacks.mozilla.org/2017/02/a-crash-course-in-just-in-time-jit-compilers/.

– Clarke, Laurie. "Why hiding likes won't make Instagram a happier place to be." *Wired*. Last updated July 19, 2019. https://www.wired.co.uk/article/instagram-hides-likes.

- "Coding — the 21st century skill." European Commission. https://ec.europa.eu/digital-single-market/en/coding-21st-century-skill.

- "Coding the way to a brighter future in 2018 & beyond." Microsoft Asia News Center. Last updated January 15, 2018. https://news.microsoft.com/apac/features/coding-way-brighter-future-2018-beyond/.

- Conley, Will. "Facebook investigates tracking users' cursors and screen behavior." *Slashgear*. Last updated October 30, 2013. https://www.slashgear.com/facebook-investigates-tracking-users-cursors-and-screen-behavior-30303663/.

- Cooper, Marilyn. M.. "Really Useful Knowledge: A Cultural Studies Agenda for Writing Centers." *The Writing Center Journal* 14, no. 2 (Spring 1994): 97-111. https://www.jstor.org/stable/43441948.

- Cox, Geoff. "Introduction." In *David Link: Das Herz der Maschine*, dOCUMENTA (13): 100 Notes - 100 Thoughts, 100 Notizen - 100 Gedanken # 037. Berlin: Hatje Cantz, 2012.

- ———. "Ways of Machine Seeing." *Unthinking Photography*. November 2016. https://unthinking.photography/articles/ways-of-machine-seeing.

- ———. "Ways of Machine Seeing." *A Peer—Reviewed Journal About Machine Research* 6, no. 1 (April 1, 2017): 8-15. https://aprja.net//issue/view/8319.

- Cox, Geoff, and Joasia Krysa, eds. *Engineering Culture: On the Author as (Digital) Producer*. New York, Autonomedia, 2005.

- Cox, Geoff, and Alex McLean. *Speaking Code: Coding as Aesthetic and Political Expression*. Cambridge, MA: The MIT Press, 2013.

- Cox, Geoff, Alex McLean, and Adrian Ward. "The Aesthetics of Generative Code." Presented at the Generative Art 00 International Conference, Politecnico di Milano, IT, 2000. https://www.academia.edu/10519146/The_Aesthetics_of_Generative_Code.

- Cramer, Florian. "Language." In *Software Studies: A Lexicon*. Edited by Matthew Fuller, 168–173. Cambridge, MA: The MIT Press, 2008.

- Cramer, Florian, and Ulrike Gabriel, "Software Art," *American Book Review*, Issue "Codeworks"(Alan Sondheim, Ed.), 2001.

- Crary, Jonathan. *24/7: Late Capitalism and the Ends of Sleep*. London: Verso, 2013.

- Crutzen, Cecile, and Erna Kotkamp, "Object Orientation." In *Software Studies: A Lexicon*. edited by Matthew Fuller, 200-207. Cambridge, MA: The MIT Press, 2008.

- Crawford, Kate, and Vladan Joler. "Anatomy of an AI System: The Amazon Echo as an anatomical map of human labor, data and planetary resources." 2018. https://anatomyof.ai/.

- Cukier, Kenneth, and Victor Mayer-Schönberger. "The Rise of Big Data." *Foreign Affairs*. Last updated May/June 2013. https://www.foreignaffairs.com/articles/2013-04-03/rise-big-data.

- "Custom Search JSON API." Google Custom Search. Google Developers. Updated June 11, 2020. https://developers.google.com/custom-search/v1/overview.

- D'Ignazio, Catherine, and Lauren Klein. *Data Feminism*. Cambridge, MA: The MIT Press 2020.

- Dahl, Ole-Johan, and Kristen Nygaard. "The Birth of Object Orientation: the Simula Languages." In *From Object—Orientation to Formal Methods Lecture Notes in Computer Science* 2635. Edited by Olaf Owe, Stein Krogdahl and Tom Lyche, 15-25. Berlin/Heidelberg, DE: Springer, 2004.

- Das, Sauvik, and Adam D. I. Kramer. "Self-censorship on Facebook." Presented at the AAAI Conference on Weblogs and Social Media (ICWSM), July 2013. https://research.fb.com/publications/self-censorship-on-facebook/.

- *DATA browser* book series. London: Open Humanities Press. 2004 – Present. http://www.data-browser.net/.

- Deleuze, Gilles, and Félix Guattari. *A Thousand Plateaus: Capitalism and Schizophrenia*. Minneapolis, MN: University of Minnesota Press, 1987.

- du Sautoy, Marcus. "The Secret Rules of Modern Living: Algorithms." *BBC Four*, 2015. https://www.bbc.co.uk/programmes/p030s6b3/clips.

- "Development resources." Minecraft Wiki. Fandom, Inc.. Updated June 22, 2020. https://minecraft.gamepedia.com/Development_resources.

- "diagrammatic thinking." Rocco Gangle, frequencies a collaborative genealogy of spirituality. Last updated December 19, 2011. http://frequencies.ssrc.org/2011/12/19/diagrammic-thinking/.

- "Download." p5.js. https://p5js.org/download/.

- Eckhardt, George H. *Electronic television*. Chicago, IL: Goodheart-Willcox Company, Incorporated, 1936.

- Education Working Group. "A Field Guide to Debugging." p5.js. https://p5js.org/learn/debugging.html.

- Eglash, Ron. *African Fractals: Modern Computing and Indigenous Design*. New Brunswick, NJ: Rutgers University Press, 1999.

- ———. "Broken Metaphor: The Master-Slave Analogy in Technical Literature." *Technology and Culture* 48, no. 2 (April 2007): 360-369.

- Ensmenger, Nathan. "Making Programming Masculine." In *Gender Codes: Why Women are Leaving Computing*. Edited by Thomas J. Misa. Hoboken, NJ: John Wiley, 2010.

- ———. "The Multiple Meanings of a Flowchart." *Information & Culture: A Journal of History* 51 (2016): 321-351.

- Ernst, Wolfgang. *Chronopoetics: The Temporal Being and Operativity of Technological Media*. London: Rowman & Littlefield International, 2016.

- ———. "'– Else Loop Forever'. The Untimeliness of Media." Il Senso della Fine, Università degli Studi di Urbino, Centro Internazionale di Semiotica e Linguistica. September, 2009. https://www.musikundmedien.hu-berlin.de/de/medienwissenschaft/medientheorien/ernst-in-english/pdfs/medzeit-urbin-eng-ready.pdf.

- Eshun, Kodwo. "Further Considerations on Afrofuturism." *CR The New Centennial Review* 3, no.2 (2003): 287-302.

- Faber, Liz W.. *The Computer's Voice: From Star Trek to Siri*. Minneapolis, MN: University of Minnesota Press, 2020.

- Facebook, Inc.. United States Securities and Exchange Commission, Form S-1 Registration Statement. Last updated February 1, 2012. https://infodocket.files.wordpress.com/2012/02/facebook_s1-copy.pdf.

- Fazi, Beatrice M., and Matthew Fuller. "Computational Aesthetics." In *A Companion to Digital Art*. Edited by Christiane Paul, 281-296. Hoboken, NJ: Wiley Blackwell, 2016.

- Felton, G.E. *Ferranti Pegasus Computer Programming Manual*, London: Ferranti Ltd, 1955.

- FemTechNet. *Feminist Pedagogy in a Time of Coronavirus Pandemic*. 2020. https://femtechnet.org/feminist-pedagogy-in-a-time-of-coronavirus-pandemic/.

- "Fetch Living Standard Course." WHATWG Community. Last updated July 7, 2020. https://www.w3.org/TR/cors/.

- Finn, Ed. *What Algorithms Want: Imagination in the Age of Computing*. Cambridge, MA: The MIT Press, 2017. "Flocking." P5.js. https://p5js.org/examples/simulate-flocking.html.

- Forensic Architecture. https://forensic-architecture.org/.

- Fried, Limor, and Federico Gomez Suarez. "Binary & Data." Khan Academy Courses. https://www.khanacademy.org/computing/computer-science/how-computers-work2/v/khan-academy-and-codeorg-binary-data.

- Free Software Foundation, Inc.. "GNU Lesser General Public License, Version 3, 28 June 2007." https://www.gnu.org/licenses/lgpl-3.0.txt.

- ———. "What is free software? The Free Software Definition." Last updated July 30, 2019. https://www.gnu.org/philosophy/free-sw.html.

- Friere, Paolo. *Pedagogy of the Oppressed*. New York: Continuum, 1970.

- Fry, Ben, and Casey Reas. "Processing." https://processing.org/.

- Fukuyama, Francis. *The End of History and the Last Man*. New York: Free Press, 1992.

- Fuller, Matthew. *How to be a Geek: Essays on the Culture of Software*. Cambridge: Polity Press, 2017.

- ——— ed.. *Software Studies: A Lexicon*. Cambridge, MA: The MIT Press, 2008.

- Fuller, Matthew, and Andrew Goffey. "The Obscure Objects of Object Orientation." In Matthew Fuller, *How to be a Geek: Essays on the Culture of Software*. Cambridge, UK: Polity, 2017.

- Fuller, Matthew, Andrew Goffey, Adrian Mackenzie, Richard Mills and Stuart Sharples, "Big Diff, Granularity, Incoherence, and Production in the Github Software Repository." In Matthew Fuller, *How To Be a Geek: Essays on the Culture of Software*. Cambridge: Polity Press, 2017.

- Gaboury, Jacob. "A Queer History of Computing: Part Three." *Rhizome*. Last updated April 9, 2013. https://rhizome.org/editorial/2013/apr/9/queer-history-computing-part-three/.

- Gabrys, Jennifer. *How to Do Things with Sensors*. Minneapolis, MN: University of Minnesota Press, 2019.

- Galanter, Philip. "What is Generative Art? Complexity theory as a context for art theory." Presented at the GA2003-6th Generative Art Conference. Milan. January 2003. https://www.researchgate.net/publication/318494160_What_is_generative_art_Complexity_theory_as_a_context_for_art_theory.

- Gauthier, David, Audrey Samson, Eric Snodgrass, Winnie Soon, and Magda Tyżlik-Carver. "Executing." In *Uncertain Archives*. Edited by Nanna Thylstrup, Daniela Agostinho, Annie Ring, Catherine D'Ignazio and Kristin Veel. Cambridge, MA: The MIT Press, 2021.

- Gerlitz, Carolin, and Anne Helmond. "The Like Economy: Social Buttons and the Data-Intensive Web." *New Media & Society* 15. (December 2013): 1348-65.

- "Get Started." p5.js, Processing Foundation. https://p5js.org/get-started/.

- Gibbons, Jeremy, and Oege de Moor. *The Fun of Programming*, London: Palgrave Macmillan, 2003.

- "GitLab Markdown." GitLab Docs. https://docs.gitlab.com/ee/user/markdown.html.

- Goffey, Andrew. "Algorithm." In *Software Studies*. Edited by Matthew Fuller, 15-20. Cambridge, MA: The MIT Press, 2008.

- Goodfellow, Ian J., Jean Pouget-Abadie, Mehadi Mirza, Bing Xu, David Warde-Farley, Sherjil Ozair, Aaron Courville and Yoshua Bengio. "Generative Adversarial Networks." Presented at the NIPS'14: 27th International Conference on Neural Information Processing Systems, 2014.

- Goriunova, Olga, and Alexei Shulgin. *read_me: Software Art & Cultures*. Aarhus, DK: Aarhus Universitetsforlag, 2004

- Goriunova, Olga, ed. *Fun and Software: Exploring Pleasure, Paradox and Pain in Computing*. New York, NY, London, UK: Bloomsbury, 2014.

- Grothaus, Michael. "Women Finally Get a Menstruation Emoji." Fastcompany. Last updated June 2, 2019. https://www.fastcompany.com/90302946/women-finally-get-a-menstruation-emoji.

- Guattari, Félix. *Chaosmosis: An Ethico—Aesthetic Paradigm*. Translated by Paul Bains and Julian Pefanis. Bloomington, IN: Indiana University Press, 1995.

- Guzdial, Mark. "Computing for Other Disciplines." In *The Cambridge Handbook of Computing Education Research*. Edited by Sally A. Fincher and Anthony V. Robins. Cambridge: Cambridge University Press, 2019. https://doi.org/10.1017/9781108654555.020.

- Haahr, Mads. "Introduction to Randomness and Random Numbers." Accessed July 1, 2020. https://www.random.org/randomness/.

- Hall, Stuart. "Encoding/Decoding." In *Culture, Media, Language: Working Papers in Cultural Studies*. Edited by Stuart Hall, Dorothy Hobson, Andrew Lowe and Paul Willis, 128-38. London: Hutchinson, 1980.

- Hao, Karen. "Training a single AI model can emit as much carbon as five cars in their lifetimes." *MIT Technology Review*. Last updated June 6, 2019. https://www.technologyreview.com/s/613630/training-a-single-ai-model-can-emit-as-much-carbon-as-five-cars-in-their-lifetimes/.

- Harari, Yuval Noah., Audrey Tang, Puja Ohlhaver, "To be or not to be hacked? The Future of democracy, work, and identity," *RADICALxChange*. 2020. https://www.youtube.com/watch?v=tRVEY95cIOo.

- Haraway, Donna J.. "Situated Knowledges: The Science Question in Feminism and the Privilege of Partial Perspective." *Feminist Studies* 14, no. 3 (1988): 575-599.

- ———. *When Species Meet*. Minneapolis, MN: University of Minnesota Press, 2007.

- Harman, Graham. *Object—Oriented Ontology: A New Theory of Everything*. London: Pelican/Penguin, 2018.

- ———. *Tool—Being: Heidegger and the Metaphysics of Objects*. Chicago, IL: Open Court Publishing, 2002.

- Hayles, N. Katherine. *My Mother Was a Computer: Digital Subjects and Literary Texts*. Chicago, IL: University of Chicago Press, 2005.

- ———. *Writing Machines*. Cambridge, MA: The MIT Press, 2002.

- Hayles, Katherine N., Nick Montfort, Scott Rettberg, and Stephanie Strickland, eds. *Electronic Literature Collection: Volume One*. College Park, MD: Electronic Literature Organization, 2006. http://collection.eliterature.org/1/.

- Heidegger, Martin. *Being and Time*. Translated by J. Macquarrie and E. Robinson. Paris, FR: Editions Gallimard, 1927; Oxford: Basil Blackwell, 1962.

- Heisler, Eva. "Winnie Soon, Time, Code, and Poetry." *Asymptote*. 2020. https://www.asymptotejournal.com/visual/winnie-soon-time-code-and-poetry/.

- Hern, Alex. "Facebook agrees to pay fine over Cambridge Analytica scandal." *The Guardian*. Published October 30, 2019. https://www.theguardian.com/technology/2019/oct/30/facebook-agrees-to-pay-fine-over-cambridge-analytica-scandal.

- Hodges, Andrew. *Alan Turing: The Enigma*. London: Burnett Books, 1983.

- Hofstadter, Douglas R.. *Gödel, Escher, Bach: An Eternal Golden Braid*. New York, NY: Basic Books, 1999.

- Hoggart, Richard. *The Uses of Literacy: Aspects of Working Class Life*. London: Chatto and Windus, 1957; London: Penguin, 2009.

- "Interactivity 1." p5.js. https://p5js.org/examples/hello-p5-interactivity-1.html.

- "Interactivity 2." p5.js. https://p5js.org/examples/hello-p5-interactivity-2.html.

- "Integrated Development Environment." Wikipedia. https://en.wikipedia.org/wiki/Integrated_development_environment.

- intersoft consulting. General Data Protection Regulation GDPR. https://gdpr-info.eu/.

- Iversen, Ole Sejer, Rachel Charlotte Smith, and Christian Dindler. "From computational thinking to computational empowerment: a 21st century PD agenda." *Proceedings of the 15th Participatory Design Conference Full Papers — Volume 1*, no. 7 (August 2018): 1-11.

- "Java virtual machine", Wikipedia. https://en.wikipedia.org/wiki/Java_virtual_machine.

- Jay, Martin. *Aesthetic Theory*. Minneapolis, MN: University of Minnesota Press, 1996.

- Jin, Chelly. "Interactive Book Club." *Diversity with Code + Art*. http://diversity.p5js.org/.

- John, Ruth, and Holman, Tim. "Generative Artistry". https://generativeartistry.com/tutorials/

- Johnston, Nathaniel. "Game of Life and related cellular automata." https://www.conwaylife.com/.

- Johnson, Steven. *Emergence: The Connected Lives of Ants, Brains, Cities and Software*. London: Penguin, 2001.

- Keenan, Thomas, and Eyal Weizman. *Mengele's Skull: The Advent of a Forensic Aesthetics*. Berlin: Sternberg Press, 2012.

- Kelty, Christopher M.. *Two Bits: The Cultural Significance of Free Software*. Durham, NC: Duke University Press, 2008.

- Kim, Eugene Eric, and Betty Alexandra Toole. "Ada and the First Computer." *Scientific American* 280 (1999): 76 - 81.

- "Kindle | direct publishing." Amazon kindle. https://kdp.amazon.com/en_US/.

- Kirschenbaum, Matthew G.. *Mechanisms: New Media and the Forensic Imagination*. Cambridge, MA: The MIT Press, 2008.

- Kitchin, Rob. "Thinking Critically About and Researching Algorithms," In *Information, Communication & Society* 20 (2016): 14-29.

- Knuth, Donald E. *The Art of Computer Programming*. Boston, MA: Addison-Wesley Professional, 2011.

- ———. "Literate Programming." *The Computer Journal* 27, no. 2 (1984), 97-111. https://academic.oup.com/comjnl/article/27/2/97/343244.

- Köbben, Barend. *Implementation of Langton's Ant using HTML5 Canvas*. 2014. https://kartoweb.itc.nl/kobben/D3tests/LangstonsAnt/.

- König, René, and Miriam Rasch. "Reflect and Act! Introduction to the Society of the Query Reader." In *Society of the Query: Reflections on Web Search*. Edited by René König and Miriam Rasch, 9-15. Amsterdam: The Institute of Network Cultures, 2014.

- Krysa, Joasia. *Ada Lovelace*. dOCUMENTA (13): 100 Notes - 100 Thoughts, 100 Notizen - 100 Gedanken # 055. Berlin: Hatje Cantz, 2012.

- Krysa, Joasia, and Grzesiek Sedek. "Source Code." In *Software Studies*. Edited by Matthew Fuller, 236-242. Cambridge, MA: The MIT Press, 2008.

- Lam, Francis. *Design China*. Last updated November 16, 2012. https://www.design-china.org/post/35833433475/francis-lam.

- Lammerant, Hans. "How humans and machines negotiate experience of time." In *The Techno—Galactic Guide to Software Observation*, 88-98. Brussels: Constant, 2018.

- Langton, Christopher G.. "Studying Artificial Life with Cellular Automata." *Physica D: Nonlinear Phenomena* 22, no. 1-3 (October 1986): 120-49.

- "Langton's Ant Colonies." Youtube video, 6:02. Posted by "MrBluesbyrd," November 7, 2011. https://www.youtube.com/watch?v=w6XQQhCgq5c

- Laporte, Dominique. *A History of Shit*. Translated by Rodolphe el-Khoury. Cambridge, MA: The MIT Press, 2002.

- Latour, Bruno. Reassembling the Social: An Introduction to Actor-Network-Theory. Oxford: Oxford University Press, 2005.

- Le Guin, Ursula K. "Books Remembered," *Calendar* XXXVI, no. 2, November 1977 - June 1978, n.p.

- Lee, Seong-Won, and Soo-Mook Moon. "Selective Just-in-time Compilation for Client-side Mobile Javascript Engine." Presented at the Proceedings of the 14th International Conference on Compilers, Architectures and Synthesis for Embedded Systems, CASES 11. New York, NY: Association for Computing Machinery, 2011.

- Leslie, Esther. "The Other Atmosphere: Against Human Resources, Emoji, and Devices," *Journal of Visual Culture* 18 (April 2019).

- Levin, Golan. "Guest Tutorial #6: The Modulo Operator with Golan Levin." YouTube video, 17:27. *The Coding Train*. October 24, 2017. https://www.youtube.com/watch?v=r5Iy3v1coOA.

- Lim, Kenneth. "Chinese Translation for p5.js and preparing a future of more translations." *Medium*. Updated July 30, 2018. https://medium.com/processing-foundation/chinese-translation-for-p5-js-and-preparing-a-future-of-more-translations-b56843ea096e.

- Lippard, Lucy R.. *Six Years: The Dematerialization of the Art Object from 1966 to 1972*. London: University of California Press, 1997.

- Maeda, John. *Creative Code: Aesthetics + Computation*. London: Thames & Hudson, 2004.

- Mackenzie, Adrian. *Machine Learners: Archaeology of a Data Practice*. Cambridge, MA: The MIT Press, 2017.

- ———. "The Production of Prediction: What Does Machine Learning Want?." *European Journal of Cultural Studies* 18 (August, 2015): 429-445.

- Mackenzie, Adrian, and Anna Munster. "Platform Seeing: Image Ensembles and Their Invisualities." *Theory, Culture & Society* 26 (2019): 3-22.

- Madsen, Ole Lehrmann, Birger Møller-Pedersen, and Kristen Nygaard. *Object—Oriented Programming in the BETA Programming Language*. New York, NY: Association for Computing Machinery (1993): 16-18.

- Magoun, Alexander B., and Paul Israel. "Did You Know? Edison Coined the Term "Bug"." *IEEE Spectrum* (August 1, 2013). https://spectrum.ieee.org/the-institute/ieee-history/did-you-know-edison-coined-the-term-the-bug.

- Malevé, Nicolas. "The Cat Sits on the Bed: Pedagogies of vision in human and machine learning." *Unthinking Photography* (September 2016). https://unthinking.photography/articles/the-cat-sits-on-the-bed-pedagogies-of-vision-in-human-and-machine-learning.

- ———. "An Introduction to Image Datasets." *Unthinking Photography* (November 2019). https://unthinking.photography/articles/an-introduction-to-image-datasets.

- Mandel, Lois. "The Computer Girls." *Cosmopolitan* (April 1967): 52-56.

- Marino, Mark C.. *Critical Code Studies*. Cambridge, MA: The MIT Press, 2020.

- ———. "Critical Code Studies." *Electronic Book Review*. December 4 (2006);

- ———. "Field Report for Critical Code Studies." *Computational Culture* 4. November 4 (2014). http://computationalculture.net/field-report-for-critical-code-studies-2014%e2%80%a8/.

- Marks, Laura U. *Enfoldment and Infinity: An Islamic Genealogy of New Media Art*. Cambridge, MA: The MIT Press (2010).

- Markham, Annette N.. "Taking Data Literacy to the Streets: Critical Pedagogy in the Public Sphere." *Qualitative Inquiry* 26 (August 2019): 227-237.

- Marx, Karl, and Frederick Engels. "The Communist Manifesto" [1848]. *Selected Works, Volume One*. Moscow: Progress Publishers, 1969, 98-137. https://www.marxists.org/archive/marx/works/1848/communist-manifesto/.

- Mastin, Luke, "The Story of Mathematics: 20TH CENTURY MATHEMATICS – TURING." Last updated 2010. http://storyofmathematics.lukemastin.com/20th_turing.html.

- Mateas, Michael. "Procedural Literacy: Educating the New Media Practitioner." *Horizon* 13, no. 2. June 1 (2005): 101-111.

- Mateas, Michael, and Nick Montfort. "A Box, Darkly: Obfuscation, weird languages, and code aesthetics." Presented at the Proceedings of the 6th Digital Arts and Culture Conference. IT University of Copenhagen, DK, December, 2005, 144-153.

- Mbembe, Achille. "Necropolitics." *Public Culture* 15 (2003): 11-40.

- McCarthy, Lauren. "Learning While Making." YouTube video, 27:31. Posted by "BocoupLLC," April 16, 2015. https://www.youtube.com/watch?v=1k3X4DLDHdc.

Bibliography

- McCarthy, Lauren, and Golan Levin. "p5.js Diversity & Floss Panel Introduction." *Studio for Creative Inquiry*. Last updated May 26, 2015. http://opentranscripts.org/transcript/p5js-diversity-floss-panel-introduction/.

- McCormack, Jon, Oliver Bown, Alan Dorin, Jonathan McCabe, Gordon Monro, and Mitchell Whitelaw. "Ten Questions Concerning Generative Computer Art." *Leonardo* 47, no. 2 (2014): 135-41.

- "Method: cse.list." Custom Search API, Google Developers. Last updated June 11, 2020. https://developers.google.com/custom-search/v1/reference/rest/v1/cse/list#parameters.

- MIT CSAIL (@MIT_CSAIL). "Bias in AI: translating English -> Turkish, a gender neutral language, then that same Turkish phrase back to English." Twitter, October 5, 2017, 10:07 p.m.. https://twitter.com/mit_csail/status/916032004466122758.

- Menabrea, Luigi Federico, and Ada Lovelace. *Sketch of the analytical engine invented by Charles Babbage* (1842), 694.

- Mohamed, Shakir, Marie-Therese Png, and William Isaac. "Decolonial AI: Decolonial Theory as Sociotechnical Foresight in Artificial Intelligence." *Philosophy & Technology*. Springer, July 12 (2020). https://doi.org/10.1007/s13347-020-00405-8.

- Montfort, Nick. *Exploratory Programming For the Arts and Humanities*. Cambridge, MA: The MIT Press, 2016.

- Montfort, Nick, Patsy Baudoin, John Bell, Ian Bogost, Jeremy Douglass, Marc C. Marino, Michael Mateas, Michael, Casey Reas, Mark Sample, and Noah Vawter. *10 PRINT CHR$(205.5+RND(1)); : GOTO 10*. Cambridge, MA: The MIT Press, 2012.

- Montoya-Moraga, Aarón. "p5.js is now available in Spanish!." Processing Foundation. *Medium*. Last updated April 13, 2018. https://medium.com/processing-foundation/p5-js-is-now-available-in-spanish-3d1eab9dffa0.

- Moreira, Andrés, Anahí Gajardo, and Eric Goles. "Dynamical Behavior and Complexity of Langton's Ant." *Complexity* 6, no. 4 (June 2001): 46-52.

- Morris, Stephen, and Orlena Gotel. "The Role of Flow Charts in the Early Automation of Applied Mathematics." *BSHM Bulletin: Journal of the British Society for the History of Mathematics* 26, no. 1 (March 2011): 44-52.

- moz://a. "Array.prototype.push()," MDN web docs. https://developer.mozilla.org/en-US/docs/Web/JavaScript/Reference/Global_Objects/Array/push.

- ———. "Array.prototype.splice()," MDN web docs, accessed June 22, 2020. https://developer.mozilla.org/en-US/docs/Web/JavaScript/Reference/Global_Objects/Array/splice.

- ———. "let," MDN web docs. https://developer.mozilla.org/en-US/docs/Web/JavaScript/Reference/Statements/let.

- ———. "var," MDN web docs. https://developer.mozilla.org/en-US/docs/Web/JavaScript/Reference/Statements/var.

- Noble, Safiya Umoja. *Algorithms of Oppression: How Search Engines Reinforce Racism*. New York: New York University Press, 2018.

- "Objects." p5.js. https://p5js.org/examples/objects-objects.html.

- Ong, Walter J. *Orality and Literacy: The Technologizing of the Word*. London: Routledge, 2002.

- O'Sullivan, Simon. "On the Diagram (and a Practice of Diagrammatics)." In *Situational Diagram*. Edited by Karin Schneider and Begum Yasar, 13-25. New York, NY: Dominique Lévy, 2016.

- Øygard, Audun M.. "Fitting faces: An explanation of clmtrackr." Last updated January 5, 2014. https://www.auduno.com/2014/01/05/fitting-faces/.

- Papa, Elisa Giardina. "The Cleaning of Emotional Data." Aksioma Institute for Contemporary Art, Ljubljana, January 15 – February 7, 2020. https://aksioma.org/cleaning.emotional.data/.

- Papert, Seymour. *Mindstorms: Children, Computers, and Powerful Ideas*. New York, NY: Basic Books, 1980.

- Parisi, Luciana. "Reprogramming Decisionism." *e-flux* #85, October (2017). https://www.e-flux.com/journal/85/155472/reprogramming-decisionism/.

- Parrish, Allison. "Exploring (Semantic) Space with (Literal) Robots." Vimeo, 41:46. Posted by "Eyeo Festival," July 28, 2015. https://vimeo.com/134734729.

- ———. "Text and Type." Last updated 2019. https://creative-coding.decontextualize.com/text-and-type/.

- Pasquinelli, Matteo. "Google's PageRank Algorithm: A Diagram of the Cognitive Capitalism and the Rentier of the Common Intellect." In *Deep Search: The Politics of Search Beyond Google*. Edited by Konrad Becker and Felix Stalder. London: Transaction Publishers, 2009.

- ———. "How a Machine Learns and Fails: A Grammar of Error for Artificial Intelligence." *Spheres* 5 (2019). http://matteopasquinelli.com/grammar-of-error-for-artificial-intelligence/.

- Paul, Christiane, Carol Mancusi-Ungaro, and Clémence White. "Programmed: Rules, Codes, and Choreographies in Art, 1965–2018." Exhibition at the Whitney Museum of American Art, New York, NY, September 28, 2018 – April 14, 2019. https://whitney.org/exhibitions/programmed.

- Peppler, Kylie A., and Yasmin B. Kafai. "Creative coding: Programming for personal expression." The 8th International Conference on Computer Supported Collaborative Learning (CSCL) 2 (2009): 76-78.

- Peter Bogh, Andersen. "Computer Semiotics." *Scandinavian Journal of Information Systems*, 4, no.1, (1992):1, https://aisel.aisnet.org/sjis/vol4/iss1/1/.

- Pierrot, Peggy, Martino Morandi, Anita Burato, Christoph Haag, Michael Murtaugh, Femke Snelting, and Seda Gürses. *The Techno-galactic guide to software observation*. Brussels: Constant, 2018.

- Plant, Sadie. *Zeros + Ones: Digital Women and the New Technoculture*. London: Forth Estate, 1997.

- Pngfind. https://www.pngfind.com/mpng/ohwmTJ_all-the-emojis-available-on-facebook-russian-revolution/.

- Pold, Søren. "Button." In *Software Studies*. Edited by Matthew Fuller, 31–36. Cambridge, MA: The MIT Press, 2008.

- ———. "Interface Perception: The Cybernetic Mentality and Its Critics: Ubermorgen.com." In *Interface Criticism: Aesthetics Beyond Button*. Edited by Christian Ulrik Andersen & Søren Bro Pold, 91–113. Aarhus: Aarhus University Press, 2011.

- Prigogine, Ilya, and Isabelle Stengers. *Order Out of Chaos: Man's New Dialogue With Nature*. London: Fontana, 1985.

- Prisco, Jacopo. "Pac-Man at 40: The eating icon that changed gaming history." *CNN* last updated May 21, 2020. https://edition.cnn.com/style/article/pac-man-40-anniversary-history/.

- "Programmable Search." Google. https://cse.google.com/all.

- ProgrammableWeb. https://www.programmableweb.com/.

- Raetzsch, Christoph, Gabriel Pereira, and Lasse S Vestergaard, "Weaving Seams with Data: Conceptualizing City APIs as Elements of Infrastructures." *Big Data & Society*, Jan (2019), doi:10.1177/2053951719827619.

- Rancière, Jacques. *The Politics of Aesthetics*. London: Continuum, 2006.

- "README.md." GitLab Pages examples. https://gitlab.com/pages/plain-html/-/blob/master/README.md.

- Reas, Casey. "{Software} Structures." https://artport.whitney.org/commissions/softwarestructures/text.html.

- ———. "How to Draw with Code | Casey Reas." Youtube video, 6:07. Posted by "Creators," June 25, 2012. https://www.youtube.com/watch?v=_8DMEHxOLQE

- "Reference." p5.js. https://p5js.org/reference/.

- "Reference color ()." p5.js. https://p5js.org/reference/#/p5/color.

- "Reference const." p5.js. https://p5js.org/reference/#/p5/const.

- "Reference DOM." p5.js. https://p5js.org/reference/#group-DOM.

- "Reference ellipse ()." p5.js. https://p5js.org/reference/#/p5/ellipse.

- "Reference frameCount." p5.js. https://p5js.org/reference/#/p5/frameCount.

- "Reference Events." p5.js. https://p5js.org/reference/#group-Events.

- "Reference image()." p5.js. https://p5js.org/reference/#/p5/image.

- "Reference loadJSON()." p5.js. https://p5js.org/reference/#/p5/loadJSON.

- "Reference loadPixels()." p5.js. https://p5js.org/reference/#/p5/loadPixels.

- "Reference millis ()." p5.js. https://p5js.org/reference/#/p5/millis.

- "Reference p5. Element." p5.js. https://p5js.org/reference/#/p5.Element.

- "Reference p5.sound library." p5.js. https://p5js.org/reference/#/libraries/p5.sound.

- "Reference print ()." p5.js. https://p5js.org/reference/#/p5/print.

- "Reference push ()." p5.js. https://p5js.org/reference/#/p5/push.

- "Reference random ()." p5.js. https://p5js.org/reference/#/p5/random.

- "Reference splice()." p5.js. https://p5js.org/reference/#/p5/splice.

- "Reference Transform." p5.js. https://p5js.org/reference/#group-Transform.

- "Request A GIPHY API Key." GIPHY Support. https://support.giphy.com/hc/en-us/articles/360020283431-Request-A-GIPHY-API-Key.

- Robinson, Derek. "Function." In *Software Studies*. Edited by Matthew Fuller, 101–109. Cambridge, MA: The MIT Press, 2008.

- ———. "Variables." In *Software Studies*. Edited by Matthew Fuller, 260–266. Cambridge, MA: The MIT Press, 2008.

- Rushkoff, Douglas. *Program or Be Programmed: Ten Commandments for a Digital Age*. New York: OR books, 2010.

- Risam, Roopika. *The Poetry of Executable Code*. Last updated April 5, 2015. http://jacket2.org/commentary/poetry-executable-code.

- Rouvroy, Antoinette. "Algorithmic Governmentalities and the End(s) of Critique." The Institute for Network Cultures. Lecture. (October 2013).

- ———. "Technology, Virtuality and Utopia: Governmentality in an Age of Autonomic Computing." In *Autonomic Computing and Transformations of Human Agency*. Edited by Mireille Hildebrandt and Antoinette Rouvroy. London: Routledge, 2011.

- Sack, Warren. *The Software Arts*. Cambridge, MA: The MIT Press, 2019.

- Samuel, Arthur L. "Some studies in machine learning using the game of checkers." *IBM Journal of research and development* 3, no.3 (July 1959).

- Saragih, Jason M., Simon Lucey, and Jeffrey F. Cohn. "Face Alignment Through Subspace Constrained Mean-shifts." Presented at the IEEE 12th International Conference on Computer Vision. Kyoto, JP: 2009.

- Schneider, Karin, and Begum Yasar, eds., *Situational Diagram*. New York, NY: Dominique Lévy, 2016.

- Severance, Charles. "Javascript: Designing a Language in 10 Days." IEEE Computer Society. February (2012): 7-8.

- Shiffman, Daniel. "1.1: Code! Programming for Beginners with p5.js." YouTube video, 13:10. *The Coding Train*. September 5, 2018. https://www.youtube.com/watch?v=yPWkPOfnGsw&list=PLRqwX-V7Uu6Zy51Q-x9tMWIv9cueOFTFA&index=2.

- ———. "1.1: Introduction - p5.js Tutorial." YouTube video, 12:05. *The Coding Train*. September 1, 2015. https://www.youtube.com/watch?v=8jOUDiN7my4&list=PLRqwX-V7Uu6Zy51Q-x9tMWIv9cueOFTFA.

- ———. "1.3: Shapes & Drawing - p5.js Tutorial." YouTube Video, 25:46. *The Coding Train*. September 7, 2018. https://www.youtube.com/watch?v=c3TeLi6Ns1E&list=PLRqwX-V7Uu6Zy51Q-x9tMWIv9cueOFTFA&index=4.

- ———. "1.4: Color - p5.js Tutorial." YouTube Video, 17:25. *The Coding Train*. September 10, 2018. https://www.youtube.com/watch?v=riiJTF5-N7c&list=PLRqwX-V7Uu6Zy51Q-x9tMWIv9cueOFTFA&index=5.

- ———. "2.1: Variables in p5.js (mouseX, mouseY) - p5.js Tutorial." YouTube Video, 12:23. *The Coding Train*. September 4, 2015. https://www.youtube.com/watch?v=RnSOYNuLfQQ&list=PLRqwX-V7Uu6Zy51Q-x9tMWIv9cueOFTFA&index=8.

- ———. "2.2: Variables in p5.js (Make your own) - p5.js Tutorial." YouTube Video, 12:23. *The Coding Train*. September 4, 2015. https://www.youtube.com/watch?v=Bn_B3T_Vbxs&list=PLRqwX-V7Uu6Zy51Q-x9tMWIv9cueOFTFA&index=9.

- ———. "2.3: JavaScript Objects - p5.js Tutorial." YouTube Video 9:23. *The Coding Train*. September 4, 2015. https://www.youtube.com/watch?v=-e5h4IGKZRY&list=PLRqwX-V7Uu6Zy51Q-x9tMWIv9cueOFTFA&t=0s.

- ———. "3.1: Introduction to Conditional Statements - p5.js Tutorial." YouTube video, 11:30. *The Coding Train*. September 10, 2015. https://www.youtube.com/watch?v=1Osb_iGDdjk.

- ———. "3.2: The Bouncing Ball - p5.js Tutorial." YouTube video, 7:34. *The Coding Train*. September 11, 2015. https://www.youtube.com/watch?v=LO3Awjn_gyU.

- ———. "3.3: Else and Else if, AND and OR - p5.js Tutorial." YouTube video, 16:55. *The Coding Train*. September 11, 2015. https://www.youtube.com/watch?v=r2S7j54l68c.

- ———. "3.4: Boolean Variables - p5.js Tutorial." YouTube video, 19:38. *The Coding Train*. September 11, 2015. https://www.youtube.com/watch?v=Rk-_syQluvc.

- ———. "4.1: while and for Loops - p5.js tutorial." YouTube video, 13:50. *The Coding Train*. September 11, 2015. https://www.youtube.com/watch?v=cnRD9o6odjk.

- ———. "4.2: Nested Loops - p5.js Tutorial." YouTube video, 9:23. *The Coding Train*. September 11, 2015. https://www.youtube.com/watch?v=1c1_TMdf8b8.

- ———. "5.1: Function Basics - p5.js Tutorial." YouTube video, 12:34. *The Coding Train*. September 17, 2015. https://www.youtube.com/watch?v=wRHAitGzBrg.

- ———. "5.2: Function Parameters and Arguments - p5.js Tutorial." YouTube video, 10:31. *The Coding Train*. September 17, 2015. https://www.youtube.com/watch?v=zkc417YapfE.

- ———. "5.3: Functions and Return - p5.js Tutorial." YouTube video, 7:26. *The Coding Train*. September 17, 2015. https://www.youtube.com/watch?v=qRnUBiTJ66Y.

- ———. "6.1: Introduction to Object-Oriented Programming with ES6 - p5.js Tutorial." YouTube video, 1:57. *The Coding Train*." October 6, 2017. https://www.youtube.com/watch?v=xG2VbnvOwvg&list=PLRqwX-V7Uu6Zy51Q-x9tMWIv9cueOFTFA&index=23.

- ———. "6.2: Classes in JavaScript with ES6 - p5.js Tutorial." YouTube video, 20:08. *The Coding Train*. October 6, 2017. https://www.youtube.com/watch?v=T-HGdc8L-7w&list=PLRqwX-V7Uu6Zy51Q-x9tMWIv9cueOFTFA&index=24.

- ———. "6.3: Constructor Arguments with Classes in JavaScript - p5.js Tutorial." YouTube video, 7:49. *The Coding Train*. October 9, 2017. https://www.youtube.com/watch?v=rHiSsgFRgx4&list=PLRqwX-V7Uu6Zy51Q-x9tMWIv9cueOFTFA&index=25.

- ———. "7.1: What is an array? - p5.js Tutorial." YouTube video, 13:48. *The Coding Train*. October 2, 2015. https://www.youtube.com/watch?v=VIQoUghHSxU&list=PLRqwX-V7Uu6Zy51Q-x9tMWIv9cueOFTFA&t=0s.

- ———. "7.2: Arrays and Loops - p5.js Tutorial." YouTube video, 8:08. *The Coding Train*. October 2, 2015. https://www.youtube.com/watch?v=RXWO3mFuW-I&list=PLRqwX-V7Uu6Zy51Q-x9tMWIv9cueOFTFA&index=28.

- ———. "7.3: Arrays of Objects - p5.js Tutorial." YouTube video, 14:21. *The Coding Train*. October 10, 2017. https://www.youtube.com/watch?v=fBqaA7zRO58&list=PLRqwX-V7Uu6Zy51Q-x9tMWIv9cueOFTFA&index=29.

- ———. "9.15: 2D Arrays in JavaScript - p5.js Tutorial." YouTube video, 12:37. *The Coding Train*. July 18, 2016. https://www.youtube.com/watch?v=OTNpiLUSiB4.

- ———. "10.1: Introduction to data and APIs in JavaScript – p5.js Tutorial." YouTube video, 12:49. *The Coding Train*. October 30, 2015. https://www.youtube.com/watch?v=rJaXOFfwGVw&list=PLRqwX-V7Uu6a-SQii4RtIwuOrLJGnelOr&index=1.

- ———. "10.2: What is JSON? Part 1 – p5.js Tutorial." YouTube video, 15:55. *The Coding Train*. October 30, 2015. https://www.youtube.com/watch?v=_NFkzw6oFtQ&list=PLRqwX-V7Uu6a-SQii4RtIwuOrLJGnelOr&index=2.

– ———. "10.3: What is JSON? Part II - p5.js Tutorial." YouTube video, 16:09. *The Coding Train*. October 30, 2015. https://www.youtube.com/watch?v=118sDpLOClw&list=PLRqwX-V7Uu6a-SQil4RtIwuOrLJGnelOr&index=3.

– ———. "10.5: Working with APIs in Javascript – p5.js Tutorial." YouTube video, 15:11. *The Coding Train*. October 30, 2015. https://www.youtube.com/watch?v=ecT4206I_WI.

– ———. "10.9: New York times API and JavaScript – p5.js Tutorial." YouTube video, 15:18. *The Coding Train*. November 30, 2015. https://www.youtube.com/watch?v=lMne3LY4bks&list=PLRqwX-V7Uu6a-SQil4RtIwuOrLJGnelOr&index=9.

– ———. "10.10: The Giphy API and JavaScript - p5.js Tutorial." YouTube video, 15:02. *The Coding Train*. November 5, 2015. https://www.youtube.com/watch?v=mj8_w11MvH8&index=10&list=PLRqwX-V7Uu6a-SQil4RtIwuOrLJGnelOr.

– ———. "15.1: What is Node.js? - Twitter Bot Tutorial." YouTube video, 15:12. *The Coding Train*. November 12, 2015. https://www.youtube.com/watch?v=RF5_MPSNAtU&index=1&list=PLRqwX-V7Uu6atTSxoRiVnSuOn6JHnq2yV.

– ———. "15.2: What is NPM? - Twitter Bot Tutorial." YouTube video, 13:26. *The Coding Train*. November 13, 2015. https://www.youtube.com/watch?v=s70-Vsud9Vk.

– ———. "Beginning Guide to Machine Learning in JavaScript." YouTube Video Series, 26 episodes, 7:41:00. *The Coding Train*. Last updated February 22, 2020. https://www.youtube.com/playlist?list=PLRqwX-V7Uu6YPSwTO6y_AEYTqIwbeam3y.

– ———. "Coding Challenge #3: The Snake Game." YouTube video, 27:26. *The Coding Train*. April 20, 2016. https://www.youtube.com/watch?v=AaGK-fj-BAM.

– ———. "Coding Challenge #31: Flappy Bird." YouTube video, 21:44. *The Coding Train*. August 10, 2016. https://www.youtube.com/watch?v=cXgA1d_E-jY.

– ———. "Coding Challenge #75: Wikipedia API.", YouTube video, 24:50. *The Coding Train*. September 25, 2017. https://www.youtube.com/watch?v=RPz75gcHj18.

– ———. "Programming from A to Z Twitter API and Twitter Bots." Shiffman.net, accessed June 20, 2020. http://shiffman.net/a2z/twitter-bots/.

– ———. "Two-dimensional Arrays." Processing, accessed June 20, 2020. https://processing.org/tutorials/2darray/.

– ———. "Working with data, The Coding Train." YouTube video, 12 videos series. *The Coding Train*. October 5, 2017. https://www.youtube.com/playlist?list=PLRqwX-V7Uu6a-SQil4RtIwuOrLJGnelOr.

– Silver, David, Julian Schrittwieser, Karen Simonyan, Ioannis Antonoglou, Aja Huang, Arthur Guez, Thomas Hubert, Lucas Baker, Matthew Lai, Adrian Bolton, Yutian Chen, Timothy Lillicrap, Fan Hui, Laurent Sifre, George van den Driessche, Thore Graepel, and Demis Hassabis. "Mastering the Game of Go without Human Knowledge." *Nature* 550, no. 7676 (October 19, 2017): 354 – 59.

– "Simple Shapes." p5.js. https://p5js.org/examples/hello-p5-simple-shapes.html.

– Snelting, Femke. "Other Geometries." *transmediale journal* 3. Last updated October 31, 2019. https://transmediale.de/content/other-geometries.

– Snodgrass, Eric, and Winnie Soon. "API practices and paradigms: Exploring the protocological parameters of APIs as key facilitators of sociotechnical forms of exchange." *First Monday* 24 (January 2019). https://doi.org/10.5210/fm.v24i2.9553.

– Sollfrank, Cornelia. ed. *Beautiful Warriors: Technofeminist Praxis in the Twenty–First Century*. New York, NY: Autonomedia/Minor Compositions, 2019.

– ———. "Hacking the Art Operating System." Interviewed by Florian Cramer. Chaos Computer Club, Berlin. December 2001. http://www.artwarez.org/uploads/media/09_Sollfrank-Cramer-Interview.pdf.

– Søndergaard, Marie Louise Juul, and Lone Koefoed Hansen. "Intimate Futures: Staying with the Trouble of Digital Personal Assistants through Design Fiction." Presented at the Dis '18: Proceedings of the 2018 Designing Interactive Systems Conference. Hong Kong, China. Association for Computing Machinery, 2018.

– Soon, Winnie. *Executing Liveness: An Examination of the Live Dimension of Code Inter–actions in Software (Art) Practice*. PhD dissertation, Aarhus University, 2016.

– ———. "A Report on the Feminist Coding Workshop in p5.js." *Aesthetic Programming*, Last updated November 30, 2017. http://aestheticprogramming.siusoon.net/articles/a-report-on-the-feminist-coding-workshop-in-p5-js/.

– ———. "Throbber: Executing Micro-temporal Streams." In *Computational Culture* 7. Published October 21, 2019. http://computationalculture.net/throbber-executing-micro-temporal-streams/.

– ———. "Vocable Code." *MAI: Feminism and Visual Culture* 2 (November 10, 2018). https://maifeminism.com/vocable-code/.

– Soon, Winnie, and Geoff Cox. "Vocable Code." Presented at the Artistic Research Will Eat Itself: Proceedings of the 9th International Conference on Artistic Research. Society for Artistic Research. University of Plymouth, UK, April 2018.

– Spender, Dan. *Man–Made Language*. Abingdon, UK: Routledge & Kegan Paul, 1980. https://www.marxists.org/reference/subject/philosophy/works/ot/spender.htm.

– Stark, Luke. "Facial recognition, emotion and race in animated social media." *First Monday* 23. September (2018).

– "Start building with the power of Pexels." Pexels. https://www.pexels.com/api/.

– Stein, Dorothy. ed. *Ada: A Life and a Legacy: History of Computing*. Cambridge, MA: The MIT Press, 1985.

- Steyerl, Hito. "A Sea of Data: Pattern Recognition and Corporate Animism (Forked Version)." In *Pattern Discrimination*. Edited by Clemens Apprich, Florian Cramer, Wendy Hui Kyon Chun, and Hito Steyerl, 1-22. Lüneburg: Meson Press, 2018.

- Stiegler, Bernard, and Irit Rogoff. "Transindividuation." *e—flux* 14 (March 2010). https://www.e-flux.com/journal/14/61314/transindividuation/.

- Suchman, Lucy. *Human—Machine Reconfigurations: Plans and Situated Actions*. Cambridge: Cambridge University Press, 2007.

- Sutton, Richard S., and Andrew Barto. *Reinforcement Learning: An Introduction*. Cambridge, MA: The MIT Press, 1998.

- Sweeney, Miriam E., and Kelsea Whaley. "Technically White: Emoji Skin-tone Modifiers as American Technoculture." *First Monday* 24, July (2019).

- "Systemics #2: As we may think (or, the next world library)." Exhibition curated by Joasia Krysa at Kunsthal Aarhus, *e—flux*. Last modified November 7, 2013. https://www.e-flux.com/announcements/31936/systemics-2-as-we-may-think-or-the-next-world-library/.

- "The Cambridge Analytica Files." *The Guardian*. https://www.theguardian.com/news/series/cambridge-analytica-files.

- "The Tower of Babel." *Genesis* 2, no. 19 & 11, no. 1-9.

- Terranova, Tiziana. "Red Stack Attack! Algorithms, Capital and the Automation of the Common." *EuroNomade*. Last updated March 8, 2014. http://www.euronomade.info/?p=2268.

- Titcomb, James. "New 'gender equality' emoji to show women at work." *The Telegraph*. Last updated July 15, 2016. https://www.telegraph.co.uk/technology/2016/07/15/new-gender-equality-emoji-to-show-women-at-work/.

- Torvalds, Linus, and David Diamond. *Just for Fun: The Story of an Accidental Revolutionary*. Knutsford: Texere Publishing, 2001.

- Truckenbrod, Joan. "Joan Truckenbrod." Vimeo, 4:29. Last Updated August 27, 2018. https://vimeo.com/286993496.

- Tsing, Anna Lowenhaupt. *The Mushroom at the End of the World: On the Possibility of Life in Capitalist Ruins*. Princeton, NJ: Princeton University Press, 2017.

- Turing, Alan Mathison. "The Chemical Basis of Morphogenesis." *Philosophical Transactions of the Royal Society of London B*, (August 14, 1952): 37-72.

- ———. "Computing Machinery and Intelligence." *Mind* 49 (1950): 433-460.

- ———. "On Computable Numbers, with an Application to the Entscheidungs problem." Proceedings of the London Mathematical Society 2, no. 1 (1937): 230-265.

- Umali, Teressa. "Exclusive: Promoting Digital Literacy in the Philippine Education System." OpenGov Asia. Last updated August 8, 2019. https://www.opengovasia.com/promoting-digital-literacy-in-the-philippine-education-system/.

- Univac, Remington-Rand. *FLOW—MATIC Programming System*. Philadelphia, PA: Remington Rand Univac, Division of Sperry and Corporation, 1958.

- Vee, Annette. *Coding Literacy: How Computer Programming Is Changing Writing*. Cambridge, MA: The MIT Press, 2017.

- Valenzuela, Cristóbal. "Paperspace/training-lstm." Github. https://github.com/Paperspace/training-lstm.

- w3schools.com. "CSS Buttons." https://www.w3schools.com/csS/css3_buttons.asp.

- Wardrip-Fruin, Noah. "Christopher Strachey: The First Digital Artist?." *Grand Text Auto*, School of Engineering, University of California Santa Cruz (1 August 2005).

- ———. *Expressive Processing: Digital Fictions, Computer Games, and Software Studies*. Cambridge, MA: The MIT Press, 2012.

- Watz, Marius. "Beautiful Rules: Generative Models of Creativity." in *The Olhares de Outono* (2007). https://vimeo.com/26594644.

- "Weather." p5.js. https://p5js.org/examples/hello-p5-weather.html.

- "Web Maps JavaScript API Overview." Google Maps Platform, Google Developers. Last updated July 9, 2020. https://developers.google.com/maps/documentation/javascript/.

- Wei Ho, Chih et al. "Examining the impact of pair programming on female students." North Carolina State University. Dept. of Computer Science (2004).

- Weizenbaum, Joseph. "ELIZA—a Computer Program for the Study of Natural Language Communication between Man and Machine." *Communications of the ACM* 9, no. 1 (1996): 36-45.

- West, Sarah Myers, Meredith Whittaker, and Kate Crawford. "Discriminating Systems: Gender, Race and Power in AI." AI Now Institute, New York University, April (2019). https://ainowinstitute.org/discriminatingsystems.html.

- "what is the abbreviation of GIT? [closed]." *Stack Overflow*. https://stackoverflow.com/questions/43959748/what-is-the-abbreviation-of-git.

- "Wikipedia: Tay (bot)." Wikimedia Foundation. Last modified June 20, 2020, 17:03. https://en.wikipedia.org/wiki/Tay_(bot).

- "Wikipedia: Unicode." Wikimedia Foundation. Last modified July 7, 2020, 9:32. https://en.wikipedia.org/wiki/Unicode#Origin_and_development.

- Williams, Raymond. *Keywords: A Vocabulary of Culture and Society*. London: Fontana, 1983.

- Witt, Steve. "Chinese Characters as Ancient "Emoji", *Glocal Notes*, 2015. https://publish.illinois.edu/iaslibrary/2015/10/21/chinese-characters/.

- Wing, Jeannette M.. "Computational Thinking," *Commun. ACM* 49, no. 3 (March 2006): 33-35.

- Zuboff, Shoshana. *The Age of Surveillance Capitalism: The Fight for a Human Future at the New Frontier of Power*. New York: PublicAffairs, 2019.

- ———. "Shoshana Zuboff on Surveillance Capitalism | VPRO Documentary." Youtube video, 49:59. Posted by "vpro documentary," December 20, 2019. https://youtu.be/hIXhnWUmMvw.

List of Projects

Showcase of students projects can be found at
https://gitlab.com/aesthetic-programming/book/-/blob/master/source/showcase.md.

- "A hackable text editor for the 21st Century." Atom.
 https://atom.io/.

- "atom-live-server-package." Atom.
 https://atom.io/packages/atom-live-server.

- Bell, John P. *Asterisk Painting*. n.d.
 http://www.johnpbell.com/asterisk-painting/.

- Blas, Zach. *Facial Weaponization Suite*. 2011-14.
 http://www.zachblas.info/works/facial-weaponization-suite/.

- Bouse, Brad. *Solving Sol*. n.d. Last updated July 14, 2020.
 https://github.com/wholepixel/solving-sol.

- Breeze, Mez. *MEZANGELLE*. 1994 – ongoing.
 https://anthology.rhizome.org/mez-breeze.

- Burnham, Jack. "Software – Information Technology: Its New
 Meaning for Art." Exhibition at the Jewish Museum, New York, NY,
 September 16 – November 8, 1970, and Smithsonian Institution,
 Washington, D.C., December 16, 1970 – February 14, 1971.

- "Call for Works 2015: CAPTURE ALL." transmediale / art &
 digitalculture. https://transmediale.de/content/call-for-works-
 2015.

- Chicau, Joana, and Jonathan Reus. *Anatomies of Intelligence &
 the Concept of Aesthesis*.
 https://anatomiesofintelligence.github.io/.

- ———. "Anatomies of Intelligence." NN Cluster initiative, Aarhus
 University, 2019.
 https://anatomiesofintelligence.github.io/workshop_presentati
 on.html.

- Choi, Taeyoon. *Signing Coders*. Ongoing.
 http://taeyoonchoi.com/soft-care/signing-coders/.

- Cirio, Paolo, Alessandro Ludovico, and UBERMORGEN. 2005. "GWEI –
 Google Will Eat Itself." https://www.gwei.org/index.php.

- Cox, Geoff, and Duncan Shingleton. *hallo welt!* (hello world!). Last
 updated July 1, 2008. http://www.anti-thesis.net/hello-world-
 60/.

- Cramer, Florian. "I Love You [rev-eng]." 2006. Digital Craft.org.
 Exhibition, Kulturbüro. http://www.digitalcraft.org/iloveyou/.

- Conway, John Horton. "The Game of Life." 1970. Internet Archive
 Wayback Machine.
 https://web.archive.org/web/20181007111016/http://web.sta
 nford.edu/~cdebs/GameOfLife/.

- db-db-db (aka Francis Lam). "Tofu Go!" 2012. Apple App Store.
 https://apps.apple.com/us/app/tofu-go/id441704812.

- Dullaart, Constant. "DVD guy MVI_9443.AVI." YouTube video, 1:00.
 Posted by "Constantdullaart." January 14, 2019.
 https://www.youtube.com/playlist?
 list=PLCUGKK4FUkbMdnNii8qoRy9_tMvqE8XHB.

- ———. "Nein Gag." Panke Gallery, Berlin. March – April 2019.
 http://www.upstreamgallery.nl/news/545/constant-dullaart-
 solo-show-nein-gag-at-panke-gallery-berlin.

- Fan, Lai-Tze, and Nick Montfort. "Dial." *The New River: A Journal
 of Digital Art and Literature*. Spring 2020.
 http://thenewriver.us/dial/.

- Fiebrink, Rebecca. *Wekinator*. 2009. http://www.wekinator.org/.

- Fiola, Joseph. "JosephFiola/GenArt." 2016.
 https://github.com/JosephFiola/GenArt.

- Freeke, Saskia. "All the Daily Things." 2018. Vimeo, 06:30. January 2,
 2019. https://vimeo.com/309138645.

- "Friendly Machine Learning for the Web." ml5.js, accessed June 20,
 2020. https://ml5js.org/.

- Giardina Papa, Elisa. *The Cleaning of Emotional Data*. 2020.
 https://aksioma.org/cleaning.emotional.data/.

- Gross, Benedikt, Bohnacker, Hartmut, Laub, Julia, Lazzeroni,
 Claudius. "Generative Design Sketches." n.d.
 http://www.generative-gestaltung.de/2/.

- Grosser, Ben. "Eat Food Not Bombs." 2019.
 https://editor.p5js.org/bengrosser/full/Ml3Nj2X6w.

- ———. *Facebook Demetricator*. 2012-present.
 https://bengrosser.com/projects/facebook-demetricator/.

- ———. *Instagram Demetricator*. 2018.
 https://bengrosser.com/projects/instagram-demetricator/.

- ———. *Twitter Demetricator*. 2018.
 https://bengrosser.com/projects/twitter-demetricator/.

- Hanafi, Amira. *Mexicans in Canada*. 2020.
 http://amiraha.com/mexicansincanada/.

- Harwood, Graham. "Class Library." In Software Studies. Edited by
 Matthew Fuller, 37–39. Cambridge, MA: MIT Press, 2008.

- Hatcher, Ian. *The All-New*. Boston, MA: Anomalous Press, 2015.
 http://anomalouspress.org/books/all-new.php.

- ———. *Not Not*. 2016. MP3 audio, 6:30.
 https://soundcloud.com/ihatch/5-notnot.

- Hoff, Melanie. *Digital Love Languages ♡ Codes of Affirmation*,
 at the School for Poetic Computation Online,
 2020. http://lovelanguages.melaniehoff.com/syllabus/>.

- ———. *Generative Tarot*. 2019.
 https://www.melaniehoff.com/generativetarot/.

- Horikawa, Junichiro. *20200509_lifeline*. 2020.
 https://www.openprocessing.org/sketch/891619.

– Howe, Daniel. *RiTa library*. 2006-ongoing.
http://rednoise.org/rita/.

– Huang, Lingdong. *wenyan-lang*. 2019. https://wy-lang.org/.

– Kazemi, Darius. "Corpora - A repository of JSON files." Last updated
May 19, 2020.
https://github.com/dariusk/corpora/tree/master/data.

– Kearney-Volpe, Claire, Govindarajan, Mathura, and Morales-Navarro,
Luis. *p5.js Web Editor*. 2018. https://editor.p5js.org/.

– Kearney-Volpe, Claire. "p5.js access project."
https://www.clairekv.com/p5js-ux-research.

– Knowles, Alison, and James Tenney. *A House of Dust*. 1967. Re-
implemented by Nick Montfort. *For Memory Slam*. 2014.
https://nickm.com/memslam/a_house_of_dust.html.

– Laczko, Juli. *webmachines*, Digital Power, ACM SIGGRAPH, 2020.
https://digital-power.siggraph.org/piece/webmachine/.

– Landsteiner, Norbert. *ELIZA Terminal*. 2005.
https://www.masswerk.at/elizabot/eliza.html.

———. *Eliza Test*. 2005.
https://www.masswerk.at/elizabot/eliza_test.html.

– Le Witt, Sol. *Wall Drawing #289*. 1976.

– Li, Fei-Fei, Jia Deng, Olga Russakovsky, Alex Berg, Kai Li. *ImageNet*.
Last updated 2016. http://image-net.org/.

– Link, David. *Love Letters_1.0: MUC=Resurrection. A
Memorial*. 2009. Exhibited dOCUMENTA(13), Kassel, 2012.
http://www.alpha60.de/art/love_letters/.

– Lorusso, Silvio. *The Best is Yet to Come*. 2012.
https://silviolorusso.com/work/the-best-is-yet-to-come/.

– Malevé, Nicolas. *Exhibiting ImageNet*, The Photographers
Gallery, July 1 – September 13, 2019.
https://thephotographersgallery.org.uk/whats-on/digital-
project/exhibiting-imagenet.

———. *12 Hours of ImageNet*. Premiered on 5 Nov 2019.
https://www.youtube.com/watch?v=PC60JL-IMzA.

– McCarthy, Lauren. *p5.js*. 2014. https://lauren-mccarthy.com/p5-
js.

———. *LAUREN*. 2017. https://lauren-mccarthy.com/LAUREN.

– Montfort, Nick. *Memory Slam*. 2014.
https://nickm.com/memslam/.

– Nagayama, Tomokazu (@nagayama). "すべりこみ," Twitter, April 3,
2020, 4:44 p.m..
https://twitter.com/nagayama/status/1246086230497845250
?s=19.

———. "daily coding," Github.
https://github.com/nagayama/dailycoding/blob/master/202
0/04/03.html.

– Node.js, Open JS Foundation. https://nodejs.org/en/.

– Old Boys Network (OBN). https://www.obn.org/.

– Open Source Publishing (OSP). http://osp.kitchen/.

– Øygard, Audun M. *clmtrackr*. 2017.
https://github.com/auduno/clmtrackr.

– Pritchard, Helen, and Winnie Soon. *Recurrent Queer
Imaginaries*. Exhibition Research Lab, Liverpool John Moores
University — School of Art and Design, November 2019 – January
2020. https://www.exhibition-research-
lab.co.uk/exhibitions/recurrent-queer-imaginaries/.

———. *Recurrent Queer Imaginaries*, Digital Power, ACM
SIGGRAPH, 2020, https://digital-
power.siggraph.org/piece/recurrent-queer-imaginaries/.

– Process Studio. *Aimoji*. 2019.
https://process.studio/works/aimoji-ai-generated-emoji/.

– "processing/p5.js." Github.
https://github.com/processing/p5.js/wiki.

– Queer AI. https://queer.ai/.

– Read_me Festival 1.2. "Software art / software art games." Festival
at the Macros-center, Moscow, May 18 - May 19, 2002.
http://readme.runme.org/1.2/.

– Read_me Festival 2.3. "Software art festival." Festival at the Media
Centre Lume, Helsinki, May 30 - May 31, 2003. http://www.m-
cult.org/read_me/.

– Read_me Festival 2004. "Software art festival." Aarhus, August 23 -
August 27, 2004. http://readme.runme.org/2004/.

– Readme100. "Temporary Software Art Factory." Festival at the
State and City Library of Dortmund, Dortmund, November 4 -
November 5, 2005. http://readme.runme.org/.

– Reas, Casey. *{Software}Structure #003A*. 2004.
https://whitney.org/exhibitions/programmed?
section=1&subsection=6#exhibition-artworks.

– *ReCode Project*. 1976-78. http://recodeproject.com/.

– Reinfurt, David. *Multi*. 2015. http://www.o-r-g.com/apps/multi.

– Rozendaal, Rafaël. *Sleep Mode: The Art of the Screensaver*. Het
Nieuwe Instituut, Rotterdam. 2017.
https://hetnieuweinstituut.nl/en/press-releases/sleep-mode-
art-screensaver.

– Runme.org. http://runme.org/.

– Sayo, Yurika (@sayo), *Tanabata (七夕)*. Open Processing. n.d.
https://www.openprocessing.org/sketch/926326.

– Savičić, Gordan. *LOADING (THE BEAST 6:66/20:09)*.
October 2009.
https://www.yugo.at/processing/archive/index.php?
what=loading.

– School for Poetic Computation. https://sfpc.io/.

– Shi, Yining. "p5.playground: an Interactive Programming Tool for
p5.js." 2016. https://1023.io/p5-inspector/.

– Sollfrank, Cornelia. *Female Extension*. 1997.
http://www.artwarez.org/femext/index.html.

———. *Net.Art Generator*. 1997-ongoing. http://net.art-
generator.com/.

– Soon, Winnie. *Asterisk Painting* ported to p5.js, and modified.
Last updated October 12, 2019.
https://editor.p5js.org/siusoon/sketches/YAk1ZCieC.

– ———. *nonsense*, 2015. http://siusoon.net/nonsense/.

– ———. *Throb*. Last updated April 11, 2019. http://siusoon.net/throb/.

– ———. *Vocable Code (Education/live coding version)*. Last updated May 5, 2020. https://dobbeltdagger.net/VocableCode_Educational/.

– Soon, Winnie, and Helen Pritchard. *Queer Motto API – To know exactly how many times to cry*, 2021. http://siusoon.net/queer-motto-api.

– Støg, Use All Five, and PAIR teams. *Teachable Machine 1.0*. 2017. https://teachablemachine.withgoogle.com/v1/.

– Surma, Greg. *Text Predictor*. 2018. https://github.com/gsurma/text_predictor.

– Temkin, Daniel. *esoteric.codes*. 2011. https://esoteric.codes/.

– "The first single application for the entire DevOps lifecycle - GitLab | GitLab." GitLab. https://about.gitlab.com/.

– Truckenbrod, Joan. *Coded Algorithmic Drawing Series*. Digital Photographic Layered Textiles, 2001. https://joantruckenbrod.com/gallery/#(grid|filter)=.coded.

– UBERMORGEN, *The Project Formerly Known as Kindle Forkbomb*. 2013. Wikimedia foundation. Last modified May 4, 2020. https://en.wikipedia.org/wiki/The_Project_Formerly_Known_As_Kindle_Forkbomb.

– Valenzuela, Cristóbal. "Training a LSTM network." Github. 2018. https://github.com/Paperspace/training-lstm.

– Visti, Anders, and Tobias Stenberg. *WUOS: Wrocław Urban Operating System*. 2019. https://andersvisti.dk/work/wuos-2019.

– Ward, Adrian. *Auto—Illustrator*. 2002. http://www.medienkunstnetz.de/works/autoillustrator/.

– "wholepixel / solving-sol." Github. https://github.com/wholepixel/solving-sol/blob/master/289/cagrimmett/index.html.

– "Wordnet: A Lexical Database for English." Princeton University. https://wordnet.princeton.edu/.

– Žilák, Martin. "recursive fractal tree in p5.js." n.d. https://editor.p5js.org/marynotari/sketches/BJVsL5ylz.

Acknowledgments

RunMe https://aesthetic-programming.gitlab.io/book/p5_SampleCode/acknowledgement/

```
1   //open the web browser console
2
3   let thankYou = [
4       "Each other \
5       - for an excellent collaboration",
6
7       "Loren Britton \
8       - for copyediting, and helpful critical comments",
9
10      "Matthew Fuller \
11      - for inspiration, and endorsement",
12
13      "Lauren McCarthy \
14      - for inspiration, and critical comments on the draft",
15
16      "Jennifer Gabrys \
17      - for critical comments on the draft, and endorsement",
18
19      "Søren Pold \
20      - for critical comments on the draft",
21
22      "Open Humanties Press, Gary Hall, Sigi Jöttkandt and David Ottina \
23      - in support of publishing in experimental form",
24
25      "Open Source Publishing, Stéphanie Vilayphiou and Gijs de Heij \
26      - for design and workshopping",
27
28      "p5.js & mL5.js community \
29      - for the contribution of promoting coding and visual Literacy \
30      via open source tools and documentation",
31
32      "Audun M. Øygard \
33      - for providing the open source face tracker Library",
34
35      "Magda TyżLik-Carver and Christian ULrik Andersen \
36      - for teaching Software Studies course in parallel to Aesthetic Programming, \
37      as well as their critical comments on the draft",
38
39      "Instructors of the course - AP: \
40      Frederik Westergaard, Nils Rungholm Jensen, Tobias Stenberg, \
41      Malthe Stavning ErsLev, Ann Karring, Simone Morrison, \
```

Aesthetic Programming

```
42    Nynne Lucca Christianen, Ester Marie Aagaard, and Noah Aamund \
43    - for keeping the class learning momentum and assisting the course",
44
45    "Simon Katan and Theodoros Papatheodorou from Goldsmiths, University of London \
46    - for allowing one of us to observe the programming class across levels",
47
48    "Helen Pritchard \
49    - for ongoing inspiration and collaboration, \
50    and for hosting one of us in order to complete the book at Goldsmiths, University of London",
51
52    "Anders Visti \
53    - for the suggestion to include the example of Langton's Ant, \
54    help on the Live-coding interface of Vocable Code and many other small details",
55
56    "Joan Truckenbrod \
57    - for providing earlier works and discussing her work",
58
59    "Ben Grosser \
60    - for providing information and discussing his work",
61
62    "Joana Chicau and Jonathan Reus \
63    - for the excellent workshop conducted at Aarhus University",
64
65    "John P. Bell \
66    - for permission to reapproriate his artwork",
67
68    "David Reinfurt \
69    - for permission to use Multi",
70
71    "Francis Lam \
72    - for permission to use Tofu Go!",
73
74    "Nicolas Malevé \
75    - for his inspirational work",
76
77    "Cornelia Sollfrank \
78    - for the ongoing dialogues with her inspirational work",
79
80    "Norbert Landsteiner \
81    - for permission to use ELIZA Terminal and ELIZA Test",
82
83    "Daniel Shiffman \
84    - for the excellent online instructional videos",
85
86    "Anyone else we might have forgotten, sorry"
87  ];
88
```

Acknowledgments

```
89  function draw() {
90      frameRate(1);
91      print(random(thankYou));
92  }
```

AESTHETIC PROGRAMMING
A Handbook of Software Studies

Winnie Soon and Geoff Cox

Published by Open Humanities Press 2020
https://openhumanitiespress.org

Liquid Books
Series Editor: Gary Hall

* * *

Web http://www.aesthetic-programming.net

Repository https://gitlab.com/aesthetic-programming/book

ISBN (print) 978-1-78542-094-8

ISBN (PDF) 978-1-78542-093-1

* * *

Published with support from Aarhus University Research Foundation

Designed by Open Source Publishing (Gijs de Heij & Stéphanie Vilayphiou)

Edited by Loren Britton

Printed in the USA
CPSIA information can be obtained
at www.ICGtesting.com
LVHW082321150823
755329LV00009B/374